VITRUVIUS

ON ARCHITECTURE

II

VITRUVIUS

ON ARCHITECTURE

EDITED FROM THE HARLEIAN MANUSCRIPT 2767 AND
TRANSLATED INTO ENGLISH BY
FRANK GRANGER, D.Lit., A.R.I.B.A.
PROFESSOR IN UNIVERSITY COLLEGE, NOTTINGHAM

IN TWO VOLUMES
II

CAMBRIDGE, MASSACHUSETTS
HARVARD UNIVERSITY PRESS
LONDON
WILLIAM HEINEMANN LTD
MCMLXII

First printed 1934
Reprinted 1956, 1962

Printed in Great Britain

PA
6968
.A1
1936
v.2

CONTENTS

CONTENTS

vi

PREFACE TO THE FIRST EDITION

In bringing to completion an attempt to base the text of Vitruvius on a single primary MS. the critical notes below the Latin text of Books VI. to X., continue the evidence of Books I. to V. to the excellence of *H.* While the emphasis of the first five books is upon architecture in the usual sense of the word, the second five books disclose the world of Greek science as a background to engineering and restore the full picture of Vitruvius.

Mr. Frank Richards, M.A., the translator of the *Aeneid*, has given me valuable help in the final revision for the press. Nor must the printer's reader be left without thanks for his continuous and scholarly co-operation.

FRANK GRANGER.

UNIVERSITY COLLEGE,
 NOTTINGHAM,
 July, 1933.

INTRODUCTION

Vitruvius as the Historian of Science

It is only in modern times that Vitruvius has been regarded mainly as an architect, and that attention has been almost concentrated upon his exposition of the orders of architecture to the neglect of the major part of his achievement. Not unnaturally the expectation has been raised that his style should exhibit the qualities of order, arrangement and symmetry which he somewhat confusedly traces in architecture, Book I. ii. 1. If with more propriety we follow tradition and approach him as an engineer, the case is altered. As Caspar Barth [1] well puts it according to Morhof: *est styli genus . . . coactim nimirum eruditionem Graecam sapiens, et manum opificis, non ingenium scriptoris, olens.* "His style in a word combines Greek science with the touch of the craftsman rather than the manner of the writer." In this respect he anticipates the two most universal geniuses of the Renaissance. Michael Angelo's " style is obscure, crabbed, ungrammatical." [2] Again, " Italian scholars declare that Leonardo's grammar is that of the small Florentine shopkeeper." [3] But, for

[1] *Polyhistor*, I, Book IV. xi. 17.
[2] Symonds, *Life of Michelangelo* (1893), Vol. II. 168.
[3] Müntz, *Leonardo da Vinci, tr.* (1898), Vol. II. 22.

all that, he was a brilliant and accurate man of science.[1] Vitruvius, also, illustrates the not infrequent separation of scientific insight from the command of literary expression. Yet his style is well adapted to the needs of the laboratory and workshop.

Like Leonardo, Vitruvius records experiments and their uses : a lighted lamp as a test for foul air in a well, ii. 191; the effects of white lead on those who work it and the consequent danger of lead pipes in the supply of water, ii. 189; the vibration of bronze in response to the use of iron implements in a neighbouring tunnel and the consequent military precautions, ii. 367. Over against such experimental results were the mathematical principles, almost confined to geometry owing to the imperfect notation of numbers, and the resulting cramping of arithmetic. The geometrical achievements of the Greeks were stimulated by the empirical formulae of Egyptian builders and the astronomical observations of the Chaldaeans. But the sense of the universal came first in Hellas to its complete expression and carried geometry no less than metaphysics to levels not often reached in after times and rarely transcended. The inspiration of science no less than that of literature and of art was attributed to the Muses, and Vitruvius adopted this as an article of his creed from a legend about Pythagoras, ii. 203.

The realm of natural science was almost alien to the Athenian mind, so richly endowed in other fields.[2] The *Clouds* of Aristophanes and Plato's *Apology*, exhibit from two angles, that of the con-

[1] Mach, *Science of Mechanics*, tr. (1902), 520.
[2] Diels, *Vorsokratiker*, ii. 83, 116.

INTRODUCTION

servative and that of the moralist the disinclination of the Athenian intellect towards natural science. Plato and Meton are almost the only Athenians whose works appear in the history of science.

Vitruvius, in the preface to Book IX., traces the development of geometry from its beginnings to the solution of the Delian problem, the duplication of the cube. Later on in the same book he enumerates the astronomers in whom he traces the operation of the divine mind, ii. 247. The founders of scientific geography, ii. 175, opened out a subject which still awaits full fruition. If we assign the thinkers whom Vitruvius enumerates to their places of origin we might be led to infer that Asia Minor, Macedonia, Sicily, Southern Italy were more receptive of scientific inspiration than Attica. For the Athenian temper shrank from applying science to the observation of nature, and Plato treated Democritus with silent disapproval, incorporating in the *Timaeus* with the disdain of the abstract thinker, the *specific* observations of Democritus.[1]

The legendary wish of Plato to destroy the works of Democritus was countered for the time by their wide circulation; the catalogue made by Thrasyllus, himself a Platonist, contains evidence not to be neglected of their survival into the first Christian century. Hence the importance of Vitruvius as bridging " the gap between the dominating idealism of Plato and Democritus' rational observation of nature with its anticipation of modern theories." [2] We owe to *H* and its descendant *h* the correct state-

[1] Zeller, *Phil. der. Griechen*, II. i. 791.
[2] Heiberg, *Geschichte der Mathematik u. Naturwissenschaften im Alterthum*, 12.

ment of Democritus' theory of perspective, ii. 71, which follows from his principle that "things" are not real but dependent upon "atoms": a principle which is parallel to the dependence of things upon the Platonic "ideas," ii. 89. It is the presence of Democritean principles in the background of the *de architectura* that rescues it from a purely archaeological interest. Neither Platonism nor the Church is to blame for the disappearance of Democritus, who was represented in the public libraries of the early empire. Like the greater part of the Greek literary tradition, Democritus disappeared in the confusion which followed upon the assassination of Alexander Severus A.D. 235.

VITRUVIUS AS THE HISTORIAN OF MACHINERY

Compared with Greek science, Greek mechanics was in its infancy.[1] The backward state of metallurgy almost limited the mechanical engineer to the occasional use of bronze. Ancient artillery itself was constructed of wood and operated by elastic tension like a bow. Vitruvius carried his manual to the middle of the tenth book before he thus turned from the service of peace to that of war, ii. 325. The practical character of his definitions is shown by the fact that catapults and balistae have been constructed and operated in modern times by following his rules.[2] The plates at the end of this volume show how water-power was applied to clocks and organs and other purposes of peace. The application

[1] Mach, *op. cit.*, 520.
[2] Neuburger, *Technical Arts and Sciences*, 222.

of water-power to time-pieces and automata was controlled by a balancing weight of sand. The principle of equilibrium involved is correctly named by *H*, ii. 275, but has not been so understood by the editors; it furnishes the difficult problem of virtual velocity. More simple cases are found in the principle of the balance, and of the lever. We must be content with this glimpse into ancient mechanics, of which the theoretical importance went far beyond its achievements in practice. Its weakness in this respect was partly compensated by slave labour which was brought in to work the capstans of pulleys, ii. 285; water-wheels, ii. 303; treadmills, ii. 309.

Generally speaking skilled labour seems to have been free, and to have enjoyed a status somewhat higher than in modern times. The precautions taken against poisoning by gases or by lead have a strangely modern sound, like the baths and public libraries which were soon established even in towns of a moderate size all over the empire.

Building artificers were organised into *collegia* or benefit societies and often worked in gangs of ten, *decuriae*, under a foreman, *decurio*. The plasterers, ii. 95, were probably freemen; the paviours may have been slaves, ii. 83. They were engaged and paid by the works manager, *praefectus fabrum*, a term replaced by " architect." Vitruvius contemplates the case in which the owner acts as his own works manager, ii. 9.

He wrote for the foreman and the works manager, and his book sheds a light upon the social conditions of the early empire comparable to that furnished by the New Testament. The evidence furnished by the latter, however, is blurred in the English Authorised

and Revised Versions by the mistranslation of *doulos*, which in the 120 places in which it occurs is never correctly translated " slave " in spite of the Latin versions which always give *servus*. Throughout the N.T. the artificer is usually a freeman,[1] and yet he is repeatedly identified with the slave by the use of " servant " for both the slave and the free employee.

It was the free artificer working for Christian employers who created the early Christian art, which came to perfection by the third century, and anticipated the mediaeval art to which Vitruvius' *de architectura* also served as a manual.

[1] Granger, *Legal Status of Labour in the N.T.* Nottingham, J. and H. Bell, 1933.

VITRUVIUS AND THE
CRAFTSMEN OF ROME[1]

I

THE Roman craftsmen were scarcely disturbed
during the first three centuries of the empire by the
political catastrophes which transformed the Roman
state into an Oriental despotism. They displayed
their traditional skill impartially in the service of
the imperial religion and of the Christian clients
who, as time went on, became its passive opponents.
From Augustus to Diocletian the reigning monarch
was a patron of the arts and added to the archi-
tectural splendours of the capital. Increased know-
ledge has shown that the church itself fostered no
less some of the finest achievements of the Roman
tradition.

Over against this conservatism of the capital and
indeed of the western provinces, Christian buildings
in the east took another turn. For example, the
earliest churches of Old Cairo[2] date at least from
the third century. Similarly, Syria, Asia Minor, and
North-west Africa seem to have preceded the west
generally in the construction of churches as distinct

[1] Many years ago Professor Burkitt called my attention to
Richter and Taylor's *Golden Age of Classical Christian Art*. A
similar thesis is elaborated in the following pages. The his-
torian of Roman Art must include a survey of the Christian
material.

[2] Butler, *Ancient Coptic Churches of Egypt*, 1. 2.

from the use of secular buildings for religious purposes. The eastern architects made large use of domed structures, while the architects of the west were able to develop their designs, with but little variation, from the form of the basilica as the Romans knew it. Against such a background Roman craftsmen, not necessarily Christian, felt themselves at home.

Classical Christian art was thus the prophecy of the new world which was to rise upon the ruin of the empire of Augustus. It is the eastern development of Christian architecture which is the basis of theories like that of Josef Strzygowski, which would derive not only architecture but other forms of Christian craftsmanship from Oriental sources. But while we trace the influence of Roman tradition as formulated by Vitruvius, we vindicate for the west a leading part in the painting, sculpture and minor arts of the first three Christian centuries.

The craftsmen who carried out the commissions of Christian clients enjoyed the protection of the State. For the form of imperial government inaugurated by Augustus, the patron of Vitruvius, was directed towards the supremacy of Roman law, not only as embodying Roman traditions but as allied to the universal principles of justice. It was Stoicism that effected this union and spoke from the Roman throne by the lips of Marcus Aurelius. To be a Roman citizen was to enjoy legal protection, extended to every race within the imperial borders, including Jewish artisans like Paul the tentmaker. We can trace the free craftsmen during this time: the architect and the physician no less than the paviour, the mason, the carpenter. For the empire brought freedom not only to artificers but to pro-

fessional men. Cyrus and Chrysippus, two of Cicero's architects, had been slaves; so too Hyginus, the keeper of the Palatine library under Augustus; so too Antonius Musa, the emperor's physician. But this servile status was a passing circumstance due to the subjection of Greece by Sulla in 86 B.C. In the case of " architects," the Latin equivalent *praefectus fabrum* was often used as an honorific title. The extension of Roman citizenship by Caracalla to all communities in the empire was accompanied by the parallel extension of Roman law, thus completing a process already begun by the Julian emperors.

The Roman craftsmen served the extension of the scheme of empire. Vipsanius Agrippa and Asinius Polio[1] were the two greatest administrators of Augustus, and, between them, determined the material outlines of his great design. In order to understand the picture of the Roman world, we must set them in a higher relief than the historical tradition seems at first sight to admit. Agrippa combined in one person the general, the statesman, the savant, the engineer and the loyal friend of Augustus. Six words of Paterculus make the portrait: *uni parens . . . scientissimus . . . consultis facta coniungens*. Polio is the complement of Agrippa. While Agrippa surveyed the geography of the empire, its roads and cities, Polio assembled the literature and science of the time in the first public library in Rome, and thus " made human genius a common possession." His library was also a museum of sculpture and painting, a precedent which was widely followed. Hence he is coupled as an architect

[1] The spelling varies between Polio and Pollio.

with Vitruvius in the *Epitome* of Faventinus. By an extraordinary blunder "Polio" was regarded as the cognomen of Vitruvius!

For the term "architect" which includes the engineer, is also applied to the controller of libraries. Polio like Agrippa and Vitruvius was one of Pliny's authorities for the *Natural History* so far as that describes the state of the empire, its roads and cities, its background of history and craftsmanship. The loss of Polio's history from 60 B.C. to the battle of Philippi is due perhaps to his hostile criticism of Caesar and Cicero, and to an archaising and rugged style; his masculine grasp of facts, however, left its mark upon later historians—Suetonius, Tacitus, Plutarch,—and his realism was a powerful antidote to the rhetoric in fashion. Through him we understand how Vitruvius and the elder Pliny and above all Augustus himself in the *Monumentum Ancyranum* could dispense with the graces of style in the presence of their mighty theme.

Augustus and Pliny describe the material embodiment of empire as thus realised. Vitruvius furnishes the precepts by which succeeding generations were guided in their undertakings. His work seems at once to have become authoritative, not only as regards the classical orders of Books III. and IV.—his rules, indeed, can be traced in Spain as well as Africa—but rather as a manual of construction and of technical processes generally.

II

The survey of the empire made by Agrippa was exhibited by him in two forms: one in a map (per-

haps plotted on a sphere) in the Porticus Vipsania, the other, by way of description, on the pages of his geographical commentaries. The latter went little beyond statistics, and enumerated the dimensions of known lands and seas, the course of the roads and the sites and distances of cities, as well as of natural features such as rivers and mountains. Agrippa, indeed, furnished much of the material assembled by Pliny the Elder in the geographical books of the *Natural History*, but Pliny often falls into inaccuracy when he leaves the official statistics of the empire. We can trace in his work, however, the material of the itineraries which Vitruvius himself used. The latter defines the position of places by reference to the roads, but we need not assume that he had himself traversed them when he refers to the road to the temple of Ammon [1] or to the road in Cappadocia between Mazaca and Tyana.[2] The rich and, in the main, accurate geographical references of Vitruvius are on a level with the rest of his work. He blends the scientific geography of Greece with the measurements of Roman surveyors and furnishes the description of the hodometer [3] by which distances are measured by sea as well as on land. On land the hodometer supplemented the measurement by paces of which every thousandth was marked, hence the " mile." [4] Vitruvius, in his account of pavements,[5] gives a specification which is appropriate to roads of elaborate construction and uses terms of general application to roadmaking. He also refers to the use of piles upon made ground

[1] Book VIII. iii. 7. [2] Book VIII. iii. 9.
[3] Book X. ix. [4] Strabo, 322.
[5] Book VII. i. 3.

like those driven by Germanicus [1] over the marshes of Westphalia, an expedient often necessary because the Roman engineers went on their way regardless of marshy ground.

Along with the making of roads came the construction of permanent camps (where there were no towns) to mark the route or destination of these military highways. Vitruvius' rules for fortification, and for laying out the spaces so enclosed,[2] are not applicable to the small town formed by a permanent camp. He rather lays down the general principles of town-planning.[3] But there is one feature in Greek and Roman town-planning which escapes the great blemish in modern colonisation, the loneliness of the settler. Instead of sending the separate colonist or group of colonists to settle where chance might conduct, a suitable site was chosen and a large part of the town laid out and constructed. It is true indeed that the colonies in the provinces under the empire were mainly of a military character, but this does not affect the value of the architectural precedent. Of this Timgad is a complete type. It was founded under Trajan A.D. 100 and completed within twenty years. It lay on the road from Theveste to Lambaesis, and the road itself formed the main highway of the town. The architects who were engaged took with them the methods of construction described by Vitruvius, and the soldiers of the Third Legion laboured upon the works which were to furnish them with a military depot and a home.

The beauty of these foundations took account of

[1] Tac. *Ann.* I. 61. [2] Book I. v.
[3] Book I. *cc.* iv, vii; Book II. pref.

practical needs. The successive inventions of the Romans were directed towards the comfort, the warmth and dryness of interiors. The strong brick walls and the few openings which made the private house secure on the outside, passed to the baptistries and basilicas of the church.

The system of heating by " hanging floors " raised upon small pilasters of brick is described by Vitruvius.[1] In the space so formed hot air circulated from a furnace. This contrivance is said to have been invented by L. Sergius Orata,[2] c. 100 B.C. It was first applied to baths and then to private houses. The numerous remains of Roman villas in Britain suggest that in this way the terrors of our English winters were alleviated. Such an invention would naturally commend itself to the Roman victims of malaria like Maecenas, who indeed is credited with the first hot swimming bath. Agrippa extended the luxury of the bath to the populace by leaving to them in his will his gardens and his baths,[3] " so that they might bathe gratis." The baths furnished a popular lounge and were even supplied with libraries,[4] a circumstance in which architectural evidence supplements the silence of literature.

Yet the farm gained also. There is a typical representation on a mosaic in the museum at Tunis. The farm-houses of the earlier republic were finer than houses in the town,[5] but the case was reversed under the empire. Vitruvius, even so, has to warn the farmer against allowing his taste for architectural elegance to interfere with the needs of agriculture.[6]

[1] Book V. x.
[2] Plin. N.H. IX. 168.
[3] Dio Cass. LIV. 29.
[4] Platner, 522.
[5] Varro, R.R. I. xiii. 6.
[6] Book VI. vi.

The decline of the small-holder and the growth of *latifundia* was compensated by the growth of the tenant class, without whom the working of the large estates would have been impossible. The spread of the security which was assured through Roman law brought with it the revival of the country-side. Virgil's picture of the old farmer with his small plot [1] may be taken along with Horace's five tenants who went to market and voted in the elections at Varia.[2] Vitruvius' instructions about farm-houses are suitable for small as well as large farms.[3]

But the contrast between the countryman and the townsman was often present to the Roman mind. Not for the countryman, the resources of the larger towns, the baths, the theatre, the libraries, the rhetorical and poetical displays and—for the more general taste—the games in the amphitheatre. Yet the increasing sense of the beauty of landscape and of pastoral life and the enjoyment of a safe obscurity were motives not without effect. The multiplication of colonies throughout the empire furnished markets for farm produce and so enabled the countryman to pay his way. The municipal storehouses were amongst his best customers.[4]

But where the land was worked by slave labour, the contrast for the slave was all in favour of the town. The slaves who performed their duties in the large houses of the great cities were in some respects better placed than the free craftsman or small trader. In the country, slave labour worked the wine and oil presses,[5] the water-wheels, the

[1] *Geor.* IV. 125 ff. [2] *Ep.* I. 14. 3. [3] Book VI. vi.
[4] Book V. ix. 8. [5] Book VI. vi. 3.

flour-mills.[1] In the town-house, the architect had regard to the convenience of the slave himself.[2]

III

But Roman comfort was carried to the extreme of luxury. And the greatest minds followed in the train of the sensuous grandee. Cicero's palaces were to be found not only in Rome where he bought Crassus' house on the Palatine, but at Tusculum, where he had a magnificent place which once belonged to Sulla. And there were others at Antium where he kept his library: at Astura, a little island off the coast of Latium, where he retreated for solitude, besides country houses at Arpinum and on the coast of Campania. The sculpture and painting of Greece made the contents of his mansions scarcely less costly than the mansions themselves. All this gives point, perhaps intended, to the contrast severely drawn by Horace between the unhappy splendour of the palace by the sea and his own peaceful farm in a Sabine valley. Augustus ranged himself on the side of Horace. His modest house on the Palatine, his furniture, his home-made clothes verged upon the stingy. Yet his public undertakings were splendid. The marble which he claimed to have substituted for brick at Rome refers not less to the incrustation of interiors than to the columns and sculpture outside. As time went on, public amenities grew out of private undertakings. We shall see the municipal library and the Christian basilica springing from the Roman palace. The basilica is

[1] Book X. v. and vi. [2] Book VII. iii. 4; iv. 5.

represented magnificently by Sta. Maria Maggiore and its mosaics.[1]

It is a strange episode in the history of philosophical sects that Horace and Augustus, who represent the simplicity of private life, should have inclined to an Epicurean standpoint, while Seneca, the eminent Stoic moralist, should have overtopped the monarch himself in the amenities of his parks and the magnificence of his country houses.[2] Yet it is possible that Roman taste was not immediately offended by the contrast between the profession of the Stoic creed and Seneca's vast accumulations of wealth. Vitruvius in a striking passage [3] declares that professors of rhetoric must be housed with distinction and in sufficient space to accommodate their audiences, while high officers of state must have parks and majestic avenues of trees and palaces with libraries and basilicas finished in the magnificence of public buildings. In judging Nero, therefore, we are met by the question whether Seneca by declining the "gardens, the money, the country houses lavished on him" [4] by Nero would not have lost some of his influence over his pupil. The same passage of Vitruvius illustrates two episodes in the life of Nero's contemporary, St. Paul. After giving a rhetorical display at Athens which sheds some light on the kind of lecture he was to deliver for nearly four years, he taught for eighteen months at Corinth in the mansion of Titius Justus. He also lectured for two years in the "lounge" *schola* of a wealthy citizen of Ephesus, Tyrannus,[5] who may himself have

[1] Richter and Taylor, *op. cit.* [2] Tac. *Ann.* XIV. 52.
[3] Book VI. v. 2. [4] Tac. *Ann.* XIV. 55.
[5] *Acts* xix. 9.

been a rhetorician. It is noteworthy that the apostle's second and third journeys almost coincided with the five years in which, under the control of a soldier and a rhetorician, the empire was well governed. Paul's experiences on the sea are a striking evidence of the peace which reigned. To the outer world Paul would present himself at first not so much as a teacher of religion but as an example of the numerous and characteristic class of peripatetic orators whose displays were a popular form of entertainment. Their fees were on the scale of those given to a prima donna in our time. We shall see later how the large apartments in which such shows were held, passed easily into the forms of the church-building.

The rhetorical business, therefore, was one of the most profitable of the day. That Christian teachers should generally (but not always) refuse remuneration brought them into line with other cases, relatively few, found especially among the Stoic sect. But these exceptions did not affect the general view. Hence the silversmiths' trade union at Ephesus would regard Paul from the economic standpoint,[1] as a dangerous rival who threatened a business which furnished useful employment to many persons. That the silversmiths raised the cry " religion in danger " was a natural move. Ephesus gained much from the presence of a widely popular shrine, although it is certain that many who shouted the loudest were, as far as Artemis went, disbelievers at heart. The case of the coppersmith, to whom we owe the exquisite works in bronze like those found at Pompeii and elsewhere, was the same with that

[1] *Acts* xix. 25.

of the silversmith. The hostility of Alexander the coppersmith [1] towards St. Paul may have had a business basis. But this conflict between the Church and the craftsman was a local and passing phase. In most places the artisans who became Christians continued at their trade and carried over into Christian art the themes of Greek mythology. They also shared in the reaction against the unreality of the public lecture-room with its veneer of philosophic jargon over a rhetorical background. For their growing realism in building and the allied trades went hand in hand with the science of the day: its experiments which anticipated modern chemistry, its advances in mechanics, its presentation of spatial problems in a geometrical rather than an analytic form.

But the new realism which we shall trace in the development of classical Christian art found its fierce background in the service of the arts towards the maintenance of the Roman empire. Vitruvius the engineer was compelled at the end of his work to " turn from the machines which may be carried out for useful purposes or for amusement in times of peace and tranquillity " to " the inventions which serve both to protect against danger and to satisfy the needs of safety." Such was his interpretation of the military engineering which the empire demanded. [2] Apollodorus, a Greek architect from Damascus, followed this example and after executing some magnificent schemes of Trajan, constructed a military bridge over the Danube for Hadrian, to whom also he dedicated a famous work on siege tactics. The Forum of Trajan had for its focus the

[1] 2 *Tim.* iv. 14.　　　[2] Book X. ix, x.

Column with its spiral relief recording with the detail of a careful historian, and after no long interval, the emperor's Dacian campaigns.

The intention of the sculptors was, so to speak, living portraiture, like the figures at Madame Tussaud's. (It is possible that the column was coloured.) But this masterpiece of realism had been anticipated in the reliefs of the Arch of Titus, in which the figures stood out from the background in such a way as to produce an effect of aerial perspective. The discovery of perspective and its application was made in the time of Pericles.[1] It controlled the dimensions of the Parthenon,[2] revolutionised painting, and affected the working of gems.[3] Perspective anticipated photography in its presentation of the real, and the history of painting and sculpture might be regarded as alternate reactions from, and towards, perspective treatment. In a striking passage Vitruvius demands "imitations taken from reality,"[4] and thus announces the tendency of imperial Roman art towards the "illusionism" formulated by Wickhoff. But this is more than a technical motive: in the Column of Trajan it is employed to furnish a visible counterpart of the *Monumentum Ancyranum* of Augustus. The artist does not shrink from the full presentation of warfare, its horror no less than its victories. If in one piece Trajan is shown receiving the submission of the Dacians,[5] in another, Roman army surgeons

[1] Book VII. pref. 11.
[2] See my article "The Parthenon and the Baroque," *J.R.I.B.A.*, 1931, 735 ff.
[3] Pl. K and note. [4] Book VII. v. 3.
[5] Strong, *Roman Sculpture*, Pl. 55.

are shown tending the wounded, whose suffering is indicated by their attitude; and in yet another Dacian women torture Roman prisoners.

Whereas, therefore, oratory had declined into rhetoric with the limitations of political freedom, sculpture and painting took fresh life in the presentation of the real. "Here also is a tear for human lot" in the beauty of the *landscape* against which the human tragi-comedy is presented.[1] But the later editors, following Fra Giocondo, have substituted *gardening*[2] and thus weakened the emphasis which is demanded. The sculptures of Trajan's Column end with beautiful landscapes, a mountain lake by day and again the goddess Night brooding among forest trees over a lonely shed in which two Dacians are going to their rest.

IV

The garden has been the vestibule to landscape. But gardening was scarcely known to the Greeks, at least in the current sense, until Alexandrian times. In Egypt, however, gardens and parks were found as early as the Old Empire, and beer—the national drink—was accompanied not only by bread but also by the indispensable "flowers of yesterday and to-day."[3] Hence the Greek palaces of Alexandria took over into their peristyles the plants which the Egyptian gardeners trained. In the more temperate climate of Italy horticulture was less dependent on

[1] Book V. vi. 9.
[2] *topiarii* for *topeodi*, with which we may perhaps compare ἀγγειώδης from ἀγγεῖον.
[3] Erman, *Life in Ancient Egypt* (tr.), 194.

irrigation. The garden spread out into the park adjoining the house, and the architect in his planning provided windows to overlook the garden.[1] Nor was Persian precedent without its effect. The brilliant city of Cyzicus, long dependent upon Persia, gave its name to large rooms with folding windows and a northern aspect, opening upon gardens. For these the precedent was to be found in the " paradises " of the Persians, first mentioned by Xenophon. That Cyzicus should give a name not only to " *oeci* " but to " *triclinia* " [2] was probably due to its architectural tradition.

The city possessed three official architects in control of public buildings and machinery.[3] The Greek and Roman architects, therefore, like Kent and Capability Brown and Repton in eighteenth-century England, helped to change the face of the Roman empire to the beauties of Italian and other landscape.

The limitations which we have traced in Attic culture, its alienation from science and its insensibility to nature other than human, were the price paid, and profitably paid, for its unassailable supremacy within the limits marked out by itself. After thus mastering one field, the human spirit went on to fresh conquests. Hellenistic and Roman culture are not, therefore, to be regarded as cases of degeneracy from Atticism, but rather of movement into fresh fields.

We have traced the history of science. The coming of landscape into the human view deserves special consideration. Theophrastus, one of Vitruvius' authorities, reached the highest level

[1] Book VI. iii. 10. [2] Book VI. vii. 3.
[3] Strabo, 575.

which antiquity attained in descriptive natural science. His botanical works inspired Vitruvius' account of Italian timber,[1] and his mineralogy guided the descriptions of marble and mineral pigments and less precious materials in the seventh book. Vitruvius' interest in gardens is especially shown by two passages [2] in which he lays down the principles which still govern the lay-out of Italian gardens such as the Pincio, the *collis hortorum*; his insistence on well-constructed paths and on the use of trees for shade is still respected. In the gardens of Jerusalem and neighbourhood, the olive gardens west of Jerusalem in the time of our Lord were of the Italian type and the view of the Temple from Gethsemane anticipated the view of St. Peter's from the Pincian.

Vitruvius' casual references to medicine are rather concerned with regimen. The anatomy of the fauna which along with the flora characterised the landscape, was little understood. Galen[3] of Pergamus was still to come, and carry anatomy to the point which was not to be transcended for eleven hundred years—in this respect the Dark Ages beyond doubt—which elapsed before the coming of Mondino at Bologna. The scene on Trajan's Column where an army surgeon attends to the wounds of a soldier discloses the source of the advance in the anatomy of the limbs. Superstition, soon to regain its sway, opposed as far as it could the dissection of the human body.

[1] Book II. ix. x. [2] Book V. ix. 5; xi. 4.
[3] A.D. 129–199.

CRAFTSMEN OF ROME

V

The elaborate presentation of detail on a large scale that can be traced upon the Column of Trajan and on the scarcely inferior Column of Antoninus served historical purposes. To stigmatise as pedantic this attention to detail is to misunderstand the meaning of the "realist" movement. Rather should we acknowledge the technical mastery which is displayed, first on this large scale, and secondarily in the sarcophagi of the second and third centuries, culminating in the sarcophagus of the Capitol, representing Achilles at the Court of Lycomedes.[1] This sarcophagus also marks the end of the period before us. We can thus trace a period of three centuries from the accession of Augustus to the death of Mamaea, A.D. 235, in which there is advance in science and no trace of degeneracy in craftsmanship.[2]

[1] There is a cast in the British Museum.

[2] The traditional identification of the reclining figures on the lid as Mamaea and her son Alexander Severus is obviously incorrect, as regards the latter. The man, according to precedent, is the husband of the woman. Her "hairdress is that of the Princesses of the Emesene dynasty."* I do not think that this fact has been sufficiently regarded. It supports the identification of the woman with Mamaea. In that case the man represents her husband Gessianus, the father of Alexander. The identification of Mamaea has been rendered more difficult by the unfortunate restoration of the bust of Mamaea in the British Museum. Mamaea, if we may judge from the two fine busts in the Louvre,† and from most

* Mrs. Strong, *Roman Sculpture*, 319.

† Nos. 1075, 1336. There is a third bust, 1053, which is doubtful. To pass from the sarcophagus of the Capitol to the first two busts is a convincing proof of the identification proposed.

The reign of Mamaea, A.D. 223–235, was in many respects the most brilliant episode in the history of Roman well-being. Ulpian, the peer of the great jurists whom he succeeded, Salvius Julianus and Gaius, and along with him Dio Cassius, the able historian of the empire, were the ministers of Mamaea in her financial and economic measures. A papyrus fragment [1] adds a third name, Julius Africanus, who filled the post of imperial librarian, a soldier, an engineer, and a Father of the Church. As the Director of the Pantheon library, he was at the head of the movement which provided even small provincial towns with public libraries. In this capacity he advised the empress in other matters as well; the sculpture, for example, which furnished the busts of authors to accompany the library shelves. To him was probably due the placing of the imperial sarcophagus in its hiding-place, the Monte del Grano, where it was preserved for thirteen centuries until its discovery in 1582. The assassination of the empress and her son at Mainz in 235 marked the end of the scheme of empire laid down by Augustus, described by Vipsanius Agrippa, and receiving a material embodiment in accordance with the precepts of Vitruvius.

of the coins which bear her superscription, had a profile not unlike that of Queen Victoria. But the British Museum bust, like so many others, had a broken nose, and the restorer added a nose not unlike Ellen Terry's. Leaving this bust out of account, we may regard the sarcophagus as prepared during Mamaea's lifetime to receive, ultimately, her ashes.

[1] *P. Oxy.* III. 412.

VI

The exterior peace which is so illusive (high prosperity such as that of Mamaea's government preceded the collapse of the old Roman order) passed into an interior peace, that of the Church. But so long as the old order continued, the Christian community made use of the traditional craftsmanship, and of this tradition Vitruvius was a guardian. Two centuries after the death of Mamaea, Sidonius Apollinaris, in his letters,[1] quotes Vitruvius as the typical architect. Amid the general decline of science, the craftsman received a glimmer of light from Vitruvius. To return to art, there was no general prejudice in the early Church against the employment of the Greek and Roman myths as the topics of ornament. Alexander the coppersmith had his Christian successors in the worker in ivory and the marble masons.[2] Their love of craftsmanship was as high as their pagan rivals. In the same way the house of Titius Justus at Corinth and the *schola* of Tyrannus at Ephesus were doubtless decorated in the current style. In order to understand the representation of Christian subjects we may compare the parallel religions of Mithra and Isis. The Roman tolerance was always ready to welcome foreign worships, and on various grounds Vitruvius assigns the temples of Isis and Serapis to the neighbourhood of the quays.[3] A fine bust of a Roman woman, Fundilia Rufa, probably of the early second

[1] IV. 3. 5; VIII. 6. 10.
[2] Marucchi, *Epigrafia Cristiana*, 290, 291, 293.
[3] Book I. vii. 1.

century, has the head-dress of Isis.[1] It was not
until the second century that Mithra-worship became
influential at Rome: by the end of the same century
Commodus, who was represented by the sculptor as
Heracles, appeared also as Mithra. The influence
of Mithraism on Christian art is therefore negligible.

Christianity in its apocalyptic form could not make
terms with the empire any more than Judaism
with the Oriental despotism of Antiochus Epiphanes
two centuries before. The burning of Rome,
A.D. 64, brought this conflict to its first clear expres-
sion. Whatever the actual origin of the fire it is
certain that Nero and the more fanatical Christians
rejoiced at it. Nero found now the opportunity to
rebuild his capital; an opportunity which was
missed after the fire of London. His architects,
who were also engineers, were Severus and Celer,[2]
whom by their names we may presume to have been
in the Roman tradition.

The odium which fell upon the Christians as
guilty of incendiarism, and therefore enemies of
the state, was resented by St. Luke, who seems to
have published his two books soon after the fire in
order, by an historical narrative, to reassure the
new converts or the friends of the rising faith. The
imperial government and troops appear as a just and
almost kindly background to which the Christian
is bound to adjust himself.[3] We leave Paul at
the end of *Acts* as a theological lecturer who had
continued for two years receiving the general public
into his own hired mansion (?) "*without let or
hindrance.*" The fire of Rome, which brought the

[1] Nemi Collection, Castle Museum, Nottingham.
[2] Tac. *Ann.* XV. 42. [3] *Rom.* xiii. 1.

martyrdom of SS. Peter and Paul, was attributed by the general judgment to the action of Nero. But externally it left very little mark upon the attitude of the government to the Church.

VII

Hence the artisans of Rome continued to work for Christian employers. It was even possible for members of the Flavian house to attach themselves to the Christian Church. The evidence of the catacombs supplements and interprets the historians. Flavius Clemens, like Polycarp later,[1] was put to death for " atheism " (ἀθεότης), to be interpreted as Christianity.[2] Flavia Domitilla, whose relationship to Vespasian is doubtful, perhaps a niece, gave permission for the excavation of a Christian catacomb. Part of this was used for the burial of her relatives. The decoration of the vaulted roof of one of the apartments consists of a vine trailing with all the freedom of nature over the whole walls.[3] The craftsman employs the current methods and exhibits the excellence of the best contemporary work. More than this, Christian painting so advanced that the best surviving examples of second-century painting are done by artists employed on Christian buildings. Vitruvius' demand for " imitations taken from reality "[4] is satisfied by Christian art not only, as we have seen, in sculpture, but in landscape. After designing the garden, the architect calls upon the painter to portray it. A Roman turn is thus

[1] *Martyrdom*, 9. [2] Suet. *Dom.* 15.
[3] Northcote, *Roma Sotterranea*, 73.
[4] Book VII. v. 3.

given. Or shall we say that just as Egyptian gardens furnished models to Alexandria, so the Egyptian portrayal of gardens influenced the Alexandrian artists and thus came to Rome? In this case at least Strzygowski's emphasis on Oriental influences is justified.

With the garden the Roman palace is complete. The architect has taken all the instruments of splendour and worked them up into one significant scheme. The definition of Vitruvius is translated into its consequences. " The science of the architect depends upon many disciplines and various apprenticeships which are carried out in other arts." [1] But with the realism which characterises him, he not only recognises the amateur who builds for himself, but gives him encouragement, and suggests,[2] as one of the main purposes of the *de architectura*, that it should help the amateur. But the impulse to build is instinctive and carried to excess becomes almost morbid. The architectural passion was not confined to Nero: the Golden House as a palace of art was countered by the imagined splendour of the New Jerusalem, as the lines of old Babylon were repeated in the somewhat heavy contours of Ezekiel's vision. But when the ultimate significance of material things reached sublimity in the service of the Church, architecture passed by natural transitions to the achievement of Justinian. The Church of the Holy Wisdom at Byzantium after a millennium corresponded to the Parthenon.

Of this development the Book of Revelation is an anticipation and reveals its mysteries to the western

[1] Book I. i. 1. [2] Book VI. pref. 7.

craftsman.[1] Hence its appeal to the western mind over against the suspicion and rejection of the east. The craftsman might not understand the references to Jewish history. But he would understand the throne of the judge and the twenty-four assessors arranged round him circular fashion.[2] He would at once think of the great halls or basilicas [3] in the palaces of wealthy citizens where an apse or semi-circular recess served as a tribunal. He would regard the door which was opened in heaven as the entrance to the hall from the end opposite to the throne, and the " sea of glass like crystal " as a mosaic pavement with its cubes of glass and marble.[4] The furniture of the building is indicated in some detail—the candlesticks, the censers, the seals, the jewels.

But unfortunately the prophecy of *Revelation* was only realised in part. The later Byzantine and the Mediaeval architects omitted to plan their cities. Their water supplies [5] were not brought on the lines described by Vitruvius in his eighth book. Their drainage [6] was not as good even as that of old Jerusalem.[7] The decline in the fine arts went along with the decline of the useful arts, of the sciences and of medicine. But the mechanical arts were sustained by the valuable and cherished recipes of Vitruvius.

The construction of organs, such as Vitruvius describes, came under the supervision of the archi-

[1] *E.g.* apse of S. Pudenziana, Rome.
[2] *Rev.* iv and v. [3] Vitr. Book VI. v. 2.
[4] G. G. Scott, *English Church Architecture*, 29.
[5] Cf. *Rev.* xxii. 1. [6] *Rev.* xxi. 27.
[7] Neuburger, *Technical Arts and Sciences*, 438.

tect, who was also a machinist: *machinator*. Severus
and Celer, Nero's architects,[1] were in the Vitruvian
tradition and doubtless superintended the construc-
tion of his organs. Nero " spent part of his day
with organs, *organa hydraulica*, of a new and hitherto
unknown kind." [2] They had several stops, up to
eight at least.[3] They were also supplemented by
other instruments, such as the trombone,[4] especially
when they were used in the circus to mark the
entrance of the gladiators.[5] The organ was early
used in the Church.[6] It may be taken indeed that it
followed the general law: until the downfall of
Alexander Severus the surroundings of Christian
worship included all the arts of the day. The organ
especially was characteristic of the west and indeed
was developed by the Church. Claudian speaks of
its deep murmurs and melodies,[7] and it gave an
added beauty to the music of the cathedral of Milan.
It is somewhat surprising that most of the current
histories of Roman art ignore music altogether.

VIII

By a happy accident we are enabled to bring our
survey to a close under the guidance of Sextus
Julius Africanus. The fragment from Oxyrhynchus,[8]
in which he speaks of his directorship of the Pantheon
library, gains added meaning when we realise that
his interest in literature included the Christian future

[1] Tac. *Ann*. XV. 42. [2] Suet. *Nero*, 41.
[3] Book X. viii. [4] Baumeister, fig. 603.
[5] Petronius, 36. [6] Tert. *Bapt*. 8.
[7] *Manl. Theod. Cons*. 316–319.
[8] *P. Oxy*. iii. 412. 8.

as well as the past. The library [1] of the Roman palace, along with the basilica, passed into the service of the Church. Christian architecture, literature [2] and music were to hand on through the Middle Ages the corresponding elements of the classical tradition. But Vitruvius and Africanus were prized also for their military works, to which Vitruvius [3] passes with a note of warning already quoted. " Inventions serve both to protect against danger and to satisfy the needs of safety." The brilliant civilisation of Rome was to live only so long as the Roman legions guarded the Rhine, the Danube and the Euphrates. The same secondary cause was also needed to protect the infancy of the Church.

[1] Book VI. iv.; v. 2.
[2] Kenyon, *Books and Readers in Greece and Rome*, 97, on papyrus codices.
[3] Book X. x. 1.

BIBLIOGRAPHY

ADDITIONAL MSS. OF VITRUVIUS

The *Anthology* [1] (not yet published) of William of
Malmesbury, Harl. 3969, fol. 8 v., begins a series of
extracts from Vitruvius. The spelling Victruvius
indicates that they were transcribed from a MS.
written at St. Augustine's Abbey, Canterbury,
Vol. I. *intro.* xix. The interest of William was mainly
aroused by the military engineering of Book X., and
by the mechanical devices described in both Book IX.
and Book X. To the latter topic he makes a sum-
mary reference: *omittantur illa quae sunt quidem ad
audiendum grata sed ad intellegendum gravia, quo
lesbius* (*i.e.* Ctesibius) *hydraulica organa invenit, quo
nam ut curru sedens intelligas quot milia vel terrae vel
aquae peregisti, quo modo Archimedes furtum illum
reprendit qui argentū auree coronae iunxerit.* William
obviously regarded the *de architectura* as a practical
manual. It is probable that the builders of the
Norman church at Malmesbury, with its fine South
Porch (still standing), followed some of its precepts.

A century later Vincent of Beauvais, *c.* 1250,
incorporated into his *Speculum* material taken from
Vitruvius. His MS. of Vitruvius was derived from
S or *G*, as is shown by his quoting the interpolation

[1] This reference is due to Dr. M. R. James.

of *S* in Book I. i. 1: *cuius iudicio probantur omnia.*
He uses the mediaeval Latin *architectoria* for *archi-
tectura,* implying "architector" once current in
English with its feminine "architectress," a term
which might well be revived. Like William of
Malmesbury, he is occupied with the practical
application of Vitruvius' text-book to mechanics and
to building construction and neglects the description
of the orders.

We are thus prepared for the fragments of a late
MS. of Vitruvius [1] to be found in the Public Record
Office to which Mr. Charles Johnson drew my atten-
tion: Chancery Bundle 34, File 11, Folios 35–40.

NOTE ON THE SPELLING OF *H* [2]

The Latin text of this edition is taken from the
Harleian MS. 2767. The spelling is therefore not uni-
form; I have included all the variations which seem
to be legitimate. In the *Monumentum Ancyranum*
along with more usual forms *apsenti* and *inmisso* occur:
conlegio with *collega* in the same sentence. This
precedent is followed by Munro in his *Lucretius* and
Housman in his *Manilius.* Munro has *committere,*
v. 782, and *inmissis* below, v. 787. Housman has
inmota, v. 428, and *immotis,* i. 632. He prints *delabsa*
and quotes Ribbeck for *labsus* in thirty places of the

[1] I reported this discovery at greater length, *Journal of
Royal Institute of British Architects,* April 1931.
[2] The circumstance that all extant MSS. of Vitruvius
descend from *H*—the case of *G* is dealt with in the next
section—makes it possible to follow throughout—subject to
the emendations recorded—the spellings current before the
Carolingian revision and the changes introduced after the
revision.

best MSS. of Virgil, *ad* v. 732. He gives the nom. plur. of the 3rd decl. in *is*, i. 601, v. 222, *etc.*, the acc. plur. in *is* frequently. There are traces of *quoquere* for *coquere* in the best MSS. of Manilius, v. 533 and 683: I have admitted *quoquendum* to the text, V. ix. 8.

I hesitated to write, with *H*, *scribsi scribtum* and the corresponding forms even with the support of the Amiatinus vulgate. But *praescribta* is once found in Lucretius, once also *elabsa*, Munro *ad* vi. 92. I have recorded both *oportunus* and *opportunus*; *obportunus* never occurs.

There is a special reason why *H* should be found thus faithful to older forms. So far as *H* follows the form of specifications, it is of a quasi-legal character. *Lex* represents " specification " twice in Book I. i. 10 and again in Book VII. v. 8. This fact, in my opinion, entirely precludes the extensive recasting of the order of the text proposed by Krohn in his review of my first volume, *Phil. Woch.*, Dec. 24, 1932. Compared with most technical treatises, the ten books on Architecture are much above the average in order and clearness.

The Interpolations in *G*

There are some fifty cases in which *G* offers readings which are not represented in *H* by corresponding phrases or single words. There are also many cases in which *G* makes useful and obvious corrections in *H*, and not a few corrections which are less obvious and yet convincing. A brief review of these will throw light upon the method of the scribe. They all are made in the spirit of a Ciceronian, as

BIBLIOGRAPHY

Ciceronianism was understood after Alcuin. The least valuable corrections are those which assimilate the spelling of *H* to later forms, *e.g. Volturnus* to *Vulturnus, formonsos to formosos,* nor is there any reason to be grateful for the correction of *imperii* to *imperio* after *potiretur,* VI. i. 11, especially when *G* has *rerum potiretur,* VII. pref. 17. He shows acquaintance with the subject-matter when he corrects *aliis* to *alis,* VI. iii. 4, but in the main his services are grammatical, as when he substitutes *indignans* for *indignus,* VII. pref. 8. He is a better " grammarian " than the scribe of *H* but he is not so faithful. This formula of the copyist is abundantly illustrated in the changes which were made in the Greek text of the N.T.: for the Vulgate we can trace the similar method of Alcuin and his school in dealing with the Amiatinus. The critical notes of Wordsworth and White show the Vallicellanus—the best example of Alcuin's recension—differing from the Amiatinus in the same way as *G* differs from *H,* but not to the same extent. The reason for this difference is the greater difficulty of Vitruvius.

Apart from the introductions to the ten books and from the historical parentheses, the language of Vitruvius is like that of a specification: technical and *elliptical.* The craftsman writing for craftsmen assumes a background of knowledge which is only in part shared by the layman. As Vitruvius himself says: " only those who are experienced in his subject-matter, will find his descriptions easy to understand," X. viii. 6. For the most part, indeed, the interpolations of *G* do not add to our knowledge and are harmless. I have inserted for information the longer interpolations of *G* in the second five

xliv

books without translating them. Two of them are obviously caused by the omission of *sunt*: VII. pref. 14 and VII. v. 2. Two are merely duplications of epithets: VIII. i. 2, and IX. pref. 15. IX. ii. 2 is a gloss to explain the reference to the moon.

But two interpolations have seriously corrupted the text. The interpolation of *G*, III. v. 2 destroyed *H*'s description of the Attic base as a roundel above and a sweeping scotia (with its fillets) below. Attic examples of such a base are found in the Temple of Apollo by Ictinus at Bassae and the Nike Temple at Athens. The translation of *H* runs: " taking the plinth away, the remainder is to be divided into four parts; the top part is to be the torus, the remainder is to be the scotia with its fillets." There is an interesting parallel in our Norman, or, as the French more correctly say, Roman architecture. The Norman bases in Canterbury Cathedral exhibit several cases of the roundel and scotia according with the formula of *H*. The tradition of this MS. was specially guarded in the adjoining library of St. Augustine's Abbey, Vol. I. *intro.* xix. The other serious interpolation of *G*, Book III. iii. 7, is both inaccurate and superfluous.

The faults as well as the excellences of *G* are due to its origin. They characterise the revision which all or nearly all Latin MSS. received, in the interest of grammar, along with the revision of all Church books decreed in 789. It is reasonably certain, therefore, that *G* represents the form which Vitruvius took after a similar revision. By the courtesy of the editors of the *Classical Review* a full discussion of the interpolations of *G* and a defence of the primacy of

BIBLIOGRAPHY

H appeared in May 1932, pp. 58–61, but cf. *Class. Rev.*, 1934, 229.

Books of Reference for Vitruvius, Books VI–X

The following list supplements the Bibliography of the first volume and deals mainly with Greek science and engineering.

Whitehead: *Introduction to Mathematics*, London, 1927.

Heath: *History of Greek Mathematics*, Oxford, 1921.

Heiberg: *Geschichte der Mathematik u. Naturwissenschaften im Alterthum*, Munich, 1925.

Thevenet: *Veterum mathematicorum opera omnia*, Paris, 1693.

Diels: *Fragmente der Vorsokratiker*, Berlin, 1922; esp. Democritus, Vol. II.

Hippocrates: *ed.* Jones and Withington, Loeb Series, London.

Ps. Aristoteles: *de mirabilibus auscultationibus* et *mechanica*, *ed.* Apelt, Leipzig, 1888.

Lucretius: *de rerum natura*, 4th ed., *ed.* Munro, Cambridge, 1886.

Manilius: *Astronomica*, *ed.* Housman, London, 1903–1930.

Hero Alexandrinus: *ed.* Schmidt, Leipzig, 1899 (who assigns him a date after A.D. 55. Vol. I. pref. xxiii; he also translates Vitruvius I. vi. 2; IX. ix. 2–5; X. xii and xiii, Vol. I. pp. 490–505).

Mach: *Science of Mechanics*, tr. McCormack, Chicago, 1902.

Sackur: *Vitruv und die Poliorketiker*, Berlin, 1925.

Robertson: *Greek and Roman Architecture*, Cambridge, 1929.

VITRUVIUS

ON ARCHITECTURE

BOOKS VI—X

VITRUVII
DE ARCHITECTURA
LIBER SEXTUS

1 ARISTIPPUS philosophus Socraticus, naufragio cum eiectus ad Rhodiensium litus animadvertisset geometrica schemata descripta, exclamavisse ad comites ita dicitur: 'bene speremus! hominum enim vestigia video.' Statimque in oppidum Rhodum [1] contendit et recta [2] gymnasium devenit, ibique de philosophia disputans muneribus est donatus, ut non tantum se ornaret, sed etiam eis, qui una fuerunt, et vestitum et cetera, quae opus essent ad victum, praestaret. Cum autem eius comites in patriam reverti voluissent interrogarentque eum, quidnam vellet domum renuntiari, tunc ita mandavit dicere: eiusmodi possessiones et viatica liberis oportere parari, quae etiam e naufragio una possent enare.[3]

2 Namque ea vera praesidia sunt vitae, quibus neque fortunae tempestas iniqua neque publicarum rerum mutatio neque belli vastatio potest nocere. Non minus eam sententiam augendo Theophrastus, hor-

[1] Rodum *H*. [2] recta *H*: recte *G*, recta via *S*.
[3] enare *Gr*.: enarrare *H*.

[1] Aristippus of Cyrene taught that pleasure was the end of conduct.

2

VITRUVIUS

ON ARCHITECTURE

BOOK VI

PREFACE

1. THE philosopher Aristippus,[1] a follower of
Socrates, was shipwrecked on the coast at Rhodes,
and observing geometrical diagrams drawn upon the
sand, he is said to have shouted to his companions:
" There are good hopes for us; for I see human
footsteps! " Forthwith he made for the city of
Rhodes and came straight to the gymnasium. There
he disputed on philosophical topics and was so richly
rewarded that he not only fitted himself out, but
supplied his companions with clothing and other
necessaries of life. When they wanted to go home,
and asked him what message he wished them to
take, he enjoined on them to say, that men should
provide for their children wealth and travelling
equipment of such a kind, that, even after ship-
wreck, it can swim to land along with its owners.

2. For those are the true safeguards of life which
are immune from the stormy injustice of Fortune,
the changes of politics and the ravages of war.
Theophrastus,[2] indeed, carries that opinion further,

[2] Theophrastus, the follower and successor of Aristotle.

3

tando doctos potius esse quam pecuniae confidentes,
ita ponit: doctum ex omnibus solum neque in alienis
locis peregrinum neque amissis familiaribus et
necessariis inopem amicorum, sed in omni civitate
esse civem difficilesque fortunae sine timore posse
despicere casus; at[1] qui non doctrinarum sed felici-
tatis praesidiis putaret se esse vallatum, labidis
itineribus vadentem non stabili[2] sed infirma con-
flictari vita.

3 Epicurus vero non dissimiliter ait:[3] pauca sapien-
tibus fortunam tribuere, quae autem maxima et
necessaria sunt, animi mentisque cogitationibus
gubernari. Haec ita etiam plures philosophi dixe-
runt. Non minus poetae, qui antiquas comoedias
graece scripserunt, easdem sententias versibus in
scaena pronuntiaverunt, ut Crates,[4] Chionides, Aristo-
phanes, maxime etiam cum his Alexis, qui Atheni-
enses ait oportere ideo laudari, quod omnium Grae-
corum leges cogunt parentes ⟨ali⟩[5] a liberis, Atheni-
ensium non omnes nisi eos, qui liberos artibus eru-
dissent. Omnia enim munera fortunae cum dantur,
ab ea faciliter adimuntur; disciplinae vero coniunctae
cum animis nullo tempore deficiunt, sed permanent
4 stabiliter ad summum exitum vitae. Itaque ego
maximas infinitasque parentibus ago atque habeo
gratias, quod Atheniensium legem probantes me
arte erudiendum curaverunt, et ea, quae non potest

¹ ad qui H. ² stabilis H. ³ ait S : aut. H.
 ⁴ Crates *Bondam* : eucrates, H. ⁵ *add. rec.*

¹ Epicurus refined on the morals of Aristippus, and com-
bined them with the atomic philosophy of nature, Diog. X. 144.
 ² Crates introduced systematic plots into Greek comedy,
Arist. *Poet.* 5.

and exhorts us to trust in learning rather than wealth. He lays down this principle: that, alone of all mankind, the scholar is no stranger in foreign lands; after losing kinsmen and intimates he still finds friends; he is a citizen in every state, and fearlessly despises the awkward chances of fortune; on the other hand, the man who thinks himself fortified and guarded by good fortune rather than by education, steps along slippery paths and struggles with a life unstable and insecure.

3. Epicurus,[1] too, says in a similar strain: the gifts of fortune to the wise are few but great and indispensable, namely, that they be governed by the judgments of the mind and heart. So also most philosophers have spoken. The poets too of old, who wrote Greek comedies, delivered on the stage the same opinions in their verses: Crates,[2] for example, Chionides,[3] Aristophanes,[4] but, most of all, Alexis,[5] who says that the Athenians deserve praise because the laws of all the other Greeks compel children to maintain their parents, whereas the laws of Athens only applied to those parents who had their children taught a trade. For all gifts of Fortune, as they are bestowed by her, so are they easily withdrawn; but when training is conjoined with mental power, it never fails, but abides secure to the final issue of life. 4. Therefore, I feel and return great and unbounded gratitude to my parents, because they approved the law of Athens and had me trained in a calling, wherein one cannot pass

[3] One of the earliest Greek writers of comedy.

[4] Aristoph. *Frag.* 540 mentions Eucrates. *Cf. H.* supra.

[5] Writer of middle comedy; his plays were translated into Latin.

esse probata sine litteraturae encyclioque doctri-
narum omnium disciplina. Cum ergo et parentium
cura et praeceptorum doctrinis auctas haberem copias
disciplinarum, philologis et philotechinis rebus com-
mentariorumque scribturis me delectans eas pos-
sessiones animo paravi, e quibus haec est fructuum
summa: nullas[1] plus habendi esse necessitates
eamque esse proprietatem, divitiarum maxime,
nihil desiderare. Sed forte nonnulli haec levia
iudicantes putant eo[2] esse sapientes, qui pecunia
sunt copiosi. Itaque plerique ad id propositum
contendentes audacia adhibita cum divitiis etiam
notitiam sunt consecuti.

5 Ego autem, Caesar, non ad pecuniam parandam
ex arte dedi studium, sed potius tenuitatem cum
bona fama quam abundantiam cum infamia sequen-
dam probavi. Ideo notities parum est adsecuta.
Sed tamen his voluminibus editis, ut spero, etiam
posteris ero notus. Neque est mirandum, quid ita
pluribus sim ignotus. Ceteri architecti rogant et
ambigunt, ut architectent;[3] mihi autem a prae-
ceptoribus est traditum: rogatum, non rogantem
oportere suscipere curam, quod ingenuus color
movetur pudore petendo rem suspiciosam. Nam
beneficium dantes, non accipientes ambiuntur.
Quid enim putemus suspicari, qui rogetur de patri-
monio sumptus faciendos committere gratiae pe-

[1] nullas *G* : nulla *H*. [2] putantes eo esse *H*.
 [3] architentent *H*.

[1] *orbis doctrinae*, Quint. I. 10. 1. 'The unity of the
subjects included in a general education,' *cf.* Book I. 1. 12.

6

muster without knowledge of letters, and of the
' liberal arts.'[1] When therefore both the care of my
parents and the instruction of my teachers had
increased my stock of knowledge, I found delight in
literary and technical matters and in the works
written upon them, thus acquiring mental possessions
of which this is the total profit: that there is no
necessity of getting more and more, and that pro-
perty consists in requiring nothing, least of all, riches.
But some perhaps make light of these considerations
and think that those who are wealthy are thereby
wise. Therefore many persons, striving to that end,
combine wealth with assurance, and make the further
gain of celebrity.

5. But, your Highness, I have not studied with
the view of making money by my profession; rather
have I held that a slight fortune with good repute is
to be pursued more than abounding wealth accom-
panied by disgrace. Thus little celebrity has come
my way. Yet by publishing these volumes,[2] my
name will reach, I hope, to after times. Nor is
there cause for wonder why I am unknown to the
general. Other architects beg and wrangle to obtain
commissions; but I follow a rule laid down by my
masters: not to seek employment but to be sought
out; since an open countenance[3] changes for shame
when a request is made of a doubtful character.
For the giver of a favour is courted, not the receiver.
For what do we think will be suspected by a man
who is asked to entrust expenditure at his own cost
to the pleasure of the petitioner? Will he not

[2] The books *de architectura* were probably published at
various times.
[3] *ingenui voltus puer ingenuique pudoris*, Juv. XI. 154. *Cf.*
Prop. I. iv. 13.

tentis, nisi praedae conpendiique eius causa iudicet
6 faciundum? Itaque maiores primum a genere pro-
batis operam tradebant architectis, deinde quaere-
bant, si honeste essent educati, ingenuo pudori, non
audaciae protervitatis permittendum iudicantes.
Ipsi autem artifices non erudiebant nisi suos liberos
aut cognatos et eos viros bonos instituebant, quibus
tantarum rerum fidei pecuniae sine dubitatione
permitterentur.

Cum autem animadverto ab indoctis et inperitis
tantae disciplinae magnitudinem iactari et ab is,
qui non modo architecturae sed omnino ne fabricae
quidem notitiam habent, non possum non laudare
patres familiarum eos, qui litteraturae fiducia con-
firmati per se aedificantes ita iudicant: si inperitis
sit committendum, ipsos potius digniores esse ad
suam voluntatem quam ad alienam pecuniae con-
7 sumere summam. Itaque nemo artem ullam aliam
conatur domi facere, uti sutrinam, fullonicam aut
ex ceteris, quae sunt faciliores, nisi architecturam,
ideo quod, qui profitentur, non arte vera sed falso
nominantur architecti. Quas ob res corpus archi-
tecturae rationesque eius putavi diligentissime con-
scribendas, opinans in munus omnibus gentibus non
ingratum futurum. Igitur, quoniam in quinto de
opportunitate communium operum perscribsi, in hoc
volumine privatorum aedificiorum ratiocinationes et
commensus symmetriarum explicabo.

[1] The Roman ideal of a gentleman, *ingenuus*, included
modesty, and was nearer to the Christian ideal than that of
the Stoic, which, in some cases, leaned to a Cynical disregard
of decency.

judge that it is to be done for the profit and advantage of the other man? 6. Therefore our forefathers used to entrust commissions to architects of approved descent in the first place; in the second place they inquired if they were well brought up, considering that they should employ men with a sense of honour,[1] rather than persons of a bold and insolent turn. For the craftsmen themselves trained only their own children and kindred, and those apprentices who were so worthy, that large sums could be entrusted without hesitation to their loyalty.

But while I observe that an art of such magnificence is professed by persons without training and experience, by those who are ignorant not only of architecture but even of construction, I cannot refrain from praising those owners of estates who, fortified by confidence in their own erudition, build for themselves, judging that if inexperienced persons are to be employed, they themselves are entitled to spend their own capital to their own liking rather than to that of anyone else. For no one attempts to practise any other calling at home, such as shoe-making or fulling or any other easy occupation, with the one exception of architecture, because persons who profess it are falsely called architects in the absence of a genuine training. And so I considered it a duty to compile with care a system and method of architecture, imagining it would serve a purpose generally acceptable. Therefore since in the fifth book I dealt with the suitable provision of public buildings, in this book I will explain the calculations involved in private buildings and the adjustment of their proportions.

9

VITRUVIUS

I

1 HAEC autem ita erunt recte disposita, si primo
animadversum fuerit, quibus regionibus aut quibus
inclinationibus mundi constituantur. Namque aliter
Aegypto, aliter Hispania, non eodem modo Ponto,
dissimiliter Romae, item ceteris terrarum et regionum
proprietatibus oportere videntur constitui genera
aedificiorum, quod alia parte solis cursu premitur
tellus, alia longe ab eo distat, alia per medium
temperatur. Igitur, uti constitutio mundi ad terrae
spatium in inclinatione signiferi circuli et solis cursu
disparibus qualitatibus naturaliter est conlocata, ad
eundem modum etiam ad regionum rationes caelique
varietates videntur aedificiorum debere dirigi con-
2 locationes. Sub septentrione aedificia testudinata
et maxime conclusa et non patentia, sed conversa
ad calidas partes oportere fieri videntur. Contra
autem sub inpetu solis meridianis regionibus, quod
premuntur a calore, patentiora conversaque ad sep-
tentrionem et aquilonem sunt faciunda. Ita, quod
ultra natura laedit, arte erit emendandum. Item
reliquis regionibus ad eundem modum temperari,
quemadmodum caelum est ad inclinationem mundi
conlocatum.
3 Haec autem ex natura rerum sunt animadvertenda
et consideranda atque etiam ex membris corpori-
busque gentium observanda. Namque sol quibus
locis mediocriter profundit vapores, in his conservat

[1] *signifer orbis*, Lucr. v. 691.
[2] See diagram of winds, Vol. I. Pl. A.
[3] *illud quod cecidit forte, id arte ut corrigas.* Ter. *Ad.* IV. 7.
23.

CHAPTER I

THE INFLUENCE OF CLIMATE UPON ARCHITECTURE

1. Now we shall proceed aright herein if first we observe in what regions or latitudes of the world, our work is placed. For the style of building ought manifestly to be different in Egypt and Spain, in Pontus and Rome, and in countries and regions of various characters. For in one part the earth is oppressed by the sun in its course; in another part, the earth is far removed from it; in another, it is affected by it at a moderate distance. Therefore since, in the sun's course through the inclination of the zodiac,[1] the relation of the heavens to the earth is arranged by nature with varying effects, it appears that in like manner the arrangement of buildings should be guided by the kind of locality and the changes of climate. 2. Towards the north, buildings, I think, should be vaulted, thoroughly shut in rather than exposed, and with an aspect to the warmer quarter. On the other hand, where the sun is violent in the southern regions because they are oppressed by the heat, buildings should be open to the air with a northern, or north-eastern,[2] aspect. Thus we may remedy by art the harm that comes by chance.[3] In other regions also, buildings are to be similarly adjusted to suit the relation of climate to latitude.

3. Now these things are to be observed and weighed in the light of Nature, and further to be tested by the figure and physique of different peoples. For in those regions where the sun pours forth a moderate heat, he keeps the body duly tem-

corpora temperata; quaeque proxime currendo
deflagrant, eripit exurendo temperaturam umoris;
contra vero refrigeratis regionibus, quod absunt a
meridie longe, non exhauritur a coloribus umor, sed
ex caelo roscidus aer in corpora fundens [1] umorem
efficit ampliores corporaturas vocisque sonitus gra-
viores. Ex eo quoque, ⟨quae⟩ [2] sub septentrionibus
nutriuntur gentes, inmanibus corporibus, candidis
coloribus, derecto capillo et rufo, oculis caesis,
sanguine multo ab umoris plenitate caelique re-
4 frigerationibus sunt conformati; qui autem sunt
proximi ad axem meridianum subiectique solis cur-
sui, brevioribus corporibus, colore fusco, crispo capillo,
oculis nigris, cruribus validis, sanguine exiguo solis
impetu perficiuntur. Itaque etiam propter san-
guinis exiguitatem timidiores sunt ferro resistere,
sed ardores ac febres subferunt sine timore,[3] quod
nutrita sunt eorum membra cum fervore; itaque
corpora, quae nascuntur sub septentrione, a febri
sunt timidiora et inbecilla, sanguinis autem abun-
dantia ferro resistunt sine timore.

5 Non minus sonus vocis in generibus gentium dis-
pares et varias habet qualitates, ideo quod terminatio
orientis et occidentis circa terrae librationem, qua
dividitur pars superior et inferior mundi, habere
videtur libratam naturali modo circumitionem, quam
etiam mathematici *orizonta* dicunt. Igitur cum id
habemus certum animo sustinentes, ab labro, quod
est in regione septentrionali, linea traiecta ad id,
quod est supra meridianum axem, ab eoque altera
obliqua [4] in altitudinem ad summum cardinem, qui

[1] fundans *H*. [2] *add. Ro*. [3] tumore *H*.
[4] altera obliqua *Laet* : -am *bis H*.

[1] *I.e.* the bounding-line.

pered; where he comes near and the earth scorches, he burns out and removes the moisture; whereas in the cold regions, because they are far distant from the south, the moisture is not drawn out from their complexions, but the dewy air from the sky pours moisture into the body, enlarges the physique and deepens the voice. Hence, also, the races of the north receive nourishment, and are characterised by tall stature, fair complexion, straight red hair, blue eyes, fullness of blood, owing to the abundance of moisture and the cool climate. 4. Those, however, who are nearest to the southern climes and under the sun's orbit, owing to his violence, have a smaller stature, dark complexion, curly hair, black eyes, strong legs, and thinness of blood. Therefore, also, because of their thin blood, they fear to resist the sword, but endure heat and fever without fear, because their limbs are nourished by heat. Those persons who are born under a northern sky, are weak and more timid in face of fever, but fearlessly resist the sword owing to their fullness of blood.

5. In like manner the sound of the voice has varied qualities which differ with different races. And the reason is that the limits between east and west around the level of the earth (where the upper and lower part of the world is divided) seem to have the circumference naturally levelled, and this the astronomers name the *horizon*.[1] Therefore when we have kept this fixed in our mind, let a line be drawn from the margin which is in the north to the margin which is towards the south, and from the latter a second line [2] inclined upwards to the pole which is

[2] The lines of longitude do not follow the curvature of the earth, but are assumed to be drawn in a straight line from the equator to the north pole of the heavens.

est post stellas septentrionum, sine dubitatione animadvertemus ex eo esse schema [1] trigonii mundo, uti organi, quam *sambucen* Graeci dicunt.

6 Itaque quod est spatium proximum imo cardini [2] ab axis linea in meridianis finibus, sub eo loco quae sunt nationes, propter brevitatem altitudinis ad mundum sonitum vocis faciunt tenuem et acutissimum, uti in organo chorda, quae est proxima angulo. Secundum eam autem reliquae ad mediam Graeciam remissionibus efficiunt in nationibus sonorum cantiones.[3] Item a medio in ordinem crescendo ad extremos septentriones sub altitudines caeli nationum spiritus sonitibus [4] gravioribus a natura rerum exprimuntur. Ita videtur mundi conceptio tota propter inclinationem consonantissime per solis temperaturam ad harmoniam esse conposita.

7 Igitur quae nationes sunt inter axis meridiani cardinem ab septentrionalis medio positae, uti in diagrammate[5] musico medianae vocis habent sonitum in sermone; quaeque progredientibus ad septentrionem sunt nationes, quod altiores habent distantias mundi,[6] spiritus vocis habentes umore [7] repulsos ad hypatas et proslambanomenos,[8] a natura rerum sonitu graviore coguntur uti; eadem ratione medio progredientibus ad meridiem gentes paranetarum ⟨netarum⟩[9]que acutissimam sonitus vocis perficiunt tenuitatem. Hoc autem verum esse, ex umidis naturae locis graviora fieri et ex fervidis acutiora,

[1] scaena *H*.　　　　[2] cardini *rec* : -ne *H*.
[3] cansiones *H* : cantiones *h*.
[4] sonitibus *rec* : sonitus *H*.　　　[5] india grāmata *H*.
[6] mundi *Kr* : admundi (*cum* ad *add*.) *H*.
[7] umore *rec* : -rem *H*.　　[8] *acc. pl.*　　　[9] *add. Fea.*

[1] A kind of harp: a triangular stringed instrument.

behind the stars of the Great Bear. From this we shall undoubtedly perceive that the world has a triangular lay-out, like the sackbut which the Greeks call *sambucê*.[1]

6. Therefore if we take the region in the south which is nearest to the lowest point, the nations which are under that quarter, have vocal sounds which are thin and very shrill, because of the small height towards the limit of the universe, like the string of the instrument which is next to the angle. Next to this, the other strings so far as Greece which is in the middle, produce by their relaxation, the pitch of the voice for each nation. Further, rising regularly from the middle to the height in the furthest north, the national pitch is naturally produced with deeper tones. Thus the whole system of the world because of the slope from south to north seems to be most agreeably adjusted to harmony by the temperature of the sun.

7. Therefore the nations which are placed in the middle between the equator and the north pole have in conversation a middle accent corresponding to the musical diagram; the nations as we move northwards, because they have a greater distance between them and the universe, have a vocal accent driven by greater moisture to the *hypatae* [2] and *proslambanomenoe* [2] and are compelled by Nature to use a deeper voice; in the same way as we progress from the middle to the south, the nations have a very shrill accent corresponding to the *paranetae* [3] and *netae*.[3] 8. We can observe by experiment that heavier and deeper effects arise in damp places, and lighter and shriller

[2] The lowest notes : see Vol. I. Pl. F.
[3] The highest notes : *ib.*

licet ita experiendo animadvertere. Calices duo in
una fornace aeque cocti aequoque pondere ad crepi-
tumque uno sonitu sumantur. Ex his unus in aquam
demittatur, postea ex aqua eximatur; tunc utrique
tangantur. Cum enim ita factum fuerit, largiter
inter eos sonitus discrepabit, aequoque pondere non
poterunt esse. Ita et hominum corpora uno genere
figurationis et una mundi coniunctione concepta alia
propter regionis ardorem acutum spiritum aeris ex-
primunt tactu, alia propter umoris abundantiam
gravissimas effundunt sonorum qualitates.

9 Item propter tenuitatem caeli meridianae nationes
ex acuta fervore mente expeditius celeriusque moven-
tur ad consiliorum cogitationes; septentrionalis [1]
autem gentes infusae crassitudine caeli, propter
obstantiam aeris umore refrigeratae stupentes
habent mentes. Hoc autem ita esse a serpentibus [2]
licet aspicere, quae, per calorem cum exhaustam
habent umoris refrigerationem, tunc acerrime mo-
ventur, per brumalia autem et hiberna tempora ab
mutatione caeli refrigerata, inmota sunt stupore.
Ita non est mirandum, si acutiores efficit calidus
aer hominum mentes, refrigeratus autem contra
tardiores.

10 Cum sint autem meridianae nationes animis acutis-
simis infinitaque sollertia consiliorum, simul ad forti-
tudinem ingrediuntur, ibi succumbunt, quod habent
exuctas ab sole animorum virtutes; qui vero re-
frigeratis nascuntur regionibus, ad armorum vehe-
mentiam paratiores sunt; magnis virtutibus sunt
sine timore, sed tarditate animi sine considerantia
inruentes sine sollertia suis consiliis refragantur.

[1] nom. pl.
[2] nom. pl. serpentia, *Vulg. Act.* X. 12.

effects in hot places. Let two cups be taken equally
burnt in one kiln of equal weight, and of the same
sound when struck. Of these let one be plunged
into water and then taken out of the water. Then
let both be struck. When this is done, there will be
a considerable difference of sound between them,
and they will differ in weight. So also the bodies of
human beings born of the same shape and under
the same conjunction of the heavens will vary:
some on account of the heat of the region have,
under its influence, an acute or shrill accent, others
on account of the abundant moisture, pour forth the
heaviest or deepest utterances.

9. Southern nations also, owing to the rarity of
the atmosphere, with minds rendered acute by the
heat, are more readily and swiftly moved to the
imagination of expedients; but northern peoples
steeped in a thick climate amid reluctant air, are
chilled by the damp, and have sluggish minds. We
can observe this in the case of snakes: they move
quickest when the heat has drawn away the damp
with its chilling effect; but in the rainy and wintry
seasons they are chilled by the change of climate,
and are sluggish and motionless. Hence we need
not wonder if warm air renders the human mind
more acute, and a cool air impedes.

10. Now while the southern peoples are of acute
intelligence and infinite resource, they give way
when courage is demanded because their strength
is drained away by the sun; but those who are born
in colder regions, by their fearless courage are better
equipped for the clash of arms, yet by their slowness
of mind they rush on without reflection, and through
lack of tactics are balked of their purpose. Since,

17

Cum ergo haec ita sint ab natura rerum in mundo
conlocata et omnes nationes inmoderatis mixtioni-
bus disparatae, vero inter spatium totius orbis ter-
rarum regionisque medio mundi populus Romanus
11 possidet fines. Namque temperatissimae ad utram-
que partem et corporum membris animorumque
vigoribus pro fortitudine sunt in Italia gentes.
Quemadmodum enim Iovis stella inter Martis fer-
ventissimam et Saturni frigidissimam media currens
temperatur, eadem ratione Italia inter septentriona-
lem meridianamque ab utraque [1] parte mixtionibus
temperatas et invictas habet laudes. Itaque con-
siliis refringit barbarorum virtutes, forti manu [2]
meridianorum cogitationes. Ita divina mens civitatem
populi Romani egregiam temperatamque regionem
conlocavit, uti orbis terrarum imperii [3] potiretur.
12 Quodsi ita est, uti dissimiles regiones ab inclina-
tionibus caeli variis generibus sint comparatae, ut
etiam naturae gentium disparibus animis et corporum
figuris qualitatibusque nascerentur, non dubitemus
aedificiorum quoque rationes ad nationum gentium-
que proprietates apte distribuere, cum habeamus ab
ipsa rerum natura sollertem et expeditam monstra-
tionem.

 Quoad potui summa ratione proprietates locorum
ab natura rerum dispositas animadvertere, exposui,
et, quemadmodum ad solis cursum et inclinationes
caeli oporteat ad gentium figuras constituere aedifi-

[1] utroque *H*. [2] (manu) consiliis *H* (*del. Joc.*).
 [3] imperii *H* : imperio *G*.

18

therefore, the disposition of the world is such by Nature, and all other nations differ by their unbalanced temperament,[1] it is in the true mean within the space of all the world and the regions of the earth, that the Roman people holds its territories. 11. For in Italy the inhabitants are exactly tempered in either direction, both in the structure of the body, and by their strength of mind in the matter of endurance and courage. For just as the planet Jupiter is tempered by running in the middle between the heat of Mars and the cold of Saturn, in the same manner Italy presents good qualities[2] which are tempered by admixture from either side both north and south, and are consequently unsurpassed. And so, by its policy, it curbs the courage of the northern barbarians; by its strength, the imaginative south. Thus the divine mind has allotted to the Roman state an excellent and temperate region in order to rule the world.

12. But if regions differing in climate are assigned to different nations so that the natures of peoples that arise, should vary in mind, and in shape and quality of body, we shall not hesitate to arrange the methods of our buildings also, to suit the characters of nations and peoples, since from Nature herself we have skilled and ready guidance.

As far as I could observe systematically regional characteristics ordained by Nature, I have expounded them, and have said how, in reference to the sun's course and the differences of climate, we ought to determine the style of our house so as to suit the

[1] 'Temperament' corresponds to chemical combination, but applies to physiological and mental combination as well.

[2] *Laudes*, 'grounds of praise.'

ciorum qualitates, dixi; itaque nunc singulorum generum in aedificiis conmensus symmetriarum et universos et separatos breviter explicabo.

II

1 NULLA architecto maior cura esse debet, nisi uti proportionibus ratae partis habeant aedificia rationum exactiones. Cum ergo constituta symmetriarum ratio fuerit et conmensus ratiocinationibus explicati, tum etiam acuminis est proprium providere ad naturam loci aut usum aut speciem, adiectionibus temperaturas efficere, cum de symmetria sit detractum aut adiectum, uti id videatur recte esse formatum in aspectuque nihil desideretur.

2 Alia enim ad manum species [1] videtur, alia in excelso, non eadem in concluso, dissimilis in aperto, in quibus magni iudicii est opera, quid tandem sit faciundum. Non enim veros videtur habere visus effectus, sed fallitur saepius iudicio ab eo mens. Quemadmodum etiam in scenis [2] pictis videntur columnarum proiecturae, mutulorum ecphorae,[3] signorum figurae prominentes, cum sit tabula sine dubio ad regulam plana. Similiter in navibus remi, cum sint sub aqua directi, tamen oculis infracti videntur; et quatenus eorum partes tangunt summam planitiem liquoris,[4] apparent, uti sunt, directi,

[1] species esse v. *G* : species se v. *H*.
[2] scenis *G* : caenis *H*, Plin. *N.H.* XII. 10.
[3] ecphorę *G* : esphorae *H*.
[4] liquoris *G* : liquores *H*.

[1] Optical adjustments, Book III. iii. 13.
[2] Architectural style of painting, 80–30 B.C.

needs of the body. It remains now to explain in brief, both generally and particularly, the symmetrical adjustment of the several methods of building.

CHAPTER II

PROPORTION IN BUILDING

1. THE architect's greatest care must be that his buildings should have their design determined by the proportions of a fixed unit. When therefore account has been taken of the symmetries of the design and the dimensions have been worked out by calculation, it is then the business of his skill to have regard to the nature of the site, either for use or beauty, to produce a proper balance by adjustment, adding or subtracting from the symmetry of the design, so that it may seem to be rightly planned and the elevation [1] may lack nothing.

2. For one kind of appearance is seen near at hand; another, in a lofty building; yet another in a confined site; a different one in an open site. And it is the business of a fine judgment to determine exactly what is to be done in these cases. For the eyes do not appear to bring accurate results, but the judgment is often deceived by it: just as when, in the paintings of stages, there seem to be projecting columns, corbelled mutules, outstanding shapes of statues, although the picture is undoubtedly vertical and regular.[2] Similarly in the case of ships, when the oars are put straight in the water, yet to the eyes they seem broken: until their parts touch the topmost level of the liquid, they appear straight, as indeed they are, but when

21

cum vero sub aqua sunt dimissi, per naturae per-
lucidam raritatem remittunt enatantes ab suis cor-
poribus fluentes imagines ad summam aquae plani-
tiem, atque eae ibi commotae efficere videntur
3 infractum remorum oculis aspectum. Hoc autem
sive simulacrorum inpulsu seu radiorum ex oculis
effusionibus, uti physicis placet, videmus, utramque
rationem videtur ita esse, uti falsa iudicia oculorum
4 habeat aspectus. Cum ergo, quae sunt vera, falsa
videantur et nonnulla aliter quam sunt oculis pro-
bentur, non puto oportere esse dubium, quin[1] ad
locorum naturas aut necessitates detractiones aut
adiectiones fieri debeant, sed ita, uti nihil in his
operibus desideretur. Haec autem etiam ingenio-
rum acuminibus, non solum doctrinis efficiuntur.

5 Igitur statuenda est primum ratio symmetriarum,
a qua sumatur sine dubitatione commutatio, deinde
explicetur operis futuri locorum unum spatium longi-
tudinis, cuius semel constituta fuerit magnitudo,
sequatur eam proportionis ad decorem apparatio,
uti non sit considerantibus aspectus eurythmiae
dubius. De qua, quibus rationibus efficiatur, est
mihi pronuntiandum, primumque de cavis aedium,
uti fieri debeant, dicam.

[1] quin *G* : quam *H*.

they are let down under the water, owing to the transparent thinness of the element, they send back images [1] flowing from their substance, which float at the topmost level of the water, and being there disturbed, they seem to the eyes to produce a broken appearance of the oars. 3. Now whether we see by the impression of images upon the eye, or by the effusion of rays from the eyes, as the natural philosophers teach us, both explanations suggest that the vision of the eyes gives false judgments. 4. Since, therefore, what is real seems false, and some things are approved by the eyes as other than they really are, I do not think it should be doubtful that we ought to add or subtract, as needed by the nature or requirements of our sites: but this is done by native skill and not by rule alone.

5. We must therefore first determine the method of the symmetries, from which these modifications are to be correctly deduced. Then the unit [2] of length for the site of the future work is to be set forth. When the magnitude of this is once determined, there will follow upon it the adjustment of the proportions to the decor so that the appearance of eurythmy [3] may be convincing to the observer. How this result is to be attained, it is now my duty to show, and I will first speak on the right arrangement of the courtyards of houses.

[1] *imagines = simulacra = eidola* of Democritus, which are supposed to be transmitted from the object to the eye.

[2] The unit is a practical expedient for furnishing the various 'scantlings' or dimensions.

[3] Eurythmy is the suitable display of details in their context. Book I. ii. 3.

III

1 CAVA aedium quinque generibus sunt distincta, quorum ita figurae nominantur: tuscanicum, corinthium, tetrastylon, displuviatum, testudinatum. Tuscanica sunt, in quibus trabes in atrii latitudine traiectae habeant interpensiva et collicias ab angulis parietum ad angulos tignorum incurrentes, item asseribus stillicidiorum in medium conpluvium deiectus. In corinthiis[1] isdem rationibus trabes[2] et conpluvia conlocantur, sed a parietibus trabes recedentes in circuitione circa columnas componuntur. Tetrastyla sunt, quae subiectis sub trabibus angularibus columnis et utilitatem trabibus et firmitatem praestant, quod neque ipsae magnum impetum coguntur habere neque ab interpensivis onerantur.

2 Displuviata autem sunt, in quibus deliquiae aream[3] sustinentes stillicidia reiciunt. Haec hibernaculis maxime praestant utilitates, quod compluvia eorum[4] erecta non obstant luminibus tricliniorum. Sed ea habent in refectionibus molestiam magnam, quod circa parietes stillicidia defluentia, continent fistulae, quae non celeriter recipiunt ex canalibus aquam defluentem itaque redundantes restagnant, et intestinum et parietes in eis generibus aedificiorum corrumpunt. Testudinata vero ibi fiunt, ubi

[1] corinthiis *G* : corinthii *H*. [2] traues *H*.
[3] aream *Gr* : arcam *H*. [4] eorum *ed* : earum *H*.

[1] *interpensiva*, cross-beams at right angles to main beams; frequent at Pompeii.
[2] The internal angles where sloping roofs meet.
[3] Corinthian has more columns than tetrastyle.

CHAPTER III

ON THE PLAN OF A HOUSE

1. THE courtyards of houses are of five different styles, and the names of them are as follows: Tuscan, Corinthian, Tetrastyle, Displuviate, Vaulted. The Tuscan are those in which the beams which are carried across the atrium have trimmers [1] to them and valleys [2] running down from the angles of the walls to the angles of the beams; thus there is a delivery of the rainfall from the eaves into the middle of the court. In the Corinthian [3] manner, the beams and open space [4] are arranged in the same way, but the beams, starting from the walls, are fixed upon columns surrounding the open space. The tetrastyle courtyards have angle columns under the beams, which gain thereby in usefulness and strength, because they are not compelled to bear great pressure and are not loaded by the trimmers.

2. Displuviate courtyards are those in which the rafters which support the frame of the opening carry the gutters down.[5] They are very advantageous for winter apartments because the central openings are raised and do not impede the lights of the triclinia. But there is this disadvantage in the upkeep: when the rain-water flows down, the pipes round the walls receive it, but do not quickly take the water flowing from the channels; as they receive it, they are clogged with the surplus water. Consequently the joiner's work and the walls are damaged. Vaulted courtyards are employed when

[4] *interdius*, Varro, *R. R.* I. 13. 3.
[5] See Plate J.

non sunt impetus magni et in contignationibus supra
spatiosae redduntur habitationes.

3 Atriorum vero latitudines ac longitudines tribus
generibus formantur. Et primum genus distri-
buitur, uti, longitudo cum in quinque partes divisa
fuerit, tres partes latitudini dentur; alterum, cum
in tres partes dividatur, duae partes latitudini tribu-
antur; tertium, uti latitudo in quadrato paribus
lateribus describatur inque eo quadrato diagonius [1]
linea ducatur, et quantum spatium habuerit ea linea
4 diagonii, tanta longitudo atrio detur. Altitudo
eorum, quanta longitudo fuerit quarta dempta, sub
trabes extollatur; reliquum lacunariorum et arcae
supra trabes ratio habeatur.

Alis [2] dextra ac sinistra latitudinis, cum sit atrii
longitudo ab [3] xxx pedibus ad pedes xL, ex tertia
parte eius constituatur. Ab xL ad pedes L longitudo
dividatur in partes tres s,[4] ex his una pars alis detur.
Cum autem erit longitudo ab quinquaginta pedibus
ad sexaginta, quarta pars longitudinis alis tribuatur.
A pedibus Lx ad Lxxx longitudo dividatur in partes
quattuor et dimidiam,[5] ex his una pars fiat alarum
latitudo. A pedibus octoginta ad pedes centum
in quinque partes divisa longitudo iustam consti-
tuerit latitudinem alarum. Trabes earum liminares
ita altae ponantur, ut altitudine latitudinibus sint
aequales.

5 Tablinum, si latitudo atrii [6] erit pedum viginti,
dempta tertia eius spatio reliquum tribuatur. Si
erit ab pedibus xxx ad xL, ex atrii latitudine tablino

[1] diagonios *Schn* : diagonius *H*.
[2] alis *G* : allis *H*. [3] ad xxx *H*.
[4] s *add. Ro.* [5] dimidiam *G* : dimidia *H*.
[6] atrii *S* : atrium *H*.

the span is not great, and they furnish roomy apartments in the story above.

3. The length and breadth of the *atrium* [1] is planned in three ways. The first arrangement is to divide the length into five parts, and to give three of these to the width; the second divides the length into three parts and assigns two to the width; in the third arrangement a square is described upon the width, and the diagonal of the square is drawn: whatever is the size of the diagonal supplies the length of the atrium. 4. The height of the atrium to the underside of the beams is to be three-quarters of the length. The remaining quarter is to be assigned as the dimension of the ceiling and of the roof, above the beams.

The width of the *alae* or wings, on the right and the left, is to be one-third of the length of the atrium when it is from 30 to 40 feet; from 40 to 50 feet the length is to be divided into three parts and a half, and one is to be given to the alae. When the length is from 50 to 60 feet, a fourth part is to be assigned to the alae. From 60 to 80 feet let the length be divided into four parts and a half: of these one is to be the width of the alae. From 80 to 100 feet the length divided into five parts will determine the breadth of the alae. The lintel beams are to be placed so high, that, in height, the alae are equal to their breadth.

5. The *tablinum* or alcove, if the breadth of the atrium is 20 feet, must be two-thirds in width. If the breadth of the atrium is 30 to 40 feet, half is to

[1] This and similar terms will be understood by reference to Pl. I.

dimidium tribuatur. Cum autem ab XL ad LX, latitudo dividatur in partes quinque, ex his duo tablino constituantur. Non enim atria minora ab maioribus [1] easdem possunt habere symmetriarum rationes. Si enim maioribus symmetriis utemur in minoribus, neque tablino neque alae utilitatem poterunt habere, sin autem minorum in maioribus utemur, vasta et inmania in his ea erunt membra. Itaque generatim magnitudinum rationes exquisitas 6 et utilitati et aspectui conscribendas putavi. Altitudo tablini ad trabem adiecta [2] latitudinis octava constituatur. Lacunaria eius tertia latitudinis ad altitudinem adiecta extollantur.

Fauces minoribus atriis e tablini [3] latitudine dempta tertia, maioribus dimidia constituantur.[4] Imagines item alte cum suis ornamentis ad latitudinem sint constitutae.

Latitudines ostiorum [5] ad altitudinem; si dorica erunt, uti dorica, si ionica erunt, uti ionica perficiantur, quemadmodum de thyromatis in quibus quarto libro rationes symmetriarum sunt expositae.

Conpluvii lumen latum latitudinis atrii ne minus quarta, ne plus tertia parte relinquatur; longitudo, uti atrii pro rata parte fiat.

7 Peristyla autem in transverso tertia parte longiora sint quam introssus.[6] Columnae tam altae quam porticus latae fuerint peristyliorum; intercolumnia

[1] ad maioribus *H*. [2] adiecta *rec* : abiecta *H*.
[3] & ablinii *H*, et tablini *G*.
[4] constituantur *G* : -atur *H*.
[5] ostiorum *Joc* : eorum *H*.
[6] introssus *H* : *inscrr*.

[1] Book IV. vi. 1 ff.

be given to the alcove. When the breadth is from
40 to 60, two-fifths are to be assigned to the alcove.
For the smaller atria cannot have the same kind of
symmetry as the larger. For if we use the symmetry
of the larger atria in the smaller, it cannot be useful
for the alcove or the wing. But if we use the sym-
metry of the smaller in the larger, the details will
be huge and monstrous. Therefore I thought that
according to their kinds the exact dimensions should
be registered with a view both to use and to effect.
6. The height of the alcove to the cornice is to be
one-eighth more than its breadth. The panelled
ceiling is to be raised higher than the cornices by
one-third of the breadth.

The main entrance for smaller atria is to be two-
thirds of the width of the alcove; for larger atria,
one-half. The portraits with their ornaments are
to be fixed above at a height equal to the breadth
of the alae.

The relation of the breadth to the height of the
doors is to be in the Doric manner for Doric build-
ings, in the Ionic, for Ionic buildings, as in the case
of Greek doorways of which the symmetrical relations
have been set out in the fourth book.[1]

The width of the opening of the compluvium is to
be not less than a fourth, nor more than a third, of
the width of the atrium; the length, in proportion
to the atrium.

7. The peristyles[2] lie crosswise, and should be
one-third wider than they are deep. The height of
the columns is to be the same as the breadth of the
colonnade of the peristyle. The inter-columniations

[2] The mediaeval cloister was developed from the peristyle
in this sense. Cf. *amplissimum peristylum.* Cic. *Dom.* 116.

ne minus trium, ne plus quattuor columnarum crassi-
tudine inter se distent. Sin autem dorico more in
peristylo columnae erunt faciundae, uti in quarto
libro de doricis scripsi, ita moduli sumantur, et ad eos
modulos triglyphorumque rationes disponantur.

8 Tricliniorum quanta latitudo fuerit, bis tanta
longitudo fieri debebit. Altitudines omnium con-
claviorum, quae oblonga fuerint, sic habere debent
rationem, uti longitudinis et latitudinis mensura
componatur et ex ea summa dimidium sumatur, et
quantum fuerit, tantum altitudini detur. Sin autem
exhedrae aut oeci quadrati fuerint, latitudinis dimi-
dia addita altitudines educantur. Pinacothecae uti
exhedrae amplis magnitudinibus sunt constituendae.
Oeci corinthii tetrastylique quique aegyptii vocantur
latitudinis et longitudinis,[1] uti supra tricliniorum
symmetriae scriptae sunt, ita habeant rationem, sed
propter columnarum interpositiones spatiosiores con-
stituantur.

9 Inter corinthios autem et aegyptios hoc erit dis-
crimen. Corinthii simplices habent columnas aut
in podio positas aut in imo; supraque habeant
epistylia et coronas aut ex intestino opere aut albario,
praeterea supra coronas curva lacunaria ad circinum
delumbata. In aegyptiis autem supra columnas
epistylia et ab epistyliis ad parietes, qui sunt circa,
inponenda est contignatio, supra coaxationem pavi-
mentum, subdiu ut sit circumitus. Deinde supra
epistylium ad perpendiculum inferiorum columnarum
inponendae sunt minores quarta parte columna.

[1] latitudinis et longitudinis *Joc* : -nes *bis H.*

[1] Book IV. iii. 3.

are to extend not less than three or more than four diameters of the columns. But if the columns in the peristyle are to be in the Doric style, the modules are to be taken as I described in the fourth book [1] about Doric detail, and the columns and triglyphs arranged accordingly.

8. The length of *triclinia*, or dining-rooms, must be twice their width. The height of all apartments which are oblong must be so arranged that the length and breadth are added together; of this sum half is taken, and this gives the height. But if they shall be exedrae or square *oeci*,[2] the height is to be one and a half times the width. Picture galleries (like exedrae) are to be made of ample dimensions. Corinthian and tetrastyle halls and those which are called Egyptian, are to have the same proportion of length and breadth as in the description of the triclinia, but owing to the use of columns they are to be more spacious.

9. There is this difference between a Corinthian and an Egyptian oecus. The Corinthian has one row of columns placed either upon a stylobate or upon the ground. Above, it is to have architraves and cornices either of fine joinery or plaster, and above the cornices, curved ceilings rounded to a circular section. In the Egyptian saloons, however, architraves are placed above the columns, and floor joists are to be carried from the architraves to the walls opposite. On the floor boards a pavement is to be laid that there may be a balcony in the open. Then above the architrave, and perpendicularly above the lower columns, columns one-fourth shorter

[2] Large apartments, halls. There was an exedra and an oecus in the Museum at Alexandria. Strabo XVII. 794.

VITRUVIUS

Supra earum epistylia et ornamenta lacunariis ornantur, et inter columnas superiores fenestrae conlocantur; ita basilicarum ea similitudo, non corinthiorum tricliniorum videtur esse.

10 Fiunt autem etiam non italicae consuetudinis oeci, quos Graeci cyzicenos appellant. Hi conlocantur spectantes ad septentrionem et maxime viridia prospicientes, valvasque[1] habent in medio. Ipsi autem sunt ita longi et lati, uti duo triclinia cum circumitionibus inter se spectantia possint esse conlocata, habentque dextra ac sinistra lumina fenestrarum valvata,[2] uti de tectis per spatia fenestrarum viridia prospiciantur. Altitudinis eorum dimidia latitudinis addita constituuntur.

11 In his aedificiorum generibus omnes sunt faciendae earum symmetriarum rationes, quae sine inpeditione loci[3] fieri poterunt, luminaque, parietum altitudinibus si non obscurabuntur, faciliter erunt explicata; sin autem inpedientur ab angustiis aut aliis necessitatibus, tunc erit[4] ut ingenio et acumine de symmetriis detractiones aut adiectiones fiant, uti non dissimiles veris symmetriis perficiantur venustates.

[1] ualbas *H G*.
[2] fen. viridia valvata *H* : viridia *del. Joc.*
[3] loci *ed* : locis *H*. [4] tunc erit *G* : tenerit *H S*.

are to be placed. Above their architraves and orna-
ments they have panelled ceilings, and windows are
placed between the upper columns. Thus the
Egyptian halls resemble basilicas [1] rather than
Corinthian apartments.

10. Other halls in a foreign manner are those
which the Greeks call Cyzicene. These are situated
with a north aspect, and especially with an outlook
upon gardens; they have folding windows in the
middle. The halls themselves are broad and long
enough to have two triclinia facing each other, with
room to pass round; and these, on both hands, have
garden windows with folding lights, so that the
guests, under cover,[2] may have a view of the garden.[3]
The height of the hall must be one and a half times
its width.

11. In buildings of this kind, all the rules of
symmetry must be followed, which are allowed by
the site, and the windows will be easily arranged
unless they are darkened by high walls opposite.
But if they are obstructed by the narrowness of the
street or by other inconveniences, skill and resource
must alter the proportions by decreasing or adding,
so that an elegance may be attained in harmony
with the proper proportions.

[1] Santa Maria Maggiore at Rome was perhaps a third-
century basilica in a private house. At any rate, the later
(Liberian) building is of this type.

[2] *tectum quo imbris causa vitandi succederet.* Cic. *Dom.*
116.

[3] *Cyrus aiebat viridiorum* διαφάσεις *latis luminibus non
tam esse suaves.* Cic. *Att.* II. 3.

IV

1 Nunc explicabimus, quibus proprietatibus genera aedificiorum ad usum et caeli regiones apte [1] debeant exspectare. Hiberna triclinia et balnearia uti occidentem hibernum spectent, ideo quod vespertino lumine opus est uti, praeterea quod etiam sol occidens adversus habens splendorem, calorem remittens efficit vespertino tempore regionem tepidiorem. Cubicula et bybliothecae ad orientem spectare debent; usus enim matutinum postulat lumen, item in bybliothecis libri non putrescent. Nam quaecumque ad meridiem et occidentem spectant, ab tiniis [2] et umore libri vitiantur, quod venti umidi advenientes procreant eas et alunt infundentesque umidos spiritus pallore volumina conrumpunt.

2 Triclinia verna et autumnalia ad orientem; tum [3] enim praetenta luminibus adversus solis impetus progrediens ad occidentem efficit ea temperata ad id tempus, quo opus solitum est uti. Aestiva ad septentrionem, quod ea regio, non ut reliquae per solstitium propter calorem efficiuntur aestuosae, ea quod est aversa a solis cursu, semper refrigerata et salubritatem et voluptatem in usu praestat. Non minus pinacothecae et plumariorum textrina [4] pictorumque officinae, uti colores eorum in opere propter constantiam luminis inmutata permaneant qualitate.

[1] apte *Fav*: actae *H*. [2] tiniis *H*: Verg. *G*. IV. 246.
[3] tum *Schn*: cum *H*. [4] textrina *S*: extrina *H*.

[1] Varro, *R. R.* I. 13. 7. Varro by changing doors and windows at Corcyra brought his men safely through a pestilence, *ib.* I. 4. 5.
[2] *cubicula—diurna nocturna.* Plin. *Ep.* I. 3. 1.

CHAPTER IV

ON THE ASPECT OF THE SEVERAL APARTMENTS

1. Now we will explain the adjustments by which the various apartments may look out suitably to their proper aspects.[1] The baths and winter dining-rooms should look towards the winter setting sun, because there is need of the evening light. Besides, when the setting sun faces us with its splendour, it reflects the heat and renders this aspect warmer in the evening. Private rooms [2] and libraries should look to the east, for their purpose demands the morning light. Further, the books in libraries will not decay. For in apartments which look to the south and west, books are damaged by the bookworm and by damp, which are caused by the moist winds on their approach, and they make the papyrus rolls mouldy by diffusing moist air.

2. The spring and autumn dining-rooms should look to the east. For exposed as they are to the light, the full power of the sun moving to the west renders them temperate at the time when the need to use them is customary. The summer dining-rooms should have a northern aspect. For while the other aspects, at the solstice, are rendered oppressive by the heat, the northern aspect, because it is turned away from the sun's course, is always cool, and is healthy [3] and pleasant in use. Not less should the picture galleries, the weaving-rooms of the embroiderers, the studios of painters, have a north aspect, so that, in the steady light, the colours in their work may remain of unimpaired quality.

[3] Varro, *R. R.* I. 4. 5.

V

1 CUM ad regiones caeli ita ea fuerint disposita,
tunc etiam animadvertendum est, quibus rationibus
privatis aedificiis propria loca patribus familiarum
et quemadmodum communia cum extraneis aedi-
ficari debeant. Namque ex his quae propria sunt,
in ea non est potestas omnibus intro eundi nisi
invitatis, quemadmodum sunt cubicula, triclinia,
balneae ceteraque, quae easdem habent usus rationes.
Communia autem sunt, quibus etiam invocati suo
iure de populo possunt venire, id est vestibula, cava
aedium, peristylia, quaeque eundem habere possunt
usum. Igitur is, qui communi sunt fortuna, non
necessaria magnifica vestibula nec tabulina neque
atria, quod in aliis officia praestant ambiundo neque [1]
2 ab aliis ambiuntur. Qui autem fructibus rusticis
serviunt, in eorum vestibulis stabula, tabernae, in
aedibus cryptae, horrea, apothecae ceteraque, quae
ad fructus servandos magis quam ad elegantiae
decorem possunt esse, ita sunt facienda. Item
feneratoribus et publicanis commodiora et specio-
siora et ab insidiis tuta, forensibus autem et disertis
elegantiora et spatiosiora ad conventos excipiundos,
nobilibus vero, qui honores magistratusque gerundo
praestare debent officia civibus, facienda sunt vesti-
bula regalia alta, atria et peristylia amplissima,[2]
silvae ambulationesque laxiores ad decorem maies-

[1] neque *Perr*: quae *H*.
[2] *Cf.* porticum pavimentatam . . . amplissimum peri-
stylum. Cic. *Dom.* 116.

[1] Crowded vestibule of jurisconsult. Cic. *de Or.* I. 200.
[2] Wine-store often in roof to receive the smoke. Hor. *Od.*
III. 8. 11.

CHAPTER V

ON BUILDING SUITABLY FOR DIFFERENT RANKS OF SOCIETY

1. When we have arranged our plan with a view to aspect, we must go on to consider how, in private buildings, the rooms belonging to the family, and how those which are shared with visitors, should be planned. For into the private rooms no one can come uninvited, such as the bedrooms, dining-rooms, baths and other apartments which have similar purposes. The common rooms are those into which, though uninvited, persons of the people can come by right, such as vestibules,[1] courtyards, peristyles and other apartments of similar uses. Therefore magnificent vestibules and alcoves and halls are not necessary to persons of a common fortune, because they pay their respects by visiting among others, and are not visited by others. 2. But those who depend upon country produce must have stalls for cattle and shops in the forecourt, and, within the main building, cellars, barns, stores[2] and other apartments which are for the storage of produce rather than for an elegant effect. Again, the houses of bankers and farmers of the revenue should be more spacious and imposing and safe from burglars. Advocates and professors of rhetoric should be housed with distinction, and in sufficient space to accommodate their audiences. For persons of high rank who hold office and magistracies, and whose duty it is to serve the state, we must provide princely vestibules, lofty halls and very spacious peristyles, plantations and broad avenues finished in a majestic

tatis perfectae; praeterea bybliothecas, basilicas
non dissimili modo quam publicorum operum mag-
nificentia comparatas, quod in domibus eorum
saepius et publica consilia et privata iudicia
arbitriaque conficiuntur.

3 Ergo si his rationibus ad singulorum generum
personas, uti in libro primo de decore est scriptum,
ita disposita erunt aedificia, non erit quod repre-
hendatur; habebunt enim ad omnes res commodas
et emendatas explicationes. Earum autem rerum
non solum erunt in urbe aedificiorum rationes, sed
etiam ruri, praeterquam quod in urbe atria proxima
ianuis solent esse, ruri ab pseudourbanis statim
peristylia, deinde tunc atria habentia circum porticus
pavimentatas [1] spectantes ad palaestras et ambula-
tiones.

Quoad potui urbanas rationes aedificiorum sum-
matim perscribere, proposui; nunc rusticorum
expeditionum, ut sint ad usum commodae quibusque
rationibus conlocare oporteat eas, dicam.

VI

1 PRIMUM de salubritatibus, uti in primo volumine
de moenibus conlocandis scribtum est, regiones aspi-
ciantur et ita villae conlocentur. Magnitudines
earum ad modum agri copiasque fructuum con-

[1] pavimentatas *Joc* : pavimenta *H.*

[1] Book I. ii. 5.

manner; further, libraries and basilicas arranged in a similar fashion with the magnificence of public structures, because, in such palaces, public deliberations and private trials and judgments are often transacted.

3. Therefore if buildings are planned with a view to the status of the client, as was set forth in the first book under the head of decor,[1] we shall escape censure. For our rules will be convenient and exact in every respect. Moreover, we shall take account of these matters, not only when we build in town, but in the country; except that, in town, the halls adjoin the entrance, in the country the peristyles of mansions built town-fashion come first, then the atria surrounded by paved colonnades overlooking the palaestra and the promenades.

I have set forth as I am able the general methods of building in town. I will now state the methods of building in the country,[2] with a view to convenience in use, and especially to the disposition of the site.

CHAPTER VI

ON FARM BUILDINGS

1. AND first with respect to salubrity: the aspects of sites must be examined, and the farm-houses placed, as we have written in the first volume about the positions of town walls.[3] The size of a farm-house is to be arranged to suit the amount of land

[2] *illorum (sc. anticorum) villae rusticae erant maioris preti quam urbanae quae nunc sunt pleraque contra.* Varro, *R. R.* I. 13. 6.

[3] Book I. iv. Varro, *R. R.* I. 4. 4.

parentur. Chortes magnitudinesque earum ad peco-
rum numerum, atque quot[1] iuga boum opus fuerint
ibi versari, ita finiantur. In chorte culina quam
calidissimo loco designetur.[2] Coniuncta autem
habeat bubilia, quorum praesepia ad focum et orientis
caeli regionem spectent, ideo quod boves lumen et
ignem spectando horridi non fiunt; item agricolae
regionum inperiti non putant oportere aliam re-
2 gionem caeli boves spectare nisi ortum solis. Bubi-
lium autem debent esse latitudines nec minores
pedum denum nec maiores v denum; longitudo,
uti singula iuga ne minus pedes occupent septenos.
Balnearia item coniuncta sint culinae; ita enim
lavationi rusticae ministratio non erit longe. Torcular
item proximum sit culinae; ita enim ad olearios
fructus commoda erit ministratio. Habeatque con-
iunctam vinariam cellam habentem ab septentrione
lumina fenestrarum; cum enim alia parte habuerit,
quae sol calfacere possit, vinum, quod erit in ea
cella, confusum ab calore efficietur inbecillum.
3 Olearia autem ita est conlocanda, ut habeat a
meridie calidisque regionibus lumen; non enim
debet oleum congelari, sed tempore caloris extenuari.
Magnitudines autem earum ad fructuum rationem
et numerum doliorum sunt faciundae, quae, cum
sint cullearia, per medium occupare debent pedes
quaternos. Ipsum autem torcular, si non cocleis
torquetur sed vectibus et prelo premetur, ne minus
longum pedes xl constituatur; ita enim erit vectiario

[1] quod H. [2] desinetur H.

[1] Varro, *R. R.* I. 13. 1. [2] Book I. iv. 2.
[3] Varro, *R. R.* I. 13. 7.

and of the crops. The farm-yards and their dimensions are to correspond to the number of cattle and the yoke of oxen which are required. In the farm-yard the warmest place must be assigned to the kitchen, and, adjoining this, to the cowhouses,[1] the mangers of which are to look towards the hearth and towards the east, for cattle which face light and heat do not lose their sleekness. And even farmers who are ignorant about aspects, do not think that cattle ought to face any quarter of the sky but the east. 2. The width of the stalls should be not less than ten nor more than fifteen feet; lengthwise each yoke should have not less than seven feet. The baths also should be next to the kitchen; in this way the service of baths for the farm will be near by. The oilpress should be next the kitchen, for in this way the service will be convenient for the olive harvest. Next let there be the wine-cellar, having windows with light from the north.[2] For when light is drawn from a quarter heated by the sun, the wine will be affected by the heat, and thin.

3. The oil store is to be so situated as to receive light from the south and the warm quarter.[3] For the oil should not be congealed, but kept thin by the warm weather. The dimensions of the store should answer to the amount of the harvest and the number of the jars. When these contain 20 amphorae, they should occupy four feet each on the average. The press, if it is not turned by a screw,[4] but is worked by levers and a press-beam, is to be not less than 40 feet long. This will leave room for

[4] This was a Greek invention. Plin. N. H. XVIII. 317.

spatium expeditum. Latitudo eius ne minus pedum senum denum; nam sic erit ad plenum opus facientibus libera versatio et expedita. Sin autem duobus prelis loco opus fuerit, quattuor et viginti pedes latitudini dentur.

4 Ovilia et caprilia ita sunt magna facienda, uti singula pecora areae ne minus pedes quaternos et semipedem, ne plus senos possint habere. Granaria sublinita[1] et ad septentrionem aut aquilonem spectantia disponantur; ita enim frumenta non poterint cito concalescere, sed ab flatu refrigerata diu servantur. Namque ceterae regiones procreant curculionem et reliquas bestiolas, quae frumentis solent nocere. Equilibus, quae maxime in villa loca calidissima fuerint, constituantur, dum ne ad focum spectent; cum enim iumenta proxime ignem stabulantur, horrida fiunt.

5 Item non sunt inutilia praesepia, quae conlocantur extra culinam in aperto contra orientem; cum enim in hieme anni sereno caelo in ea traducuntur matutino boves, ad solem pabulum capientes fiunt nitidiores. Horrea, fenilia, farraria, pistrina extra villam facienda videntur, ut ab ignis periculo sint villae tutiores. Si quid delicatius in villis faciundum fuerit, ex symmetriis quae in urbanis supra scripta sunt constituta, ita struantur, uti sine inpeditione rusticae utilitatis aedificentur.

6 Omniaque aedificia ut luminosa sint, oportet curari; sed quae sunt ad villas, faciliora videntur esse, ideo quod paries nullius vicini potest opstare,

[1] sublinita *Gr*: sublinata *H* : *cf.* liniantur, *supra* V. x. 3.

[1] Book I. iv. 2.

the man who works the levers. The width of the room must be not less than 16 feet, so that when the men are fully at work, their movements will be free and easy. But if two presses are required in the place, the width should be 24 feet.

4. The sheep and goat folds are to be such a size that each animal occupies not less than $4\frac{1}{2}$ or more than 6 feet. The granaries are to have a concrete floor, and a north or north-east aspect.[1] For in this way the corn will not soon become overheated, but keeps good, being cooled by the draughts. For other aspects produce the weevil and other small creatures, which usually damage the corn. Stables are to be so placed as to have the warmest part of the farm buildings, provided they do not look towards the hearth. For when draught horses are stabled next the fire, they lose their sleekness.

5. Further, mangers are not without their advantages, which are put outside the kitchen in the open on the east. For when the cattle are led up in fine winter weather for their morning feed, they become more sleek by eating their fodder in the sun. Barns, stores for hay and meal, bakehouses, should be outside the farm-house, that they may be more safe from fire. If a touch of elegance [2] is required in a farm-house, it should be built in a symmetrical manner, which things are described above for town houses, yet without interfering with the needs of agriculture.

6. Care is required that all buildings should be well lighted. This is more easy in farm buildings because there are no party walls to interfere;

[2] *eleganter aedificet agricola, nec sit tamen aedificator.* Colum. I. 4. 1. Cf. *minus aedificator.* Nepos, *Atticus.* 13.

in urbe autem aut communium parietum altitudines aut angustiae loci inpediundo faciunt obscuritates. Itaque de ea re sic erit experiundum. Ex qua parte lumen oportet sumere, linea tendatur ab altitudine parietis, qui videtur obstare, ad eum locum, quo oporteat inmittere, et si ab ea linea in altitudinem cum prospiciatur, poterit spatium puri caeli amplum videre, in eo loco lumen erit sine inpeditione.

7 Sin autem officient trabes seu limina[1] aut contignationes, de superioribus partibus aperiatur et ita inmittatur. Et ad summam ita est gubernandum, ut, ex quibuscumque partibus caelum prospici poterit, per ea fenestrarum loca relinquantur; sic enim lucida erunt aedificia. Cum autem in tricliniis ceterisque conclavibus maximus est usus luminum, tum etiam itineribus, clivis, scalis, quod in his saepius alius aliis obviam venientes ferentes sarcinas solent incurrere.

Quoad potui, distributiones operum nostratium ut sint aedificatoribus non obscurae, explicui; nunc etiam, quemadmodum Graecorum consuetudinibus aedificia distribuantur, uti non sint ignota, summatim exponam.

VII

1 Atriis Graeci quia non utuntur, neque aedificant, sed ab ianua introeuntibus itinera faciunt latitudinibus non spatiosis, et ex una parte equilia,[2] ex

[1] limina *ed* : lumina *H*.
[2] equilia *Joc* : aequalia *H*.

whereas in cities, the heights of party walls or the narrow streets are in the way, and cause lack of light. Therefore trial should be made as follows. In the quarter from which light is required, a line should be drawn from the top of the party wall which seems to obstruct, to the point where light should be admitted. If the amount of open sky seems sufficient when we look up from that line, the light will not be obstructed.

7. But if the light is hindered by beams or lintels or flooring, there must be an opening made above to admit the light. And the whole must be so controlled that from whatever quarter the sky can be seen, window openings must be left there;[1] for in this way the buildings will be well lighted. Now there is special need of light in dining-rooms and other apartments, and also in passages, sloping ways, and staircases, because, in these, persons who come with burdens often run into one another when they meet.

As far as I can, I have explained the arrangement of our buildings that they may not be obscure to our own builders; now I will also explain briefly how buildings are arranged according to Greek custom, so that they too may not be unknown.

CHAPTER VII

ON GREEK MANSIONS

1. The Greeks,[2] not using atria, do not build as we do; but as you enter, they make passages of scanty width with stables on one side, and the

[1] *per ea*, neuter of general reference.
[2] The reference is probably to the Alexandrian age.

altera ostiariis cellas, statimque ianuae interiores
finiuntur. Hic autem locus inter duas ianuas graece
thyroron appellatur. Deinde est introitus in peristylon.
Id peristylum in tribus partibus habet porticus inque [1]
parte, quae spectat ad meridiem, duas antas inter
se spatio amplo distantes, in quibus trabes inve-
huntur, et quantum inter antas distat, ex eo tertia
adempta spatium datur introrsus. Hic locus apud
nonnullos prostas, apud alios pastas nominatur.

2 In his locis introrsus constituuntur oeci magni, in
quibus matres familiarum cum lanificis habent ses-
sionem. In prostadis [2] autem dextra ac sinistra
cubicula sunt conlocata, quorum unum thalamus,
alterum amphithalamus dicitur. Circum autem in
porticibus triclinia cotidiana, cubicula, etiam cellae [3]
familiaricae constituuntur. Haec pars aedificii
gynaeconitis appellatur.

3 Coniunguntur autem his domus ampliores habentes
lautiora peristylia, in quibus pares sunt quattuor
porticus altitudinibus, aut una, quae ad meridiem
spectat, excelsioribus columnis constituitur. Id
autem peristylum, quod unam altiorem habet porti-
cum, rhodiacum dicitur. Habent autem eae domus
vestibula egregia et ianuas proprias cum dignitate
porticusque peristyliorum albariis et tectoriis et ex
intestino opere lacunariis ornatas, et in porticibus,
quae ad septentrionem spectant, triclinia cyzicena
et pinacothecas, ad orientem autem bybliothecas,
exhedras ad occidentem, ad meridiem vero spec-
tantes oecos quadrata ostia ampla magnitudine, uti
faciliter in eo quattuor tricliniis stratis ministra-
tionum ludorumque operis locus possit esse spatiosus.

[1] inque *rec* : in quae *H.* [2] prostadis *Joc* : prostadii *H.*
 [3] sellae *Gr* (Varro *R. R.* I. 13. 4).

porter's rooms on the other; and these immediately adjoin the inner entrance. The space between the two entrances is called in Greek *thyroron*. You then enter the peristyle. This has colonnades on three sides. On the side which looks southward, there are two piers at a fair distance apart, on which beams are laid. The space behind is recessed two-thirds of the distance between the piers. The recess by some is called *prostas*, *pastas* by others.[1]

2. As we pass in, there is the Great Hall in which the ladies sit with the spinning women. Right and left of the recess are the bedchambers, of which one is called the *thalamus*, the other the *amphithalamus*. Round the colonnades are the ordinary dining-rooms, the bedrooms and servants' rooms. This part of the building is called the women's quarter, *gynaeconitis*.

3. Next to this is a larger block of buildings with more splendid peristyles; in these the colonnades are equal in height, or else the colonnade which looks to the south has loftier columns. The peristyle which has one colonnade higher is called Rhodian. These buildings have splendid approaches and doorways of suitable dignity. The colonnades of the peristyles are finished with ceilings of stucco, plaster, and fine wood panelling. In the colonnades which face the north are Cyzicene triclinia and picture galleries; on the east the libraries, the exedrae on the west; halls and square entrances [2] face the south that there may be ample room for four triclinia, and for the servants who attend them and assist in the amusements.

[1] Ap. Rh. I. 789.
[2] The *quadrata ostia* should perhaps be retained as halls open in front to the air.

4 In his oecis fiunt virilia convivia; non enim fuerat institutum matris familiarum eorum moribus accumbere. Haec autem peristylia domus andronitides dicuntur, quod in his viri sine interpellationibus mulierum versantur. Praeterea dextra ac sinistra domunculae constituuntur habentes proprias ianuas, triclinia et cubicula commoda, uti hospites advenientes non in peristylia sed in ea hospitalia recipiantur. Nam cum fuerunt Graeci delicatiores et fortuna opulentiores, hospitibus advenientibus instruebant triclinia, cubicula, cum penu cellas, primoque die ad cenam invitabant, postero mittebant pullos, ova, holera, poma reliquasque res agrestes. Ideo pictores ea, quae mittebantur hospitibus, picturis imitantes xenia appellaverunt. Ita patres familiarum in hospitio non videbantur esse peregre, habentes secretam 5 in his hospitalibus liberalitatem.[1] Inter duo autem peristylia et hospitalia itinera sunt, quae mesauloe dicuntur, quod inter duas aulas media sunt interposita; nostri autem eas andronas appellant.

Sed hoc valde est mirandum, nec enim graece nec latine potest id convenire. Graeci enim *andronas* appellant oecus, ubi convivia virilia solent esse, quod eo mulieres non accedunt. Item aliae res sunt similes, uti xystus, prothyrum, telamones [2] et nonnulla alia eius modi. *Xystos* enim est graeca appellatione porticus ampla latitudine, in qua athletae per hiberna tempora exercentur; nostri autem hypaethrus ambulationes xysta [3] appellant, quas

[1] *post* liberalitatem *H paginam versam folii* 87 *vacuam exhibet.*
[2] thalamones *H.* [3] xysta *ed* : xysti *H.*

[1] The paintings of still life by Dutch painters, correspond to the groups of fruit, poultry, etc. in Roman mosaics.

4. In these halls men's banquets are held. For it was not customary for women to join men at dinner. Now these peristyles are called the men's block, for in them men meet without interruption from the women. Moreover, on the right and left lodges are situated with their own entrances, dining-rooms and bedrooms, so that guests on their arrival may be received into the guest-houses and not in the peristyles. For when the Greeks were more luxurious and in circumstances more opulent, they provided for visitors on their arrival, dining-rooms, bedrooms, and store-rooms with supplies. On the first day they invited them to dinner; afterwards they sent poultry, eggs, vegetables, fruit, and other country produce. Therefore painters, when they portrayed what was sent to guests, called them guest-gifts.[1] Thus the heads of families in a guest-house [2] do not seem to be away from home when they enjoy private generosity in the visitors' quarters. 5. Now between the two peristyles and the visitors' quarters there are passages called *Mesauloe*, because they are between the two *aulae* or halls. But we call them *Androctes*, the men's quarters.

It is very remarkable that this suits neither Greek nor Latin usage. For the Greeks call *androctes* the halls where the men's banquets take place, because women are excluded. Yet other terms are of like application, such as xystus, prothyrum, telamones, and so forth. For xystus in its Greek signification is a colonnade of ample breadth where the athletes are trained in the winter;[3] but we give the name of xysta to promenades in the open, which the Greeks

[2] *hospitium, Acts* xxviii. 23.
[3] Repeated from Book V. xi. 4.

Graeci *paradromidas* dicunt. Item *prothyra* graece dicuntur, quae sunt ante in ianuas vestibula, nos autem appellamus prothyra, quae graece dicuntur *diathyra*.

6 Item si qua virili figura signa mutulos aut coronas sustinent, nostri telamones appellant, cuius rationes,[1] quid ita aut quare dicantur, ex historiis non inveniuntur, Graeci vero eos *atlantas* vocitant. Atlas enim formatur historia sustinens mundum, ideo quod is primum cursum solis et lunae siderumque omnium versationum rationes vigore animi sollertiaque curavit hominibus tradenda, eaque re [2] a pictoribus et statuariis deformatur pro eo beneficio sustinens mundum, filiaeque eius Atlantides, quas nos vergilias, Graeci autem *pliadas* nominant, cum 7 sideribus in mundo sunt dedicatae. Nec tamen ego, ut mutetur consuetudo nominationum aut sermonis,[3] ideo haec proposui, sed uti non sint ignota philologis, exponenda iudicavi.

Quibus consuetudinibus aedificia italico more et Graecorum institutis conformantur, exposui et de symmetriis singulorum generum proportiones perscribsi. Ergo [4] quoniam de venustate decoreque ante est conscriptum, nunc exponemus de firmitate, quemadmodum ea sine vitiis permanentia ad vetustatem conlocentur.

[1] ratione *H.* [2] re *Joc :* res *H.*
[3] sermones *H.* [4] ergo *G :* ero *H.*

call *paradromides*. The Greeks give the name pro-
thyra to the vestibules which are in front and serve
as the entrance; we call prothyra what, in Greek
are named *diathyra*.[1]

6. Again, if statues of the male figure support
brackets or cornices, we call them *telamones*, nor do
we find in any treatises what they are and why
they are so called. But the Greeks call them
Atlantes. For, in history,[2] Atlas is represented as
sustaining the universe, because he was the first by
his powerful intellect and skill to set forth to man-
kind the sun's course and the revolutions of the
moon and all the stars. And therefore because of
this service he is represented by painters and statu-
aries as sustaining the world. His daughters, the
Atlantides, whom we call Vergiliae and the Greeks
Pleiades, are placed among the constellations in the
universe. 7. I have put this forth not with the
purpose of changing any nomenclature or language
in common use, but I thought that these explanations
should not be unknown to scholars.

I have expounded the traditions by which build-
ings are designed in the Italian manner, and by
Greek rules, and have enumerated the proportions
which determine the symmetries of the different
styles. We have already, therefore, written on
grace and propriety in architecture; it remains to
deal with stability and the means by which build-
ings may be planned so as to endure without defect.[3]

[1] Wicket-gate at the front door.

[2] Euhemerus, in a work translated by Ennius, taught the
doctrine represented here, that the gods were originally famous
men.

[3] Book I. iii. 2.

VITRUVIUS

VIII

1　AEDIFICIA quae plano pede instituuntur, si fundamenta eorum facta fuerint ita, ut[1] in prioribus libris de muro et theatris nobis est expositum, ad vetustatem ea[2] erunt sine dubitatione firma. Sin autem hypogea concamarationesque instituentur, fundationes eorum fieri debent crassiores, quam quae in superioribus aedificiis structurae sunt futurae. Eorumque parietes, pilae, columnae ad perpendiculum inferiorum medio conlocentur, uti solido respondeant; nam si in pendentibus onera fuerint parietum aut columnarum, non poterint habere perpetuam firmitatem.

2　Praeterea inter lumina secundum pilas et antas postes si supponentur, erunt non vitiosae. Limina enim et trabes structuris cum sint oneratae, medio spatio pandantes frangunt sublisi[3] structuras; cum autem subiecti fuerint et subcuneati postes, non patiuntur insidere[4] trabes neque eas laedere.

3　Item administrandum est, uti levent onus parietum fornicationes cuneorum[5] divisionibus et ad centrum respondentes earum conclusurae. Cum enim extra trabes aut liminum capita arcus cuneis erunt conclusae, primum non pandabit materies levata onere; deinde, si quod vetustate vitium ceperit, sine molitione fulturarum faciliter mutabitur.

4　Itemque, quae pilatim aguntur aedificia et cune-

[1] ut *G* : aut *H*.　　[2] eae *H*.
[3] sublisi *e₂ Sulp* : sub lysi *H*.　　[4] insidera *H*.
[5] cuneorum *H* : cum eorum.

[1] Book I. v. 1.　　[2] Book V. iii. 3.
[3] *pendo* = overhang. Lucr. vi. 195.
[4] Voussoirs = wedge-shaped stones of an arch.

CHAPTER VIII

ON THE STABILITY OF BUILDINGS

1. Buildings which start from the level of the ground, if the foundations are so laid, as we have explained in previous books with reference to city walls [1] and theatres,[2] will assuredly be solid and durable. But if there are spaces underground and vaulted cellars, the foundations must be wider than the structures in the upper parts of the building. The party walls, the piers, the columns, are to be placed with their centres perpendicularly above the lower parts, so as to correspond to the solid. For if the weight of the dividing walls or of the columns is over open spaces,[3] it cannot be permanently sustained.

2. Further, if supports are put for the piers and pilasters between the windows, these faults will be avoided. For when lintels and bressumers are loaded with walling, they sag in the middle and cause fractures by settlement; but when piers are placed underneath and wedged up, they do not allow the beams to settle and injure the structure above.

3. We must also contrive to relieve the weight of the walling by arches with their voussoirs,[4] and their joints directed to a centre. For when arches, with their voussoirs, are carried outside the beams and lintels, in the first place the wood relieved of its burden will not sag; in the second place, if it decays in course of time, it will easily be replaced without the labour of shoring up.

4. Moreover, when buildings rest upon piers, and

orum divisionibus coagmentis ad centrum respond-
entibus fornices concluduntur, extremae pilae in his
latiores spatio sunt faciundae, uti vires eae habentes
resistere possint, cum cunei ab oneribus parietum
pressi per coagmenta ad centrum se prementes
extruderent incumbas. Itaque si angulares pilae
erunt spatiosis magnitudinibus, continendo cuneos
firmitatem operibus praestabunt.

5 Cum in his rebus animadversum fuerit, uti ea
diligentia in his adhibeatur, non minus etiam obser-
vandum est, uti omnes structurae perpendiculo
respondeant neque habeant in ulla parte proclina-
tiones. Maxima autem esse debet cura substruc-
tionum, quod in his infinita vitia solet facere terrae
congestio. Ea enim non potest esse semper uno
pondere, quo solet esse per aestatem, sed hibernis
temporibus recipiendo ex imbribus aquae multi-
tudinem crescens et pondere et amplitudine dis-
rumpit et extrudit structurarum saeptiones.

6 Itaque, ut huic vitio medeatur, sic erit faciundum,
ut primum pro amplitudine congestionis crassitudo
structurae constituatur. Deinde in frontibus ante-
rides, sive erismae sunt, una struantur, eaeque inter
se distent tanto spatio, quanta altitudo substructionis
est futura, crassitudine[1] eadem, qua substructio; pro-
currat autem ab imo, pro quam[2] crassitudo consti-
tuta fuerit substructionis, deinde contrahatur grada-
tim, ita uti summam habeat prominentiam, quanta
operis est crassitudo.

[1] crassitudine *Joc* : -nis *H*.
[2] pro quam *Ro* : per quam *H*.

[1] In these sections, Vitruvius furnished the mediaeval
builders with the main principles of Gothic architecture. *Cf.*

54

arches are constructed with voussoirs and with joints directed to a centre, the end piers in the buildings are to be set out of greater width, so that they may be stronger and resist when the voussoirs, being pressed down by the weight of the walling owing to the jointing, thrust towards the centre and push out the imposts. Therefore if the angle piers are of wide dimensions, they will restrain the thrust and give stability to the buildings.[1]

5. When proper attention has been given herein that such care be taken, we must not less be on our guard that every part of a building maintains its perpendicular and that no part leans over. But the greatest care must be taken in the substructures, because, in these, immense damage is caused by the earth piled against them. For it cannot remain of the same weight as it usually has in the summer: it swells in the winter by absorbing water from the rains. Consequently by its weight and expansion it bursts and thrusts out the retaining walls.

6. To avoid this damage, therefore, we must proceed as follows. The thickness of the walling must answer to the amount of earth. Next, supporting walls or buttresses are to be carried up at the same time. The interval between them is to be the same as the height of the substructure, and the thickness that of the substructure. They are to project at the base in accordance with the thickness determined for the substructure. Then they are to be gradually diminished, so that at the top they may project as much as the thickness of the walling.

Seneca, *Ep.* 95. 53. *Societas nostra lapidum fornicationi simillima est: quae casura nisi invicem obstarent, hoc ipso sustinetur.*

7 Praeterea introrsus contra terrenum coniuncta
muro serratim struantur, uti singuli dentes ab muro
tantum distent, quanta altitudo futura erit sub-
structionis; crassitudines [1] autem habeant dentium
structurae uti muri. Item in extremis angulis cum
recessum fuerit ab interiore angulo spatio altitudinis
substructionis, in utramque partem signetur, et ab
his signis diagonius [2] structura conlocetur, et ab ea
media altera coniuncta cum angulo muri. Ita dentes
et diagonioe [3] structurae non patientur tota vi premere
murum, sed dissipabunt retinendum [4] impetum
congestionis.[5]

8 Quemadmodum sine vitiis opera constitui oporteat
et uti caveatur incipientibus, exposui. Namque de
tegulis aut tignis aut asseribus mutandis non est
eadem cura quemadmodum de his, quod ea, quamvis
sunt vitiosa, faciliter mutantur. Ita quae [6] nec
solidi quidem putantur esse, quibus rationibus haec
poterint esse firma et quemadmodum instituantur,
exposui.

9 Quibus autem copiarum generibus oporteat uti,
non est architecti potestas, ideo quod non in omnibus
locis omnia genera copiarum nascuntur, ut in proximo
volumine est expositum; praeterea in domini est
potestate, utrum latericio an caementicio an saxo
quadrato velit aedificare. Itaque omnium operum
probationes tripertito considerantur, id est fabrili
subtilitate et magnificentia et dispositione. Cum
magnificenter opus perfectum aspicietur, a domini [7]
potestate inpensae laudabuntur; cum subtiliter,

[1] crassitudinis *H*. [2] diagonios *Joc*: -nius *H S*.
[3] diagoniae *H*. [4] retinendo *rec*: -dum *H*.
[5] congestiones *H S*. [6] itaque *H*.
[7] a domini *Meister*: abomni *H*.

7. Further, against the earth on the inside, the wall must have projections like the teeth of a saw, such that the intervals between them are equal to the height of the substructure. The thickness of the teeth must be that of the main wall. Further, in the outer angles of the substructure, taking a distance from the internal angle equal to the height of the substructure, we must mark a point on either side and a diagonal wall is to be built between them, and from the middle of the diagonal wall, another wall is to be built to the interior angle of the main wall. The teeth and the diagonal walls will not allow the full pressure to fall upon the main wall but will distribute the thrust of the earth, which we have to hold in check.

8. How buildings can be carried out so as to avoid failure, and how precautions must be taken in the first stages, has been explained. For the same care is not needful in repairing roof tiling, or principals or rafters, which if faulty are easily repaired, as in the foundations. I have also described how those parts of a building which are not considered to belong to the solid can be made stable, and how they are to be constructed.

9. An architect cannot control the kinds of material which it is necessary to use, for the reason that not all kinds of material occur in all places, as was explained in the last book.[1] Besides, the client decides whether he is to build in brick or rubble or ashlar. Therefore the test of all building is held to be threefold: fine workmanship, magnificence, architectural composition. When a building has a magnificent appearance, the expenditure of those who control it, is praised. When the craftsmanship is

[1] Book V. vi. 7; xii. 5.

officinatoris probabitur exactio; cum vero venuste
proportionibus et symmetriis habuerit auctoritatem,
10 tunc fuerit gloria area[1] architecti. Haec autem
recte constituuntur, cum is et a fabris et ab idiotis
patiatur accipere se consilia. Namque omnes
homines, non solum architecti, quod est bonum,
possunt probare, sed inter idiotas et eos hoc est
discrimen, quod idiota, nisi factum viderit, non
potest scire, quid sit futurum, architectus autem,
simul animo constituerit, antequam inceperit, et
venustate et usu et decore quale sit futurum, habet
definitum.

Quas res privatis aedificiis utiles putavi et quemad-
modum sint faciundae, quam apertissime potui,
perscripsi; de expolitionibus[2] autem eorum, uti
sint elegantes et sine vitiis ad vetustatem, insequenti
volumine exponam.

[1] area *Gr* : gloria aria architecti *H*.
[2] expolitionibus *S* : expoliationibus *H*.

good, the supervision of the works is approved. But when it has a graceful effect due to the symmetry of its proportions, the site [1] is the glory of the architect. 10. His work is duly accomplished when he submits to receive advice from his workmen and from laymen. For all men, and not only architects, can approve what is good. But there is this difference between the architect and the layman, that the layman cannot understand what is in hand unless he sees it already done; the architect, when once he has formed his plan, has a definite idea how it will turn out in respect to grace, convenience, and propriety.

I have described, as explicitly as I can, the details which are useful in private buildings and how they are to be carried out. In the next book I will treat of the methods of finishing the work, so that they may be ornamental, free from defects and permanent.

[1] But the conjecture *area* is doubtful.

BOOK VII

LIBER SEPTIMUS

1 MAIORES cum sapienter tum etiam utiliter in-
stituerunt, per commentariorum relationes cogitata
tradere posteris, ut ea non interirent, sed singulis
aetatibus crescentia voluminibus edita gradatim
pervenirent vetustatibus ad summam doctrinarum
subtilitatem. Itaque non mediocres sed infinitae
sunt his agendae gratiae, quod non invidiose silentes
praetermiserunt, sed omnium generum sensus con-
scribtionibus memoriae tradendos curaverunt.

2 Namque si non ita fecissent, non potuissemus scire,
quae res in Troia fuissent gestae, nec quid [1] Thales,
Democritus, Anaxagoras, Xenophanes reliquique
physici sensissent de rerum natura, quasque Socrates,
Platon, Aristoteles, Zenon, Epicurus aliique philosophi
hominibus agendae vitae terminationes finissent, seu
Croesus,[2] Alexander, Darius ceterique reges quas res
aut quibus rationibus gessissent, fuissent notae,
nisi maiores praeceptorum conparationibus omnium
memoriae ad posteritatem commentariis extulissent.

3 Itaque quemadmodum his gratiae sunt agendae,

[1] nequid *H.* [2] croessus *H.*

[1] Vitruvius, probably, has in view (*a*) histories *commentarii*;
(*b*) collections of opinions, beginning with Theophrastus'
Opinions of Natural Philosophers.
[2] Zeno of Citium in Cyprus, probably a Semite, founded the
Stoic philosophy so called from the Frescoed Colonnade *Stoa*

BOOK VII

Preface

1. Our predecessors, wisely and with advantage, proceeded by written records to hand down their ideas to after times, so that they should not perish, but being augmented from age to age and published in book form, they should come step by step in the course of time to a complete and accurate body of knowledge. Hence we must render to them more than moderate thanks, indeed the greatest, because they did not let them all go in jealous silence, but provided for the record in writing of their ideas in every kind.[1]

2. If they had not done so, we could not have known the history of Troy, nor the natural philosophy of Thales, Democritus, Anaxagoras, Xenophanes, and the rest; nor should we have been acquainted with the precepts of Socrates, Plato, Aristotle, Zeno,[2] Epicurus, and other philosophers for the conduct of human life, nor with the actions and policy of Croesus, Alexander, Darius, and other monarchs, unless our predecessors in their records and collections of opinions had published these matters to posterity and the memory of the world.

3. While, then, these men deserve our gratitude,

Poikile, at Athens in which he taught. The Peripatetic (Aristotelian) philosophy derived its name from the Cloisters, *peripatoi*, of the gymnasium in which the master taught.

contra,[1] qui eorum scripta furantes pro suis prae-
dicant, sunt vituperandi, quique non propriis cogi-
tationibus scriptorum nituntur, sed invidis moribus
aliena violantes gloriantur, non modo sunt repre-
hendendi,[2] sed etiam, qui impio more vixerunt,
poena condemnandi. Nec tamen hae res non
vindicatae curiosius ab antiquis esse memorantur.
Quorum exitus iudiciorum qui fuerint, non est
alienum, quemadmodum sint nobis traditi, explicare.

4 Regis [3] Attalici magnis philologiae dulcedinibus
inducti cum egregiam bybliothecam Pergami ad
communem delectationem instituissent, tunc item
Ptolomaeus infinito zelo cupiditatisque incitatus [4]
studio non minoribus industriis ad eundem modum
contenderat Alexandriae comparare. Cum autem
summa diligentia perfecisset, non putavit id satis
esse, nisi propagationibus inseminando curaret
augendam. Itaque Musis et Apollini ludos dedi-
cavit et, quemadmodum athletarum, sic com-
munium [5] scriptorum victoribus praemia et honores
constituit.

5 His ita institutis, cum ludi adessent, iudices litterati,
qui ea probarent, erant legendi. Rex, cum iam sex
civitatis [6] lectos habuisset nec tam cito septumum
idoneum inveniret, retulit ad eos, qui supra byblio-
thecam fuerunt, et quaesiit, si quem novissent ad

[1] sunt agendae contra *rec* : sunt agendaest contra *H*.
[2] repraehendi *H*. [3] regis *H*. [4] incitatis *H*.
[5] sicommunium *H*. [6] excivitatibus *G*.

[1] The Attalid dynasty ruled from 280 B.C. to 133 B.C.
Eumenes I (263–241), Attalus I (241–197), Eumenes II (197–
159) fostered the library. The building which housed it was
erected by Eumenes II.

on the other hand we must censure those who plunder
their works and appropriate them to themselves;
writers who do not depend upon their own ideas, but
in their envy boast of other men's goods whom they
have robbed with violence, should not only receive
censure but punishment for their impious manner of
life. And this practice, as we are informed, was
duly dealt with by the ancients. It is not out of
place to relate the results of these trials as they
have been handed down.

4. The Attalid kings,[1] impelled by their delight
in literature, established for general perusal [2] a fine
library at Pergamus. Then Ptolemy, moved by
unbounded jealousy and avaricious desire, strove
with no less industry to establish a library at
Alexandria after the same fashion.[3] When he had
completed it with great diligence, he did not think
it enough unless he should provide for its increase
by sowing and planting. So he consecrated games
in honour of the Muses and Apollo, and estab-
lished prizes and honours for the successful writers
of the day, in the same way as for successful
athletes.

5. When the arrangements were completed, and
the games were at hand, learned judges had to be
chosen to examine the competitors. When the
king had chosen six persons from the city and
could not quickly find a seventh [4] person suitable,
he consulted the governors of the library whether

[2] *delectatio = voluptas suavitate auditus animum deleniens.*
Cic. *Tusc.* IV. 9. 20.
[3] Ptolemy Philadelphus built two great libraries to contain
his collections, completed by his successor, Euergetes.
[4] In Greek idiom implies six others.

id expeditum. Tunc ei dixerunt esse quendam
Aristophanen, qui summo studio summaque dili-
gentia cotidie omnes libros ex ordine perlegeret.
Itaque conventu ludorum, cum secretae sedes
iudicibus essent distributae, cum ceteris Aristo-
phanes citatus, quemadmodum fuerat locus ei
6 designatus, sedit. Primo poetarum ordine ad certa-
tionem inducto cum recitarentur scripta, populus
cunctus significando monebat iudices, quod pro-
barent. Itaque, cum ab singulis sententiae sunt
rogatae, sex una dixerunt, et, quem maxime anim-
adverterunt multitudini placuisse, ei primum
praemium, insequenti secundum tribuerunt. Aris-
tophanes vero, cum ab eo sententia rogaretur, eum
primum renuntiari iussit, qui minime populo pla-
7 cuisset. Cum autem rex et universi vehementer
indignarentur, surrexit et rogando impetravit,[1] ut
paterentur se dicere. Itaque silentio facto docuit unum
unum ex his eum esse poetam, ceteros aliena reci-
tavisse; oportere autem iudicantes non furta sed
scripta probare. Admirante populo et rege dubi-
tante, fretus memoriae certis armariis infinita
volumina eduxit et ea cum recitatis conferendo
coegit ipsos furatos de se confiteri. Itaque rex
iussit cum his agi furti condemnatosque cum igno-
minia dimisit, Aristophanen vero amplissimis mune-
ribus ornavit et supra bybliothecam constituit.

[1] impetravit *rec* : imperavit *H*.

[1] Aristophanes the critic 257–180 B.C. The reign of
Euergetes (*ob.* 222) fits in with the story.

[2] Aristophanes probably worked in the library many years
before he succeeded Eratosthenes as head.

[3] Probably Ptolemy III Euergetes.

[4] *Armarium*, sometimes recess in wall of library as at Timgad.

they knew anyone prepared for such a duty. They gave the name of Aristophanes,[1] who read each book in the library systematically day by day with comprehensive ardour and diligence. Therefore at the assemblage for the games special seats were allotted to the judges, and Aristophanes, being summoned with the rest, took his seat in the place allotted to him. 6. The competition for poets was first on the list; and when their poems were recited, the whole multitude by its utterances warned the judges what to approve. When, therefore, the judges were asked one by one, the six agreed and gave the first prize to the poet who, they observed, most pleased the audience; the second prize to the person who came next in their approval. Aristophanes,[2] however, when his opinion was asked, voted that the first place should be given to the candidate who was least liked by the audience. 7. When the king [3] and all the company showed great indignation, he rose and obtained permission to speak. Amid a general silence he informed them that only one of the competitors was a true poet; the others recited borrowed work, whereas the judges had to deal with original compositions, not with plagiaries. The assembly were surprised and the king was doubtful. Aristophanes relying upon his memory produced a large number of papyrus rolls from certain bookcases,[4] and comparing these with what had been recited he compelled the authors to confess they were thieves. The king then ordered them to be brought to trial for theft. They were condemned and dismissed in disgrace, while Aristophanes was raised to high office and became librarian.[5]

[5] c. 195 B.C.

VITRUVIUS

8 Insequentibus annis a Macedonia [1] Zoilus, qui
adoptavit cognomen, ut Homeromastix vocitaretur,
Alexandriam venit suaque scripta contra Iliadem et
Odyssean [2] comparata regi recitavit. Ptolomaeus
vero, cum animadvertisset poetarum parentem
philologiaeque omnis ducem absentem vexari et,
cuius ab cunctis gentibus scripta suspicerentur, ab
eo vituperari, indignans [3] nullum ei dedit responsum.
Zoilus autem, cum diutius in regno fuisset, inopia
pressum [4] summisit ad regem postulans, ut aliquid
9 sibi tribueretur. Rex vero respondisse dicitur
Homerum, qui ante annos mille decessisset, aevo
perpetuo multa milia hominum pascere, item
debere, qui meliore ingenio se profiteretur, non modo
unum sed etiam plures alere posse. Et ad summam
mors eius ut parricidii damnati varie memoratur.
Alii enim scripserunt a Philadelpho esse in crucem
fixum, nonnulli Chii [5] lapides esse coniectos, alii
Zmyrnae vivom in pyram coniectum. Quorum
utrum ei acciderit, merenti digna constitit poena;
non enim aliter videtur promereri, qui citat eos,
quorum responsum, quid senserint scribentes, non
potest coram indicari.
10 Ego vero, Caesar, neque alienis indicibus mutatis
interposito nomine meo id profero corpus neque
ullius cogitata vituperans institui ex eo me adprobare, sed omnibus scriptoribus infinitas ago gratias,
quod egregiis ingeniorum sollertiis ex aevo conlatis

[1] machedonia *H.*
[2] iliaden et odissian *H.*
[3] indignans *G* : indignus *H S.*
[4] pressum summisit *H S* : *sc.* se esse.
[5] Chii *Salmasius* : cɪɪeɪ *H G.*

68

8. Some years after, Zoilus, who had taken a surname so as to be called the Scourge of Homer, came from Macedonia to Alexandria, and read his works directed against the *Iliad* and *Odyssey*. Ptolemy, however, observed that the father of poets and the founder of literature was attacked in his absence, and that Zoilus abused one whose works were looked up to by all nations, and in his indignation would not reply to him. Zoilus, however, remaining some time in Egypt, was overcome by poverty and submitted his name to the king for an allowance. 9. The king is said to have replied that Homer, whose death occurred many years before, had through all that age of time furnished a livelihood to many thousands; a man, therefore, who claimed to be of a finer talent should be able to maintain not only one but many others as well. In fine, Zoilus was condemned for parricide, and his death is variously recorded. Some have written that he was crucified by Philadelphus;[1] others that he was stoned at Chios; others that he was thrown alive on a burning pyre in Smyrna. Whichever happened to him, the penalty fitted the culprit. Such seems to be the desert of a man who calls into court those who can no longer reply publicly, when asked what they meant by their writings.

10. But this encyclopaedia, your Highness, is not presented under my own name with the suppression of my authorities, nor have I set out to gain approbation by vituperating any man's ideas. For I owe great gratitude to all those who with an ocean of intellectual services which they gathered from all

[1] This statement supports the currency of the anecdote, and suggests that the critic was not identical with the orator.

abundantes alius [1] alio genere copias praeparaverunt,
unde nos uti fontibus haurientes aquam et ad propria
proposita traducentes facundiores et expeditiores
habemus ad scribendum facultates talibusque con-
fidentes auctoribus audemus institutiones novas
comparare.

11 Igitur tales ingressus eorum quia [2] ad propositi
mei rationes animadverti praeparatos, inde sumendo
progredi coepi. Namque primum Agatharchus [3]
Athenis Aeschylo docente tragoediam ad scaenam
fecit,[4] et de ea commentarium reliquit. Ex eo
moniti Democritus et Anaxagoras de eadem re
scripserunt, quemadmodum oporteat, ad aciem
oculorum radiorumque extentionem [5] certo loco
centro constituto, ad lineas ratione naturali respon-
dere, uti de incerta re incertae imagines [6] aedi-
ficiorum in scaenarum picturis redderent speciem et,
quae in directis planisque frontibus sint figurata, alia
abscedentia, alia prominentia esse videantur.

12 Postea Silenus de symmetriis doricorum edidit
volumen; de aede ionica Iunonis quae est Sami
Rhoecus et [7] Theodorus; ionice Ephesi quae est

[1] alius *Oudendorp*: aliis *H*. [2] quia *Ro*: quae *H*.
[3] agatharcus *G*, -tarcus *H S*.
[4] ad scaenam fecit *e₂*, *ed*: *Athenis architectus praeerat Dionysiis*.
[5] extentione *H S*.
[6] incerta re incertae imagines *h*: incerta rem *c fortasse ex* incerta re‾ *H*.
[7] *text. Gr*: de aede iŏnonis quae est Samii dorica zeodorus *H, C.R.* 1924, 112.

[1] *Institutiones* = manual.

time, each in his department provided stores from which we, like those who draw water from a spring and use it for their own purposes, have gained the means of writing with more eloquence and readiness; and trusting in such authorities we venture to put together a new manual [1] of architecture.

11. Because, then, I observed that such beginnings had been made towards the method of my undertaking, I drew upon these sources and began to go forward. For to begin with: Agatharchus [2] at Athens, when Aeschylus was presenting a tragedy, was in control of the stage, and wrote a commentary about it. Following his suggestions, Democritus [3] and Anaxagoras [3] wrote upon the same topic, in order to show how, if a fixed centre is taken for the outward glance of the eyes and the projection of the radii, we must follow these lines in accordance with a natural law, such that from an uncertain object, uncertain images may give the appearance of buildings in the scenery of the stage, and how what is figured upon vertical and plane surfaces can seem to recede in one part and project in another. [4]

12. Subsequently Silenus [5] published a work upon Doric proportions; Rhoecus and Theodorus [6] on the Ionic temple of Juno which is at Samos;

[2] Agatharchus, son of Eudemus, of Samos. By introducing perspective, he revolutionised Greek paintings; cf. Plat. *Rep.* X. 602. The play was the trilogy of the Oresteia.

[3] Previously mentioned together, VII. *pref.*

[4] For the text and interpretation of this passage, see my article *The Parthenon and the Baroque*, *J.R.I.B.A.* 1931, 755 ff.

[5] Not otherwise known.

[6] Rhoecus and Theodorus worked together, Plin. *N.H.* XXXV. 152.

Dianae, Chersiphron [1] et Metagenes; de fano
Minervae, quod est Prienae ionicum, Pytheos; [2]
item de aede Minervae, dorice quae est Athenis in
arce, Ictinos [3] et Carpion; Theodorus Phocaeus de
tholo, qui est Delphis; Philo de aedium sacrarum
symmetriis et de armamentario,[4] quod fuerat Piraei
portu; Hermogenes de aede Dianae, ionice quae
est Magnesia pseudodipteros, et Liberi Patris Teo [5]
monopteros; [6] item Arcesius [7] de symmetriis corin-
thiis et ionico Trallibus Aesculapio, quod etiam ipse
sua manu dicitur fecisse; de Mausoleo Satyrus et
Pytheos.[8]

13 Quibus vero felicitas maximum summumque con-
tulit munus; quorum enim artes aevo perpetuo
nobilissimas laudes et sempiterno florentes habere
iudicantur, et cogitatis egregias operas praestiterunt.
Namque singulis frontibus singuli artifices [9] sump-
serunt certatim partes ad ornandum et probandum
Leochares, Bryaxis, Scopas,[10] Praxiteles, nonnulli
etiam putant Timotheum, quorum artis eminens

[1] cresiphon *H*.
[2] Pytheos *Schn* : phyleos *H S*.
[3] ictionos *H*.
[4] armamentario *ed* : armentario *H*.
[5] Teo *Joc* : &eo *H S*, et eo *G*.
[6] monopteros *G* : monocteros *H S*.
[7] Arcesius *Ro* : argelius *H*.
[8] saturus *H* : phiteus *H*.
[9] singulis artifices *H*. [10] scaphas *H*.

[1] Robertson, *Greek and Roman Architecture*, 94 n.
[2] Robertson, 148.
[3] Lethaby, *Greek Buildings*, 83.
[4] Robertson, 141. [5] Lethaby, 208.
[6] Specification recorded C.I.A. II. 1054.

BOOK VII. Preface

Chersiphron and Metagenes on the Ionic temple of Diana which is at Ephesus[1]; Pythius on the temple of Minerva in the Ionic style which is at Priene;[2] Ictinus[3] and Carpion on the Doric temple of Minerva which is on the Acropolis at Athens; Theodorus[4] of Phocaea on the Tholos at Delphi; Philo[5] ⟨of Eleusis⟩ on the proportions of temples and the arsenal[6] which was in the harbour of the Piraeus; Hermogenes[7] on the pseudodipteral Ionic temple of Diana[8] at Magnesia and the monopteral temple of Father Bacchus[9] at Teos; Arcesius on Corinthian proportions, and the Ionic temple at Tralles[10] to Aesculapius, whose image is said to have been carved by him; Satyrus and Pythius on the Mausoleum.[11]

13. And on these last, good fortune conferred the greatest and highest boon. For their works are adjudged to have a merit which is famous throughout the ages and of unfading freshness[12] and they employed distinguished artists on their undertakings. For on the several elevations, different rival craftsmen took their share in decorations wherein they competed: Leochares,[13] Bryaxis,[14] Scopas,[15] Praxiteles,[16] and some add Timotheus.[17] The out-

[7] Book III. iii. 8. [8] Robertson, 155.
[9] Robertson, 157.
[10] Ruins described; Fellows, *Asia Minor*, 276.
[11] Lethaby, 37 ff.
[12] This eternal freshness was specially attributed to the structures of Pericles, Plut. *vit.* XIII.
[13] Book II. viii. 11, Plin. *N.H.* XXXVI. 31.
[14] Plin. *N.H.* XXXIV. 73.
[15] Works distinguished by intense expression.
[16] The exquisite finish of his works: Athen. XIII. 591.
[17] Book II. viii. 11; carved draperies very finely.

excellentia coegit ad septem spectaculorum eius operis pervenire famam.

14 Praeterea minus nobiles multi praecepta symmetriarum conscripserunt, uti Nexaris, Theocydes,[1] Demophilos, Pollis, Leonidas,[2] Silanion, Melampus, Sarnacus, Euphranor. Non minus de machinationibus, uti Diades, Archytas, Archimedes, Ctesibios,[3] Nymphodorus, Philo Byzantius,[4] Diphilos,[5] Democles, Charias,[6] Polyidos, Pyrrhos,[7] Agesistratos.[8] Quorum ex commentariis, quae utilia esse his rebus animadverti, [collecta in unum coegi corpus, et ideo maxime, quod animadverti][9] in ea re ab Graecis volumina plura edita, ab nostris oppido quam pauca. Fufidius[10] enim mirum de his rebus primus instituit edere volumen, item Terentius Varro de novem disciplinis unum de architectura, P. Septimius duo.

15 Amplius vero in id genus scripturae adhuc nemo incubuisse videtur, cum fuissent et antiqui cives magni architecti, qui potuissent non minus eleganter scripta comparare. Namque Athenis Antistates et

[1] theocides *H S.* [2] leonidas *G* : -des *H S.*
[3] &esibios *H S*, et esibios *G.* [4] phylobyzanteos *H S.*
[5] diphylos *H S.* [6] charidas *H.*
[7] phyrros *H.* [8] agesistratas *H.*
[9] collecta—animadverti *G* : *om. H S.*
[10] Fufidius *Schn* : Fuficius *H.*

[1] Book II. viii. 11.
[2] Painter, master of Zeuxis, Plin. *N.H.* XXXV. 61.
[3] Painter, Plin. *N.H.* XXXIV. 91.
[4] Made portrait statues, Plin. *N.H.* XXXIV. 81.
[5] Painter and sculptor, and writer: type of versatile genius.
[6] Book X. xiii. 3. Polyidus and Diades are named in a list of *mechanici* in a papyrus of about 100 B.C. *Pap. Berol.* P. 13044.

standing excellence of their work caused the fame of the Mausoleum to be included in the seven wonders [1] of the world.

14. In addition to these, many men of less fame have compiled the rule of symmetry, such as Nexaris, Theocydes, Demophilus,[2] Pollis,[3] Leonidas, Silanion,[4] Melampus of Sarnaca, Euphranor.[5] Others have written on machinery: Diades,[6] Archytas,[7] Archimedes,[8] Ctesibius,[9] Nymphodorus,[10] Philo of Byzantium,[11] Diphilus,[12] Democles,[13] Chaerias,[6] Polyidus,[6] Pyrrhus,[14] Agesistratus. As to the useful contributions to our subject which I found in their commentaries, many volumes have been published by the Greeks, exceedingly few by our own writers. For Fufidius [15] curiously enough was the first to publish a volume on these topics. Further, Varro included one volume in his work On the Nine Disciplines [16]; Publius Septimius [17] wrote two volumes.

15. Up to now no one seems to have gone further in this kind of writing, although our citizens of old have been great architects who might have compiled works of equal precision. For at Athens the archi-

[7] Book I. i. 17.

[8] Book I. i. 7, 17.

[9] Book IX. viii. 2; I. i. 7.

[10] "Inventor of scientific toys." Athen. I. 19.

[11] Wrote on 'mechanics,' contemporary of Ctesibius.

[12] Perhaps architect to Quintus Cicero. Cic. *Q. Fr.* III. 1. 1.

[13] Plin. *N.H.* XXXIV., XXXV. in list of authorities; Strabo I. 58.

[14] Wrote on siege engines, Athen. *Math. Vett.* 2.

[15] Probably a friend of Cicero, *Fam.* XIII. xi. 3, and aedile at Arpinum, Wilm. 2050.

[16] Encyclopædia of Education.

[17] Quaestor of Varro who dedicated to him first three books, *de lingua Latina*.

Callaeschros [1] et Antimachides et Porinos [2] architecti
Pisistrato aedem Iovi Olympio facienti fundamenta
constituerunt, post mortem autem eius propter
interpellationem reipublicae [3] incepta reliquerunt.
Itaque circiter annis quadringentis [4] post Antiochus
rex, cum in id opus inpensam esset pollicitus, cellae
magnitudinem et columnarum circa dipteron con-
locationem epistyliorumque et ceterorum orna-
mentorum ad symmetriam distributionem magna
sollertia scientiaque summa civis Romanus Quos-
sutius [5] nobiliter est architectatus. Id autem opus
non modo volgo, sed etiam in paucis a magnificentia
nominatur.

16 Nam quattuor locis sunt aedium sacrarum mar-
moreis operibus ornatae dispositiones, e quibus
propriae de his nominationes clarissima fama nomi-
nantur quorum excellentiae prudentesque [6] cogita-
tionum apparatus suspectus habent in deorum
sesemasmenois.[7] Primumque aedes Ephesi Dianae
ionico genere ab Chersiphrone [8] Gnosio et filio eius
Metagene [9] est instituta, quam postea Demetrius,
ipsius Dianae servos, et Paeonius Ephesius dicuntur
perfecisse. Mileti [10] Apollini item ionicis symmetriis
idem Paeonius Daphnisque [11] Milesius instituerunt.
Eleusine Cereris [12] et Proserpinae cellam inmani

[1] callescheros *H S*. [2] porinos *G* : pormos *H S*.
[3] reipublice *G S* : regi publice *H*.
[4] quadringentis *Meurs.* : ducentis *H*.
[5] quosutius *H* : quossutius *H*ᶜ. [6] prudentis *H S*.
[7] sesemasmenois *Gr* : sesemaneo *H G, cf.* Plato, *Legg.* 954a.
[8] ab cresiphone *H*. [9] metagine *H S*.
[10] meleti *H*. [11] daphnis *G* : daphinis *H S*.
[12] cereris *G S* : ca&eris *H*.

[1] These names may have been taken from an inscription.
[2] The correction *quadringentis* for *ducentis* seems necessary.

tects [1] Antistates and Callaeschrus and Antimachides and Porinus laid the foundations for Pisistratus when he was building a temple to Olympian Jupiter. After his death they abandoned his undertaking because of the interruption caused by the republic. About four hundred [2] years after, king Antiochus undertook the cost of the building. A Roman citizen Cossutius, an architect of great skill and scientific attainments, finely designed the great sanctuary with a double colonnade all round and with the architrave symmetrically disposed. And this building is famous owing to its magnificence not only with the crowd but with the experts.

16. For in four places temples have been erected and finished with marble, whence their names are current and most renowned. Their fine character and the skilful management of their design gains a high regard among the chefs-d'œuvre of religion.[3] First of all the temple of Diana [4] at Ephesus was planned in the Ionic style by Chersiphron of Cnossus and his son Metagenes; afterwards Demetrius, a temple warden [5] of Diana, and Paeonius [6] of Ephesus are said to have completed it. At Miletus the same Paeonius, and Daphnis of Miletus, built for Apollo [7] in the Ionic style. At Eleusis, Ictinus [8] built the temple of Ceres and Proserpine in the Doric manner,

[3] Lit. " sealed." Treasures of the gods were sealed.

[4] *Ante,* 12.

[5] Ordinarily *aedituos* = Gk. *neokoros*; cf. *Acts* xix. 35 : *neokoros polis.*

[6] Lethaby, 34.

[7] Didymaeum; the former temple was burnt by Darius 496 B.C.; this, the new temple, scarcely less than the Artemisium at Ephesus, was never finished.

[8] His subordinate architects are enumerated, Plut. *Pericles,* 13.

77

magnitudine Ictinos dorico more sine exterioribus
columnis ad laxamentum usus sacrificiorum pertexit.
17 Eam[1] autem postea, cum Demetrius Phalereus
Athenis rerum potiretur, Philo ante templum in
fronte columnis constitutis prostylon fecit; ita aucto
vestibulo laxamentum initiantibus[2] operique sum-
mam adfecit auctoritatem. In asty vero ad Olym-
pium amplo modulorum conparatu corinthiis sym-
metriis et proportionibus, uti s.s. est,[3] architectandum
Quossutius[4] suscepisse memoratur, cuius com-
mentarium nullum est inventum. Nec tamen a
Cossutio solum de his rebus scripta sunt desideranda
sed etiam a G. Mucio,[5] qui magna scientia confisus
aedes Honoris et Virtutis Marianae,[6] cellae colum-
narumque et epistyliorum symmetrias legitimis artis
institutis perfecit.[7] Id vero si marmoreum fuisset,
ut haberet, quemadmodum ab arte subtilitatem, sic
ab magnificentia et inpensis auctoritatem, in primis
et summis operibus nominaretur.
18 Cum ergo et antiqui nostri inveniantur non
minus quam Graeci fuisse magni architecti et nostra
memoria satis multi, et ex his pauci praecepta edi-
dissent, non putavi silendum, sed disposite singulis
voluminibus de singulis exponeremus. Itaque,
quoniam sexto[8] volumine privatorum aedificiorum
rationes perscripsi, in hoc, qui septimum tenet
numerum, de expolitionibus, quibus rationibus et
venustatem et firmitatem habere possint, exponam.

[1] eam *ed* : ea *H G*.
[2] initiantibus *G* : initientibus *H S*.
[3] uti s.s. est *H* : uti cc ē *e₂ cum schol.* ' pro notis s.s. e. ut
in Blandiniano.' *Hae notae in h* : *cf. Vol. I. xxiii.*

[4] cossutius *G S* : quofutiuſ *Hᵉ*.
[5] A. G. mutio *H S*. [6] marinianae *H S*.
[7] perficit *H*. [8] sexto *Hᶜ* : secto *H*.

and of an immense size without exterior columns; it was covered in to afford a convenient space for sacrifice.

17. When Demetrius of Phaleron was master of Athens,[1] Philo [2] erected columns in front before the temple and turned it into a prostyle building. Thus by enlarging the approach he gave space for the initiates and great impressiveness to the building. In the city the Olympeum was designed with Corinthian symmetries and proportions and an ample module by the architect Cossutius, as already described.[3] No specification by him is extant. Not only do we miss such a work from Cossutius but also from Gaius Mucius,[4] who,—in the temple of Honour and Virtue erected by Marius,—relying upon his scientific acquirements, finished off the symmetries of the sanctuary, the columns and the entablature, in accordance with the legitimate rules of art. But if it had been of marble so as to be impressive by a costly magnificence, no less than marked by a skilful precision, it would have a name among the buildings of the first and highest class.

18. While, therefore, our predecessors are found, no less than the Greeks, to have been great architects, and sufficiently many in our own time, few of them have published their methods. Hence I thought we ought not to remain silent, but we should set forth methodically the various branches of the subject in separate volumes. Therefore, after describing in the sixth book the arrangements of private buildings, in this book, which is the seventh, I will explain how they are finished in such a way as to combine durability with elegance.

[1] 317–307 B.C. [2] *Ante*, 12.
[3] *Ante*, 15. [4] Book III. ii. 5.

1 PRIMUMQUE incipiam de ruderatione, quae principia
tenet expolitionum, uti curiosius summaque provi-
dentia solidationis ratio habeatur. Et si plano pede
erit eruderandum, quaeratur, solum [1] si sit perpetuo
solidum, et ita exaequetur, et inducatur cum
statumine rudus. Sin autem omnis aut ex parte
congesticius [2] locus fuerit, fistucationibus cum magna
cura solidetur. In contignationibus vero diligenter
est animadvertendum, ne qui paries, qui non exeat
ad summum, sit extructus sub pavimentum, sed
potius relaxatus supra se pendentem habeat coaxa-
tionem. Cum enim solidus exit, contignationibus
arescentibus aut pandatione sidentibus,[3] permanens
structurae soliditate dextra ac sinistra secundum se
facit in pavimentis necessario rimas.

2 Item danda est opera, ne commisceantur axes
aesculini querco, quod quercei,[4] simul umorem per-
ceperunt, se torquentes rimas faciunt in pavimentis.
Sin autem aesculus non erit et necessitas coegerit
propter inopiam, querceis [5] sic videtur esse faciun-
dum, ut secentur tenuiores; quo minus [6] enim
valuerint, eo facilius clavis [7] fixi continebuntur.
Deinde in singulis tignis extremis partibus axis bini
clavi figantur, uti nulla ex parte possint se torquendo
anguli excitare. Namque de cerro aut fago seu
farno nullus ad vestutatem potest permanere.

[1] non solum *ante ras.* H. [2] coniesticius H S.
[3] sedentibus H. [4] querqui H G.
[5] quaercis H, quercis G Sᶜ. [6] minum H.
[7] clavis G : clavi H S.

[1] *quercus aesculus*, II. ix. 9. [2] *quercus robur*, II. ix. 8.

CHAPTER I

ON PAVEMENTS

1. First, I will begin with rubble paving, which is the first stage in finishing, so that account may be taken, with special care and great foresight, of a solid foundation. If we must carry out our paving on level ground we must inquire whether the soil is solid throughout; it is then to be levelled, and rubble must be spread over the surface. But if there is a made site, in whole or in part, it must be rammed very carefully with piles. In the case of upper floors great attention must be given, lest any wall in the story below is built right up to the pavement; it is rather to stop short and have the joists carried free above it. For when the wall is taken up solid, if the flooring above dries or sags as it settles, the wall being of a solid structure, necessarily causes cracks, right and left of it, in the pavements above.

2. Attention must also be given not to mix planks of winter oak [1] with common oak. [2] For common oak, when it becomes moist, warps and makes cracks in the pavement. But if there is no winter oak and need drives, we must work with common oak, using thin planks. For the weaker they are, the more easily will they be kept in their place by nails. Then two nails are to be driven in each joist at the edges of the plank, so that the corners of the planks may not warp and rise up. No plank of Turkey oak, [3] beech, or ash [4] can remain durable.

[3] quercus cerris, II. ix. 9.
[4] farnus, probably a technical word.

Coaxationibus factis, si erit, filex, si non, palea
substernatur, uti materies ab calcis vitiis defendatur.
3 Tunc insuper statuminetur ne minore saxo, quam
qui possit manum implere. Statuminationibus in-
ductis,[1] rudus si novum erit, ad tres partes una calcis
misceatur, si redivivum fuerit, quinque ad duum
mixtiones habeant responsum. Deinde rudus [2] in-
ducatur et vectibus ligneis, decuriis inductis, cre-
briter pinsatione [3] solidetur, et id non minus pinsum
absolutum crassitudine sit dodrantis. Insuper ex
testa nucleus [4] inducatur mixtionem habens ad tres
partes unam calcis, ne minore crassitudine pavi-
mentum digitorum senûm. Supra nucleum ad regu-
lam et libellam exacta pavimenta struantur sive
4 sectilia seu tesseris. Cum ea exstructa fuerint et
fastigia sua exstructionem habuerint, ita fricentur,
uti, si sectilia sint, nulli gradus in scutulis aut trigonis
aut quadratis seu favis extent, sed coagmentorum
conpositio planam habeat inter se derectionem, si
tesseris structum erit, ut eae omnes angulos habeant
aequales; cum enim anguli non fuerint omnes
aequaliter pleni, non erit exacta, ut oportet, fricatura.
Item testacea spicata tiburtina sunt diligenter
exigenda, ut ne habeant lacunas nec extantes tu-
mulos, sed extenta et ad regulam perfricata. Super
fricaturam, levigationibus et polituris cum fuerint
perfecta, incernatur marmor, et supra loricae ex
calce et harena inducantur.

[1] inductis *ed* : -tus *H*. [2] inrudus *H*.
[3] pinsatione *G* : piscatione *H S*. [4] nucleŏs *H*.

[1] *Decuriae* of labourers, usually of slaves, Sen. *Ep.* 47, 9.
[2] *Opus signinum* made of potsherds and lime, used at
Pompeii for pavements.

After finishing the flooring, fern—if you have it—
or else straw, is to be spread over, so that the wood
may be protected against the injury caused by lime.
3. Next a layer of stones is to be spread, each of
which is not less than a handful. After spreading
the stones, the rubble, if it is fresh, is to be mixed,
three parts to one of lime; if it is of old materials,
five parts of rubble are to be mixed with two of lime.
Let it then be laid on, and rammed down with
repeated blows by gangs [1] of men using wooden
stamps. When the stamping is finished, it must be
not less than nine inches thick. Upon this, a hard
coat of powdered pottery is to be laid, three parts
to one of lime, forming a layer of six inches.[2] On
the finishing coat, a pavement [3] of marble slabs or
of mosaic is to be laid to rule and level. 4. When
it is laid, and the proper fall is adjusted, it is
to be rubbed down; so that, if the pavement is
of marble, no projecting edges may arise in the
diamonds or triangles or squares or hexagons; [4] but
the adjustment of the joints is to be level one with
another. If it is mosaic, the edges of the tesserae
are all to be level. For when the edges are not
even, the rubbing down will be imperfect. So also
Tiburtine tiles [5] laid herring-bone fashion, are to be
carefully handled so that they do not present gaps
or ridges, being spread out and rubbed to a level.
After the rubbing down, when they are completely
smoothed and finished, marble dust is sprinkled over,
and over that coats of lime and sand are to be applied.

[3] Caesar took with him on his campaigns the materials for
paving his headquarters with mosaics and marble, Suet. *Vit.*46.
[4] *Opus sectile* in marble in geometric forms.
[5] Philander, *ad loc.*, reports them in the villas of Vopiscus
and Hadrian at Tivoli.

5 Subdiu vero maxime idonea faciunda sunt pavimenta, quod contignationes umore crescentes aut siccitate decrescentes seu pandationibus sidentes[1] movendo se faciunt vitia pavimentis; praeterea gelicidia et proinae[2] non patiuntur integra permanere. Itaque si necessitas coegerit, ut minime vitiosa fiant, sic erit faciundum. Cum coaxatum fuerit, super altera coaxatio transversa sternatur clavisque fixa duplicem praebeat contignationi loricationem. Deinde ruderi novo tertia pars testae tunsae admisceatur, calcisque duae partes ad quinque mortarii mixtionibus praestent responsum.

6 Stataminatione facta rudus inducatur, idque pistum absolutum ne minus pede sit crassum.[3] Tunc autem nucleo inducto, uti s. s. est, pavimentum e tessera grandi circiter binûm digitûm caesa struatur fastigium habens in pedes denos digitos[4] binos; quod si bene temperabitur et recte fricatum fuerit, ab omnibus vitiis erit tutum. Uti autem inter coagmenta materies ab gelicidiis ne laboret, fracibus[5] quotannis[6] ante hiemem saturetur; ita non patietur in se recipere gelicidii pruinam.

7 Sin autem curiosius videbitur fieri oportere, tegulae bipedales inter se coagmentatae supra rudus substrata materia conlocentur habentes singulis coagmentorum frontibus excelsos canaliculos digitales. Quibus iunctis inpletur calx ex oleo subacta, confricenturque inter se coagmenta compressa. Ita calx, quae erit haerens in canalibus, durescendo [contestateque solidescendo][7] non patietur aquam

[1] sedentes H.
[2] proinae H: vera lectio apud Kr. qui hic, ut alibi, Ro correxit.
[3] grassum H.
[4] digitus H S.
[5] fragibus H.
[6] quodannis H.

5. Such pavements are most suitable to be used in the open. For wood floors swell with damp, or shrink in dry weather, or sag and settle, and make faulty pavements by giving way. Besides, ice and hoar-frost hinder their durability. But if need compels, we must limit their failure as far as possible in the following manner. After laying the floor, a second floor is to be laid above cross-wise; being fixed with nails, it will furnish a double coating to the joists. Then a third part of broken pottery is to be mixed in the fresh rubble, and two parts of lime are to answer to five [1] when mixed in the mortar.

6. Let the ground be spread with this, and the rubble be laid over it and pounded thoroughly to a thickness of not less than a foot. Then the finishing coat is to be put on as already described, and the pavement is to be laid with tesserae about two inches thick, with a fall of two inches in ten feet. If this is well mixed and properly rubbed over, it will be safe against all damage. That the mortar between the joints may not be affected by the frost, let it be soaked every year with oil lees before the winter. In this way it will not take up the frost into itself.

7. But if special care seems to be needed, tiles two feet square jointed together are to be laid upon the pavement of mortar, with small channels an inch deep on each side. When these are joined, lime tempered with oil is to be filled in, and the joints are to be pressed together and rubbed down. Thus the lime which will remain in the channels will harden and prevent water or anything else from passing

[1] *I.e.* One part potsherds, two parts rubble, two parts lime.

[7] contestateque solidiscendo *G.* *om. H S, del. G*ᵉ.

neque aliam rem per coagmenta transire. Cum
ergo fuerit hoc ita perstratum, supra nucleus[1]
inducatur et virgis caedendo subigatur. Supra
autem sive ex tessera grandi sive ex spica[2] testacea
struantur fastigiis, quibus est supra scriptum, et
cum sic erunt facta, non cito vitiabuntur.

II

1 Cum a pavimentorum cura discessum fuerit, tunc
de albariis operibus est explicandum. Id autem erit
recte, si glaebae calcis optimae ante multo tempore,
quam opus fuerit, macerabuntur, uti, si qua glaeba
parum fuerit in fornace cocta, in maceratione diu-
turna liquore defervere coacta uno tenore[3] conquo-
quatur. Namque cum non penitus macerata sed
recens sumitur, cum fuerit inducta habens latentes
crudos calculos, pustulas emittit. Qui calculi, in
opere uno tenore cum permacerantur, dissolvunt et
2 dissipant tectorii politiones. Cum autem habita erit
ratio macerationis et id curiosius opere praeparatum
erit, sumatur ascia et, quemadmodum materia dola-
tur, sic calx in lacu macerata ascietur. Si ad eam
offenderint calculi, non erit temperata; cumque
siccum et purum ferrum educetur, indicabit eam
evanidam et siticulosam; cum vero pinguis fuerit et
recte macerata, circa id ferramentum uti glutinum
haerens omni ratione probabit esse temperatam.

[1] nucreus *H*. [2] expica *H*, *om. G*.
[3] tenore *Joc* : tempore *H*.

[1] The Roman stucco-work is unusually fine, and has pre-
served the fresco-paintings in a remarkable manner.

through the joints. When this has so been laid, the first finishing coat is to be spread, beaten with staves and so kneaded. Upon this, are to be put the pavements of thick tesserae or of tiles laid herringbone, with the fall already described, and when this is done, damage will not quickly arise.

CHAPTER II

ON THE PREPARATION OF STUCCO

1. WE now pass from the preparation of pavements to plasterers'[1] work. It will be necessary to obtain lumps of the best lime and crush it long before it is required; so that if any lump be imperfectly burnt in the kiln, owing to the long crushing, it is forced by the moisture to lose its heat and is tempered to an even quality. For when it is applied fresh and not thoroughly slaked; if, without due care it is spread containing rough lumps, it causes blisters. And these lumps of lime, when they get a thorough slaking after the work is begun, break up and destroy the surface of the stucco. 2. Now when attention is given to the slaking and care is taken in preparing the work, a trowel[2] is to be taken and the lime which is being slaked in the pit is to be chopped as one chops wood. If lumps are met in the chopping, the lime is not slaked. When the trowel is drawn out dry and clean, it shows that the lime is poor and absorbent; when, however, the lime is rich and duly slaked, it clings round the tool like glue, and shows that it is properly mixed. Then

[2] Neuburger, 407.

Tunc autem machinis comparatis camerarum dis-
positiones in conclavibus expediantur, nisi lacunariis
ea fuerint ornata.

III

1 CUM ergo camerarum postulabitur ratio, sic erit
faciunda. Asseres directi disponantur inter se ne
plus spatium habentes pedes binos, et hi maxime
cupressei,[1] quod abiegnei ab carie et ab vetustate
celeriter vitiantur. Hique asseres, cum ad formam
circinationis [2] fuerint distributi, catenis dispositis ad
contignationes, sive tecta erunt,[3] crebriter [4] clavis
ferreis fixi religentur. Eaeque catenae ex ea materia
comparentur, cui nec caries nec vetustas nec umor
possit nocere, id est e buxo, iunipero, olea, robore,
cupresso ceterisque similibus praeter quercum, cum
ea se [5] torquendo rimas faciat [6] quibus inest operibus.
2 Asseribus dispositis tum tomice ex [7] sparto
hispanico harundines graecae tunsae ad eos, uti forma
postulat, religentur. Item supra cameram materies
ex calce et harena mixta subinde inducatur, ut, si
quae stillae [8] ex contignationibus aut tectis ceci-
derint, sustineantur. Sin autem harundinis graecae
copia non erit, de paludibus tenues colligantur [9] et
mataxae tomice [10] ad iustam longitudinem una crassi-

[1] cupraessi *H*. [2] circinationes *H S*.
[3] tecta erunt *G* : tecter *H*. [4] crebiter *H*.
[5] ea se *Joc* : eas *H*. [6] faciat *Joc* : faciant *H S*.
[7] tomice ex *Joc* : tomices *H S Gᶜ*, tonices *G*.
[8] qua est ille *H*.
[9] colligantur *G Sᶜ* : -gatur *H S*. [10] tomicae *H*.

[1] Cicero watched over the work at his brother Quintus'
country houses. He approved the pavements but not all the

the scaffolding is to be made ready, and the curved ceilings of the apartments are to be executed, unless they have straight panelled ceilings.

CHAPTER III

ON STUCCO

1. WHEN, therefore, curved ceilings [1] are in question, we must proceed as follows. Parallel laths are to be put not more than two feet apart. They are to be of cypress wood; deal is soon affected by decay and by age. The laths being fixed to the shape of an arch, are to be secured by wooden ties [2] to the floor or roof above, and fastened with an abundance of iron nails. The ties are to be of timber unaffected by decay or age or damp, such as box-wood, juniper, olive, winter oak, cypress and the like, except the common oak, which warps and causes cracks where it is used.

2. When the ribs are in their place, Greek reeds are to be bruised and bound to the ribs with cords of Spanish broom as the shape of the curve requires. Further, on the upper surface of the arch, mortar, mixed with lime and sand, is to be spread, so that if any drippings fall from the floor or roof above, they may be held up. If there be no supply of Greek reed, thin reeds are to be collected from the marshes, and are to be made up in bundles with cords of rough thread [3] to the right length and of equal

arched ceilings. One to which he gave the name *testudo* had a fine curve. Cf. *Q. Fr.* III. 1.

[2] *catena* = wooden tie, Cato, *R. R.* xviii. 9.

[3] *Mataxa, Schol.* Ar. *Ran.* 586.

tudine alligationibus temperentur, dum ne plus inter
duos [1] nodos alligationibus binos pedes distent, et
hae ad asseres, uti supra scriptum est, tomice [2]
religentur cultellique lignei in eas configantur.
Cetera omnia, uti supra scriptum est, expediantur.
3 Cameris dispositis et intextis imum caelum earum
trullissetur, deinde harena derigatur, postea autem
creca aut marmore poliatur.

Cum camerae politae fuerint, sub eas coronae sunt
subiciendae, quam maxime tenues et subtilis opor-
tere fieri videbitur; cum enim grandes sunt, pondere
deducuntur nec possunt se sustinere. In hisque
minime gypsum debet admisceri, sed excepto [3]
marmore uno tenore perduci, uti ne praecipiendo
non patiatur uno tenore opus inarescere. Etiamque
cavendae sunt in cameris priscorum dispositiones,
quod earum planitiae coronarum gravi pondere
4 inpendentes sunt periculosae. Coronarum autem
sunt figurae aliae caelatae. Conclavibus autem, ubi
ignis aut plura lumina sunt ponenda, pura [4] fieri
debent, ut ea [5] facilius extergeantur; in aestivis et
exhedris, ubi minime fumus est nec fuligo potest
nocere, ibi caelatae sunt faciendae. Semper enim
album opus propter superbiam candoris non modo ex
propriis sed etiam alienis aedificiis concipit fumum.
5 Coronis explicatis parietes quam [6] asperrime trul-
lissentur, postea autem supra, trullissatione [7]
subarescente, deformentur derectiones harenati, uti
longitudines ad regulam et ad lineam, altitudines ad
perpendiculum, anguli ad normam respondentes

[1] duos G: uos H, .ii.os S. [2] tomice G: -cae H.
[3] ex creto Joc: excepto H. [4] pura $H\ G$.
[5] eo $Bondam$: ea H, *neutrum generale* = eae res.
[6] quem H. [7] trullissatione S: -nĕ G, -nem H.

thickness, provided that not more than two feet separates the knots of the bundles. These then are to be fixed with cord to the ribs as already described, and wooden pins are to be driven through them. Everything else is to be done as already described. 3. When the arched surfaces are fixed and inter-woven with the reeds, the under surface is to be rough cast; then sand is to be applied and after-wards finished with hair mortar or marble.

When the coved surfaces are finished, the cornices must be carried along the springing below them, and these must be made as light and slender as possible. For when they are large, they settle under their own weight and cannot keep their place. Gypsum should not be employed, but selected marble of uniform texture, lest the gypsum by setting too soon prevent the work from drying uniformly. Further, we must avoid in these arched ceilings the old arrangements, because, in them, the projecting surfaces of the cornices overhang dangerously with their heavy weight. 4. Now there are other and more elaborate forms of cornice. In apartments, however, where there is a fire and lamps, the cornices should be plain so that they may be the more easily dusted. They can be carved in summer rooms and exedrae where there is very little smoke and soot cannot do any damage. For plaster work, with its glittering whiteness, takes up the smoke that comes from other buildings as well as from the owner's.

5. When the cornices are finished, the walls are to be rough-cast as coarsely as possible, and when the rough-cast is nearly dry, the surface of sand must be shaped in such a way that the lengths are set out by the rule and square, the heights by the

exigantur; namque sic emendata tectoriorum [1] in picturis erit species. Subarescente iterum et tertio inducatur; ita cum fundatior erit ex harenato [2] derectura, eo firmior erit ad vetustatem soliditas tectorii.

6 Cum ab harena praeter trullissationem non minus tribus coriis fuerit deformatum, tunc e marmore graneo [3] derectiones sunt subigendae, dum ita materies temperetur, uti, cum subigatur, non haereat ad rutrum, sed purum ferrum e mortario [4] liberetur. Grandi inducto et inarescente alterum corium mediocre dirigatur; id cum subactum fuerit et bene fricatum, subtilius inducatur. Ita cum tribus coriis harenae et item marmoris solidati parietes fuerint, neque rimas neque aliud vitium in se recipere poterunt.

7 Sed et liaculorum subactionibus fundata soliditate marmorisque candore [5] firmo levigata,[6] coloribus cum politionibus inductis nitidos [7] expriment splendores. Colores autem, udo [8] tectorio cum diligenter sunt inducti, ideo non remittunt sed sunt perpetuo permanentes, quod calx, in fornacibus excocto liquore facta raritatibus et evanida, ieiunitate coacta corripit in se quae res forte contigerunt, mixtionibusque ex aliis potestatibus conlatis seminibus seu principîs una solidescendo, in quibuscumque membris est formata

[1] tectoriorum *Joc*: tectorum *H*.
[2] harenato *G*: -ta *H S*.
[3] graneo (granio *Fav.*) *Kr*: grandio *H*.
[4] murtario *H*.　　　　[5] candore *ed*: -rē *G S*, -rem *H*.
[6] levigata *Ro*: -tae *G*, -te *H S*.　　　[7] nitidus *H*.
[8] udo *Joc*: nudo *H*.

plummet, the corners by the set-square. For in this way the designs of the fresco-paintings will not be interfered with. A second and third coat is to be applied, as the one underneath dries. Thus when the solidity of the plaster is the more established from the application of the coats of sand, it is the more stable and enduring.

6. When in addition to the rough-cast, not less than three coats of sand have been laid, then coats of powdered marble are to be worked up, and the mortar is to be so mixed, that when it is worked up it does not adhere to the trowel, but the iron comes clean from the mortar. When a thick layer has been spread and is drying, a second thin coat is to be spread. And when this has been worked up and rubbed over, a still finer coat is to be applied. When the walls have been made solid with three coats of sand and also of marble, they will not be subject to cracks or any other fault.

7. After they are rendered solid by the use of the plasterer's tools and polished to the whiteness of marble, they will show a glittering splendour when the colours [1] are laid on with the last coat. When the colours are carefully laid upon the wet plaster, they do not fail but are permanently durable, because the lime has its moisture removed in the kilns, and becoming attenuated and porous, is compelled by its dryness to seize upon whatever happens to present itself. It gathers seeds or elements by mixture with other potencies,[2] and becoming solid

[1] The colours employed in the 'incrustation style' at Pompeii, are such as might be found in marble : black, white, reddish-violet, warm wine-red, dirty yellow, dark bluish-green, no blue. Baumeister, *Denkmäler*, 1376.

[2] *Potestates herbarum*, Verg. *A.* xii. 396.

cum fit arida, redigitur, uti sui generis proprias
videatur[1] habere qualitates.

8 Itaque tectoria, quae recte sunt facta, neque
vetustatibus fiunt horrida neque, cum extergentur,
remittunt colores, nisi si parum diligenter et in arido
fuerint inducti.[2] Cum ergo itaque in parietibus
tectoria facta fuerint, uti supra scriptum est, et
firmitatem et splendorem et ad vetustatem per-
manentem virtutem poterunt habere. Cum vero
unum corium harenae et unum minuti marmoris erit
inductum, tenuitas eius minus valendo faciliter
rumpitur nec splendorem politionibus propter in-
becillitatem crassitudinis proprium optinebit.

9 Quemadmodum enim speculum argenteum tenui la-
mella ductum incertas et[3] sine viribus habet remissiores
splendores, quod autem e solida temperatura fuerit
factum, recipiens in se firmis viribus politionem
fulgentes in aspectu certasque considerantibus
imagines reddet, sic tectoria, quae ex tenui sunt
ducta, non modo sunt rimosa, sed etiam celeriter
evanescunt, quae autem fundata harenationis et
marmoris soliditate sunt crassitudine spissa, cum sunt
politionibus[4] crebris subacta, non modo sunt nitentia,
sed etiam imagines expressas aspicientibus ex eo
opere remittunt.

10 Graecorum vero tectores non solum his rationibus
utendo faciunt opera firma, sed etiam mortario
conlocato, calce et harena ibi confusa, decuria
hominum inducta ligneis vectibus pisant materiam,
et ita ad cisternam[5] subacta tunc utuntur. Itaque
veteribus parietibus nonnulli crustas excidentes pro

[1] videatur *Joc* : videtur *H*. [2] inducti *Joc* : -ta *H*.
[3] incertas et *G S* : incerta. sed *H*.
[4] poliitionibus *H*. [5] cisternam *Gr* : certamen *H*.

with whatever parts it is formed, it dries together so that it seems to have the qualities proper to its kind.

8. Stucco, therefore, when it is well made, does not become rough in lapse of time, nor lose its colours when they are dusted, unless they have been laid on carelessly and on a dry surface. When, therefore, stucco has been executed on walls in accordance with these instructions, it will retain its firmness and brilliance and fine quality. But when only one coat of sand and one of sifted marble is applied, the thin stucco cannot resist damage and is easily broken, and it does not keep a finish of proper brilliance because of its inadequate thickness.

9. For just as a silvered mirror covered with a thin layer gives back confused and ineffective reflections, while one that is made with a solid layer takes by its firmness a good finish, and reflects images which shine to the view and are clear to the spectator, so stucco which is spread with thin mortar soon cracks and perishes, while that which is based upon solid sand and marble of a suitable thickness, and is worked up by repeated polishing, not only shines but reflects clear images [1] from the wall to the spectator.

10. The Greek [2] plasterers not only make their work firm by using these methods, but they make a mortar trough with lime and sand mixed, and a gang of men beat the mortar with wooden staves, and they use the mortar thus worked up in the pit. Therefore some cut out panels from old walls and

[1] The stucco serves in some places as a mirror.
[2] Greek materials and technique were taken over and developed by Roman craftsmen.

abacis utuntur, ipsaque tectoria abacorum et speculorum divisionibus circa se prominentes habent expressiones.

11 Sin autem in craticiis tectoria erunt facienda, quibus necesse est in arrectariis et transversariis rimas fieri, ideo quod, luto cum linuntur, necessario recipiunt umorem, cum autem arescent, extenuati in tectoriis faciunt rimas, id ut non fiat, haec erit ratio. Cum paries totus luto inquinatus fuerit, tunc in eo opere cannae clavis muscariis perpetuae figantur, deinde iterum luto inducto, si priores transversariis harundinibus[1] fixae sunt, secundae erectis figantur, et uti supra scriptum est, harenatum et marmor et omne tectorium inducatur. Ita cannarum duplex in parietibus harundinibus transversis fixa perpetuitas nec tegmina nec rimam ullam fieri patietur.

IV

1 Quibus rationibus siccis locis tectoria oporteat fieri, dixi; nunc, quemadmodum umidis locis politiones[2] expediantur, ut permanere possint sine vitiis, exponam. Et primum conclavibus, quae plano pede fuerint, in imo pavimento alte circiter pedibus tribus pro harenato testa trullissetur[3] et dirigatur, uti eae partes tectoriorum ab umore ne vitientur. Sin autem aliqui paries perpetuos habuerit umores, paululum ab eo recedatur et struatur alter tenuis

[1] harundibus *H*. [2] poliitiones *H*.
[3] trullissetur *H S*.

[1] *Pes* = ground; cf. ' footing,' Seneca, *Tranq. An.* X. 4.
96

use them like easel pictures. For the plaster work itself being divided into panels and mirrors, furnishes images which seem to stand out from it.

11. But if plastering is required on timber partitions, owing to their uprights and cross-pieces, cracks are bound to appear in it. For when they are coated with clay they must take up moisture; and when dry they shrink and cause cracks in the plaster. Hence the following precautions must be taken. When the whole wall has been smeared with clay, reeds are to be fixed right along with broad-headed nails. When a second layer of clay is put on, if the first coat has been set with horizontal reeds, the second must be set with the reeds vertical; according to the previous instructions, coats of sand and marble and indeed the complete coat of stucco may then be laid on. The double unbroken rows of reeds fixed crosswise on the walls will prevent any flaking off and the occurrence of cracks.

CHAPTER IV

ON STUCCO IN DAMP PLACES

1. I HAVE described how plastering is to be done in dry places: I will now explain how stucco is executed in damp places so as to avoid blemishes. And first as to rooms on the level ground.[1] To the height of about three feet from the pavement, rough-cast made of powdered earthenware instead of sand, is to be laid on, so that this part of the plaster may not suffer from damp. But if any wall shows continued damp, we must go a little behind it, and build another wall, thin and distant from the first,

distans ab eo, quantum res patietur, et inter duos
parietes canalis ducatur inferior, quam libramentum
conclavis fuerit, habens nares ad locum patentem.
Item, cum in altitudinem perstrictus [1] fuerit, relin-
quantur spiramenta; si enim non per nares umor
et in imo et in summo habuerit exitus, non minus in
nova structura se dissipabit. His perfectis paries
testa trullissetur et dirigatur et tunc tectorio poliatur.

2 Sin autem locus non patietur structuram fieri,
canales fiant et nares exeant [2] ad locum patentem.
Deinde tegulae bipedales ex una parte supra mar-
ginem canalis [3] inponantur, ex altera parte besalibus
pilae substruantur, in quibus duarum tegularum
anguli sedere possint, et ita a pariete eae distent,[4]
ut ne plus pateant palmum. Deinde insuper erectae
hamatae [5] tegulae ab imo ad summum ad parietem
figantur, quarum interiores partes curiosius picentur,
ut ab se respuant liquorem; item in imo et in summo
supra camaram habeant spiramenta.[6]

3 Tum autem calce ex aqua liquida dealbentur, uti
trullissationem testaceam [7] non respuant; namque
propter ieiunitatem quae est a fornacibus excocta
non possunt recipere nec sustinere, nisi calx subiecta
utrasque res inter se conglutinet et cogat coire.[8]
Trullissatione inducta pro harenato testa dirigatur,
et cetera omnia, uti supra scripta sunt in tectorii [9]
rationibus, perficiantur.

4 Ipsi autem politionibus eorum ornatus proprios

[1] perstructus *S* : perstrictus *H G*.
[2] exeunt *H*. [3] canales *H*.
[4] distent *G S*c : distant *H S*.
[5] hamatae *Gr* : amatae *H S*, ammate *G*.
[6] spiramenta *Joc* : stramenta *H*.
[7] testaceam *rec* : testae tam *H*.
[8] cogat *G* : cogitat quoire *H*. [9] tectorii *S* : -rio *H*.

as far as the case admits. Between the two walls, a gutter must be laid lower than the level of the room, with outlets into the open. Further, when the wall is built to the top, ventilation holes are to be left. For unless the moisture has outlets, it will none the less diffuse itself over the new wall. When these precautions have been taken, let the wall be rough-cast with powdered pottery, brought to an even surface and finished with plaster.

2. But if the space is not enough for another wall, let gutters be made with outlets to the open. Then let two-foot tiles [1] be placed above the edge of the gutter on the one side; on the other side, piers [2] of eight-inch bricks are to be built up, to take the edges of two tiles, and let the piers be distant not more than one palm's length from the wall. Then let flanged [3] tiles be fixed to the wall vertically from the bottom to the top. Their inner side is to be carefully covered with pitch so as to reject the moisture. Also let there be air-holes at the bottom, and at the top above the spring of the ceiling.

3. They are then to be whitened over with lime and water so that they do not reject the rough-cast of powdered brick; for from the dryness that comes in the kiln they can neither take nor keep this coating unless the lime that is applied, glues both together and causes their union. When the rough-cast is put on, broken pottery is to be used instead of sand and the remainder is to be finished as described above about plastering.

4. The craftsmen, again, in the stucco-work, must

[1] 18-inch tiles, *sesquipedales*, Book V. x. 2.
[2] Book V. x. 2. [3] Lit. ' hooked.'

debent habere ad decoris rationes, uti et ex locis
aptas et generum discriminibus non alienas habeant
dignitates. Tricliniis hibernis non est utilis com-
positione nec melographia [1] nec camerarum coronario
opere subtilis ornatus, quod ea et ab ignis fumo
et ab luminum crebris fuliginibus conrumpuntur.
In his vero supra podia abaci ex atramento sunt
subigendi et poliendi cuneis silaceis [2] seu miniaceis [3]
interpositis; explicatae camerae pure politae; etiam
pavimentorum non erit displicens, si qui anim-
advertere voluerit Graecorum ad hibernaculorum
usum. Minime sumptuosus est utilis apparatus.
5 Foditur enim intra [4] libramentum triclini altitudo
circiter pedum binûm, et solo festucato inducitur aut
rudus aut testaceum pavimentum ita fastigatum, ut in
canali habeat [5] nares. Deinde congestis et spisse
calcatis carbonibus inducitur et sabulone et calce et
favilla mixta materies crassitudine semipedali. Ad
regulam et libellam summo libramento cote despu-
mato redditur species nigri pavimenti. Ita conviviis
eorum et, quod poculis et pytismatis [6] effundetur,
simul cadit siccescitque, quique versantur ibi mini-
strantes, etsi nudis pedibus fuerint, non recipiunt
fraces [7] ab eius modi genere pavimenti.

[1] megalographia *Joc* : melographia *H* ; *cf.* μελογραφέω *eccl.*
vide infra v. 2.
[2] silaceis *Joc* : sileceis *H*. [3] se ominia|ceis *H*.
[4] intra = infra *ut saepe.*
[5] habeat *ed* : habeant *H*.
[6] pytismatis *Salm* : sputismatis *H*.
[7] fraces *Gr* : fragus *H*.

[1] Book I. ii. 5.

keep the designs in accordance with 'decor,'[1] that they may have a character fitted to their place and adjusted to the differences of style. In winter dining-rooms, painting of detail[2] is not useful in the composition, nor fine mouldings in the cornice under the vault, because they are damaged by the smoke from the fire and the frequent soot from the lamps.[3] In these rooms, immediately above the dado, panels of black are to be worked up and finished with strips of yellow ochre or vermilion intervening. The arched ceilings have a plain finish. As to the pavements, it will not be unsatisfactory if we observe the arrangement of Greek winter apartments. A useful construction is not at all expensive. 5. For inside the levelled surface of the triclinium a depth of about two feet is dug. The ground is well rammed and a pavement of rubble or pounded brick is laid with a fall towards the gutter and its outlets. Then charcoal is collected and crushed by treading, and a mixture six inches thick of ashes, sand and lime is laid. The top surface is then rubbed with stone to rule and level, and has the appearance of a black pavement. At banquets, therefore, the wine which is thrown from the cups[4] or spit out after tasting[5] dries as it falls. And although the servants who are employed there are barefooted, their feet are not stained by the wine-lees on this kind of pavement.

[2] $m.$ = 'anatomical drawing,' hence 'detail.' See v. 2. Plato uses μέλος and μέρος interchangeably, e.g. Plat. Phileb. 14E.

[3] Supra, c. iii. 4.

[4] The throwing of wine from the cup, libatio, was done in honour of a deity, or, like a toast, in honour of a person.

[5] Wine was distinguished in tasting as rough, asperum, or smooth, lene, Ter. Haut. 458.

VITRUVIUS

V

1 CETERIS conclavibus, id est vernis, autumnalibus,
aestivis, etiam atriis et peristylis, constitutae sunt
ab antiquis ex[1] certis rebus certae[2] rationes pic-
turarum. Namque pictura imago fit eius, quod est
seu potest esse, uti homines, aedificia, naves, reli-
quarumque rerum, e quibus finitis[3] certisque cor-
poribus figurata similitudine sumuntur exempla.
Ex eo antiqui, qui initia expolitionibus instituerunt,
imitati sunt primum crustarum marmorearum
varietates et conlocationes, deinde coronarum,
filicularum,[4] cuneorum inter se varias distributiones.
2 Postea ingressi sunt, ut etiam aedificiorum figuras,
columnarum et fastigiorum[5] eminentes proiec-
turas[6] imitarentur, patentibus autem locis, uti
exhedris, propter amplitudines parietum scaenarum
frontes tragico more aut comico seu satyrico desig-
narent, ambulationibus vero propter spatia longi-
tudinis varietatibus topiorum ornarent a certis[7]
locorum proprietatibus imagines exprimentes; pin-
guntur enim portus, promunturia, litora, flumina,
fontes, euripi,[8] fana, luci, montes, pecora, pastores.
Nonnulli locis item signorum melographiam habentes
deorum simulacra seu fabularum dispositas explica-

[1] ex certis *Joc* : & certis *H*.
[2] certę rationes *G* : ca&erationes *H*.
[3] finitis *Mar* : finibis *H*.
[4] filicularum *Gr* : siliculorum *H*.
[5] fastidiorum *H S*.
[6] protecturas *Gr* : prolecturas *H S*.
[7] certis e_2 : adcertis *H*. [8] eurypi *H G*.

[1] *Exemplum* = Gk. *paradeigma*, Herod. II. 86.
[2] Incrustation style : (*a*) plain, (*b*) florid.

CHAPTER V

ON WALL-PAINTING

1. In other apartments for use in spring, autumn or summer, and also in atria and cloisters, the ancients used definite methods of painting definite objects. For by painting an image is made of what is, or of what may be; for example, men, buildings, ships, and other objects; of these definite and circumscribed bodies, imitations [1] are taken and fashioned in their likeness. Hence the ancients who first used polished stucco, began [2] by imitating the variety and arrangement of marble inlay; then the varied distribution of festoons, ferns, coloured strips.

2. Then they proceeded to imitate the contours of buildings, the outstanding projections of columns and gables; [3] in open spaces, like exedrae, they designed scenery [4] on a large scale in tragic, comic, or satyric style; in covered promenades, because of the length of the walls, they used for ornament the varieties of landscape gardening, [5] finding subjects in the characteristics of particular places; for they paint harbours, headlands, shores, rivers, springs, straits, temples, groves, hills, cattle, shepherds. In places, some have also the anatomy of statues, the images of the gods, or the representations of legends;

[3] The latter was the transition to architectural style, Bm. 1377.

[4] Book V. vi. 9. Vitruvius suggests that the incrustation style corresponds to the tragic scenery; the architectural, to comic; the third, the landscape style, to satyric.

[5] Stuart Jones suggests 'landscape' as the name of the third style, *Companion*, 402. This precisely corresponds to *topeodi species, H.* V. vi. 9.

tiones, non minus troianas pugnas seu Ulixis erra-
tiones per topia, ceteraque, quae sunt eorum simi-
libus rationibus ab rerum natura procreata.

3 Sed haec, quae ex veris [1] rebus exempla sume-
bantur, nunc iniquis moribus inprobantur. ⟨Nam
pinguntur⟩ [2] tectoriis monstra potius quam ex rebus
finitis imagines certae: pro columnis enim struuntur
calami striati, pro fastigiis appagineculi cum crispis
foliis et volutis, item candelabra aedicularum sus-
tinentia figuras, supra fastigia eorum surgentes ex
radicibus cum volutis [3] teneri plures habentes in se
sine ratione sedentia sigilla, non minus coliculi
dimidiata [4] habentes sigilla alia humanis, alia besti-
arum capitibus.

4 Haec autem nec sunt nec fieri possunt nec fuerunt.
Ergo ita novi mores coegerunt, uti inertiae mali
iudices convincerent artium virtutes: quemadmodum
enim potest calamus vere sustinere tectum aut
candelabrum ornamenta fastigii, seu coliculus [5] tam
tenuis et mollis sustinere sedens sigillum, aut de
radicibus et coliculis ex parte flores dimidiataque
sigilla procreari? At haec falsa videntes homines
non reprehendunt sed delectantur, neque animad-
vertunt, si quid eorum fieri potest necne. Iudiciis
autem infirmis obscuratae mentes non valent probare,
quod potest esse cum auctoritate et ratione decoris.
Neque enim picturae probari debent, quae non
sunt similes veritati, nec, si factae sunt elegantes ab
arte, ideo de his statim debet ' recte ' iudicari, nisi

[1] veris e_2: v&eris *H*, veteris *S*, veteribus *G*.
[2] nam pinguntur *G*: *om. H S*.
[3] voluteis *H*.
[4] dimidiata *Joc*: dimidiati *H*.
[5] culiculus *H S*.

further, the battles of Troy and the wanderings of
Ulysses over the countryside with other subjects
taken in like manner from Nature.

3. But these which were imitations based upon
reality are now disdained by the improper taste [1] of
the present. On the stucco are monsters rather
than definite representations taken from definite
things. Instead of columns there rise up stalks;
instead of gables, striped panels with curled leaves
and volutes. Candelabra uphold pictured shrines
and above the summits of these, clusters of thin
stalks rise from their roots in tendrils with little
figures seated upon them at random. Again,
slender stalks with heads of men and of animals
attached to half the body.

4. Such things neither are, nor can be, nor have
been. On these lines the new fashions compel bad
judges to condemn good craftsmanship for dullness.
For how can a reed actually sustain a roof, or a
candelabrum the ornaments of a gable? or a soft and
slender stalk, a seated statue? or how can flowers
and half-statues rise alternately from roots and
stalks? Yet when people view these falsehoods, they
approve rather than condemn, failing to consider
whether any of them can really occur or not. Minds
darkened by imperfect standards of taste cannot
discern the combination of impressiveness with a
reasoned scheme of decoration. For pictures can-
not be approved which do not resemble reality.
Even if they have a fine and craftsmanlike finish,
they are only to receive commendation if they

[1] Vitruvius follows the Stoic insistence on reality, as dis-
tinguished from the fantastic compositions which transformed
the ' architectural ' style under Alexandrian influences.

argumentationes certas rationes habuerint sine offensionibus explicatas.

5 Etenim etiam Trallibus cum Apaturius Alabandius eleganti manu finxisset scaenam in minusculo theatro, quod ecclesiasterion [1] apud eos vocitatur, in eaque fecisset columnas, signa, centauros sustinentes epistylia, tholorum [2] rotunda tecta, fastigiorum prominentes versuras, coronasque capitibus leoninis ornatas, quae omnia stillicidiorum e tectis habent rationem, praeterea supra ea nihilominus episcenium, in qua tholi, pronai, semifastigia omnisque tecti varius picturis fuerat ornatus, itaque cum aspectus eius scaenae propter asperitatem eblandiretur omnium visus et iam id opus probare fuissent parati, tum Licymnius [3] mathematicus prodiit et ait 6 ' Alabandis satis acutos ad omnes res civiles haberi,[4] sed propter non magnum vitium indecentiae insipientes eos esse iudicatos,[5] quod in gymnasio [6] eorum quae sunt statuae omnes sunt causas [7] agentes, foro discos tenentes aut currentes seu pila ludentes. Ita indecens inter locorum proprietates status signorum publice civitati [8] vitium existimationis adiecit. Videamus item nunc, ne a picturis scaena efficiat et nos Alabandis [9] aut Abderitas. Qui enim vestrum domos supra tegularum tecta potest habere aut columnas seu fastigiorum expolitionis?[10] Haec enim supra contignationis ponuntur, non supra tegularum tecta. Si ergo, quae non possunt in

[1] ἐκκλησιαστήριον *Joc* : eglisinterion *H*.
[2] tholorum *Joc* : pholumorum *H S Gᵒ*.
[3] Licymnius *Sillig* : lichinus *H*.
[4] haberi *G* : habere *H S*. [5] iudicatus *H S*.
[6] gipnasio *H*. [7] causas *G* : causa *H S*.
[8] civitati *Joc* : -tis *H*. [9] Alabandis *Kr* : alabandas *H*.
[10] explitionis *H* : expolicionis *S*.

exhibit their proper subject without transgressing the rules of art.

5. At Tralles,[1] Apaturius of Alabanda had invented scenery of fine technique for the tiny theatre which they call the Small Assembly. In this he showed columns, statues, or centaurs supporting the architraves, the orbed roofs of domes, the projecting angles of pediments, cornices having lions' heads which provided outlets for the rain from the roofs. Besides, the story above the scenery had domes, porticoes, half pediments, and every kind of roof, with varied pictorial ornament. When, therefore, the appearance of such a stage, by its high relief,[2] charmed the eyes of all, and they were already on the point of applauding it, Licymnius the mathematician came forward and said, that (6) ' the inhabitants were shrewd enough in politics, but they had the reputation of being stupid because of one not very great fault, inconsistency. In the gymnasium, the statues were all of politicians; in the public assembly, they were of quoit-throwers or runners or javelin-throwers. Thus the unsuitable disposition of the statues added a blemish to the city in public estimation. Let us see to it that our stage scenery with its pictures does not make us citizens of Alabanda or of Abdera![3] For who of you can have above your roof tiles, buildings with columns and elaborate gables? For the latter stand upon floors, not above the roof tiles. If therefore,

[1] VII. *pref.* 12.
[2] The effect of perspective is compared to repoussé work; cf. Verg. *A.* v. 267. *cymbia . . . aspera signis.*
[3] Abdera, proverbially a city of fools; Alabanda, proverbial for its luxury, Strabo XIV. 661.

veritate rationem habere facti, in picturis pro-
baverimus, accedimus et nos his civitatibus, quae
propter haec vitia insipientes sunt iudicatae.'

7 Itaque Apaturius contra respondere non est ausus,
sed sustulit scaenam et ad rationem veritatis commu-
tatam postea correctam adprobavit.[1] Utinam dii
inmortales fecissent, uti Licymnius[2] revivisceret et
corrigeret hanc amentiam tectoriorumque errantia
instituta! Sed quare vincat veritatem ratio falsa,
non erit alienum exponere. Quod enim antiqui
insumentes laborem ad industriam probare contende-
bant artibus, id nunc coloribus et eorum alleganti[3]
specie consecuntur, et quam subtilitas artificis
adiciebat operibus auctoritatem, nunc dominicus
sumptus efficit, ne desideretur.

8 Quis enim antiquorum non uti medicamento minio
parce videtur usus esse? At nunc passim plerumque
toti parietes inducuntur. Accedit huc chrysocolla,
ostrum, armenium. Haec vero cum inducuntur,
etsi non ab arte sunt posita, fulgentes oculorum
reddunt visus, et ideo quod pretiosa sunt, legibus
excipiuntur, ut ab domino, non a redemptore reprae-
sententur.

Quae commune facere[4] potui, ut ab errore dis-
cedatur in opere tectorio, satis exposui; nunc de
apparitionibus, ut succurrere potuerit, dicam, et
primum, quoniam de calce initio est dictum, nunc de
marmore ponam.

[1] adprobabit *H S*. [2] uti licinius *H G*, utlicinius *S*.
[3] alleganti *Gr*: aliganti *H*.
[4] cummonefacere *H* = κοινωνεῖν *N.T.*

we approve in pictures what cannot justify itself
in reality, we are added to those cities which, because
of such faults, are esteemed slow-witted.'

7. So Apaturius had not the courage to reply,
and removed the scenery; and when this was
altered to resemble reality, he obtained sanction
for his correction. O that heaven would raise
Licymnius to life, and amend this madness, and the
roving fashions of the fresco-painters! Now it
is not foreign to our purpose to explain why a false
method overcomes the truth. The aims which
the ancients sought to realise by their painstaking [1]
craftsmanship, the present attains by coloured
materials and their enticing appearance. The
dignity which buildings used to gain by the subtle
skill of the craftsman, is not even missed owing to
the lavish expenditure of the client.

8. For who of the ancients is not found to use
minium as sparingly as the apothecary? But at
the present day whole walls are covered with it
everywhere. To it is added malachite, purple,
Armenian ultramarine. And when these are ap-
plied, apart from any question of skill, they affect
the vision of the eyes with brilliance. Because of
their costliness they are excluded in the specification,
so that they are charged to the client and not to
the contractor.

I have sufficiently set forth the advice I could give
for avoiding mistakes in the plaster work. I will now
deal with the necessary supplies, as it may occur
to me; and first—since lime has been mentioned to
begin with—I will now describe marble.

[1] ad industriam = de industria.

VI

1 MARMOR non eodem genere omnibus regionibus procreatur, sed quibusdam locis glaebae ut salis micas perlucidas habentes nascuntur, quae contusae et molitae praestant operibus utilitatem. Quibus autem locis eae copiae non sunt, caementa marmorea, sive assulae [1] dicuntur, quae marmorarii ex operibus deiciunt, contunduntur [2] et moluntur, subcretum in operibus utuntur. Aliis locis, ut inter Magnesiae et Ephesi fines, sunt loca, unde foditur ⟨glaeba⟩ parata, quam nec molere nec cernere opus est, sed sic est subtilis,[3] quemadmodum si qua est manu contusa et subcreta.

Colores vero alii [4] sunt, qui per se certis locis procreantur [5] et inde fodiuntur, nonnulli ex aliis rebus tractationibus aut mixtionum [6] temperaturis compositi perficiuntur, uti praestent in eandem operibus utilitatem.

[1] assilae H.
[2] contunduntur et molliuntur et is qui ex his etc. viii. 2.—expolitus et aridus ix. 3 H. verum ordinem restituit Lorentzen.
[3] subtilis ed. Fl : subtilius H.
[4] aliis H.
[5] procrehentur H.
[6] mixtionum Nohl : mixtionibus H.

[1] At this point the next leaf of the archetype begins : est subcretum, and goes on to interarescant, infra viii. 2. The next leaf but one begins et is qui ex his, viii. 2, and goes on to expolitus et aridus, ix. 3. These two leaves were interchanged so that the second followed upon contunduntur et molliuntur in H and the first leaf followed upon the end of the second after expolitus et aridus. In the Escorial MS. e₂ there is the marginal note at moliuntur (sic): Inversa sunt haec omnia eadem serie

CHAPTER VI

ON THE USE OF MARBLE

1. MARBLE is not found of the same kind in all regions. In some places, blocks occur with shining flakes, as of salt. And these being crushed and ground are of use. But where there are no such supplies, marble-rubble, or splinters as they are called, which the marble workers throw down from their benches, are crushed and ground.[1] This material when sifted the plasterers use in their work. Elsewhere, for example between the boundaries of Magnesia and Ephesus, there are places where it is dug up ready for use, and need not be ground nor sifted.[2] It is as fine as if it had been crushed by hand and sifted.

There are other coloured materials which occur in a natural state in certain places, and are dug up from mines. Yet others are composed of different substances and are treated and blended so as to serve the same [3] purposes in buildings.

quae in Blandiniano c habetur. (c = codice.) The end of the second leaf is marked, but *est* is attached to *aridus. subcretum* is an accusative after *utuntur*. Jocundus, who first printed the text in the proper order, rewrote the Latin of the chapter on marble after *deiciunt*, down to *colores vero*, etc., where he takes up the text again. His interpolation appeared in the Tauchnitz Latin text and was followed by Gwilt; it was detected by Schneider, who, however, thought that Jocundus took it from a MS.

[2] When a compound verb occurs, it is repeated in the simple form, e.g. *exposui* and *ponam*, VII. v. 8; here *subcretum, cernere.*

[3] *In eandem*: use of preposition before direct object; cf. Cyprian *ad Donatum* 1, *in arbores et in vites videmus.*

VII

1 PRIMUM autem exponemus, quae per se nascentia fodiuntur, uti sil,[1] quod graece *ochra*[2] dicitur. Haec vero multis locis, ut etiam in Italia, invenitur; sed quae fuerat optima, attica, ideo nunc non habetur, quod Athenis argentifodinae cum habuerunt familias, tunc specus sub terra fodiebantur ad argentum inveniendum. Cum ibi vena forte inveniretur, nihilominus uti argentum persequebantur[3]; itaque antiqui egregia copia silis ad politionem operum sunt usi.

2 Item rubricae copiosae multis locis eximuntur, sed optimae paucis, uti Ponto Sinope, et Aegypto, in Hispania Balearibus, non minus etiam Lemno, cuius insulae vectigalia Atheniensibus senatus populusque

3 Romanus concessit fruenda. Paraetonium vero ex ipsis locis, unde foditur, habet nomen. Eadem ratione melinum, quod eius metallum[4] insula cycladi

4 Melo dicitur esse. Creta viridis item pluribus locis nascitur, sed optima Zmyrnae; hanc autem Graeci *Theodoteion*[5] vocant, quod Theodotus nomine fuerat, cuius in fundo id genus cretae primum est

5 inventum. Auripigmentum, quod *arsenicon* graece dicitur, foditur Ponto. Sandaraca[6] item pluribus locis, sed optima Ponto proxime flumen Hypanim habet metallum.

[1] sil *Schn* : si *H*. [2] ochras *H*.
[3] persequebatur *H*. [4] metallum *Ro* : metalli insulae *H*.
[5] theodoteū *H*. [6] pontos andarea *H*.

[1] " Yellow and scarlet appeal to the undamaged eye."— William Morris, *Life* by Mackail, I. 106.

[2] The ochres, yellow and red, are earths coloured by iron oxide.

[3] At Laurium near Sunium. [4] About 167 B.C.

[5] Calcium carbonate.

CHAPTER VII

ON NATURAL COLOURS

1. First we will describe the colours [1] which are dug up in their natural state, such as the yellow [1] material which the Greeks call ochre.[2] This is found in many places, as also in Italy. What used to be the best, the Attic, is not available now, for the following reason. When the silver mines at Athens [3] were worked, shafts were dug underground to find silver; but when a vein of ochre happened to be found, they worked it no less than silver. Hence the ancients used a large amount of yellow in their frescoes.

2. Abundant *red* ochre, also, is extracted in many places, but the best is only found in a few, such as Sinope in Pontus, and in Egypt, in Spain in the Balearic Isles, and also in Lemnos, where the Roman government [4] handed over the revenues to the Athenians. 3. Paraetonium white [5] has its name from the place [6] where it is mined. In the same way Melian white has its name because a mine is said to occur in Melos, an island of the Cyclades. 4. Green chalk is found in many places, but the best is from Smyrna, which the Greeks call *Theodoteion*, because Theodotus was the name of the man on whose land it was first found. 5. Orpiment,[7] which the Greeks call arsenic is mined in Pontus. Red arsenic [8] also, in many places, but the best is mined in Pontus close to the river Hypanis.[9]

[6] Paraetonium on the coast of Tripoli.
[7] Arsenious sulphide. [8] Arsenic disulphide.
[9] River Boug, in S. Russia.

VITRUVIUS

VIII

1 INGREDIAR nunc minii rationes explicare. Id autem agris Ephesiorum Cilbianis[1] primum esse memoratur inventum. Cuius et res et ratio satis magnas habet admirationes. Foditur enim glaeba quae dicitur, antequam tractationibus ad minium perveniant, vena uti ferrum,[2] magis subrufo colore, habens circa se rubrum pulverem. Cum id foditur, ex plagis ferramentorum crebras emittit laerimas argenti vivi, quae a fossoribus statim colliguntur.

2 Hae glaebae, cum collectae sunt in officinam, propter umoris plenitatem coiciuntur in fornacem, ut interarescant,[3] et is qui ex his ab ignis vapore fumus suscitatur, cum resedit in solum furni, invenitur esse argentum vivum. Exemptis glaebis guttae eae, quae residebunt,[4] propter brevitates non possunt colligi, sed in vas aquae[5] converruntur et ibi inter se congruunt et una confunduntur. Id autem cum sint quattuor sextariorum mensurae, cum expenduntur, invenientur esse pondo centum.

3 Cum in aliquo[6] vase est confusum,[7] si supra id lapide[8] centenarium pondus inponatur, natat in summo neque eum liquorem potest onere suo premere nec elidere nec dissipare. Centenario sublato si ibi auri scripulum ponatur, non natabit,

[1] Cilbianis *Phil* : cliuianis *H*.
[2] ferrum *Ro* : ferro *H*.
[3] interarescant fuerit ceram punicam *etc.* (ix. 3) *H*.
[4] resedebunt *H*.
[5] in vasa quae *H*.
[6] alico *H*.
[7] confusum *ed* : -sus *H*.
[8] lapidē *H*.

CHAPTER VIII

ON VERMILION AND QUICKSILVER

1. I WILL now go on to describe the treatment of minium [1] or vermilion. It is said to have been discovered in the Cilbian Fields of Ephesus.[2] The material and its treatment is sufficiently wonderful. For what is called the ore is first extracted. Then, using certain processes, they find minium. In the veins the ore is like iron, of a more carroty colour, with a red dust round it. When it is mined, and is worked with iron tools, it exudes many drops of quicksilver, and these are at once collected by the miners.

2. When the ore has been collected in the workshop, because of the large amount of moisture, it is put in the furnace to dry. The vapour which is produced by the heat of the fire, when it condenses on the floor of the oven, is found to be quicksilver. When the ore is taken away, the drops which settle because of their minuteness cannot be gathered up, but are swept into a vessel of water: there they gather together and unite. Four sextarii of quicksilver when they are weighed come to 100 lbs.[3]

3. When quicksilver is poured into a vessel, and a stone weight of 100 lbs. is placed upon it, the stone floats upon the surface. For it is unable by its weight to press the liquid down and so squeeze it out and separate it. If the stone is taken away and a scruple [4] of gold is placed upon the quicksilver, it

[1] Sulphide of mercury.
[2] A fuller account is given by Pliny, *N.H.* XXXIII. 113.
[3] *Sextarius* = ·96 pint; *libra* = ·7 lb. [4] 17·5 gr.

VITRUVIUS

sed ad imum per se deprimetur. Ita non ampli-
tudine ponderis sed genere singularum rerum
gravitatem esse non est negandum.

4 Id autem multis rebus est ad usum expeditum.
Neque enim argentum neque aes sine eo potest
recte inaurari. Cumque in vestem intextum est
aurum eaque vestis contrita[1] propter vetustatem
usum non habeat honestum, panni in fictilibus vasis
inpositi supra ignem conburuntur. Is cinis coicitur[2]
in aquam, et additur eo argentum vivum. Id
autem omnis micas auri corripit in se et cogit secum
coire. Aqua diffusa cum id in pannum infunditur et
ibi manibus premitur, argentum per panni raritates
propter liquorem extra labitur, aurum compressione
coactum intra purum invenitur.

IX

1 REVERTAR nunc ad minii temperaturam. Ipsae
enim glaebae, cum sunt aridae, contunduntur pilis
ferreis, et lotionibus et cocturis crebris relictis
stercoribus efficiuntur, ut adveniant, colores. Cum
ergo emissae[3] sint ex minio[4] per argenti vivi relic-
tionem quas in se naturales habuerat virtutes,
2 efficitur tenera natura et viribus inbecillis. Itaque
cum est in expolitionibus conclavium tectis inductum,
permanet sine vitiis suo colore; apertis vero, id est
peristyliis aut exhedris aut ceteris eiusdem modi
locis,[5] quo sol et luna possit splendores et radios

[1] constrita *H*.　　[2] coigitur *H*.
[3] emissae sint (*Schn*) *Ro* : emissa esset *H*.
[4] minio *Schn* : minii *H*.
[5] *post* locis *H paginam aversam folii 103, fortasse propter
membranae tenuitatem, vacuam exhibet.*

will not swim, but is pressed down to the bottom, of itself. We cannot deny, therefore, that the gravity of bodies depends on their species [1] and not on their volume.

4. Quicksilver is adapted for many uses. Without it neither silver nor brass can be properly gilt. When gold is embroidered in cloth, and the garment, being worn out by age, is no longer fit for use, the cloth is put in earthenware vessels and burnt over the fire. The ashes are thrown into water, and quicksilver is added. This collects all the particles of gold and combines with them. The water is then poured away and the remainder is placed on a cloth, and is pressed by hand. Under this pressure the quicksilver being liquid passes through the pores of the cloth, and the pure gold is retained within.

CHAPTER IX

ON THE PREPARATION OF MINIUM

1. I will now return to the preparation of vermilion. When the ore is dry, it is bruised with iron rammers, and by frequent washing and heating, the waste is removed and the colour is produced. When, therefore, the quicksilver has thus been removed, minium loses its natural virtues, and becomes soft and friable.[2] 2. And so when it is used in the finishing of enclosed apartments, it remains of its own colour without defects; but in open places like peristyles and exedrae and so forth, where the sun and moon can send their brightness and their rays,

[1] Principle of specific gravity stated.
[2] Neuburger, 193.

inmittere, cum ab his locus tangitur, vitiatur et
amissa virtute coloris denigratur. Itaque cum et
alii multi tum etiam Faberius scriba, cum in Aventino [1]
voluisset habere domum eleganter expolitam,
peristyliis parietes omnes induxit minio, qui post dies
xxx facti sunt invenusto varioque colore. Itaque
primo locavit inducendos alios colores.

3 At [2] si qui subtilior fuerit et voluerit expolitionem
miniaciam suum colorem retinere, cum paries
expolitus et aridus est,[3] ceram punicam [4] igni lique-
factam paulo oleo temperatam saeta inducat; deinde
postea carbonibus in ferreo vase compositis eam
ceram a primo cum pariete calfaciundo sudare
cogat fiatque, ut peraequetur; deinde tunc candela
linteisque [5] puris [6] subigat, uti signa marmorea nuda
4 curantur (haec autem *ganosis* [7] graece dicitur): ita
obstans cerae punicae [8] lorica non patitur nec lunae
splendorem nec solis radios lambendo [9] eripere his
politionibus colorem. Quae autem in Ephesiorum
metallis fuerunt officinae, nunc traiectae sunt ideo
Romam, quod id genus venae postea est inventum
Hispaniae regionibus, quibus metallis glaebae por-
tantur et per publicanos Romae curantur. Eae
autem officinae sunt inter aedem Florae et Quirini.
5 Vitiatur minium [10] admixta calce. Itaque si qui

[1] aventino *rec* : adventino *H*. [2] at *E G* : ad *H S*.
[3] et aridus est subcretum *etc.* (*supra* c. vi. 1).
[4] punicam *e₂ Sulp* : pumicam *H*.
[5] linteis (*Plin. N.H.* XXXIII. 122) : cunctis *H*.
[6] puris *ed* : pluris *H*.
[7] γάνωσις *Welcker* : gnosis *H*. [8] pumicae *H S*.
[9] lambendo *ed* : labendo *H*. [10] minimum *H*.

[1] After being in Caesar's service, he forged documents for
Antony. Cic. *Att.* XIV. 18. 1.

the part so affected is damaged and becomes black, when the colour loses its strength. Among the many instances of this is the case of the public official Faberius.[1] He wished to have his palace on the Aventine[2] elegantly finished, and had all the walls of the peristyle covered with vermilion. In a month the walls turned to an unpleasant and uneven colour; and so he was the first to let a contract for laying on other colours.

3. But if anyone proceeds in a less crude fashion, and wishes a vermilion surface to keep its colour after the finishing of the wall is dry, let him apply with a strong brush Punic wax melted in the fire and mixed with a little oil. Then putting charcoal in an iron vessel, and heating the wall with it, let the wax first be brought to melt, and let it be smoothed over, then let it be worked over with waxed cord and clean linen cloths, in the same way as naked marble statues; this process is called *ganōsis* in Greek. 4. Thus a protective coat of Punic wax does not allow the brilliance of the moon or the rays of the sun to remove the colour from these finished surfaces by playing on them. The workshops which were in the Ephesian mines are now removed to Rome, because this kind of vein has been discovered in parts of Spain. The ore from the Spanish mines is conveyed to Rome and dealt with by the farmers-general. The workshops[3] are between the temples of Flora and Quirinus.[4]

5. Minium is adulterated by the admixture of

[2] This plebeian quarter became fashionable under the empire.

[3] On the Quirinal. Platner, 371.

[4] Book III. ii. 7.

velit experiri id sine vitio esse, sic erit faciendum. Ferrea lamna sumatur, eo minium inponatur, ad ignem conlocetur, donec lamna candescat. Cum e candore color mutatus fuerit eritque ater, tollatur lamna ab igni, et sic refrigeratum restituatur in pristinum colorem; sine vitio esse probabit; sin autem permanserit nigro colore, significabit se esse vitiatum.

6 Quae succurrere potuerunt mihi de minio, dixi. Chrysocolla adportatur a Macedonia; foditur autem ex is locis, qui sunt proximi aerariis metallis. Armenium[1] et indicum nominibus[2] ipsis indicatur, quibus in locis procreatur.

X

1 INGREDIAR nunc ad ea, quae ex aliis generibus tractationum temperaturis commutata recipiunt colorum proprietates. Et primum exponam de atramento, cuius usus in operibus magnas habet necessitates, ut sint notae, quemadmodum praeparentur certis rationibus artificiorum, ad id temperaturae.

2 Namque aedificatur locus uti laconicum et expolitur marmore subtiliter et levigatur. Ante id fit fornacula habens in laconicum nares, et eius praefurnium magna diligentia conprimitur, ne[3] flamma extra dissipetur. In fornace resina conlocatur.[4] Hanc autem ignis potestas urendo cogit

[1] armenium *Schn* : minium *H.*
[2] nominibus *E G* : inomnibus *H S.*
[3] nec *H et a. ras. S.*
[4] collocetur *H S.*

lime. If anyone wishes to test its purity, the method is as follows. Take an iron plate, put the minium on it and set it on the fire until the plate is red-hot. When the colour is changed by the heat and is black, take the plate from the fire, and let the minium, on cooling, regain its former colour : its purity will be demonstrated. But if it remains black, it shows adulteration.

6. I have said what seemed of practical use about minium. Malachite is imported from Macedonia ; it is mined in places which adjoin the copper mines. Ultramarine (armenium [1]) and indigo (indicum [2]) show by their names the places where they are found.

CHAPTER X

ON BLACK

1. I WILL now proceed to those materials which, by special processes, are changed substantially, and acquire the properties of colour. And first I will deal with black. The use of this in buildings is often necessary, so that we must know how the tempering of materials for the purpose is carried out by special craftsmanship.

2. A vaulted apartment is built like a sweating chamber,[3] and is covered carefully with a marble facing and smoothed down. In front of it a small furnace is built with outlets into the chamber, and the mouth of the furnace is carefully enclosed so that the flame does not escape. Resin is placed in the furnace. Now the fiery potency burns it and compels

[1] Probably azurite; perhaps powdered lapis lazuli.
[2] Indian ink. [3] Book V. x. 5.

emittere per nares intra laconicum fuliginem, quae
circa parietem et camerae curvaturam adhaerescit.
Inde collecta partim componitur ex gummi subacta[1] ad
usum atramenti librarii, reliquum tectores glutinum
3 admiscentes in parietibus utuntur. Si autem hae
copiae non fuerint paratae, ita necessitatibus erit
administrandum, ne expectatione morae res retin-
eatur. Sarmenta aut taedae schidiae comburantur;
cum erunt carbones, extinguantur, deinde in mor-
tario cum glutino[2] terantur; ita erit atramentum
4 tectoribus non invenustum. Non minus si faex vini
arefacta et cocta in fornace fuerit et ea contrita cum
glutino in opere inducetur, super quam[3] atramenti
suavitatis efficiet colorem; et quo magis ex meliore
vino parabitur, non modo atramenti, sed etiam indici
colorem dabit imitari.

XI

1 CAERULI temperationes Alexandriae primum sunt
inventae, postea item Vestorius[4] Puteolis instituit
faciundum. Ratio autem eius, e quibus est inventa,
satis habet admirationis. Harena enim cum nitri
flore conteritur adeo subtiliter, ut efficiatur quem-
admodum farina; et aes cyprum[5] limis crassis uti
scobis facta[6] mixta conspargitur, ut conglomeretur;
deinde pilae manibus versando efficiuntur et ita

[1] subacta *Schn* : subacto *x*.
[2] glotino *H*.
[3] super quam *Ro* : superque *H*.
[4] Vestorius e_2 : Nestorius e_2 *schol*, *Sulp*.
[5] cyprum *H* : cyprium e_2 *Sulp*. *Plin. N.H.* XXXIV. 116.
[6] facta *Kr* : factam *H*.

it to emit soot through the outlets into the chamber. The soot clings round the walls and vaulting of the chamber. It is then collected and in part compounded with gum and worked up for the use of writing ink; the rest is mixed with size and used by fresco-painters for colouring walls. 3. But if this cannot be obtained, we must satisfy our requirements without holding back the works by the delay involved. Brushwood or pine-chips must be burnt, and when they are charred they are to be pounded in a mortar with size. Thus the fresco-painters will have a not unpleasant black colour. 4. Again, a black colour even more pleasant than this is produced if the dregs of wine are dried and burnt in a furnace, and applied to the walls after being ground with size. The use of the finer wines will allow us to imitate not only black but indigo.

CHAPTER XI

ON BLUE AND YELLOW

1. THE processes for making blue were first discovered at Alexandria; afterwards also Vestorius founded a factory at Puteoli.[1] His method and his ingredients are sufficiently noteworthy. Sand is ground with flowers of soda to such fineness that it becomes like flour. Cyprian copper is sprinkled from rough files like fine dust so that it combines with the mixture. Then, it is rolled by hand into

[1] Vestorius, a banker of Puteoli, was the friend of Cicero and Atticus. He advised Cicero about building, *Att.* XIV. 9. 1. He was not interested in philosophy but a sound accountant, *Att.* XIV. 12. 3.

conligantur, ut inarescant; aridae componuntur in
urceo fictili, urcei in fornace: ita [1] aes et ea harena
ab ignis vehementia confervescendo cum coaruerint,
inter se dando et accipiendo sudores a proprietatibus
discedunt suisque rebus per ignis vehementiam
2 confectis [2] caeruleo rediguntur colore. Usta vero,
quae satis habet utilitatis in operibus tectoriis, sic
temperatur. Glaeba silis [3] boni coquitur,[4] ut sit in
igni candens; ea autem aceto extinguitur et efficitur
purpureo colore.

XII

1 DE cerussa aerugineque, quam nostri aerucam
vocitant, non est alienum, quemadmodum com-
paretur, dicere. Rhodo enim doleis sarmenta con-
locantes aceto suffuso supra sarmenta conlocant
plumbeas massas, deinde ea operculis obturant, ne
spiramentum obturatum emittatur. Post certum
tempus aperientes inveniunt e massis plumbeis cerus-
sam. Eadem ratione lamellas aereas conlocantes
2 efficiunt aeruginem, quae aeruca appellatur. Cerussa
vero, cum in fornace coquitur, mutato colore ad
ignem incendi efficitur sandaraca—id autem incendio
facto ex casu didicerunt homines—et ea multo
meliorem usum praestat, quam quae de metallis per
se nata foditur.

[1] ita *Schn* : sita ut *H*. [2] confectis *Rode* : -ti *H*.
[3] silis *rec* : silix *H*. [4] quoquitur *H*.

[1] Artificial cinnabar discovered by Callias of Athens 315 B.C.
Plin. N.H. XXXIII. 113.
[2] Lead acetate.

balls and they are put together to dry. When dry they are collected in an earthenware jar, and the jars are put in a furnace. In this way the copper and the sand burning together owing to the vehemence of the fire dry together, and, interchanging their vapours, lose their properties; and their own character being overcome by the vehemence of the fire, they acquire a blue colour. 2. Burnt ' cinnabar,' [1] which is very useful in plastering, is mixed as follows. Ore of good yellow ochre is roasted to a bright heat. It is quenched with vinegar and becomes of a purple colour.

CHAPTER XII

ON WHITE LEAD, VERDIGRIS, RED LEAD

1. It belongs to our subject to deal with the production of white lead and verdigris which our people call *aeruca*. At Rhodes they place a layer of chips in a large vessel, and pouring vinegar over them, they then put lumps of lead on the top. The vessel is covered with a lid lest the vapour which is enclosed should escape. It is opened after a certain time and the lead is found to be changed into *cerussa*.[2] In the same way, by using plates of copper they obtain verdigris or *aeruca*.[3] 2. When white lead is roasted in a furnace, under the heat of the fire it changes its colour and becomes red lead or *sandaraca*.[4] This fact was accidentally discovered in a conflagration. A much better result is obtained in this way than from the natural substance which is procured from the mines.

[3] Basic copper acetate; mixed with wine, the green of MSS.
[4] Lead oxide.

XIII

1 INCIPIAM nunc de ostro dicere, quod et carissimam
et excellentissimam habet praeter hos colores aspec-
tus suavitatem. Id autem excipitur e conchylio
marino, e quo purpura [1] efficitur, cuius non minores
sunt quam ceterarum ⟨rerum⟩ [2] naturae consideran-
tibus admirationes, quod habet non in omnibus
locis, quibus nascitur, unius generis colorem, sed
2 solis cursu naturaliter temperatur. Itaque quod
legitur Ponto et Gallia, quod hae regiones sunt
proximae ad septentrionem, est atrum; progredien-
tibus inter septentrionem et occidentem invenitur
lividum; quod autem legitur ad aequinoctialem
orientem et occidentem, invenitur violacio colore;
quod vero meridianis regionibus excipitur, rubra
procreatur potestate, et ideo hoc Rhodo etiam insula
creatur ceterisque eiusmodi regionibus, quae prox-
3 imae sunt solis cursui. Ea conchylia, cum sunt lecta,
ferramentis circa scinduntur, e quibus plagis pur-
purea [3] sanies, uti lacrima profluens, excussa in
mortariis terendo comparatur. Et quod ex con-
charum marinarum testis eximitur, ideo ostrum
est vocitatum. Id autem propter salsuginem cito
fit siticulosum, nisi mel habeat circa fusum.

XIV

1 FIUNT etiam purpurei colores infecta creta rubiae [4]
radice et hysgino,[5] non minus et ex floribus alii

[1] purpora H S. [2] add. Joc.
[3] purporea H S. [4] rubiae Joc : rubra H.
[5] et hysgino Joc (Plin. N.H. XXXV. 45): et excygno H.

[1] Gk. *ostreon* = oyster.

CHAPTER XIII

ON PURPLE

1. WE now turn to purple, which of all is most prized and has a most delightful colour excellent above all these. It is obtained from sea shells which yield the purple dye, and inspires in students of nature as much wonder as any other material. For it does not yield the same colour everywhere, but is modified naturally by the course of the sun. 2. What is collected in Pontus and Gaul is black because these regions are nearest to the north. As we proceed between the north and west it becomes a leaden blue. What is gathered in the equinoctial regions, east and west, is of a violet colour. But in the southern regions it has a red character; for example, in Rhodes and other similar regions which are nearest the sun's course. 3. When the shells have been collected, they are broken up with iron tools. Owing to these beatings a purple ooze like a liquid teardrop is collected by bruising in a mortar. And because it is gathered from the fragments of sea shells it is called *ostrum*.[1] On account of its saltness it soon dries unless it is mixed with honey.[2]

CHAPTER XIV

ON ARTIFICIAL COLOURS

1. PURPLE colours are also made by dyeing chalk with madder and hysginum.[3] Other colours also

[2] It is replaced in modern times by indigo derivatives.
[3] Dye made from a parasite of *quercus coccifera*, a small oak-bush found in Spain and N. Africa.

colores. Itaque tectores, cum volunt sil atticum [1]
imitari, violam aridam coicientes in vas cum aqua,[2]
confervefaciunt ad ignem, deinde, cum est tempera-
tum, coiciunt ⟨in⟩ [3] linteum, et inde manibus ex-
primentes recipiunt in mortarium aquam ex violis
coloratam, et eo cretam infundentes et eam terentes
efficiunt silis attici colorem.

2 Eadem ratione vaccinium temperantes et lac-
tem miscentes purpuram faciunt elegantem. Item
qui non possunt chrysocolla propter caritatem uti,
herba, quae luteum appellatur, caeruleum inficiunt,
et utuntur viridissimum colorem; haec autem
infectiva appellatur. Item propter inopiam coloris
indici cretam selinusiam [4] aut anulariam vitro,[5]
quod Graeci *isatin* [6] appellant, inficientes imitationem
faciunt indici coloris.

3 Quibus rationibus et rebus ad dispositionem
firmitatis quibusque decoras oporteat fieri picturas,
item quas habeant omnes colores in se potestates,
ut mihi succurrere potuit, in hoc libro perscripsi.
Itaque omnes aedificationum perfectiones, quam
habere debeant opportunitatem ratiocinationis, sep-
tem voluminibus sunt finitae; insequenti autem de
aqua, si quibus locis non fuerit, quemadmodum
inveniatur et qua ratione ducatur quibusque rebus,
si erit salubris et idonea, probetur, explicabo.

[1] sil acticum *H*.
[2] vas cum aqua *E G* : vas cum quā *H*. [3] *add. ed.*
[4] selinusiam *Joc* (*Plin. N.H.* XXXV. 46): Sinysiam *H*.
[5] vitro *Schn* : vitroque *H*.
[6] ἴσατιν *Turnebus* : insallim *H*.

are obtained from flowers. When the stucco painters wish to imitate Attic ochre, they put dried yellow violets into a vessel with water and boil them. Then, when it is ready, it is poured on a cloth and squeezed by hand. They receive in a mortar the water coloured by the violets, and pouring chalk into it and rubbing it, they obtain the colour of Attic ochre.

2. In the same way they prepare whortleberries and mix them with milk, thus making a fine purple. Malachite is dear, and those who cannot afford it steep blue dye with the herb which is called weld [1] and obtain a brilliant green. This is called dyer's green. Also, because of the scarcity of indigo they make a dye of chalk from Selinus, or from broken beads, along with woad (which the Greeks call *isatis*), and obtain a substitute for indigo.

3. I have described in this book what suggested itself as of practical use, about the methods and materials required for stability, and how painting is employed in decoration, and, further, about the properties of colours. Thus in seven books I have defined the right methods of building and the due adjustment of the design. In the following book, which is about water, I will explain how it may be found where it is lacking, how it may be supplied and by what tests we may determine its wholesomeness and suitability for its purpose.

[1] A kind of mignonette yielding a yellow dye.

BOOK VIII

LIBER OCTAVUS

1 DE septem sapientibus Thales Milesius omnium
rerum principium aquam est professus, Heraclitus
ignem, Magorum sacerdotes aquam et ignem,
Euripides, auditor Anaxagorae, quem philosophum
Athenienses scaenicum appellaverunt, aera et terram,
eamque e caelestium imbrium conceptionibus in-
seminatam fetus gentium et omnium animalium in
mundo procreavisse, et quae ex ea essent prognata,
cum dissolverentur temporum necessitate[1] coacta
in eandem[2] redire, quaeque de aere nascerentur,[3]
item in caeli regiones reverti neque interitiones
recipere et dissolutione mutata in eam recidere, in
qua ante fuerant,[4] proprietatem. Pythagoras vero,
Empedocles, Epicharmos aliique physici et philo-
sophi haec principia esse quattuor proposuerunt:
aerem, ignem, terram, aquam, eorumque inter se
cohaerentiam[5] naturali figuratione e generum dis-
criminibus efficere qualitates.

[1] necessitate *S* : -tē *H G*.
[2] eandem *G* : eadem *H S*.
[3] de aere nascentur *G*, dehacre nascentur *H*, de hac renasce-
rentur *S*.
[4] fuerant *G* : fuerat *H*.
[5] cohaerentiam *Gal* : -tia *H*.

[1] In the preface to Book VII, the pre-Socratic philosophers
are distinguished as '*physici*'.
[2] The names are variously given, *e.g.* Plato, *Protag.* 343A.

BOOK VIII

PREFACE

1. THALES [1] of Miletus, one of the Seven Wise Men,[2] affirmed that the principle of all things is water; Heraclitus, fire; the priests of the Magi,[3] water and fire; Euripides,[4] the pupil of Anaxagoras, whom the Athenians named the philosopher on the stage, air and earth.[5] 'The earth,' he said, 'impregnated by the seed contained in the rain from the sky, gives birth to mankind and all creatures living in the world; and whatever is born of earth, when it is dissolved by the necessary compulsion of time, returns to the same earth. What is born of the air returns to the regions of the sky and is not subject to destruction, but being changed by dissolution returns to that property of which it consisted before.' Pythagoras, Empedocles, Epicharmus,[6] and other physicists and philosophers affirmed that there are four principles: air, fire, earth, water; and that their coherence taking shape according to kind produces attributes in accordance with the variation of species.

[3] In the *LXX Daniel* i. 20, φιλόσοφοι corresponds to μάγοι in Theodotion's version of *Daniel* which from an early date had replaced the *LXX Daniel*. Swete, *Introduction*, 47.

[4] Plato, *Rep.* 568A.

[5] Fr. 836 (Nauck).

[6] Of Syracuse, comic dramatist and philosopher, met Aeschylus at the court of Hiero I.

2 Animadvertimus vero non solum nascentia ex his esse procreata, sed etiam res omnes non ali sine eorum potestate neque crescere nec tueri. Namque corpora sine spiritus [1] redundantia non possunt habere vitam, nisi aer influens cum incremento fecerit auctus et remissiones continenter. Caloris vero si non fuerit in corpore iusta conparatio, non erit spiritus animalis neque erectio firma, cibique vires non poterunt habere coctionis temperaturam. Item si non terrestri cibo membra corporis alantur, deficientur et ita a terreni principii mixtione erunt deserta.

3 Animalia vero si fuerint sine umoris potestate, exsanguinata et exsucata a principiorum liquore interarescent. Igitur divina mens, quae proprie necessaria essent gentibus, non constituit difficilia et cara, uti sunt margaritae, aurum, argentum ceteraque, quae neque corpus nec natura desiderat, sed sine quibus mortalium vita non potest esse tuta, effudit ad manum parata per omnem mundum. Itaque ex his, si quid forte defit in corpore spiritus, ad restituendum aer adsignatus id praestat. Apparatus autem ad auxilia caloris solis impetus et ignis inventus tutiorem efficit vitam. Item terrenus fructus escarum praestans copiis supervacuis desiderationibus alit et nutrit animales pascendo continenter. Aqua vero non solum potus sed infinitas usu praebendo necessitates, gratas, quod est gratuita, praestat utilitates.

4 Ex eo etiam qui sacerdotia gerunt moribus Aegyptiorum, ostendunt omnes res e liquoris potestate consistere. Itaque cum hydria aqua [2] ad templum

[1] spiritus *Schn* : spiritu *H*.
[2] hydriâ aqua *Ro* ; hydrio quem *H*.

2. We observe, however, that things are not only created of them at birth, but also are nourished, grow, and are preserved by their power. For apart from the flow of breath, bodies cannot have life unless the influx of air continually increases inspiration and respiration. If there is not in the body a due provision of heat, there will be neither breath of life nor firm and upright pose, and the properties of food will lack the effect of digestion. Again, if the members of the body are not nourished by the produce of the earth they will waste away, being deprived of the mixture of that element.

3. Animals which lack the water lose their blood and juices, and dry up their liquid part. Therefore the Divine Mind has not made those things which are specially necessary to mankind as inaccessible and expensive as are pearls, gold, silver and the like, which neither our body nor our nature requires, but has poured forth ready to hand through all the world what is necessary for the safety of our mortal life. Therefore, if of these elements there is a need of breath, the air appointed to supply it, does so. The heat of the sun and the invention of fire are ready to help us with warmth and to render our life more safe. Further, the fruit of the earth, surpassing our need of food by abundant supplies, feeds and nourishes animals by unfailing diet. Water, moreover, by furnishing not only drink but all our infinite necessities, provides its grateful utility as a gracious gift.

4. Hence also those who fill priesthoods of the Egyptian tradition [1] show that all things arise from the principle of water. Therefore, after carrying water

[1] Plutarch, *de Iside*, 59. Water is identified with Osiris. Thales is said to have been inspired by Egyptian priests.

aedemque casta religione refertur, tunc in terra pro-
cumbentes manibus ad caelum sublatis inventionis [1]
gratias agunt divinae benignitati.

Cum ergo et a physicis et philosophis et ab sacer-
dotibus iudicetur ex [2] potestate aquae omnes res
constare, putavi, quoniam in prioribus septem
voluminibus rationes aedificiorum sunt expositae, in
hoc oportere de inventionibus aquae, quasque habeat
in locorum proprietatibus virtutes, quibusque ration-
ibus ducatur, et quemadmodum ante [3] probetur,
scribere.

I

1 Est enim maxime necessaria et ad vitam et ad
delectiones [4] et ad usum cotidianum. Ea autem
erit facilior, si erunt fontes aperti et fluentes. Sin
autem non profluent, quaerenda sub terra sunt
capita et colligenda. Quae sic erunt experienda, uti
procumbatur in dentes, antequam sol exortus fuerit,
in locis, quibus erit quaerendum, et in terra mento
conlocato et fulto prospiciantur eae regiones; sic
enim non errabit excelsius quam oporteat visus,
cum erit inmotum mentum, sed libratam altitudinem
in regionibus certa finitione designabit. Tunc, in
quibus locis videbuntur umores concrispantes et in
aera surgentes, ibi fodiatur; non enim in sicco loco
hoc potest signum fieri.

2 Item animadvertendum est quaerentibus aquam,
quo genere sint loca; certa enim sunt, in quibus

[1] inventionis *Ro* : -nibus *H*. [2] & potestate *H*.
[3] ante *Ro* : inte *H*. [4] delectiones *H et a. c. G*.

in a vessel to the precincts and temple with pure reverence, they fall upon the ground, raise their hands to heaven and return thanks to the divine goodwill for its invention.

Therefore, inasmuch as physicists philosophers and the clergy judge that everything consists of the principle of water, I thought fit that, having explained in the previous seven volumes the methods of building, I should write in the present volume about the discovery of water, the qualities of its special sources, the methods of water-supply and of testing water before using it.

CHAPTER I

ON FINDING WATER

1. WATER is very necessary for life, for delight, for daily use. Water will be more accessible if the springs flow in the open. But if they do not flow above ground, sources are to be sought and collected underground. The method of trial is to fall on one's face before sunrise in the place where the search is to take place, and placing and supporting one's chin on the ground, to look round the neighbourhood. For when the chin is fixed, the sight will not wander higher than it ought, but will mark the same level throughout the landscape, with a definitely limited height. Thereupon digging is to be carried out where moisture seems to curl upwards and rise into the air; for this indication cannot arise on dry ground.

2. Those who look out for water must also observe the nature of the ground; for there are certain

nascitur. In creta tenuis et exilis et non alta est copia; ea erit non optimo sapore. Item sabulone soluto tenuis, sed inferioris loci invenietur; ea erit limosa et insuavis. Terra autem nigra sudoris et stillae exiles inveniuntur, quae ex hibernis tempestatibus collectae in spissis et solidis locis subsidunt; haec habent optimum saporem. Glarea vero mediocres et non certae[1] venae reperiuntur; hae quoque sunt egregia suavitate. Item sabulone masculo harenaque carbunculo certiores [et stabiliores][2] sunt copiae; eaeque[3] sunt bono sapore. Rubro saxo et copiosae et bonae, si non per intervenia dilabantur et liquescant. Sub radicibus autem montium et in saxis silicibus uberiores et affluentiores; eaeque[4] frigidiores sunt et salubriores. Campestribus autem fontibus salsae, graves, tepidae, non suaves,[5] nisi quae ex montibus sub terra submanantes erumpunt in medios campos ibique[6] arborum umbris contectae praestant montanorum fontium suavitatem.

3 Signa autem, quibus terrarum generibus supra scriptum est, ea invenientur nascentia: tenuis iuncus, salix erratica, alnus, vitex, harundo, hedera aliaque, quae eiusmodi sunt, quae non possunt nasci per se sine umore. Solent autem eadem in lacunis nata esse, quae sidentes[7] praeter reliquum agrum excipiunt ex imbribus et agris per hiemem propterque capacitatem diutius conservant umorem. Quibus non est

[1] non certae *Joc* (*Fav., Plin.*) : non incertae *H.*
[2] et stabiliores *G* : om. *H S.* [3] eeque *G* : aeque *H.*
[4] aeque *H.* [5] suavis *H.*
[6] medio campo sibique *H S.* [7] sedentes *H.*

[1] *Creta* = clay from which bricks, etc. are made, Book II, viii. 19.

places where it rises. In clay [1] the supply is thin and
scanty and near the surface; this will be not of the
best flavour. In loose gravel the supply is scanty
but it is found lower down; this water will be
muddy and unpleasant. In black earth, moisture
and small drops are found; when these gather
after the winter rains and settle in hard solid
receptacles, they have an excellent flavour. But in
gravel small and uncertain currents are found; these
also are of unusual sweetness. In coarse gravel,
common sand and red sand,[2] the supply is more
certain, and this is of good flavour. The waters
from red rock are copious and good, if they do not
disperse through the interstices and melt away. At
the foot of mountains [3] and in flinty rocks water flows
more copiously; and this is more cool and whole-
some. Springs on level ground are salt, coarse,
lukewarm and unpleasant, unless they flow from the
mountains underground, and break out in the middle
of the fields, and there under the shadows of the
trees they furnish the sweetness of mountain springs.

3. The following growths will be found to show
where the kinds of soil already described are found;
the slender bulrush, the wild willow, the alder, the
agnus castus, reeds, ivy and the like which cannot
grow without moisture. These plants usually grow
in marshy places; for these, settling below the level
of the rest of the ground, receive water from the rains
and from the rest of the land in winter, and because
of their capacity retain the moisture. We must

[2] The pebble beds and the New Red Sandstone of the
Triassic series supply abundant water.
[3] Cretaceous formations containing water are found all along
the Apennines.

credendum, sed quibus regionibus et terris, non
lacunis, ea signa nascuntur, non sata, sed naturaliter
per se procreata, ibi est quaerenda.

4 In quibus si eae significabuntur inventiones, sic
erunt experiundae. Fodiatur quoquoversus locus
latus ne minus pedes ⟨tres, altus pedes⟩ [1] quinque,
in eoque conlocetur circiter solis occasum scaphium
aereum aut plumbeum aut pelvis. Ex his quod erit
paratum, id [2] intrinsecus oleo ungatur ponaturque
inversum, et summa fossura operiatur harundinibus
aut fronde, supra terra obruatur; tum postero die
aperiatur, et si in vaso stillae sudorisque erunt, is
locus habebit aquam.

5 Item si vasum ex creta factum non coctum in ea
fossione eadem ratione opertum positum fuerit, si
is locus aquam habuerit, cum apertum fuerit,[3] vas
umidum erit et iam dissolvetur ab umore. Vellusque
lanae si conlocatum erit in ea fossura, insequenti
autem die de eo aqua expressa erit, significabit
eum locum habere copiam. Non minus si lucerna
concinnata oleique plena et accensa in eo loco
operta fuerit conlocata et postero die non erit exusta,
sed habuerit reliquias olei et enlychni [4] ipsaque
umida invenietur, indicabit eum locum habere aquam,
ideo quod omnis tepor ad se ducit umores. Item
in eo loco ignis factus si fuerit et percalfacta terra
et adusta vaporem nebulosum ex se suscitaverit, is
6 locus habebit aquam. Cum haec ita erunt pertemp-
tata et, quae supra scripta sunt, signa inventa, tum
deprimendus est puteus in eo loco, et si erit caput

not rely upon these places, but water is to be sought in those regions and soils other than marshes in which such trees are found naturally, and not artificially planted.

4. When such a discovery is indicated, we must make trials in the following way. A hole is to be dug not less than three feet square and five feet deep, and about sunset a bronze or lead vessel, or a basin, is to be placed there. Whichever it is, must be smeared inside with oil and put upside down, and the top of the hole covered with rushes or leaves; and earth must be thrown above. On the next day it is to be opened, and if there are drops of water and moisture in the vessel, water will be found.

5. Further, if a vessel made of clay, but not burnt, be covered in the same way and put in the pit, if there is water in the place, the vessel will be moist when opened and soon be destroyed by the moisture. Or if a fleece of wool is placed in the hole, and next day water can be squeezed from it, it will show that water is abundant there. Similarly let a lamp be trimmed and filled with oil and lit. If it is covered and put in that place and on the following day it is not burnt out, but has traces of the oil and wick and is itself found moist, it will show that water is found there, because all heat draws moisture to itself. Again, if a fire is made there and the soil which is heated and burnt raises a misty vapour from itself, the place will supply water. 6. When these experiments have been made and the above mentioned signs of water found, a well is to be sunk. If a head of

[1] *add. Phil (ex Fav.).* [2] id *S* : idque *H G.*
[3] cum apertum fuerit *om. S (del. G^c)*.
[4] enlychm *Gr* : inlychni *H S*, ≡ lychni *G^c*.

aquae inventum, plures circa sunt fodiendi et per specus [1] in unum locum omnes conducendi.

Haec autem maxime in montibus et regionibus septentrionalibus sunt quaerenda, eo quod in his et suaviora et salubriora et copiosiora inveniuntur. Aversi enim sunt solis cursui, et in his locis primum crebrae sunt arbores et silvosae, ipsique montes suas habent umbras obstantes et radii solis non directi perveniunt ad terram nec possunt umores exurere.

7 Intervallaque montium maxime recipiunt imbres et propter silvarum crebritatem nives ab umbris arborum et montium ibi diutius conservantur, deinde liquatae per terrae venas percolantur et ita perveniunt ad infimas montium radices, ex quibus profluentes fontium erumpunt fructus.[2] Campestribus autem locis contrario non possunt habere copias. Nam quaecumque sunt, non possunt habere salubritatem, quod solis vehemens impetus propter nullam obstantiam umbrarum eripit exhauriendo fervens ex planitie camporum umorem, et si quae sunt aquae apparentes,[3] ex his, quod est levissimum tenuissimumque et subtili salubritate, aer avocans dissipat in impetum caeli, quaeque [4] gravissimae duraeque et insuaves sunt partes, eae in fontibus [5] campestribus relinquuntur.

II

1 ITAQUE, quae ex imbribus aqua colligitur, salubriores habet virtutes, quod eligitur ex omnibus fontibus

[1] per specus *ed* : perspicuus *H S*, ppsicuus *G*.
[2] fructus *H* (*i. marg. G^c*) : ructus *G*.
[3] apparantes *H*. [4] quaque *H*. [5] frontibus *H*.

water is found, several wells are to be sunk round it, and all are to be brought together by underground channels into one place.

Water, however, is to be most sought in mountains and northern regions, because in these parts it is found of sweeter quality, more wholesome and abundant. For such places are turned away from the sun's course, and in these especially are many forest trees; and the mountains themselves have intervening shadows, nor do the sun's rays reach the earth directly and cause the moisture to evaporate.

7. Valleys between mountains are subject to much rain, and because of the dense forests, snow stands there longer under the shadow of the trees and the hills. Then it melts and percolates through the interstices of the earth and so reaches to the lowest spurs of the mountains, from which the product of the springs flows and bursts forth. But on the plains one cannot get supplies of water. And what there is, cannot be wholesome, because, in the absence of shadow, the violent power of the sun catches and drains, by its heat, the moisture from the level fields. And if any water is visible, the air calls out the lightest, thinnest and most subtly wholesome part and dissipates it towards the sky; but the heaviest, the harsh and unpleasant parts, are left in the field springs.

CHAPTER II

ON RAIN-WATER

1. THEREFORE rain-water has more wholesome qualities, because it comes from the lightest and

VITRUVIUS

levissimis subtilibusque tenuitatibus, deinde per aeris
exercitationem percolata tempestatibus liquescendo
pervenit ad terram. Etiamque non crebriter in
campis confluunt imbres, sed in montibus aut ad
ipsos montes, ideo quod umores ex terra matutino
solis ortu moti cum sunt egressi, in quamcumque
partem caeli sunt proclinati, trudunt aera; deinde,
cum sunt moti, propter vacuitatem loci post se
2 recipiunt aeris ruentis [1] undas. Aer autem, qui ruit,
trudens quocumque umorem per vim spiritus impetus
et undas crescentes facit ventorum. A ventis autem
quocumque feruntur [2] umores conglobati ex fontibus,
ex fluminibus et paludibus et pelago, cum tempore
solis colligunt et exhauriunt et ita tollunt in altitu-
dinem nubes. Deinde cum aeris unda nitentes, cum
perventum ad montes, ab eorum offensa et procellis
propter plenitatem et gravitatem liquescendo dis-
parguntur [3] et ita diffunditur in terras.
3 Vaporem autem et nebulas et umores ex terra
nasci haec videtur efficere ratio, quod ea habet in se
et calores fervidos et spiritus inmanes refrigeration-
esque et aquarum magnam multitudinem. Ex eo,
cum refrigeratum noctu sol oriens impetu tangit
orbem terrae et ventorum flatus oriuntur per tene-
bras, ab umidis locis egrediuntur in altitudinem
nubes. Aer autem cum a sole percalefactus [4] cum
rationibus tollit ex terra umores, licet ex balineis
4 exemplum capere. Nullae enim camerae, quae sunt

[1] ruentis *Ro* : ruentes *H*.
[2] feruntur *Hc* : feruuntur *HG*.
[3] dispargunt *H*. [4] percalcefactus *H*.

[1] *cum tempore* is doubtful; cf. *nec vernus melius floret cum
tempore ramus*, ps-Cypr. *de resurrectione* 224.

most finely tenuous of all sources; then filtering
through moving air, it liquefies in storms and so
reaches the earth. Further, it is not often that rain
showers gather in the plains, but rather on the
mountains or near them. For moisture rising from
the earth being moved by the rising sun at dawn,
thrusts the air into whatever part of the sky it
tends. Thereupon the moisture thus moved, be-
cause of the vacuum, receives behind it the waves of
rushing air. 2. Now the air which rushes on,
thrusting the moisture in whatever direction, by the
violence of the blast causes the rising force and undu-
lations of the winds. Whithersoever the wind
carries the massed moisture from springs, from rivers
and marshes and the sea, the moisture under the
sun's influence [1] is collected and drawn forth, and the
clouds are raised on high. Then the clouds, sup-
ported on the wave of air, meet the resistance of the
mountains and, becoming liquid in rain-storms, by
their fullness and weight, break and their water is
poured over the fields.

3. Now vapour and clouds and moisture seem to
rise from the earth, for this reason that the earth
contains both fervid heat and huge blasts of air,
coldness and a large amount of water. Hence
when the world is cooled by night, and the rising
sun touches it by its force, and gusts of wind rise up
through the darkness, the clouds rise on high from
the damp places. In that the air warmed by the
sun through its effect raises moisture from the earth,
we can find a parallel in the baths. 4. For the
vaulted chambers [2] which enclose a hot bath cannot

[2] Book V. x. 3.

caldariorum, supra se possunt habere fontes, sed caelum, quod est ibi [1] ex praefurniis ab ignis vapore percalefactum, corripit ex pavimentis aquam et aufert secum in camararum curvaturas et sustinet, ideo quod semper vapor calidus in altitudinem se trudit. Et primo non remittit propter brevitatem, simul autem plus umoris habet congestum, non potest sustinere propter gravitatem, sed stillat supra lavantium capita. Item [2] eadem ratione caelestis aer, cum ab sole percepit calorem, ex omnibus locis hauriendo tollit umores et congregat ad nubes. Ita enim terra fervore tacta eicit umores, etiam corpus hominis ex calore emittit [3] sudores.

5 Indices autem sunt eius rei venti, ex quibus qui a frigidissimis partibus veniunt procreati, septentrio et aquilo, extenuatos [4] siccitatibus in aere flatus spirant; auster vero et reliqui, qui a solis cursu impetum faciunt, sunt umidissimi et semper adportant [5] imbres, quod percalefacti ab regionibus fervidis adveniunt, ex omnibus [6] terris labentes eripiunt umores et ita eos profundunt ad septentrionales regiones.

6 Haec autem sic fieri testimonio possunt esse capita fluminum, quae orbe terrarum chorographiis picta itemque scripta plurima maximaque inveniuntur egressa ad septentrionem. Primumque in India Ganges et Indus ab Caucaso monte oriuntur; Syria Tigris et Euphrates; Asiae item,[7] Ponto Borysthenes, Hypanis, Tanais; Colchis [8] Phasis; Gallia Rhodanus;

[1] ibi *ed* : ubi *H*. [2] item *S* : idem *H*.
[3] emittit *h* : emit ut *H*. [4] & tenuatos *H*.
[5] adportent *H*. [6] omnis *H*.
[7] item *S G^c* : idem *H G*.
[8] conchis *H S* : colchys *G*.

have springs above them, but the ceiling which is
there heated with hot air from the furnace, takes up
water from the pavement, and carrying it up to the
curved surface of the vaulting, supports it, because
warm vapour always thrusts upward. At first,
owing to the slight amount, the ceiling does not drip,
but as soon as it has collected more moisture, it
cannot keep the water up because of its weight,
but sprinkles it on the heads of the bathers. In the
same way the air of the sky, receiving heat from the
sun, draws moisture from all directions, lifts it and
assembles it into clouds. For the earth when it is
touched by heat casts forth moisture,—the human
body also sweats from warmth.

5. This is proved by the winds. For those which
originate and blow from the coldest quarters, the
north and north-east, bring currents of air which are
rarefied by their dryness; but the south wind and
the rest, which attack us from the south, are very
moist and always bring rains, because they come
warmed from the hot regions; and as they fall, they
take up the moisture everywhere and so pour it forth
towards the north.

6. A proof of this is found in the sources of rivers,
as they are painted on maps of the world,[1] and as
they are described.[2] The most numerous and the
largest are found to issue in the north. First of all
in India, the Ganges and Indus rise in the Caucasus;
in Syria, the Tigris and Euphrates; in Asian Pontus,
the Dnieper, the Boug and the Don; in Colchis, the
Phasis; in Gaul, the Rhone; in Celtic territory, the

[1] An allusion to the map of Agrippa in the Porticus Vipsania.
Plin. *N.H.* III. 17.

[2] An allusion to the geographical work of Agrippa.

Celtica Rhenus; citra Alpis Timavos et Padus;
Italia Tiberis; Maurusia, quam nostri Mauretaniam
appellant, ex monte Atlante Dyris,[1] qui ortus ex
septentrionali regione progreditur per occidentem
ad lacum Eptagonum et mutato nomine dicitur
Agger, deinde ex lacu Eptabolo sub montes desertos
subterfluens per meridiana loca manat et influit
in Paludem quae appellatur, circumcingit Meroen,
quod est Aethiopum meridianorum regnum, ab
hisque paludibus se circumagens per flumina Astan-
sobam[2] et Astoboam[3] et alia plura pervenit per
montes ad cataractam ab eoque se praecipitans per
septentrionalem pervenit inter Elephantida et
Syenen[4] Thebaicosque in Aegyptum campos et ibi
Nilus appellatur.

7 Ex Mauretania autem caput Nili profluere ex eo
maxime cognoscitur, quod ex altera parte montis
Atlantis alia capita item profluentia ad occidentem
Oceanum, ibique nascuntur ichneumones, crocodili,
aliae similes bestiarum pisciumque naturae praeter
hippopotamos.

8 Ergo cum omnia flumina magnitudinibus in orbis
terrarum descriptionibus a septentrione[5] videantur
profluere Afrique campi, qui sunt in meridianis
partibus subiecti solis cursui, latentes penitus habent
umores nec fontes crebros amnesque raros, relinquitur,

[1] dryis *H*. [2] hastansoban *H*, -bã *S*.
[3] astoboam *G*c : adstoboam *H*. [4] suenen *H*.
[5] aseptentrionẽ *H*.

[1] Addiris, Plin. *N.H.* V. 13. Dyris = the name of Mt.
Atlas, Strabo, 825.
[2] The course of the Nile is now described.

Rhine; south of the Alps, the Timavo and Po; in Italy, the Tiber; in Morocco, which we call Maure-tania, the Dyris[1] comes from Mount Atlas. This river[2] rises in the north, turns to the west to Lake Eptagonus[3] and there, changing its name, it is called Agger.[4] Thence it flows from Lake Eptabolos[5] under mountains of the desert through the south and flows into the Marsh[6] so-called. It then winds round Meroe, which is the Southern Ethiopian kingdom, and turning from these marshes through the rivers Astansobas and Astoboas[7] and many others, it arrives through the mountains at the Cataract. Thence rushing northwards it passes into Egypt, between Elephantis and Syene and the Theban plain, and is there called the Nile.

7. What shows more than anything else that the source of the Nile rises in Mauretania, is, that on the other side of Mount Atlas there are other springs flowing to the Western Ocean, and in them are found the ichneumon, the crocodile and other animals and fishes of a like nature, but not the hippopotamus.[8]

8. Since then all rivers of magnitude seem accord-ing to the descriptions of the world to flow from the north, and the plains of Africa, which are on the south subject to the sun's course, have their moisture deeply hidden and few fountains or rivers,

[3] Probably the Albert Nyanza.

[4] Ger, Plin. *N.H.* V. 14. *Gir* in Berber signifies 'running water.'

[5] Probably the Victoria Nyanza.

[6] Probably the sudd of the White Nile.

[7] Atbara. These descriptions were probably due to traders journeying from Zanzibar.

[8] The hippopotamus is found in the Niger as well as in the upper waters of the Nile.

uti multo meliora inveniantur capita fontium, quae ad
septentrionem aut aquilonem spectant, nisi si inci-
derint in sulphurosum locum aut aluminosum seu
bituminosum. Tunc enim permutantur ⟨et⟩[1] aut
calidae aquae aut frigidae odore malo et sapore
9 profundunt fontes. Neque enim calidae aquae est
ulla proprietas, sed frigida aqua, cum incidit percur-
rens in ardentem locum, effervescit et percalefacta
egreditur per venas extra terram. Ideo diutius non
potest permanere, sed brevi spatio fit frigida. Namque
si naturaliter esset calida, non refrigeraretur calor
eius.[2] Sapor autem et odor et color[3] eius non
restituitur, quod intinctus et commixtus est propter
naturae raritatem.

III

1 Sunt autem etiam nonnulli fontes calidi, ex quibus
profluit aqua sapore optimo, quae in potione ita
est suavis, uti nec fontalis ab Camenis nec Marcia
saliens desideretur. Haec autem ab natura per-
ficiuntur his rationibus. Cum in imo per alumen aut
bitumen seu sulphur ignis excitatur, ardore percande-
facit terram, quae est supra se; autem[4] fervidum
emittit in superiora loca vaporem, et ita, si qui in îs
locis, qui sunt supra, fontes dulcis aquae nascuntur,
offensi eo vapore effervescunt inter venas et ita
profluunt incorrupto sapore.

[1] *add. Joc.* [2] calcoleius *H.*
[3] color *e₂ Sulp :* calor *H.*
[4] *fortasse soloecismus : cf.* autem non habuit, *Quint.* I. 5. 39.

[1] Lucretian phrase; cf. *textura praedita rara,* iv. 196.
Vitruvius has *rara proprietas,* Book II. iii. 4.

it remains that much better sources are found to
the north and north-east, unless they come upon
sulphur, alum or bitumen. For then they are
changed; and either hot or cold, they send forth
springs of a bad flavour or odour. 9. For there is
no special character attaching to hot water, but
when cold water, as it runs, comes upon hot ground,
it seethes and comes out warm through the cracks
above ground. Therefore it cannot retain its heat,
but soon becomes cold. For if it were naturally
warm, its warmth would not be subject to chill.
But taste and smell and colour are not surrendered,
because it is steeped and blended with these qualities
owing to its rarefied texture.[1]

CHAPTER III

ON THE NATURE OF DIFFERENT WATERS

1. THERE are some hot springs from which water
flows of excellent flavour and so pleasant to drink
that we miss neither the Fountain of the Camenae[2]
nor the conduit of the Marcian Aqueduct.[3] Hot
springs arise naturally in the following way. Fire
arises underground owing to alum or bitumen or sul-
phur, and by its heat makes the soil above it to glow.
It further sends a warm vapour to the surface of the
ground, and whatever springs of sweet water rise in
such places, meeting this vapour they surge forth
between the cracks and flow without damage to
their flavour.

[2] On the south side of the Caelian Hill, Platner, 89. Frontin.
Aquaed. 4.
[3] ' Finest of all water,' Plin. *N.H.* XXXI. 41.

2 Sunt etiam odore et sapore non bono frigidi fontes, qui ab inferioribus locis penitus orti per loca ardentia transeunt et ab eo per longum spatium terrae percurrentes refrigerati perveniunt supra terram sapore odore coloreque corrupto, uti in Tiburtina via flumen Albula et in Ardeatino fontes frigidi eodem odore, qui sulphurati dicuntur, et reliquis locis similibus. Hi autem, cum sunt frigidi, ideo videntur aspectu fervere, quod, cum in ardentem locum alte penitus inciderunt, umore et igni inter se congruentibus offensa vehementi fragore validos recipiunt in se spiritus, et[1] ita inflati vi venti coacti bullientes crebre per fontes egrediuntur. Ex his autem qui non sunt aperti, sed a[2] saxis continentur, per angustas venas vehementia spiritus extruduntur ad summos grumorum tumulos.

3 Itaque qui putant[3] se altitudine, qua sunt grumi, capita fontium posse[4] habere, cum aperiunt fossuras latius, decipiuntur. Namque uti aeneum vas non in summis labris plenum sed aquae mensurae suae capacitatis habens tribus duas partes operculumque[5] in eo conlocatum, cum ignis vehementi fervore tangatur, percalefieri cogit aquam, ea autem propter naturalem raritatem in se recipiens fervoris validam inflationem non modo implet vas, sed spiritibus extollens operculum et crescens abundat, sublato autem operculo emissis inflationibus in aere patenti rursus ad suum locum residit:[6] ad eundem modum ea capita fontium cum sunt angustiis con-

[1] et *ed* : ut *H*. [2] a *Schn* : aut *H*.
[3] qui putant *rec* : quutant *H*. [4] posse *Joc* : fosse *H*.
[5] operculum *ed* : opertum *H*. [6] resedit *H*.

[1] Sulphur baths still used.

2. There are also cold springs not of pleasant smell or taste, which, rising far below, pass through hot soil, and thereupon running a long distance are chilled and reach the surface with damage to their flavour, their smell and colour; such as the river Albula [1] on the Via Tiburtina,[2] and the cold springs near Ardea, with the same smell, and called sulphur springs, and in other like places. Now these springs, being cold, have the appearance of bubbling, because when, deep down, they come upon a hot place, the fire and water meet; and because of the collision, the springs take up with a loud noise the violent currents of air. They are thus forced by the power of the wind driven into them, to issue with much bubbling through the fountains. But those which have no outlet and are contained by rocks, are driven forth through narrow passages by the vehemence of the air-currents to the tops of hillocks.

3. Hence those who think that they can have fountain-heads of the same height as the hills find their mistake when they open out their trenches. For instance, let a bronze vessel be filled not to the brim but holding two-thirds, by measure, of its capacity of water; and let a lid be placed upon it. When it is subjected to the vehement heat of the fire, it makes the water boil. Yet, owing to its natural penetrability, it takes up a strong inflation of the heat, and not only fills the vessel but, raising the lid with the currents of air, it expands and boils over. When, however, the lid is removed, the steam passes into the open and the water settles down into its own place again. In the same way when fountain-heads are forced along narrow channels, the

[2] Road to Tivoli 16 miles north-east of Rome.

pressa, ruunt [1] in summo spiritus aquae bullitus, simul autem sunt latius aperti, exanimati per raritates liquidae potestatis residunt et restituuntur in libramenti proprietate.

4 Omnis autem aqua calida ideo [quod] [2] est medicamentosa, quod in pravis rebus percocta aliam virtutem recipit ad usum. Namque sulphurosi fontes nervorum labores reficiunt percalefaciendo exurendoque caloribus e corporibus umores vitiosos. Aluminosi autem, cum dissoluta membra corporum paralysi aut aliqua vi morbi receperunt, fovendo per patentes venas refrigerationem [3] contraria caloris [4] vi reficiunt, et hoc continenter restituuntur in antiquam membrorum curationem. Bituminosi autem interioris corporis vitia potionibus purgando solent mederi.

5 Est autem aquae frigidae genus nitrosum, uti Pinnae Vestinae, Cutiliis aliisque locis similibus, quae potionibus depurgat per alvumque transeundo etiam strumarum minuit tumores. Ubi vero aurum, argentum, ferrum, aes, plumbum reliquaeque res earum similes fodiuntur, fontes inveniuntur copiosi, sed hi maxime sunt vitiosi. Habent enim vitia aquae calidae sulphur alumen bitumen, eademque,[5] per potiones cum in corpus iniit et per venas permanando nervos attingit et artus, eos durat inflando. Igitur nervi inflatione turgentes e longitudine contrahuntur et ita aut nervicos aut podagricos efficiunt homines,

[1] compressa ruunt *G* : conpraesserunt *H.*
[2] *del. rec.* [3] refrigerationem *ed* : -ne *H.*
[4] caloris vi *Joc* : calore sui *H.*
[5] eademque *Gr* : eaedemque *H S.*

[1] Favourite phrase of Lucretius : *plumbi potestas*, v. 1242.
[2] Hippocrates, *de aere aquis locis*, is followed in some places by Vitruvius.

currents of air rush in bubbles through the water on the top; as soon as the channels are opened out wider, the springs part with the air through the pores of the liquid potency,[1] and, settling down, they regain their proper level.

4. As to the curative [2] power of warm springs, the reason is that the water being thoroughly heated in vitiated soils, takes up an additional and useful quality. For sulphur springs refresh muscular weakness by heating and burning poisonous humours from the body. Alum springs affect parts of the body which are dissolved [3] by paralysis or some stroke of disease; they warm through the open pores and overcome the cold by the opposing power of the heat, and thus forthwith the diseased parts are restored to their ancient health. Bitumen [4] springs furnish draughts which purge and heal interior defects.

5. There is an alkaline sort of cold spring, as at Penne and Cutili [5] and other like places, which, when taken, purges, and passing through the intestines, also lessens scrofulous tumours. But when gold, silver, iron, copper, lead and the like are mined, abundant springs are found, but mostly impure. They have the impurities of hot springs, sulphur, alum, bitumen; and when the water is taken into the body and, flowing through the vessels, reaches the muscles and joints, it hardens them by expansion. Therefore the muscles swelling with expansion are contracted in length. In this way men suffer from cramp or gout,

[3] *Vulg.* II. *Cor.* v. 1, *si terrestris domus . . . dissolvatur.*

[4] Berkeley, *Siris*, deals with curative virtues of tar, a form of bitumen.

[5] Towns in the Abruzzi.

ideo quod ex durissimis et spissioribus [1] frigidissimisque rebus intinctas habent venarum raritates.

6 Aquae autem species est, quae cum habeat non satis perlucidas et ipsa uti flos natat in summo, colore similis vitri purpurei. Haec maxime considerantur Athenis. Ibi enim ex eiusmodi locis et fontibus in asty et ad portum Piraeum ducti sunt salientes, e quibus bibit nemo propter eam causam, sed lavationibus [2] et reliquis rebus utuntur, bibunt autem ex puteis et ita vitant eorum vitia. Troezeni non potest id vitari, quod omnino aliud genus aquae non reperitur, nisi quod *cibdeli* habeant; itaque in ea civitate aut omnes aut maxima parte sunt pedibus vitiosi. Cilicia vero civitate [3] Tarso flumen est nomine Cydnos, in quo podagrici crura macerantes levantur dolore.

7 Sunt autem et alia multa genera, quae habent suas proprietates, ut in Sicilia flumen est Himeras, quod, a fonte cum est progressum, dividitur in duas partes; quae pars profluit contra Etruriam, quod per terrae dulcem sucum percurrit, est infinita dulcedine, quae altera parte per eam terram currit, unde sal foditur, salsum habet saporem. Item Paraetonio et quod est iter ad Ammonem et Casio [4] ad Aegyptum lacus sunt palustres, qui ita sunt salsi, ut habeant insuper se salem congelatum. Sunt autem et aliis pluribus locis et fontes et flumina ⟨et⟩ [5] lacus, qui per salifodinas percurrentes necessario salsi perficiuntur.

8 Alii autem per pingues terrae venas profluentes uncti oleo fontes erumpunt, uti Solis, quod oppidum

[1] spissioribus e_2 *ed* : spissionibus *H.*
[2] labationibus *H.*
[3] civitate *Joc* : civitas *H.*
[4] cassio *H S.* [5] *add. ed.*

because they have the pores of the vessels saturated with hard, thick and cold particles.

6. There is a kind of water which has pores insufficiently clear; a foam floats on the top, in colour like blue glass. This is especially seen at Athens where conduits [1] from such places and fountains are taken to the city and the Piraeus. No one drinks from it because of the reason given, but they use it for baths and so forth. They drink from wells and thus avoid its ill effect. This cannot be avoided at Troezene, because no other water is found there at all, except what is furnished by polluted springs; therefore in that city either all or the greatest part suffer from their feet. In the Cilician city Tarsus there is a river, Cydnus by name, in which gouty persons bathe their legs to relieve the pain.

7. There are many other kinds of water which have their properties. In Sicily, the river Himeras,[2] on leaving its source, divides into two branches: one flows towards the coast which faces Etruria and is of infinite sweetness, because it runs through the sweet juices of the soil; the other stream which runs through the other part where there are salt mines has a salt flavour. At Paraetonium and on the road to the oracle of Ammon, and at Mt. Casius in Egypt, there are marshy lakes which contain so much salt that it cakes over them. In many other places there are springs and rivers and lakes which run through salt mines and necessarily are made salt.

8. Other fountains flow through rich veins of soil and spring up with an oily surface. At Soli, a town

[1] Esp. the Enneacrunos, *J.H.S.* XIII. 141.
[2] Northern branch, the Fiume Grande; the southern, the Fiume Salso.

est Ciliciae, flumen nomine Liparis, in quo natantes aut
lavantes ab ipsa aqua unguntur. Similiter Aethiopiae
lacus est, qui unctos homines efficit, qui in eo nata-
verint,[1] et India, qui sereno caelo emittit olei magnam
multitudinem, item Carthagini fons, in quo natat
insuper oleum, odore uti scobe citreo; quo [2] oleo etiam
pecora solent ungui.[3] Zacyntho [4] et circa Dyrra-
chium [5] et Apolloniam fontes sunt, qui picis magnam
multitudinem cum aqua evomunt. Babylone [6] lacus
amplissima magnitudine, qui *limne asphaltitis* [7] appel-
latur, habet supra natans liquidum bitumen; quo [8]
bitumine et latere testaceo [9] structum murum
Sameramis circumdedit Babylonem. Item Iope [10] in
Syria Arabiaque Numidarum [11] lacus sunt inmani
magnitudine, qui emittunt bituminis maximas moles,
quas diripiunt qui habitant circa.

9 Id autem non est mirandum; nam crebrae sunt
ibi lapidicinae bituminis duri. Cum ergo per bitu-
minosam terram vis erumpit aquae, secum extrahit et,
cum sit egressa extra terram, secernitur et ita reicit
ab se bitumen. Etiamque est in Cappadocia in
itinere, quod est inter Mazaca et Tyana,[12] lacus
amplus, in quem lacum pars sive harundinis sive alii
generis si dimissa fuerit et postero die exempta, ea
pars, quae fuerit exempta, invenietur lapidea, quae
autem pars extra aquam manserit, permanet in sua
proprietate.

10 Ad eundem modum Hierapoli Phrygiae effervet
aquae calidae multitudo, e quibus circum hortos et

[1] nataverit *H.* [2] quod *H.*
[3] ungui *S*: ungeri *H.* [4] zachinto *H.*
[5] dirrachium *H.* [6] babilone *H.*
[7] limnea spartacis *H* (*corr. Schott*).
[8] quo *S*: quod *H.* [9] testaceo e_2: testatio *H.*
[10] Iope e_2 (*schol*): tope *H.*

of Cilicia, there is a river named Liparis, and those
who swim or wash in it are oiled by the water. There
is also a lake of Ethiopia which anoints men who swim
in it, and another in India which in clear weather
produces a great amount of oil. There is also a
spring at Carthage [1] on which there floats an oil
with the perfume of cedar-shavings, and with this
oil, sheep are usually dressed. In Zacynthus and
round Dyrrachium and Apollonia [2] are springs which
discharge with the water a great amount of pitch.
At Babylon there is a lake of wide extent which is
called the Asphalt Lake, with liquid bitumen floating
on it. Semiramis built a wall round Babylon of
this bitumen and burnt-brick. At Joppa in Syria,
also, and in Nomad [3] Arabia are lakes of immense
size producing much bitumen which is gathered by
the neighbouring tribes.

9. This is not surprising, because there are many
quarries of hard bitumen there. When, therefore, a
spring of water rushes through the bituminous land,
it draws the bitumen with it, and passing outside, the
water separates and deposits the bitumen. Again,
in Cappadocia, on the road between Mazaca [4] and
Tyana, there is a great lake; if part of a reed or any
other substance is let fall into it and taken out the
next day, it is turned to stone, and the part which
remains outside the water stays as it is.

10. In the same way at Hierapolis in Phrygia [5]
abundance of hot water boils up, from which a supply

[1] Arist. *Mirab.* 113. [2] *Ibid.* 127.
[3] Cf. Luc. iv. 677 : *Numidaeque vagi.*
[4] Received the name Caesarea A.D. 18. [5] Strabo, 629.

[11] numidarum *H* : *cf. Paulus s.v.* numidas dicimus quos
Graeci nomadas. [12] tuana *H.*

vineas fossis ductis inmittitur; haec autem efficitur
post annum crusta lapidea. Ita quotannis dextra ac
sinistra margines ex terra faciundo inducunt eam et
efficiunt in his[1] crustis in agris saepta. Hoc autem ita
videtur naturaliter fieri, quod in îs locis et ea terra,
quibus is nascitur, sucus subest coaguli naturae
similis; deinde cum commixta vis egreditur per
fontes extra terram, a solis et aeris calore[2] cogitur
11 congelari, ut etiam in areis salinarum videtur. Item
sunt ex amaro suco terrae fontes exeuntes vehementer
amari, ut in Ponto est flumen Hypanis.[3] A capite
profluit circiter milia XL sapore dulcissimo; deinde,
cum pervenit ad locum, qui est ab ostio ad milia CLX,
admiscetur ei fonticulus[4] oppido quam parvolus.
Is cum in eum influit, tunc tanta magnitudine
fluminis facit amaram, ideo quod per id genus terrae
et venas, unde sandaracam fodiunt,[5] ea[6] aqua
manando perficitur amara.

12 Haec autem dissimilibus saporibus a terrae proprie-
tate perficiuntur, uti etiam in fructibus videtur. Si
enim radices arborum aut vitium aut reliquorum
seminum non ex terrae proprietatibus sucum
capiendo ederent fructus, uno genere essent in
omnibus locis et regionibus omnium sapores. Sed
animadvertimus insulam Lesbon vinum protropum,[7]
Maeoniam[8] Catacecaumeniten,[9] Lydiam Tmoliten,[10]

[1] inhis *H* : *Sem. cf.* in gladio *Luc.* XXII. 49.
[2] calor *H.*
[3] Hypanis *Joc* : hipanis *H S*, Hispanis *e₂ Sulp.*
[4] fonticulos *H.*
[5] fodiunt *Müller-Str.* : fodiuntur *H.*
[6] ea *Joc* : & *H.* [7] protropum *Joc* : protyrum
[8] Maeoniam *Phil* : maloniam *H.*
[9] catacecaumeniten *Joc* : catacaecaumen. item *H.*
[10] Tmoliten *Phil* : moliton *H.*

is taken by channels round the orchards and vine-
yards. After a year the water leaves a stony crust.
So every year they make banks of soil to the right
and left, let in the water, and with the incrustations
build enclosures in the fields. The cause of this
seems to be natural, in that in these places and in the
soil where this happens there is a fluid like the
nature of rennet; thereupon when this potency is
blended and comes above ground in the springs, it
is solidified by the heat of the sun and air, as appears
in salt pits. 11. There are also sources arising from
the bitter juice of the soil and exceedingly bitter,
like those of the Boug. This river flows about 40
miles from its source with very sweet water. Then,
when it reaches a spot 160 miles from its mouth, it is
joined by a quite small spring. On flowing into the
river it makes the broad stream bitter; and this is
because the water is made bitter by flowing through
the kind of soil and the veins of earth from which they
mine red lead.[1]

12. These also acquire different flavours from the
properties of the soil, as we observe in the case of
fruits. For if the roots of trees or vines or other
plants [2] did not produce their fruits by absorbing their
juice from the properties of the soil, the flavour of
each species would be the same in every district and
region.[3] But we observe the island of Lesbos and
the Protropos [4] (a sweet wine); Maeonia and the
Catacecaumenite,[5] Lydia and the Tmolite,[6] Sicily and

[1] Book VII. xii. 2.

[2] *Semen* in Hebrew sense=' planting,' *Vulg. Isa.* XVII. 11 *al.*

[3] Vitruvius sees a relation between flora and fauna and
climate.

[4] Athen. 45E. [5] Praised by Strabo, 628.

[6] Plin. *N.H.* XIV. 74.

Siciliam Mamertinum, Campaniam Falernum, in
Terracinam et Fundis Caecubum [1] reliquisque locis
pluribus innumerabili multitudine genera vini virtu-
tesque procreari. Quae non aliter possunt fieri, nisi,
cum terrenus umor suis proprietatibus saporis [2] in
radicibus sit infusus, enutrit materiam, per quam
egrediens ad cacumen profundat proprium loci et
generis sui fructus saporem.

13 Quodsi terra generibus umorum non esset dissimilis
et disparata, non tantum in Syria et Arabia in harun-
dinibus et iuncis [3] herbisque omnibus essent odores,
neque arbores turiferae, neque piperis darent bacas,
nec murrae glaebulae, nec Cyrenis in ferulis laser nas-
ceretur, sed in omni terra regionibus eodem genere [4]
omnia procrearentur. Has autem varietates regioni-
bus et locis inclinatio mundi et solis impetus propius [5]
aut [6] longius cursum faciendo tales efficit terrae
umorisque qualitates nec solum in his rebus, sed etiam
in pecoribus et armentis haec non ita similiter
efficerentur, nisi proprietates singularum terrarum in
generibus [7] ad solis potestatem temperarentur.[8]

14 Sunt enim Boeotiae [9] flumina Cephisos et Melas,
Lucanis Crathis,[10] Troia Xanthus inque agris Cla-
zomeniorum et Erythraeorum et Laodicensium fontes.
Ad flumina cum pecora suis temporibus anni parantur
ad conceptionem partus, per id tempus adiguntur [11]
eo cotidie potum, ex eoque, quamvis [12] sint alba,

1 Caecubum *ed* : caesibum *H.*
2 saporis *rec* : -res *H.* 3 iuncis *Joc* : uineis *H.*
4 eodem genera *H*, eadem genera *S.*
5 proprius *H.* 6 aut *E* : ut *H G S.*
7 ingeneribus *H S* : inregionibus *E G.*
8 temperarentur *Sᶜ* : perarentur *H.*
9 boetiae *H.* 10 Crathis *ed* : aeraris *H.*
11 adiguntur *E* : adicuntur *H G*, adiciuntur *S.*
12 qua vis *H.*

the Mamertine,[1] Campania and the Falernian, at
Terracina and Fundi the Caecuban, and in many other
places kinds and flavours of wine are produced in a
countless multitude.[2] This would not happen unless
the juices of the soil, being infused with their charac-
teristic flavour into the roots, fed the tree, and rising
to the top, produced the flavour proper to the kind
of vine and the locality.

13. For unless the soil were unlike and disparate
in its juices, not only in Syria and Arabia would there
be perfumes in the reeds, rushes, and all herbs,
nor incense-bearing trees; nor would they yield
pepper berries, nor would there grow flakes of
myrrh; nor in Cyrene would the assafetida grow in
the stalks of silphium. But in every land and region
everything would be produced of the same kind. On
the other hand, these varieties are produced in
regions and localities by the climate and the nearer
or more distant course of the sun, and are made such
by the qualities of the juices of the soil. To go
beyond these, the like differences would not arise in
flocks and herds unless the properties of the several
soils in their own kinds were acquired according to
the sun's power.

14. For in Boeotia are the rivers Cephisus and
Melas; among the Lucanians, the Crathis; in Troy,
the Xanthus; in the territories of Clazomenae,
Erythrae and of Laodicea, there are springs. When
the cattle in their own season are about to bring
forth, they are taken daily during that time of the
year to the river to drink. Thereby, although they
are maybe white, they bring forth young in some

[1] If kept, lost its flavour, Mart. XIII. 117.
[2] For Roman wines, Plin. *N.H.* XIV. 59 ff.

procreant aliis locis leucophaea, aliis locis pulla, aliis
coracino colore. Ita proprietas liquoris, cum inît in
corpus, proseminat intinctam sui cuiusque generis
qualitatem. Igitur quod in campis Troianis proxime
flumen armenta rufa et pecora leucophaea nascuntur,
ideo id flumen Ilienses [1] Xanthum appellavisse
dicuntur.

15 Etiamque inveniuntur aquae genera mortifera,
quae per maleficum sucum terrae percurrentia
recipiunt in se vim venenatam, uti fuisse dicitur
Terracinae [2] fons, qui vocabatur Neptunius, ex quo
qui biberant inprudentes, vita privabantur; qua-
propter antiqui eum obstruxisse dicuntur. Et Chrobsi
Thracia [3] lacus, ex quo non solum qui biberint,
moriuntur, sed etiam qui laverint.[4] Item in Thessalia
fons est profluens, ex quo fonte nec pecus ullum
gustat nec bestiarum genus ullum propius [5] accedit;
ad quem fontem proxime est arbor florens purpureo
colore.

16 Non minus in Macedonia quod loci sepultus est
Euripides, dextra ac sinistra monumenti adveni-
entes duo rivi concurrunt. In unum, viatores pransi-
tare [6] solent propter aquae bonitatem, ad rivum
autem, qui est ex altera parte monumenti, nemo
accedit, quod mortiferam aquam dicitur habere.
Item est in Arcadia Nonacris [7] nominata terrae
regio, quae habet in montibus ex saxo stillantes
frigidissimos umores. Haec autem aqua [8] *Stygos
Hydor* nominatur, quam neque argentum neque
aeneum nec ferreum vas potest sustinere, sed dissilit

[1] nilienses *H S*. [2] terrae cinae *H*.
[3] thratia *H S*. [4] laberint *H*. [5] proprius *H*.
[6] pransitare *Joc*: transitare *H*. [7] non agris *H*.
[8] aquas tyglos hydor *H*: (*corr. ed*).

164

places of a dun colour, in other places of dark grey, in others raven-black. Thus the property of the liquid when it enters the body produces the kind of quality with which it is tinctured. Therefore the Trojans are said to have given the name Xanthus [1] or Chestnut to the river which flows in the plains of Troy, because in its neighbourhood the cattle are red and the sheep of a light brown colour.

15. Kinds of water are also found which cause death; these run through dangerous juices of the soil and acquire a poisonous property. Such is said to have been the spring at Terracina which was called Neptune's; people who drank of it unwittingly lost their lives. For this reason, the ancients are said to have stopped it up. At Chrobs [2] in Thrace there is a lake which brings death not only to those who drink of it, but to those who bathe in it. There is also, in Thessaly, [3] a running spring of which sheep do not taste, nor do wild animals approach it; near the spring is a tree bearing a purple flower.

16. Again, at the tomb of Euripides in Macedonia, two streams flowing to the right and the left of the monument come together. At the one stream, travellers recline and take their lunch because of the goodness of the water; but no one approaches the stream on the other side of the monument, because it is said to have poisonous water. There is also in Arcadia a district called Nonacris, [4] where among the hills icy-cold water drips from the rock. This is called the Water of Styx. Neither vessels of silver, nor of bronze, nor of iron can contain it, but it bursts

[1] Ξανθαὶ ἵπποι = chestnut mares, Hom.
[2] Arist. *Mirab.* 121.
[3] At Tempe, Plin. *N.H.* XXXI. 28. [4] Paus. VIII. 18. 4.

et dissipatur. Conservare autem eam et continere nihil aliud potest nisi mulina ungula, quae etiam memoratur ab Antipatro in provinciam[1] ubi erat Alexander, per Iollam filium perlata[2] esse et ab eo ea aqua regem esse necatum.

17 Item Alpibus in Cotti[3] regno est aqua; qui gustant, statim concidunt. Agro autem Falisco via Campana in campo Corneto est lucus, in quo fons oritur; ubique avium et lacertarum reliquarumque serpentium ossa iacentia apparent.

Item sunt nonnullae acidae venae fontium, uti Lyncesto et in Italia Velino,[4] Campania Teano aliisque locis pluribus, quae hanc habent virtutem, uti calculos, in vesicis qui nascuntur in corporibus

18 hominum, potionibus discutiant. Fieri autem hoc naturaliter ideo videtur, quod acer et acidus sucus subest in ea terra, per quam egredientes venae intinguntur acritudine, et ita, cum in corpus inierunt, dissipant quae ex aquarum subsidentia in corporibus et concrescentia offenderunt. Quare autem discutiantur ex acidis eae res, sic possumus animadvertere. Ovum in aceto si diutius positum fuerit, cortex eius mollescet[5] et dissolvetur. Item plumbum, quod est lentissimum et gravissimum, si in vase conlocatum fuerit et in eo acetum suffusum, id autem opertum et oblitum erit, efficietur, uti plumbum dissolvatur, et fiet cerussa.

19 Eisdem rationibus aes, quod etiam solidiore est

[1] provinciam *ed* : -cia *H.* [2] perlata *Laet* : -tum *H.*
[3] Cotti *Joc* : crobi *H.*
[4] Velino *Budaeus (Plin.* XXXI. 9) : vienna *H.*
[5] mollescit *H S.*

[1] Plut. *Alex.* 74.

the vessels and is lost. Nothing but the hoof of a
mule can contain and keep it. In this way it is said
to have been conveyed by Antipater,[1] through his
son Iollas, to the province where Alexander was, and
the king was killed by Antipater [2] with this water.

17. There is a spring in the Alps in the kingdom of
Cottius,[3] and those who taste of it, at once fall dead.
On the Via Campana in the Falerian district in the
neighbourhood of Cornetum there is a spring in a
grove; everywhere the skeletons of birds, lizards and
other snakes are seen lying.

There are also some acid springs, as in Lyncestis,[4]
and in Italy [5] at Velia, at Teanum in Campania
and many other places, which have this property
that, when they are drunk, they dissolve the stones
which form in the human bladder. 18. This seems to
happen by nature, because a sharp and acid juice is
present in the soil, and when currents of water pass
out of it, they are tinctured with acridity. Hence
when they enter the body, they disperse what they
meet as the water settles and solidifies in the body.
We can observe the reason why these are dissolved
by acid. If an egg is put in vinegar for some time,
the shell will become soft and dissolve. When lead
also, which is very pliant and heavy, is placed in a
vessel and vinegar is poured in, and the vessel is
covered over and sealed, the lead will be dissolved
and it will become white lead.[6]

19. In the same way, brass, which is still more

[2] Aristotle was credited with the scheme, Plin. *N.H.* XXX.
149.
[3] Cottius erected the arch of Augustus at Susa W. of Turin,
8 B.C.
[4] In Macedonia. [5] Plin. *N.H.* XXXI. 9.
[6] Book VII. xii. 1.

natura, similiter curatum si fuerit, dissipabitur
et fiet aerugo. Item margarita. Non minus saxa
silicea, quae neque ferrum neque ignis potest per se
dissolvere, cum ab igni sunt percalefacta, aceto sparso
dissiliunt et dissolvuntur. Ergo cum has res ante
oculos ita fieri videamus, ratiocinemur isdem
rationibus ex acidis propter acritudinem suci etiam
calculosos e natura rerum similiter posse curari.

20 Sunt autem etiam fontes uti vino mixti, quemad-
modum est unus Paphlagoniae, ex quo eam sine vino
potantes fiunt temulenti. Aequiculis autem in
Italia et in Alpibus natione Medullorum est genus
aquae, quam qui bibunt, efficiuntur turgidis gut-
21 turibus. Arcadia vero civitas est non ignota Clitor,[1]
in cuius agris est spelunca profluens aqua, e qua qui [2]
biberint, fiunt abstemii. Ad eum autem fontem
epigramma est in lapide inscriptum : haec sententiae
versibus graecis : eam non esse idoneam ad lavandum,
sed etiam inimicam vitibus, quod apud eum fontem
Melampus sacrificiis purgavisset rabiem Proeti
filiarum restituissetque earum virginum mentes in
pristinam sanitatem. Epigramma autem est id,
quod et subscriptum :

ἀγρότα,[3] σὺν ποίμναις τὸ μεσημβρινὸν ἤν σε βαρύνῃ [4]
 δίψος ἀν’ ἐσχατιὰς Κλείτορος [5] ἐρχόμενον,

[1] clitori *H.*
[2] aquae qui *H.*
[3] *Epigrammata quae sequuntur eadem graece extant in Eclogis
Florentinis (de mirabilibus) quae sub ficto Sotionis nomine (ex
cod. Laur.* LVI, I) *edidit H. Stephanus. H litterarum formis
utitur graecis et latinis mixtis, praecipue* ϲ, *ut in papyris pro* σ.
ΑΓΡΑΤΑ *H.*
[4] ΗΝΕΕΒΑΡΥΗΝ *H.*
[5] ΚΑΙΤΟΡΟϹ *H.*

solid, if it is treated in like manner, will be dissolved and changed into verdigris. So also pearls; and flints, which neither iron nor fire can dissolve of itself, when they are heated in the fire and sprinkled with acid, fly asunder and are dissolved.[1] Therefore, since we see these processes before our eyes, we shall conclude by the same arguments that persons suffering from stone can be cured naturally in like manner by acids owing to their pungency.

20. There are also springs, as it were, mixed with wine, such as one in Paphlagonia, and persons drinking it without wine become drunk. Among the Aquiculi in Italy and among the tribe of the Medulli in the Alps, there is a kind of water which causes goitre [2] among those who drink it. 21. In Arcadia there is the city of Clitor, not unknown,[3] in the lands of which there is a cave with running water, and those who drink of it become abstemious.[4] Against the spring there is an inscription engraved on the stone. This is the meaning of the Greek verses: that the water is not fit for washing and is also harmful to vines, because at this spring Melampus with sacrifices cleansed the madness of the daughters of Proetus and restored the minds of the girls to their former sanity. This is the inscription [5] written below:

Shepherd, if at noon thirst oppress thee as thou comest with thy flocks to the bounds of Clitor,

[1] Vinegar *acetum* is credited with an exaggerated capacity to dissolve pearls.

[2] *quis tumidum guttur miratur in Alpibus?* Juv. XIII. 162.

[3] Cf. Acts, *non ignotae civitatis, Vg.* XXI. 39; οὐκ ἄσημος Ἑλλήνων πόλις (Athens), Eur. *Ion*, 8.

[4] Ovid, *Met.* XV. 322.

[5] *Anth. Pal. App.* IV. 20. These three epigrams are found in ps. Sotion *de mirabilibus.*

τᾶς μὲν ἀπὸ κρήνης ἄρυσαι [1] πόμα καὶ παρὰ νύμφαις
 ὑδρεάςιν ςτῆςον πᾶν τὸ còν αἰπόλιον·
νάμαει μήτ' ἐπὶ λουτρὰ βάλης χροί, μή ςε καὶ αὔρη [2]
 πη⟨νή⟩νη ⟨τερπνῆς⟩ ἐντὸς [3] ἐόντα μέθης·
φεῦγε δὲ τὴν πηγὴν μεισάμπελον, ἔνθα Μελάμπους
 λυσάμενος λύσσης [4] Προιτίδας ἀρτεμέας [5]
πάντα καθαρμὸν ἔκοψεν ἀπόκρυφον, [6] ⟨εὖτ' ἄρ' ἀπ'
 Ἄργους
 οὔρεα τρηχείης ἤλυθεν Ἀρκαδίης⟩.

22 Item est in insula Cia [7] fons, e quo qui inprudentes
biberint, fiunt insipientes, et ibi est epigramma
insculptum ea sententia: iucundam eam esse
potionem fontis eius, sed qui biberit, saxeos habi-
turum sensos. [8] Sunt autem versus hi:

ἠδέ ἀπὸ ψυχροῦ πόματος λιβάς, ἅ γ' ἀναβαίνει
 ⟨πηγή, ἀλλὰ νόῳ⟩ πέτρος ὁ τήνδε πιών. [9]

23 Susis [10] autem, in qua civitate est regnum Persarum,
fonticulus est, ex quo qui biberint, amittunt dentes.
Item in eo est scriptum epigramma, quod significat [11]
hanc sententiam: egregiam esse aquam ad lavandum,
sed ea si bibatur, excutere e radicibus dentes. Et
huius epigrammatos sunt versus graece:

[1] κρηνηκαρυςαι H.
[2] ιαουτραβατιτεχραμηςηκαιΔυρη H.
[3] πη⟨μη⟩νη ⟨τερπνῆς⟩ εντος ps. Sot.: πΗΝΗϲΝΤΥϲ H.
[4] λυσαμενος λυσσης ps. Sot.: αΥϲαΜϵΝΟ|ϲαΥϲϵΗϲ H.
[5] πΡΟιΤΙααϲαρτϵΜϵιαϲ H.
[6] ΚΛΘΑΡΜΟΝϵΚΟΨϵΝϵπαΧΡΥΨΟΝ (hoc verbo finitur epigr. in
H, reliqua ex Ecl. Flor. addiderunt edd.).
[7] chia H (cea Plin.).
[8] Cf. motos H (X. iii. 9).
[9] ΗαϵλπΟΨΥΧΡΟΥπΟΜΑΤΟϲαιΒαϲααΝαΒαιΝϲΙπϵπ
ΡΟϲΟΤΗΝαϵπιωΝ H. ἅ γ' ἀναβαίνει Rouse: ἀναβάλλει cod. Laur.
αναβαίνει H: πηγή, ἀλλὰ νόῳ cod. Laur. (om. H).

Draw water from this fountain, and, near the water nymphs, give rest to all thy goats.

But cast not water for the bath on thy skin, lest the vapour harm thee when thou art plunged in the joys of wine.

Shun my vine-hating spring; here Melampus restored to sense the daughters of Proetus from their frenzy,[1]

He smote the scapegoat deep and out of sight, when from Argos he came to the mountains of wild Arcadia.

22. There is also a spring in the island of Chios,[2] and those who drink of it unawares become stupid. There is an inscription[3] carved there to this effect: that a draught of the spring is pleasant, but anyone who drinks will have fossilised notions. The verses follow.

Sweet is the flow of cooling drink, which rises in a fountain, but he who drinks of it is turned to stone in his mind.

23. At Susa also, which is the capital city of Persia, there is a small spring, and those who drink from it lose their teeth. On it there is written an inscription[4] which bears this meaning: that the water is good for bathing, but whatever is drunk, shakes out the teeth from their roots. Of this inscription the verses run as follows in Greek.

[1] Paus. VIII. 18. 7.
[2] Pliny says Ceos, *N.H.* XXXI. 15.
[3] *Anth. Pal. App.* III. 94. [4] *Anth. Pal. App.* III. 101.

[10] suesis *H.* [11] -cant *H.*

ὕδατα κρανάεντα βλέπεις, ξένε, τῶν ἄπο χερσὶν [1]
 λουτρὰ μὲν ἀνθρώποι⟨ς ἀβλαβῆ ἔστιν ἔχειν·⟩ [2]
ἢν δὲ λάβῃς κοίλου βοτανήδεος ἀγλαὸν ὕδωρ [3]
 ⟨ἄκρα μόνον δολιχοῦ χείλεος ἀψάμενος,⟩[2]
αὐτῆμαρ πριστῆρες ἐ⟨πὶ χθονὶ δαιτὸς ὀδόντες⟩ [2]
 πείπτουσιν, γεννῶν ὀρφανὰ θέντες ἕδη.[4]

24 Sunt etiam nonnullis locis fontium proprietates,
quae procreant qui ibi nascuntur egregiis vocibus ad
cantandum, uti Tarso,[5] Magnesiae, aliis eiusmodi
regionibus. Etiamque Zama est civitas Afrorum,
cuius moenia rex Iuba duplici muro saepsit ibique
regiam domum sibi constituit. Ab ea milia passus
xx est oppidum Ismuc, cuius agrorum regiones
incredibili finitae[6] sunt terminatione. Cum esset
enim Africa parens et nutrix ferarum bestiarum,
maxime serpentium, in eius agris oppidi nulla nascitur,
et si quando adlata ibi ponatur, statim moritur; neque
id solum, sed etiam terra ex his locis si alio translata
fuerit, et ibi. Id genus terrae etiam Balearibus
dicitur esse. Sed aliam mirabiliorem virtutem ea
habet terra, quam ego sic accepi.

25 Gaius Iulius Masinissae filius, cuius erant totius
oppidi agrorum possessiones, cum patre[7] Caesare
militavit. Is hospitio meo est usus. Ita cotidiano
convictu necesse fuerat de philologia disputare.
Interim cum esset inter nos de aquae potestate et

[1] Υαλτα κραναεντα βαεπεις ξενςτων αποχερςιν H.

[2] om. H.

[3] λουτραμεναντροποιηναεμ βηοκο | ιλουβοταν ηλεοσατ-
μονυδωρ H.

[4] αυτημερπρις | τηρεσεπειπτουςιντενυωνορφανλοεντεσεαη
H. πειπτουσιν hanc orthographiam ubique in evv. habent codices
NT. Vat. et Bezae: cf. μεισαμπελον supra.

[5] uti tharso H. [6] finitae ed : -ti H.

[7] patres H.

Waters from the rock you see, stranger, from
which it is safe for men to take to wash their hands;

But if you take of the fair water of the leafy cave,
and touch it but with the tip of your lips,

Forthwith those banquet grinders, your teeth,
fall on the ground, and leave empty the sockets in
your jaw.

24. There are in some places springs which have
the property of causing those who are born there to
have fine voices for singing; such as at Tarsus, in
Magnesia, and elsewhere. Further, there is in Africa
the city of Zama [1] the ramparts of which King Juba [2]
enclosed with a double wall, and built his palace
there. Twenty miles away is the town of Ismuc.
The area of the lands of this city is marked by an
incredible barrier. Africa is the mother and nurse
of wild creatures, especially snakes, but they do not
grow in the neighbourhood of Zama; and if at any
time a snake is brought and put there, it dies on the
spot. Not only so, but even if soil is taken from these
places elsewhere the same thing happens there.
(The soil of the Balearic Isles is said to be of that
kind.) It has, however, a still more remarkable
quality which I learnt in the following way.

25. Gaius Julius, the son of Masinissa, who held
possession of the whole lands of the city, fought on
the side of the late emperor. He sometimes stayed
with me, and in our daily intercourse we were often
driven to talk about scholarship. Once the question
arose between us about the potency of water and its

[1] Probably from Varro, Plin. *N.H.* XXXI. 15.
[2] Juba, the father of the historian, fought against Caesar.
Bell. Afric. 91.

eius virtutibus sermo, exposuit esse in ea terra
eiusmodi fontes, ut, qui ibi procrearentur, voces ad
cantandum egregias haberent, ideoque semper
transmarinos catlastros emere formonsos [1] et puellas
maturas eosque coniungere, ut, qui nascerentur ex
his, non solum voce egregia sed etiam forma essent
non invenusta.

26 Cum haec tanta varietas sit disparibus rebus
natura distributa quod humanum corpus est ex aliqua
parte terrenum, in eo autem multa genera sunt
umorum,[2] uti sanguinis, lactis, sudoris, urinae,
lacrimarum: ergo si in parva particula terreni tanta
discrepantia invenitur saporum, non est mirandum,
si tam in magnitudine terrae innumerabilis sucorum
reperientur varietates, per quarum venas aquae [3] vis
percurrens tincta pervenit ad fontium egressus, et
ita ex eo dispares variique perficiuntur in propriis
generibus fontes propter locorum discrepantiam et
regionum qualitates terrarumque dissimiles proprie-
tates.

27 Ex his autem rebus sunt nonnulla, quae ego per
me perspexi, cetera in libris graecis scripta inveni,
quorum scriptorum hi sunt auctores: Theophrastos,
Timaeus, Posidonios, Hegesias, Herodotus, Aristides,
Metrodorus, qui magna vigilantia et infinito studio
locorum proprietates, aquarum virtutes ab inclinatione
caelique regionum qualitates ita esse distributas
scriptis dedicaverunt. Quorum secutus ingressus in

[1] formonsos *H* : formonsam *Verg. E.* i. 5.
[2] morum *H*. [3] aquae *rec* : quae *H*.

[1] Book VI. *pref.* 2.
[2] Of Tauromenium; historian of Sicily, fl. 300 B.C.
[3] Of Apamea; philosopher, taught at Rhodes, d. 48 B.C.

virtues. He informed me that, in his country, there were springs such that those who were born in the neighbourhood had fine singing voices, and that they bought from time to time across the sea handsome youths and grown-up girls and mated them so that their children might have fine voices and good looks as well.

26. Since, therefore, such variety is produced by nature among diverse things, in that the human body is in part earthy, and at the same time contains humours of many kinds, blood, milk, sweat, urine, tears; if, therefore, in a small particle of the earthy there is found such a discrepancy of flavours, we need not wonder if in the expanse of earth there shall be found such innumerable varieties of juices. The watery energy passing along their channels is tinctured with them when it reaches the outflow of the springs. Thus for this reason springs are rendered disparate and various in their several kinds, because of the divergence of localities and the qualities of regions and the unlike qualities of soils.

27. Of these facts there are some which I have observed myself; others I have found recorded in Greek works of which I name the authors: Theophrastus,[1] Timaeus,[2] Posidonios,[3] Hegesias,[4] Herodotus,[5] Aristides,[6] Metrodorus.[7] These writers, with close attention and unlimited pains, have declared the properties of localities, the virtues of different waters, and by reference to climate, the distribution of regional qualities. Following in their footsteps, I

[4] Of Magnesia nr. Sipylus; historian, fl. 280 B.C.
[5] Of Lycia; Athen. 75.
[6] Of Miletus; historian, Plin. *N.H.* IV.
[7] Of Scepsis; historian, d. 70 B.C.

hoc libro perscripsi quae satis esse putavi de aquae
varietatibus, quo facilius ex his praescriptionibus
eligant homines aquae fontes, quibus ad usum
salientes possint ad civitates municipiaque perducere.
28 Nulla enim ex omnibus rebus tantas habere videtur
ad usum necessitates, quantas aqua, ideo quod
omnium animalium natura, si frumenti fructu privata
fuerit, arbustivo aut carne aut piscatu aut etiam
qualibet ex his reliquis rebus escarum utendo poterit
tueri vitam, sine aqua vero nec corpus animalium nec
ulla cibi [1] virtus potest nasci nec tueri nec parari.
Quare magna diligentia industriaque quaerendi sunt
et eligendi fontes ad humanae vitae salubritatem.

IV

1 EXPERTIONES autem et probationes eorum sic sunt
providendae. Si erunt profluentes et aperti, ante-
quam duci incipiantur, aspiciantur animoque adver-
tantur, qua membratura sint qui circa eos fontes
habitant homines; et si erunt corporibus valentibus,
coloribus nitidis, cruribus non vitiosis, non lippis
oculis, erunt probatissimi. Item si fons novos fossus
fuerit, et in vas corinthium sive alterius generis, quod
erit ex aere bono, ea aqua sparsa maculam non fecerit,
optima est. Itemque in aeneo si ea aqua defervefacta
et postea requieta et defusa fuerit, neque in eius
aenei fundo harena aut limus invenietur, ea aqua erit
2 item probata. Item si legumina in vas cum ea aqua
coiecta ad ignem posita celeriter percocta fuerint,

[1] ciui *H*.

[1] Alloy of gold, silver and copper.

have recorded in this book what I thought enough about the different kinds of water, so that from these instructions springs of water might be chosen from which conduits could be taken for the supply of cantons and towns.

28. For of all things, not one seems to be so necessary for use as water, since the nature of all animals, though it be deprived of the use of corn, can maintain life from shrubs or meat or fish or some other provender. But without water, neither the animal frame nor any virtue of food can originate, be maintained, or provided. Hence great diligence and industry must be used in seeking and choosing springs to serve the health of man.

CHAPTER IV

ON TESTING WATER

1. The discovery and testing of springs is to be pursued in the following manner. When they are abundant and in the open, we are to observe and consider, before we begin to lay the water on, what is the physique of those who live in the neighbourhood. If they are strong, of clear complexion, free from distortion and from inflamed eyes, the water will pass. Again, if a fresh spring be dug, and the water, being sprinkled over a vessel of Corinthian,[1] or any other good bronze, leave no trace, the water is very good. Or if water is boiled in a copper vessel and is allowed to stand and then poured off, it will also pass the test, if no sand or mud is found in the bottom of the copper vessel. 2. Again, if vegetables being put in the vessel with water and boiled, are soon

177

indicabunt aquam esse bonam et salubrem. Non
etiam minus ipsa aqua, quae erit in fonte, si fuerit
limpida et perlucida, quoque pervenerit aut pro-
fluxerit,[1] muscus non nascetur neque iuncus,[2] neque
inquinatus ab aliquo inquinamento is locus[3] fuerit,
sed puram habuerit speciem, innuitur[4] his signis
esse tenuis et in summa salubritate.

V

1 Nunc de perductionibus ad habitationes moeniaque,
ut fieri oporteat, explicabo. Cuius ratio est prima
perlibratio. Libratur autem dioptris[5] aut libris aquariis
aut chorobate, sed diligentius efficitur per chorobaten,
quod dioptrae libraeque fallunt. Chorobates autem
est regula longa circiter pedum viginti. Ea habet
ancones in capitibus extremis aequali modo perfectos
inque regulae capitibus ad normam coagmentatos,[6] et
inter regulam et ancones a cardinibus conpacta[7] trans-
versaria, quae habent lineas ad perpendiculum recte
descriptas pendentiaque ex regula perpendicula in
singulis partibus singula, quae, cum regula est
conlocata, ea quae tangent[8] aeque ac pariter lineas
describtionis, indicant libratam conlocationem.

2 Sin autem ventus interpellaverit et motionibus
lineae non potuerint certam significationem facere,
tunc habeat in superiore parte canalem longum pedes
v, latum digitum, altum sesquidigitum, eoque aqua
infundatur, et si aequaliter aqua canalis summa labra[9]

[1] limpida — profluxerit *bis ponit H.*
[2] iuncus *ed* : iuncum *H.* [3] his locus *H.*
[4] innuitur e_2 *ed.* : inbuitur *H.* [5] diobtris *H.*
[6] coagmentatus *H.* [7] conpactat *H.*
[8] tangent *ed* : tangentur *H.* [9] labra *rec* : libra *H.*

cooked, they will show that the water is good and wholesome. Likewise, if the water itself in the spring is limpid and transparent and if wherever it comes or passes, neither moss nor reeds grow nor is the place defiled by any filth, but maintains a clear appearance, the water is indicated by these signs to be light and most wholesome.

CHAPTER V

ON THE METHOD OF LEVELLING

1. I WILL now explain the supply of water to country houses and to towns. The first stage is to fix levels. This is done by dioptrae, or water levels, or the chorobates.[1] But the more accurate method is by the chorobates because the dioptrae and the water levels mislead. The chorobates is a straight plank about twenty feet long. At the extreme ends it has legs made to correspond, and fastened at right angles to the ends of the plank, and, between the plank and the legs, cross-pieces joined by tenons. These have lines accurately drawn to a perpendicular, and plummets hanging severally over the lines from the plank. When the plank is in position, the perpendiculars which touch equally and of like measure the lines marked, indicate the level position of the instrument.

2. But if the wind disturbs and, owing to their movements, the lines cannot give a certain indication, a channel is to be put on the top side of the plank, five feet long, an inch wide and an inch and a half deep. Let water be poured in. If the water evenly touches the lips of the channel, we shall know that

[1] Neuburger, *op. cit.* gives a drawing, 394.

tanget, scietur esse libratum. Ita eo chorobate cum
perlibratum ita fuerit, scietur, quantum habuerit
fastigii.

3 Fortasse, qui Archimedis libros legit, dicet non
posse fieri veram ex aqua librationem, quod ei placet
aquam non esse libratam, sed sphaeroides [1] habere
schema sed ibi habere centrum, quo loci habet orbis
terrarum. Hoc autem, sive plana est aqua seu sphae-
roides, necesse est: ⟨ad⟩ [2] extrema capita regulae
sit [3] pariter sustinere regulam aquam; sin autem
proclinatum erit ex una parte, quae erit altior, non
habuerit regulae canalis [4] in summis labris aquam.
Necesse [5] est enim, quocumque aqua sit infusa, in
medio inflationem curvaturamque habere, sed capita
dextra ac sinistra inter se librata esse. Exemplar
autem chorobati erit in extremo volumine descriptum.
Et si [6] erit fastigium magnum, facilior erit decursus
aquae; sin autem intervalla erunt lacunosa, sub-
structionibus erit succurrendum.

VI

1 DUCTUS autem aquae fiunt generibus tribus: rivis
per canales structiles, aut fistulis plumbeis, seu
tubulis fictilibus. Quorum hae sunt rationes. Si
canalibus, ut structura fiat quam solidissima,
solumque rivi libramenta habeat fastigata ne minus
in centenos pedes semipede eaeque [7] structurae

[1] phaeroides *H.* [2] *add. Ro.*
[3] regulae sit *Gr*: regula erit *H.*
[4] canalis *Joc*: canalem *H.* [5] nenesse *H.*
[6] et si *G*: et sic *H.* [7] aeque *H*, eque *G.*

the levelling is successful. Further, when we have levelled with the chorobates, we shall know the amount of the fall.

3. Perhaps the student of the works of Archimedes may say that true levelling cannot be made by means of water, because his theory is that the surface of water is not level, but is that of a sphere of which the centre is that of the earth. But whether the surface of the water is plane or spherical, it is necessary that the extreme ends of the plank should uphold the water evenly. But if there be a fall at one end, the end which is higher will not have water up to the lips of the channel. For while it is necessary that where water is poured along, there should be an inflation and curvature in the middle, it is also necessary that the ends, right and left, should be level one with another. A drawing of the chorobates is furnished at the end of the book. If the fall is considerable, the flow of the water will be made easier. If there are marshy intervals, the assistance of substructures must be sought.

CHAPTER VI

ON AQUEDUCTS, LEADEN AND EARTHERN PIPES

1. THE supply of water [1] is made by three methods : by conduits along artificial channels, or by lead pipes, or by earthenware tubes. And they are arranged as follows. In the case of channels, the structure must be on a very solid foundation ; the bed of the current must be levelled with a fall of not less than 6 inches in 100 feet. The channels are to be arched over to

[1] Neuburger, *op. cit.* 425 ff. describes in detail the water-supply of the Romans.

confornicentur, ut minime sol aquam tangat. Cumque venerit ad moenia, efficiatur castellum et castello coniunctum ad recipiendam aquam triplex inmissarium, conlocenturque in castello tres fistulae aequaliter divisae intra receptacula coniuncta, uti, cum abundaverit ab extremis, in medium receptaculum redundet.

2 Ita in medio ponentur fistulae in omnes lacus et salientes, ex altero in balneas vectigal quotannis populo praestent, ex quibus tertio in domus privatas, ne desit in publico; non enim poterint avertere, cum habuerint a capitibus proprias ductiones. Haec autem quare divisa constituerim, hae sunt causae, uti qui privatim ducent in domos vectigalibus tueantur

3 per publicanos aquarum ductus. Sin autem medii montes erunt inter moenia et caput fontis, sic erit faciendum, uti specus fodiantur[1] sub terra librenturque ad fastigium, quod supra scriptum est. Et si tofus erit aut saxum, in suo sibi canalis excidatur, sin autem terrenum aut harenosum erit, solum et parietes cum camara[2] in specu struantur et ita perducatur. Puteique ita sint facti, uti inter duos sit actus.

4 Sin autem fistulis plumbeis ducetur, primum castellum ad caput struatur, deinde ad copiam[3] aquae lumen fistularum constituatur, eaeque[4] fistulae castello[5] conlocentur ad castellum, quod erit in moenibus. Fistulae ne minus longae pedum denûm fundantur. Quae si centenariae erunt, pondus habeant in singulas pondo MCC; si octogenariae,

[1] fodientur *H.* [2] camera *H.*
[3] ad copiam aquae e_2 *ed* : adcopia quae *H.*
[4] eaeque : aeq; *H,* eque *G.*
[5] *abl. sine prep.*

protect the water from the sun. When they come to
the city walls, a reservoir is to be made. To this a
triple receptacle is to be joined, to receive the
water; and three pipes of equal size are to be put in
the reservoir, leading to the adjoining receptacles, so
that when there is an overflow from the two outer
receptacles, it may deliver into the middle receptacle.

2. From the middle receptacle pipes will be taken
to all pools and fountains; from the second receptacle
to the baths, in order to furnish a public revenue; to
avoid a deficiency in the public supply, private houses
are to be supplied from the third: for private per-
sons will not be able to draw off the water, since they
have their own limited supply from their receptacle.
The reason why I have made this division, is in order
that those who take private supplies into their houses
may contribute by the water rate to the maintenance
of the aqueducts. 3. If there are hills between the
city and the fountain head, we must proceed as
follows. Tunnels are to be dug underground and
levelled to the fall already described. If the forma-
tion of the earth is of tufa or stone, the channel may
be cut in its own bed; but if it is of soil or sand the
bed and the walls with the vaulting are to be con-
structed in the tunnel through which the water is to
be brought. Air shafts are to be at the distance of
one actus (120 feet) apart.

4. But if the supply is to be by lead pipes, first of
all a reservoir is to be built at the fountain head.
Then the section of the pipe is to be determined for
the supply of water, and the pipes are to be laid from
the reservoir to a reservoir in the city. The pipes are
to be cast in lengths of not less than 10 feet. If the
lead is 100 inches wide, they are to weigh 1200 lbs.

pondo DCCCCLX; si quinquagenariae, pondo DC; quadragenariae pondo CCCCLXXX; tricenariae pondo CCCLX; vicenariae pondo CCXL; quinûm denûm pondo CLXXX; denûm pondo CXX;[1] octonûm pondo C; quinariae pondo LX. E latitudine autem lamnarum, quot digitos habuerint, antequam in rotundationem flectantur, magnitudinum ita nomina concipiunt fistulae. Namque quae lamna fuerit digitorum quinquaginta, cum fistula perficietur ex ea lamna, vocabitur quinquagenaria similiterque reliqua.

5 Ea autem ductio, quae per fistulas plumbeas est futura, hanc habebit expeditionem. Quodsi caput habeat libramenta ad moenia montesque medii non fuerint altiores, ut possint interpellare, sed intervalla, necesse est substruere ad libramenta, quemadmodum in rivis et canalibus. Sin autem non longa erit circumitio, circumductionibus, sin autem valles erunt perpetuae, in declinato loco cursus dirigentur. Cum venerint ad imum, non alte substruitur, ut sit libratum quam longissimum; hoc autem erit venter, quod Graeci appellant *coelian*. Deinde cum venerit adversus clivum, ex longo spatio ventris leniter tumescit; exprimatur in altitudinem summi clivi.[2]

6 Quodsi non venter in vallibus factus fuerit nec substructum ad libram factum, sed geniculus erit, erumpet et dissolvet fistularum commissuras.[3] Etiam in ventre colluviaria[4] sunt facienda, per quae vis spiritus relaxetur. Ita per fistulas plumbeas aquam qui ducent, his rationibus bellissime poterunt efficere,

[1] CXX *G* : CCXX *H*. [2] clevi *H*.
[3] commissuras *rec* : commixturas *H*.
[4] colluviaria e_2 *ed* : colliviaria *H*.

[1] The reservoirs or water-towers are represented by the Roman ' Fountains.'

184

each; if 80 inches, 960 lbs.; if 50 inches, 600 lbs.; if 40 inches, 480 lbs.; if 30 inches, 360 lbs.; if 20 inches, 240 lbs.; if 15 inches, 180 lbs.; if 10 inches, 120 lbs.; if 8 inches, 100 lbs.; if 5 inches, 60 lbs.[1] The pipes receive the names of the sizes from the width of the sheets of lead in inches, before they are bent round into pipes. For when a pipe is made of a sheet of lead 50 inches wide, it is called a fifty-inch pipe, and similarly the rest.[2]

5. When, however, an aqueduct is made with lead pipes it is to have the following arrangement. If from the fountain head there is a fall to the city, and the intervening hills are not so high as to interrupt the supply, and if there are valleys, we must build up the pipes to a level as in the case of open channels. If the way round the hills is not long, a circuit is to be used; if the valleys are wide-spreading, the course will be down the hill, and when it reaches the bottom, it is carried on a low substructure so that it may be levelled as far as possible. This will form a ∪-shaped bend which the Greeks call *koilia*. When the bend comes uphill after a gentle swelling spread over the long space of the bend, the water is to be forced to the height of the top of the hill.

6. But if the bend is not made use of in the valleys, or if the pipe is not brought up to a level, and there is an elbow,[3] the water will burst through and break the joints of the pipes. Further, stand-pipes are to be made in the bend, by which the force of the air may be relaxed. In this way the supply of water by lead pipes may be carried out in the best manner, because

[2] Plin. *N.H.* XXXI. 58 seems to quote this passage.
[3] Where two pipes meet at an angle.

quod et decursus et circumductiones et ventres et expressus[1] hac ratione possunt fieri, cum habebunt a capitibus ad moenia ad[2] fastigii libramenta.

7 Item inter actus ducentos non est inutile castella conlocari, ut, si quando vitium aliqui locus fecerit, non totum onus neque[3] opus contundatur et, in quibus locis sit factum, facilius inveniatur; sed ea castella neque in decursu neque in ventris planitia neque in expressionibus neque omnino in vallibus, sed in perpetua aequalitate.

8 Sin autem minore sumptu voluerimus, sic est faciendum. Tubuli crasso corio ne minus duorum digitorum fiant, sed uti hi tubuli ex una parte sint lingulati, ut alius in alium inire convenireque possint. Coagmenta autem eorum calce viva ex oleo subacta sunt inlinienda, et in declinationibus libramenti ventris lapis est ex saxo rubro in ipso geniculo conlocandus isque pertebratus, uti ex decursu tubulus novissimus in lapide coagmentetur et primus ex librati ventris;[4] ad eundem modum adversum clivum et novissimus[5] librati ventris in cavo saxi rubri haereat et primus expressionis ad eundem modum coagmentetur.

9 Ita librata planitia tubulorum ad[6] decursus et expressionis[7] non extolletur. Namque vehemens spiritus in aquae ductione solet[8] nasci, ita ut etiam saxa perrumpat, nisi primum leniter et parce a capite aqua inmittatur et in geniculis aut versuris alligationibus aut pondere saburra contineatur.

[1] expressus *ed* : -sis *H.*
[2] adfastigii libramenta (ad *acc. Sem.*) *H.*
[3] onus neque e_2 : omneque *H.*
[4] *gen. Graec.* ? [5] novissimus e_2 *Joc* : -um *H.*
[6] ad *Mar* : aut *H.* [7] expraessionis *H.*

the descent, the circuit, the bend, the compression of the air, can be thus managed when there is a regular fall from the fountain head to the city.

7. Again, it is not without advantage to put reservoirs at intervals of 200 actus (24,000 feet), so that if a fault arises anywhere, neither the whole load of water nor the whole structure may be disturbed, but it may be more easily found where the fault is. But these reservoirs are to be neither in the descent nor on the level portion of the bend, nor on the rise, nor generally in valleys, but on unbroken level ground.

8. But if we wish to employ a less expensive method, we must proceed as follows. Earthenware pipes are to be made not less than two inches thick, and so tongued that they may enter into and fit one another. The joints are to be coated with quicklime worked up with oil. At the descents to the bend, a block of red stone is to be placed at the actual elbow, and pierced so that the last pipe [1] on the incline, and the first from the level of the bend, may be jointed in the stone. In the same way uphill: the last from the level of the bend, and the first of the ascent, are to be jointed in the same way in the hollow of the red stone.

9. Thus, by adjusting the level of the tubes, the work will not be forced out of its place at the downward inclines and the ascents. For a strong current of air usually arises in the passage of water, so that it even breaks through rocks, unless, to begin with, the water is evenly and sparingly admitted from the fountain head, and controlled at the elbows and turns by bonding joints or a weight of ballast. Every-

[1] *ex librati ventri* can hardly be right.

[8] solet e_2 *Sulp* ; solent *H*.

Reliqua omnia uti fistulis plumbeis ita sunt conlocanda. Item cum primo aqua a capite inmittitur, ante favilla inmittetur, uti coagmenta, si qua sunt non satis oblita, favilla oblinantur.[1]

10 Habent autem tubulorum ductiones ea commoda. Primum in opere quod si quod vitium factum fuerit, quilibet id potest reficere. Etiamque multo salubrior est ex tubulis aqua quam per fistulas, quod per plumbum videtur esse ideo vitiosum,[2] quod ex eo cerussa nascitur; haec autem dicitur esse nocens corporibus humanis. Ita quod ex eo procreatur, ⟨si⟩[3] id est vitiosum, non est dubium, quin[4] ipsum quoque non sit salubre.

11 Exemplar autem ab artificibus plumbariis possumus accipere, quod palloribus occupatos habent corporis colores. Namque cum fundendo plumbum flatur, vapor ex eo insidens corporis artus et inde[5] exurens eripit ex membris eorum sanguinis virtutes. Itaque minime fistulis plumbeis aqua duci videtur, si volumus eam habere salubrem. Saporemque meliorem ex tubulis esse cotidianus potest indicare victus, quod omnes, et[6] structas cum habeant vasorum argenteorum mensas, tamen propter saporis integritatem fictilibus utuntur.

12 Sin autem fontes, unde ductiones aquarum, faciamus, necesse est puteos fodere. In puteorum autem fossionibus[7] non est contemnenda ratio, sed acuminibus sollertiaque magna naturales rerum rationes considerandae, quod habet multa variaque

[1] oblinantur *ed* : -nentur *H*. [2] *neutrum generale.*
[3] si *add. Joc (post* ita). [4] quin *G* : qui in *H*.
[5] inde *h* : indie *H*.
[6] et structas *Kr.* : exstructas *H*.
[7] fossionibus *h* : possessionibus *H*.

thing else is to be fixed as for lead pipes. Further, when the water is first sent from the fountain head, ashes are to be put in first, so that if any joints are not sufficiently coated, they may be grouted with the ashes.

10. Water-supply by earthenware pipes has these advantages. First, if any fault occurs in the work, anybody can repair it. Again, water is much more wholesome from earthenware pipes than from lead pipes. For it seems to be made injurious by lead, because white lead is produced by it; and this is said to be harmful to the human body.[1] Thus if what is produced by anything is injurious, it is not doubtful but that the thing is not wholesome in itself.

11. We can take example by the workers in lead who have complexions affected by pallor. For when, in casting, the lead receives the current of air, the fumes from it occupy the members of the body, and burning them thereupon, rob the limbs of the virtues of the blood. Therefore it seems that water should not be brought in lead pipes if we desire to have it wholesome. Our daily table may show that the flavour from earthenware pipes is better, because everybody, even when they pile up their tables with silver vessels,[2] for all that, uses earthenware to preserve the flavour of water.

12. But if we are to create fountains from which come the water-supplies, we must dig wells. But in digging wells we must not make light of science. The methods of nature must be considered closely in the light of intelligence and experience, because the

[1] Poisoning from lead pipes occasionally occurs in modern times; Neuburger, *op. cit.* 434.

[2] A silver table set from the House of Menander at Pompeii, is now in the Naples Museum.

terra in se genera. Est enim uti reliquae res ex
quattuor principiis conposita. Et primum est ipsa
terrena; habetque ex umore aquae fontes; item
calores, unde etiam sulphur, alumen, bitumen
nascitur; aerisque spiritus inmanes, qui, cum graves
per intervenia fistulosa terrae perveniunt ad fossio-
nem puteorum et ibi homines offendunt fodientes, ut
naturali vaporis obturant[1] eorum naribus spiritus
animales; ita, qui non celerius inde effugiunt, ibi
interimuntur.[2]

13 Hoc autem quibus rationibus caveatur, sic erit
faciendum. Lucerna accensa demittatur; quae si
permanserit ardens, sine periculo descendetur.
Sin autem eripietur lumen a vi vaporis, tunc secun-
dum puteum dextra ac sinistra defodiantur aestuaria;[3]
ita quemadmodum per nares spiritus ex aestu⟨ariis⟩[4]
dissipabuntur. Cum haec sic explicata fuerint et
ad aquam erit perventum, tunc saepiatur a structura,[5]
nec obturentur venae.[6]

14 Sin autem loca dura erunt aut nimium venae
penitus fuerint, tunc signinis[7] operibus ex tectis[8]
aut superioribus locis excipiendae sunt copiae. In
signinis autem operibus haec sunt facienda. Uti
harena primum purissima asperrimaque paretur,
caementum de silice frangatur ne gravius quam
librarium, calx quam vehementissima mortario mixta,
ita ut quinque partes harenae ad duos respondeant.
Eorum fossa ad libramentum altitudinis, quod est

[1] obturant *Joc* : obturante *H*.
[2] interemuntur *H G*.
[3] defodiantur aestuaria *ed* : defodianturq aestuaria *H S*.
[4] aestuariis *Joc* : aestu *H*.
[5] saepiatur a structura e_2 : saepiaturas structura *H*.
[6] venae e_2 *ed* : venas *H*. [7] signinis *G* : signis *H*.
[8] tectis *Joc* : testis *H*.

soil contains many various elements. For, like other
things, it is composed of four principles. First, it is
itself earthy; from the liquid, it has springs of water;
there are various heats from which sulphur, alum and
bitumen arise; and mighty currents of air. When
these are heavy and come through the porous inter-
vals of the soil to the wells which are being dug, they
affect the excavators, in so far as the nature [1] of the
exhalation chokes the animal spirits in their nostrils.
Hence those who fail to escape at once, die there.

13. The precautions against this are to be carried
out as follows.[2] Let a lighted lamp [3] be lowered. If
it remains alight, the descent will be accomplished
without danger. If, however, the light is extinguished
by the power of the exhalation, then air-shafts [4] are
to be dug right and left adjoining the well. In this
way the vapours from the air will be dissipated, as the
air is through the nostrils. When this has been
arranged and we come to the water, then let it be
enclosed by walling without blocking up the veins.

14. But if the locality is stony, or if the veins of
water lie too deep, then supplies are to be collected
from the roofs or higher ground in cement cisterns.
We must proceed thus in making the cement. First
let the purest and roughest sand be provided; then
rubble is to be made of broken flint, no piece weighing
more than a pound; the strongest lime is to be mixed
in a trough, five parts of sand to two of lime. The
trench is to be rammed down to the level of the depth

[1] *naturali* substantive.
[2] The more humane treatment of labour under the Empire
is noteworthy.
[3] Plin. *N.H.* XXXI. 49.
[4] Palladius, IX. 9, quotes from this passage.

15 futurum, calcetur vectibus ligneis ferratis. Parieti-
bus calcatis, in medio quod erit terrenum, exinaniatur
ad libramentum infimum parietum. Hoc exaequato
solum calcetur ad crassitudinem, quae constituta
fuerit. Ea autem si duplicia aut triplicia facta
fuerint, uti percolationibus transmutari possint,
multo salubriorem [et suaviorem][1] aquae usum
efficient; limus enim cum habuerit, quo subsidat,
limpidior fiet et sine odoribus conservabit saporem.
Si non, salem addi necesse erit et extenuari.

Quae potui de aquae virtute et varietate, quasque
habeat utilitates quibusque rationibus ducatur et
probetur, in hoc volumine posui; de gnomonicis[2]
vero rebus horologiorum rationibus insequenti per-
scribam.

[1] et suaviorum *E G* : *om. H S.*
[2] gnominicis *H G S.*

desired with wooden rams shod with iron. 15. After
shaping the walls, the soil in the middle is to be
emptied to the lowest level of the walls; when this
is made even, the bottom is to be covered to the
thickness which has been determined. If the
cisterns are double or treble, so that they can be
changed by percolation, they will make the supply
of water much more wholesome. For when the
sediment has a place to settle in, the water will be
more limpid and will keep a flavour unaccompanied
by smell. If not, salt must be added to purify it.

I have laid down in this volume what I could about
the virtues and varieties of water, its uses, and how
it is supplied and tested; in the next book I will
deal with the making of dials and the theory of
time-pieces.

BOOK IX

LIBER NONUS

1 Nobilibus athletis, qui Olympia, Isthmia, Nemea vicissent, Graecorum maiores ita magnos honores constituerunt, uti non modo in conventu stantes cum palma et corona ferant [1] laudes, sed etiam, cum revertantur in suas civitates cum victoria, triumphantes quadrigis in moenia et in patrias invehantur e reque publica perpetua vita constitutis vectigalibus fruantur. Cum ergo id animadvertam, admiror, quid ita non scribtoribus eidem honores etiamque maiores sint tributi, qui infinitas utilitates aevo perpetuo omnibus gentibus praestant. Id enim magis erat institui dignum, quod athletae [2] sua corpora exercitationibus efficiunt fortiora, scriptores non solum suos sensus, sed etiam omnium, ⟨cum⟩ [3] libris ad discendum et animos exacuendos praeparant praecepta.

2 Quid enim Milo Crotoniates, quod fuit invictus, prodest hominibus aut ceteri, qui eo genere fuerunt victores, nisi quod, dum vixerunt ipsi, inter suos [4] cives habuerunt nobilitatem. Pythagorae vero praecepta, Democriti, Platonis, Aristotelis ceterorumque sapientium cotidiana perpetuis industriis culta non solum suis civibus, sed etiam omnibus gentibus

[1] ferant *ed*: ferrent e_2, fuerant *H*.
[2] athla&e *H*, adhletę *S*. [3] *add. Ro.*
[4] inter uos *H*.

[1] There is no need with *G* to supply a reference to Delphi.

BOOK IX

1. FAMOUS sportsmen who win victories at Olympia, Corinth and Nemea,[1] have been assigned such great distinctions by the ancestors of the Greeks that they not only receive praise publicly at the games, as they stand with palm and crown, but also when they go back victorious to their own people they ride triumphant with their four-horse chariots into their native cities, and enjoy a pension for life from the State. When I observe this, I am surprised that similar or even greater distinctions are not assigned to those authors who confer infinite benefits on mankind throughout the ages. For this is the more worthy of enactment, in that while sportsmen make their own bodies stronger, authors not only cultivate their own perceptions, but by the information in their books prepare the minds of all to acquire knowledge and thus to stimulate their talents.

2. For in what respect could Milo of Croton advantage mankind because he was unconquered, or others who won victories in the same kind, except that in their lifetime they enjoyed distinction among their fellow-citizens? But the daily teachings of Pythagoras, Democritus, Plato, Aristotle, and other thinkers, elaborated as they were by unbroken application, furnish ever-fresh and flowering [2] harvests,

[2] *florida prata*, Lucr. v. 785.

VITRUVIUS

recentes et floridos edunt fructus. E quibus qui a
teneris aetatibus doctrinarum abundantia satiantur,
optimos habent sapientiae sensus, instituunt civita-
tibus humanitatis mores, aequa iura, leges, quibus
3 absentibus nulla potest esse civitas incolumis. Cum
ergo tanta munera ab scriptorum prudentia privatim
publiceque fuerint hominibus praeparata, non solum
arbitror palmas et coronas his tribui oportere, sed
etiam decerni triumphos et inter deorum sedes eos
dedicandos iudicari.

Eorum autem cogitata utiliter hominibus ad vitam
explicandam e pluribus singula paucorum uti exempla
ponam, quae recognoscentes necessario his tribui
4 honores oportere homines confitebuntur. Et primum
Platonis e multis ratiocinationibus utilissimis unam,
quemadmodum ab eo explicata sit, ponam. Locus
aut ager paribus lateribus si erit quadratus eumque
oportuerit duplicare, quod opus fuerit genere numeri,
quod multiplicationibus non invenitur, eo descrip-
tionibus linearum emendatis reperitur. Est autem
eius rei haec demonstratio. Quadratus locus, qui
erit longus et latus pedes denos, efficit areae pedes
c. Si ergo opus fuerit eum duplicare, pedum cc,
item e paribus lateribus facere, quaerendum erit,
quam magnum latus eius quadrati fiat, ut ex eo cc
pedes duplicationibus areae respondeant. Id autem
numero nemo potest invenire. Namque si xiiii
constituentur, erunt multiplicati pedes cxcvi, si
xv, pedes ccxxv.

not only to their fellow-citizens but also to all mankind. Those who from tender years are satisfied thence with abundance of knowledge, acquire the best habits of thought, institute civilised manners, equal rights, laws without which no state can be secure. 3. Since, therefore, such boons have been conferred on individuals and communities by wise writers, not only do I think that palms and crowns should be awarded to them, but that triumphs also should be decreed and that they should be canonised in the mansions of the gods.

I will propose, as examples taken from a great number, several conceptions of a few thinkers which have helped the furnishing of human life, in order that the consideration of these may lead mankind to confess that honours should be conferred upon their inventors. 4. And first, out of the many and most useful theorems of Plato,[1] I will set out one with its demonstration. If there is a square area, or field with equal sides, and it is necessary to double it, there will be required some number which cannot be found by multiplication; this is determined by a perfect geometrical figure. Here is the demonstration. A square space which is ten feet long and wide makes 100 feet. If then it is necessary that it should be made double—of 200 feet—and also to make it of equal sides, we must inquire how long the side of that square is to be made, so that it may produce 200 feet, corresponding to the doubling of the area. No one can discover this by arithmetic. For if the side be 14 feet, then the multiplication gives 196 feet; if 15, then 225 feet.

[1] The Paris MS. 7227 contains an illustration indented into the text.

5 Ergo quoniam id non explicatur numero, in eo quadrato, longo et lato pedes x quod fuerit, linea ab angulo ad angulum diagonios[1] perducatur, uti dividantur duo trigona aequa magnitudine, singula areae pedum quinquagenûm, ad eiusque lineae diagonalis longitudinem locus quadratus paribus lateribus describatur. Ita quam magna duo trigona in minore quadrato quinquagenûm pedum linea diagonio fuerint designata,[2] eadem magnitudine et eodem pedum numero quattuor in maiore[3] erunt effecta. Hac ratione duplicatio grammicis rationibus ab Platone, uti schema[4] subscriptum est, explicata est in ima pagina.

6 Item Pythagoras normam sine artificis fabricationibus inventam ostendit, et quam magno labore fabri normam facientes vix ad verum perducere possunt, id rationibus et methodis emendatum ex eius praeceptis explicatur. Namque si sumantur regulae tres, e quibus una sit pedes III, altera pedes IIII, tertia[5] pedes V, eaeque regulae inter se compositae tangant alia aliam suis cacuminibus extremis schema habentes trigoni, deformabunt normam emendatam. Ad eas autem regularum singularum longitudines si singula quadrata paribus lateribus describantur, cum erit trium latus, areae habebit pedes VIIII, quod IIII, XVI, quod V erit, XXV.

7 Ita quantum areae pedum numerum duo quadrata ex tribus pedibus longitudinis[6] laterum et quattuor efficiunt, aeque tantum numerum reddidit unum ex quinque descriptum. Id Pythagoras cum invenisset,

[1] diagonios *Joc*: diagonis *H*.
[2] designata *ed*: -tae *H*.
[3] quattuori | maiore *H*. [4] scema *H*.
[5] tertia: terua *H*. [6] longitudines *H*.

5. Since arithmetic does not furnish a solution, let a diagonal line be drawn from angle to angle in the square which was 10 feet long and wide, so that two triangles of equal magnitude, each of the area of 50 feet, are described. On the length of the diagonal let a square be described with equal sides. Therefore two triangles of 50 feet in area will be drawn upon the diagonal line in the lesser square; four triangles of the same magnitude and the same number of feet will be described in the larger square. In this manner the duplication is demonstrated geometrically by Plato in accordance with the figure subjoined at the bottom of the page.[1]

6. Again, Pythagoras [2] demonstrated how to make a set-square without the help of a craftsman. And whereas the craftsman with great labour making a set-square can scarcely carry it out accurately, the exact process is explained in accordance with Pythagoras' instructions. For if three straight rods be taken, of which one is 3 feet long, the second 4 feet, the third 5 feet, and let these rods, being jointed together, touch one another at their extremities in the form of a triangle, they will make a perfect set-square.[3] Moreover, if single squares with equal sides be described along the several rods, when the side is 3 feet, it will have 9 feet in area; the 4 feet side, 16; the 5 feet side, 25.

7. Thus the square which is described on 5 feet contains an area measured in feet equal to the area produced by the two squares, one with a side of 3 feet, and one with a side of 4. When Pythagoras

[1] Vitruvius paraphrases Plato, *Meno*, 82 ff.

[2] Pythagoras himself has left no writings; we do not know what belonged to him as distinguished from his school.

[3] This proportion was known empirically to the Egyptians.

non dubitans a Musis se in [1] ea inventione monitum, maximas gratias agens hostias dicitur his immolavisse. Ea autem ratio, quemadmodum in multis rebus et mensuris est utilis, etiam in aedificiis scalarum aedificationibus, uti temperatas habeant graduum librationis, est expedita.

8 Si enim altitudo contignationis ab summa coaxatione [2] ad imum libramentum divisa fuerit in partes tres, erit earum quinque in scalis scaporum iusta longitudine inclinatio. Quam magnae fuerint inter contignationem et imum libramentum altitudinis partes tres, quattuor a perpendiculo recedant et ibi conlocentur inferiores [3] calces scaporum. Ita sic erunt temperatae; et graduum ipsarum scalarum erunt conlocationes. Item eius rei erit subscripta forma.

9 Archimedis vero cum multa miranda inventa et varia fuerint, ex omnibus etiam infinita sollertia id, quod exponam, videtur esse expressum. Nimium Hiero enim Syracusis auctus regia potestate, rebus bene gestis cum auream coronam votivam diis inmortalibus in quodam fano constituisset ponendam, manupretio locavit faciendam et aurum ad sacomam adpendit redemptori. Is ad tempus opus manu factum subtiliter regi adprobavit et ad sacomam

10 pondus coronae visus est praestitisse. Posteaquam indicium est factum dempto auro tantundem argenti in id coronarium opus admixtum esse, indignatus Hiero se contemptum esse neque inveniens, qua

[1] amusise in *H*. [2] coaxatione *S G⁶*: coaxitione *H G*.
 [3] inferiores *Gal*: interiores *H*.

[1] Vitruvius himself regarded scientific discoveries as inspired.
[2] Archimedes thus founded hydrostatics; Mach, *Science of Mechanics, tr.* 86.
[3] Hiero II, 270–216 B.C.

discovered this, in the belief that the Muses had advised [1] him in the discovery, he is said to have thanked them and sacrificed victims to them. The same calculation, as it is useful in many things and measurements, so it applies to buildings in the construction of staircases, for the adjustment of the steps.

8. For if the height of a story from the flooring above to the level below is divided into three parts, five such parts will give the inclined string of the staircase in its exact length. Taking the height between the floor above and the level below as three parts, let four parts be set off from the perpendicular and let the foot of the string be placed there. This will be so adjusted; so also will be the plotting out of the several steps of the staircase itself. The drawing of this, also, is subjoined.

9. Archimedes made many and various wonderful discoveries. Of all these the one which I will explain [2] seems to be worked out with infinite skill. Hiero [3] was greatly exalted in the regal power at Syracuse, and after his victories he determined to set up in a certain temple a crown vowed to the immortal gods. He let out the execution as far as the craftsman's wages [4] were concerned, and weighed the gold out to the contractor to an exact amount.[5] At the appointed time the man presented the work finely wrought for the king's acceptance, and appeared to have furnished the weight of the crown to scale. 10. However, information was laid that gold had been withdrawn, and that the same amount of silver had been added in the making of the crown. Hiero was indignant that he had been made light of, and

[4] Plin. *N.H.* XXXIV. 37.
[5] There was a guild of *sacomarii* makers of weights at Rome.

ratione id furtum reprehenderet, rogavit Archimeden,
uti in se sumeret sibi de eo cogitationem. Tunc is,[1]
cum haberet eius rei curam, casu venit in balineum,
ibique cum in solium descenderet, animadvertit,
quantum corporis[2] sui in eo insideret, tantum aquae
extra solium effluere. Itaque cum eius rei rationem
explicationis ostendisset, non est moratus, sed
exiluit gaudio motus de solio et nudus vadens domum
verius significabat clara voce invenisse, quod quaer-
eret; nam currens identidem graece clamabat
ευρηκα ευρηκα.

11 Tum vero ex eo inventionis ingressu duas fecisse
dicitur massas aequo pondere, quo etiam fuerat
corona, unam ex auro et alteram ex argento. Cum
ita fecisset, vas amplum ad summa labra[3] implevit
aquae, in quo dimisit argenteam massam. Cuius
quanta magnitudo in vasum depressa est, tantum
aquae effluxit. Ita exempta massa quanto minus
factum fuerat, refudit sextario mensus,[4] ut eodem
modo, quo prius fuerat, ad labra aequaretur. Ita
ex eo invenit, quantum ad certum pondus argenti
ad certam aquae mensuram responderet.

12 Cum id expertus esset, tum auream massam similiter
pleno vaso demisit et ea exempta, eadem ratione
mensura addita invenit ex aquae numero non tantum
esse:[5] minore quanto minus magno corpore eodem
pondere auri massa esset quam argenti. Postea vero
repleto vaso in eadem aqua ipsa corona demissa

[1] is S : his H. [2] in del. ed : incorporis H.
[3] libra H. [4] mensus Joc : mensus est H.
[5] non tantum esse Gr : non tantum se H.

204

failing to find a method by which he might detect the theft, asked Archimedes to undertake the investigation. While Archimedes was considering the matter, he happened to go to the baths. When he went down into the bathing pool he observed that the amount of water which flowed outside the pool was equal to the amount of his body that was immersed. Since this fact indicated the method of explaining the case, he did not linger, but moved with delight he leapt out of the pool, and going home naked, cried aloud that he had found exactly what he was seeking. For as he ran he shouted in Greek: heurēka heurēka.[1]

11. Then, following up his discovery, he is said to have taken two masses of the same weight as the crown, one of gold and the other of silver. When he had done this, he filled a large vessel to the brim with water, into which he dropped the mass of silver. The amount of this when let down into the water corresponded to the overflow of water. So he removed the metal and filled in by measure the amount by which the water was diminished, so that it was level with the brim as before. In this way he discovered what weight of silver corresponded to a given measure of water.

12. After this experiment he then dropped a mass of gold in like manner into the full vessel and removed it. Again he added water by measure, and discovered that there was not so much water; and this corresponded to the lessened quantity of the same weight of gold compared with the same weight of silver. He then let down the crown itself into the vase after filling the vase with water,

[1] 'I have found.'

invenit plus aquae defluxisse in coronam quam in
auream eodem pondere massam, et ita ex eo, quod
fuerit plus aquae in corona quam in massa, ratio-
cinatus reprehendit argenti in auro mittionem [1] et
manifestum furtum redemptoris.

13 Transferatur mens ad Archytae Tarentini et Erato-
sthenis Cyrenaei cogitata; hi enim multa et grata a
mathematicis rebus hominibus invenerunt. Itaque
cum in ceteris inventionibus fuerint grati, in eius rei
concitationibus maxime sunt suspecti. Alius enim
alia ratione explicaverunt,[2] quod Delo imperaverat [3]
responsis Apollo, uti arae eius, quantum haberent
pedum quadratorum, id duplicarentur, et ita fore
uti,[4] qui essent in ea insula, tunc religione liberar-
entur.

14 Itaque Archytas cylindrorum descriptionibus,
Eratosthenes organica mesolabi ratione idem ex-
plicaverunt. Cum haec sint tam magnis doctrinarum
iucunditatibus animadversa et cogamur naturaliter
inventionibus singularum rerum considerantes effec-
tus moveri, multas res attendens admiror etiam
Democriti de rerum natura volumina et eius com-

[1] mittionem *H* : *v.l.* mittix *pro* miscix *Petr.* 46. 5.
[2] explicaverunt *rec* : explicarentur *H*.
[3] impetraverat *H*.
[4] fore uti *Ro* : forenti *H S*.

[1] The Delian problem, the duplication of the cube is solved
by finding two mean proportionals. If $a : x :: x : y$, and
$x : y :: y : b$, then $x^2 = ay$ and $y^2 = xb$. Hence $y^4 = x^2b^2 =$
ayb^2; or $y^3 = ab^2$. Therefore if $a = 2b$, $y^3 = 2b^3$; and y is

and found that more water flowed into the space left by the crown than into the space left by a mass of gold of the same weight. And so from the fact that there was more water in the case of the crown than in the mass of gold, he calculated and detected the mixture of the silver with the gold, and the fraud of the contractor.

13. Let us turn our attention to the theorems of Archytas of Tarentum, and of Eratosthenes of Cyrene. For they made for mankind many welcome discoveries by means of mathematics. While, therefore, they were made welcome by their other inventions, they were most admired for their mathematical inspirations. For they satisfied, each by his own method, the demand which Apollo had imposed upon Delos:[1] namely, that the number of cubic feet in his altar should be doubled, and that thereby the residents in the island should be freed from a religious scruple.

14. Archytas[2] solved the problem by a diagram with cylinders; Eratosthenes by means of an instrument the *mesolabium*.[3] These theorems are apprehended with the great pleasure which such methods can give. For we are compelled, when we consider the effects of individual causes, to feel a natural emotion in the presence of inventions. After a wide survey, I admire especially Democritus' treatises on the Nature of Things, and in them the commentary in which there is figured the cutting of

the side of the cube which shall be twice the cube of which *b* is the length of the side.

[2] Hippocrates of Chios formulated the problem in the terms of the previous note. Archytas gave a geometrical solution.

[3] Eratosthenes' mechanical contrivance is illustrated on Plate K.

mentarium, quo scribitur [1] *cheirotometon*; [2] in quo
etiam utebatur anulo signaturam optice [3] est expertus.

15 Ergo eorum virorum cogitata non solum ad mores
corrigendos, sed etiam ad omnium utilitatem per-
petuo sunt praeparata, athletarum autem nobilitates
brevi spatio cum suis corporibus senescunt; [itaque
neque cum maxime sunt] [4] florentes neque posteritati
hi, quemadmodum sapientium cogitata hominum
vitae, prodesse possunt.

16 Cum vero neque moribus neque institutis scrip-
torum praestantibus tribuantur honores, ipsae autem
per se mentes aeris altiora prospicientes memoriarum
gradibus ad caelum elatae [5] aevo inmortali [6] non
modo sententias sed etiam figuras eorum posteris
cogunt esse notas. Itaque, qui litterarum iucundi-
tatibus instinctas habent mentes, non possunt non
in suis pectoribus dedicatum [7] habere, sicuti deorum,
sic Enni poetae simulacrum; Acci autem carminibus
qui studiose delectantur, non modo verborum vir-
tutes sed etiam figuram eius videntur secum habere
praesentem esse. [8]

[1] quo scribitur *Gr* : quod scribitur *H*.
[2] ΧΕΙΡΟΤΟΜΗΤΟΝ *H*.
[3] signaturam optice *Gr* : signaretur amolcie *H*.
[4] itaque neque cum maxime sunt *E G* : om. *H S*: *interpola-
tionem ineptam quae contentionem* senescunt; florentes *perdit*.
[5] elatae *Joc* : -ti *H*.
[6] aevo inmortali *E G* : aeuum imortalitati *H*.
[7] dedicatum *Joc* : -tas *H*. [8] *locutio usitata apud Vitr.*

[1] The influence of gem-cutting may perhaps be traced
in the atomic philosophy. It is possible that the hardness
of the diamond and corundum (with its allies), which is twice
the hardness of iron, along with their crystalline shape,
suggested the properties ascribed to atoms: the *ordo positura
figurae* as Lucretius puts it.
[2] Democritus' application of his theory of projection to

gems.[1] With the help of optics,[2] he investigated
the impression of the seal in the ring which he used.

15. So then the imaginations of these men were
directed throughout not only to the improvement of
conduct, but to the service of mankind. The dis-
tinctions of sportsmen soon pass along with their
physique, nor in their prime can they advantage
posterity, as the devices of thinkers advantage
human life.

16. Thus although honour is given neither to the
character nor to the excellent principles of authors,
yet their minds of themselves look upon the upper
air and rise to heaven by the staircase of human
remembrance;[3] throughout endless time they make
not only their ideas but even their portraits familiar
to posterity. Hence those whose minds are stirred
by the delights of literature cannot but have the
image of Ennius, as of a god, in the chapel of their
breast. Those who take studious delight in the
poems of Accius[4] seem to keep at their side, not only
his mighty words, but his very present portrait.

perspective was probably contained in his *actinographie*,
(Ionic for *actinographia*) Diels, *Fragmente der Vorsokratiker*,
II. 64. In that case the *cheirotometon* (Plate K) would be an
illustration of an expedient comparable to the *mesolabium*, as
an invention following upon a theory of causes. The current
mistranslation of this passage arose from rendering *scribitur* as
'write.' In technical language it often means 'draw,' as in
Cic. *Tusc.* V. 113, *lineam scribere.* Vitruvius' account of geo-
metrical figures drawn on the shore at Rhodes, along with this
passage, suggests that Jesus did not 'write,' but 'drew,' *John*
viii. 6.

[3] Vitruvius probably does not go beyond the idea of sur-
vival contained in Ennius' *volito vivos per ora virum*, 'I live
and fly from lip to lip.'

[4] Accius, the greatest tragic dramatist of Rome, was born
170 B.C.

209

17 Item plures post nostram memoriam nascentes
cum Lucretio videbuntur velut coram de rerum
natura disputare, de arte vero rhetorica cum Cicerone,
multi posterorum cum Varrone conferent sermonem
de lingua latina, non minus etiam plures philologi
cum Graecorum sapientibus multa deliberantes
secretos cum his videbuntur habere sermones, et ad
summam sapientium scriptorum sententiae corpor-
ibus absentibus vetustate florentes cum insunt inter
consilia et disputationes, maiores habent, quam
praesentium sunt, auctoritates omnes.

18 Itaque, Caesar, his auctoribus fretus sensibus
eorum adhibitis et consiliis ea volumina conscripsi,
et prioribus septem de aedificiis, octavo de aquis,
in hoc de gnomonicis rationibus, quemadmodum de
radiis solis in mundo sunt per umbras gnomonis
inventae quibusque rationibus dilatentur aut con-
trahantur, explicabo.

I

1 Ea autem sunt divina mente comparata habentque
admirationem magnam considerantibus, quod umbra
gnomonis aequinoctialis alia magnitudine est Athenis,

[1] Traces of Lucretius' influence occur in the astronomical
references of Vitruvius.

[2] Cicero, *de Oratore*, I. 62, ascribes the eloquence displayed
sometimes by architects, not to their calling, but to the art of
rhetoric; cf. Book I. i. 18.

17. Many also, born in time to come, will seem with Lucretius to investigate *The Nature of Things*, as it were, face to face,[1] or with Cicero, *The Art of the Orator*;[2] many of our posterity will hold converse with Varro[3] *On the Latin Language*; not less, also, many scholars deliberating much with the thinkers of Greece, will seem to hold secret converse with them. In a word, the ideas of scientific writers who are absent in the body, old and yet ever new, come to our counsels and investigations; and all have greater weight than if they were present with us.

18. Therefore, your Highness, I have relied on these authors, and bringing their minds and advice to bear, I have composed these volumes, dealing with buildings in the first seven, and with water in the eighth. In the present volume I will expound the methods of Dialling; how they were discovered from the rays of the sun in the universe, by the shadows of the gnomon, and in what proportions these lengthen or diminish.

CHAPTER I

ON THE UNIVERSE AND THE PLANETS

1. It is ordained by the divine spirit[4] and inspires great wonder[5] in those who consider it, that the shadow of the gnomon at the equinox is of one magni-

[3] Vitruvius drew also upon Varro's *de Re Rustica*; but his references to philosophers came, not from Varro, but from Greek sources.

[4] *hoc opus immensi constructum corpore mundi . . . vis animae divina regit.* Man. i. 247–9.

[5] *mundi et astrorum magnificentia*, Book II. i. 2.

alia Alexandriae, alia Romae, non eadem Placentiae
ceterisque orbis terrarum locis. Itaque longe aliter
distant descriptionis horologiorum locorum mutation-
ibus. Umbrarum enim aequinoctialium magnitudin-
ibus designantur [1] analemmatorum formae, e quibus
perficiuntur ad rationem locorum [2] et umbrae
gnomonum [3] horarum descriptiones. *Analemma* est
ratio conquisita solis cursu et umbrae crescentis ad
brumam [4] observatione inventa, e qua per rationes
architectonicas circinique descriptiones est inventus
effectus in mundo.

2 Mundus autem est omnium naturae rerum con-
ceptio summa caelumque sideribus conformatum.[5]
Id volvitur continenter circum terram atque mare
per axis cardines extremos. Namque in his locis
naturalis potestas ita architectata [6] est conlocavitque
cardines tamquam centra, unum a terra inmane [7] in
summo mundo ac post ipsas stellas septentrionum,
alterum trans contra sub terra in meridianis partibus,
ibique circum eos cardines orbiculos circum centra
uti in torno perfecit, qui graece *apsides* [8] nominantur,
per quos pervolitat sempiterno caelum. Ita media
terra cum mari centri loco naturaliter est conlocata.

3 His natura dispositis ita, uti septentrionali parte
a terra excelsius habeat altitudinem centrum, in
meridiana autem parte in inferioribus locis subiectum

[1] designantur *G* : desidesignantur *H*, si designantur *S G°*.
[2] locorum *rec* : longorum *H G S*.
[3] gnomoniū *H S*.
[4] ad brumam *Ro* : abrumae *H*.
[5] conformatum *G°* : -tus *H*.
[6] architecta *H S* (*cf.* naturae architectae vis, *Plin. N. H.* X.
196, *Hard.*).
[7] inmane *Gr* : inmani *H*.
[8] apsides *Gr* : pasde *H*.

tude at Athens, another at Alexandria, another at
Rome, is different at Piacenza and in other parts of
the world. Therefore the designs of dials vary widely
with change of place. For the length of the shadows
at the equinox determines the design of the *analemma*[1]
by which the hours are marked in accordance with
the locality and the shadow of the gnomon. The
analemma is an exact contrivance invented by
observing the course of the sun and the lengthening
of the shadow towards the winter, by means of
which through architectural[2] calculations and the
use of the compass, the action of the sun in the
universe is discovered.

2. The universe is the total conception of the
whole system, and the firmament with its ordered
constellations. It rolls continually round the earth
and sea, on the furthest poles[3] of its axis. For
there the power of nature like an architect, has
contrived and placed the poles like centres, one at
a vast distance from the earth at the top of the
universe and behind the very stars of the Great
Bear, and the other opposite, under the earth in
the regions of the south; and there has constructed
rims of wheels (which the Greeks call *apsides*) round
centres as in a lathe, about which the firmament
for ever rolls. Thus the middle of the earth and
sea is set by nature in the central place.

3. The arrangement of nature is such that on the
north the higher centre is exalted above the earth, while
in the southern part the centre lying under the lower

[1] Plate L. The analemma is a geometrical figure with the
help of which dials are drawn.

[2] Architecture includes engineering.

[3] Lit. ' hinges.'

a terra obscuretur, tunc etiam per medium transversa et inclinata in meridiem circuli delata zona XII signis est conformata. Quae eorum species stellis dispositis XII partibus peraequatis exprimit depictam ab natura figurationem. Itaque lucentia cum mundo reliquisque sideribus ornatu [1] circum terram mareque pervolantia cursus perficiunt ad caeli rotunditatem.

4 Omnia autem visitata et invisitata temporum necessitate sunt constituta. Ex quis sex signa numero supra terram cum caelo pervagantur, cetera sub terram subeuntia ab eius [2] umbra obscurantur. Sex autem ex his semper supra terram nituntur. Quanta pars enim novissimi signi depressione coacta versatione subiacens [3] sub terram occultatur, tantundem eius contraria e conversationis necessitate suppressa rotatione [4] circumacta trans locis patentibus ex [5] obscuris egreditur ad lucem; namque vis una et necessitas utrimque simul orientem et occidentem perficit.

5 Ea autem signa cum sint numero XII partesque duodecumas singula possideant mundi versenturque ab oriente ad occidentem continenter, tunc per ea signa contrario cursu luna, stella Mercuri, Veneris, ipse sol itemque Martis et Iovis et Saturni ut per graduum ascensionem [6] percurrentes alius alia circuitionis magnitudine ab occidenti ad orientem in mundo pervagantur. Luna die octavo et vicesimo

[1] ornatū *H*. [2] ab eis *H G*.
[3] subiacens *Gr*: subiciens *H* (*Iren. C.H.* II. 28. 3).
[4] rotatione *Joc*: notatione *H*.
[5] ex *Ro*: & *H*.
[6] ascensione *H*.

[1] The Zodiac: an imaginary belt extending about eight degrees on either side of the ecliptic.

regions is hidden. Then, moreover, along the middle
a transverse and oblique belt,[1] sinking towards the
south of the equator, is figured with the twelve
signs. (This figure of theirs with stars set in order
reveals in twelve equal parts the pattern depicted
by nature.)[2] These, as they shine in their array,
along with the heavens and the other constellations,
roll round the earth and sea and complete their
courses with the revolution of the sky.

4. Now all the signs seen or unseen are constituted
by the necessity of the seasons. While six of these
revolve above the earth along with the sky, the
others going under the earth are obscured by its
shadow. Six, however, are always placed above
the earth. For whatever part of the last sign driven
by its revolution passes under the earth and is
concealed by its depression, to that extent the con-
trary sign forced upwards by the necessity of the
revolution is carried round in rotation and from
darkness comes to light in the visible heavens.
For a single power and compulsion controls
simultaneously on both sides the rising and the
setting.

5. Now while these twelve signs possess each the
twelfth part of the firmament, and continually turn
from east to west, through these same signs in the
opposite direction the stars [3] of the moon, Mercury,
Venus, the Sun himself and also Mars, Jupiter and
Saturn as though they revolved upon a rising stair-
case of degrees, each with an orbit of its own, wander
in the firmament from west to east. The moon runs

[2] Nature as the artificer.

[3] *stella* in Manilius often = 'planet,' Housman, *ad* Man. i.
15, *adversos stellarum noscere cursus.*

et amplius circiter hora caeli circuitionem percurrens, ex quo signo coeperit ire, ad id signum revertendo perficit lunarem mensem.

6 Sol autem signi spatium, quod est duodecuma pars mundi, mense vertente vadens transit; ita XII mensibus XII signorum intervalla pervagando cum redit ad id signum, unde coeperit, perficit spatium vertentis anni. Ex eo, quem circulum luna terdecies in XII mensibus percurrit, eum sol eisdem [1] mensibus semel permetitur. Mercuri autem et Veneris stellae circa solis radios uti per centrum eum [2] itineribus coronantes regressus retrorsus et retardatione faciunt, etiam stationibus propter eam circinationem morantur in spatiis signorum.

7 Id autem ita esse maxime cognoscitur ex Veneris stella, quod ea, cum solem sequatur, post occasum eius apparens in caelo clarissimeque lucens vesperugo vocitatur, aliis autem temporibus eum antecurrens et oriens ante lucem lucifer appellatur. Ex eoque nonnumquam plures dies in signo commorantur, alias celerius ingrediuntur in alterum signum. Itaque quod non aeque peragunt numerum dierum in singulis signis, quantum sunt moratae prius, transiliendo celerioribus itineribus perficiunt [iustum cursum. Ita efficitur,] [3] uti, quod demorentur in nonnullis signis, nihilominus, cum eripiant se ab necessitate morae, celeriter consequantur iustam circuitionem.

8 Iter autem in mundo Mercuri stella ita pervolitat, uti trecentesimo et sexagensimo die per signorum

[1] cum sole isdem H. [2] eum *rec*: cum H.
[3] iustum—efficitur *E G*: om. *H S*: *interpolator quid significet vox* perficiunt *cum* uti *coniuncta, nescire videtur.*

[1] *retardatione* is doubtful.

through its orbit from the sign in which it began, on the twenty-eighth day and about an hour more, and returning to that sign completes the lunar month.

6. The sun, journeying for a month, passes over the space of a sign which is the twelfth part of the heavens. Thus in twelve months he traverses the distance of twelve signs, and when he returns to the sign from which he started, he completes the space of the revolving year. Hence the sun measures once in twelve months the circle which the moon in the same number of months runs through thirteen times. The planets Mercury and Venus, with their orbits, encircling the sun's rays as on a centre, retreat backwards and delay their course;[1] thus because of their orbit they delay at the nodes[2] in their course through the signs.

7. This is best seen from the planet Venus, because when it follows the sun it appears in the sky after sunset, and brightly shining is called the Evening Star.[3] At other times it precedes the sun, and rising before the dawn is called Lucifer. Hence sometimes they delay several days in a sign, sometimes they enter more quickly into another sign. Therefore because they do not spend uniformly a fixed number of days in the several signs, they make up by quicker movements the amount they previously delayed; so that while they delay in some signs, none the less, when they escape the compulsion of delay, they quickly make up their proper course.

8. The planet Mercury so completes its path in the firmament that, traversing the spaces of the

[2] Where the orbit of the planet intersects the ecliptic, in Greek στηριγμοί.

[3] nec matutinis fulgeret Lucifer horis Hesperos emenso dederat qui lumen Olympo, Man. i. 177–8.

spatia currens perveniat ad id signum, ex quo priore
circulatione coepit facere cursum, et ita peraequatur
eius iter, ut circiter tricenos dies in singulis signis
habeat numeri rationem.

9 Veneris autem, cum est liberata ab inpeditione
radiorum solis, xxx diebus percurrit signi spatium.
Quo minus quadragenos dies in singulis signis
patitur, cum stationem fecerit, restituit eam sum-
mam numeri in uno signo morata. Ergo totam[1]
circinationem[2] in caelo quadringentesimo et octo-
gensimo et quinto die permensa[3] iterum in id signum,
ex quo signo prius iter facere coepit.

10 Martis vero circiter sescentesimo octogensimo
tertio siderum spatia pervagando pervenit eo, ex
quo initium faciendo cursum fecerat ante, et in
quibus signis celerius percurrit, cum stationem fecit,
explet dierum numeri rationem. Iovis autem placi-
dioribus gradibus scandens contra mundi versationem,
circiter ccclx diebus in singula signa permetitur, et
consistit post annum xi et dies cccxiii[4] et redit in
id signum, in quo ante xii annos fuerat. Saturni
vero, mensibus undetriginta et amplius paucis diebus
pervadens per signi spatium, anno nono et vicensimo
et circiter diebus clx, in quo ante tricensimo fuerat
anno, in id restituitur, ex eoque, quo minus ab
extremo distat mundo, tanto maiorem circinationem
rotae percurrendo tardior videtur esse.

11 Ei autem, qui supra solis iter circinationes peragunt,

[1] ergo totam *G* : ergotam *H*.
[2] circinationem *Ro* : circitionem *H*.
[3] permansa *H*.

signs, it arrives on the three-hundred-and-sixtieth day at that sign, from which in its previous revolution it entered on its course. Its path is so averaged that it spends about thirty days in each sign.

9. The planet Venus, when it is freed from the hindrance of the sun's rays, traverses the space of some signs in thirty days; so far as it suffers an abatement from forty days in the several signs, after traversing a node, it regains that amount lost by delaying in the several signs. Therefore it completes the whole circuit in the firmament on the four-hundred-and-eighty-fifth day, in that sign from which previously it started on its journey.

10. Mars traverses the spaces of the constellations on about the six-hundred-and-eighty-third day, and reaches the place from which it previously made a beginning in making its journey; where it runs more quickly in the signs, it fulfils the proportionate number of days after passing a node. Jupiter, rising by more easy steps against the revolution of the firmament, measures about three hundred and sixty days against each sign, and after eleven years and three hundred and thirteen days it halts and returns to the sign where it had been twelve years before. Saturn, traversing a sign in twenty-nine months and a few days, takes twenty-nine years and about a hundred and sixty days to regain the sign in which it was thirty years before. From the fact that it is less distant from the furthest verge of the firmament, it seems to be more slow in traversing the greater circumference of its orbit.

11. Those planets which traverse their orbit above

[4] cccxiii *Mar*: cccxxiii *H*.

maxime cum in trigono fuerint, quod is inierit, tum
non progrediuntur, sed regressus facientes morantur,
donique cum [1] idem sol de eo trigono in aliud signum
transitionem fecerit. Id autem nonnullis sic fieri
placet, quod aiunt solem, cum longius absit abstantia
quadam, non lucidis itineribus errantia per ea sidera
obscuritatis morationibus inpedire.[2] Nobis vero id
non videtur. Solis enim splendor perspicibilis et
patens sine ullis obscurationibus est per omnem
mundum, ut etiam nobis appareant, cum facient eae
stellae regressus et morationes. Ergo si tantis
intervallis nostra species potest id animadvertere,
quid ita divinationibus splendoribusque astrorum
iudicamus obscuritatis obici posse?

12 Ergo potius ea ratio nobis [3] constabit, quod, fervor
quemadmodum omnes res evocat et ad se ducit, ut
etiam fructus e terra surgentes in altitudinem per
calorem videmus, non minus aquae vapores a fon-
tibus ad nubes per arcus excitari, eadem ratione solis
impetus vehemens radiis trigoni [4] forma porrectis
insequentes stellas ad se perducit et ante [5] currentes
veluti refrenando retinendoque [6] non patitur pro-
gredi, sed ad se regredi, in alterius trigoni signum
esse.

13 Fortasse desiderabitur, quid ita sol quinto a se
signo potius quam secundo aut tertio, quae sunt
propiora,[7] facit in his fervoribus retentiones. Ergo,
quemadmodum id fieri videatur, exponam. Eius

[1] donique cum = donicum, *Munro (ad Lucr.* ii. 1116): de-
nique cum *H.*
[2] impedire *Schn*: -ri *H.*
[3] ratio nobis *H S G*c: rationibus *G.*
[4] radiis trigoni *rec*: adiis trigoni *H.*
[5] et ante *Joc*: tantae *H*, ante *S.*
[6] r&enendoq; *H.* [7] propriora *H.*

the path of the sun, especially when they are in the trigon [1] which he has entered, do not go forward but retrograde and delay until the same sun has passed from that trigon into another sign. To some, this seems to happen because the sun, they say, being further away at a certain distance, hinders by the delay of darkness the planets wandering in their unillumined paths. To us it seems otherwise. For the splendour of the sun is perceptible and patent through all the universe without any obscuration, so that these stars appear [2] to us even when they retrograde or are stationary. Therefore if our vision can perceive it at such great distances, why do we judge that obscurity may be set against the prophetic splendours of the stars?

12. Therefore the consideration rather commends itself to us that, just as heat evokes all things and draws them to itself, as also we see the crops rising on high from the earth because of the heat, and the watery exhalations raised from the springs to the clouds along the rainbow, so in the same way the mighty force of the sun extending its rays in the form of a triangle draws to itself the planets as they follow, and, as it were curbing and restraining those which precede, prevents their onward movement and compels them to return to it and to be in the sign of another trigon.

13. Perhaps it will be asked, why does the sun cause delay by these heats, in the fifth sign away from itself rather than in the second and third? I will therefore explain how this seems to happen.

[1] Group of four signs answering to one side of an equilateral triangle described in the sun's apparent orbit.

[2] The planets even at night draw their light from the sun.

radii in mundo uti trigoni paribus lateribus [1] formae
liniationibus extenduntur. Id autem nec plus nec
minus est ad quintum [2] ab eo signo. Igitur si radii
per omnem mundum fusi circinationibus vagarentur
neque extentionibus porrecti ad trigoni formam
liniarentur, propiora [3] flagrarent. Id autem etiam
Euripides, Graecorum poeta, animadvertisse videtur.
Ait enim, quae longius a sole essent, haec vehemen-
tius ardere, propiora [4] vero eum temperata habere.
Itaque scribit in fabula Phaethonte [5] sic:

κάιει τὰ πόρρω, τἄγγυθεν δ' εὔκρατ' ἔχει. [6]

14 Si ergo res et ratio et testimonium poetae veteris
id ostendit, non puto aliter oportere iudicari, nisi
quemadmodum de ea re supra scribtum habemus.

Iovis autem inter Martis et Saturni circinationem [7]
currens maiorem quam Mars, minorem quam Saturnus
pervolat cursum. Item reliquae stellae, quo maiore
absunt spatio ab extremo caelo proxumamque habent
terrae circinationem,[7] celerius videntur, quod quae-

[1] lateribus *G*: lateribusque *H S G*ᶜ.
[2] quintum *Joc*: quintā *H*.
[3] propiora *H*ᶜ *S*: propriora *H*.
[4] propriora *H*.
[5] phaetonte *H*.
[6] ΚΑιειΤΑΤΓΟΡΡωΤΑΝΓΥΓΝΑιειεΥΧΡΑΤΑεΧει *H*: τἄγγυθεν
Valcken: ευκρατ' *Joc*.
[7] circitionem *H*.

[1] The sun is separated from the opposite trigon by the
space of a trigon on either side: each side of the equilateral
triangle corresponding to a trigon.
[2] Euripides gave expression in his plays to the philosophical
ideas of his time without engaging in purely philosophical
writing.

Its rays are spread out in the firmament on the lines
of the diagram of a triangle with equal sides. Now
each side extends neither more nor less than to the
fifth sign, from that in which the sun is.[1] For if the
rays spread over the firmament wandered in circular
orbits, and in their extension were not directed in the
form of a triangle, the nearer regions would be burnt.
Euripides,[2] the Greek poet, seems to have observed
this. For he says that what is farther from the sun
burns more vehemently, while it keeps what is
nearer in a temperate state. And so he writes as
follows in the *Phaethon* :[3]

He burns the distant: what is near he keeps
 temperate.

14. If then experience, calculation and the testi-
mony of an ancient poet [4] shows [5] this, I think we
should not judge otherwise than as we have written
above on the matter.

Jupiter, traversing its orbit between Mars and
Saturn, pursues a course longer than that of Mars,
less than Saturn's. The other planets, also, the
farther they are from the verge of the firmament,
have an orbit nearest the earth and seem to move
more swiftly, because each of them, traversing a

[3] Vitruvius, VIII. pref. 1, quoted from the *Chrysippus* a
passage almost expressed in philosophic terms. Here the
sun is a king with his palace in Ethiopia. The preceding line
runs : ' the hot fire of the king rising over the earth.'
Grotius according to Schneider was the first to connect these
two lines.

[4] Vitruvius analyses the notion of ' authority ' *auctoritas*,
which occurs so often in his work, adding ' testimony ' to the
res and *demonstratio* of I. i. 3.

[5] The singular verb corresponds to the logical unity of the
subject.

cumque earum [1] minorem circinationem peragens saepius subiens praeterit superiorem.

15 Quemadmodum, si in rota, qua figuli utuntur, inpositae fuerint septem formicae canalesque totidem in rota facti sint circum centrum in imo adcrescentes ad extremum, in quibus hae cogantur circinationem facere, verseturque rota in alteram partem, necesse erit eas contra rotae versationem nihil minus adversus itinera perficere, et quae proximum centrum habuerit, celerius pervagari, quaeque extremum orbem rotae peragat, etiamsi aeque celeriter ambulet, propter magnitudinem circinationis multo tardius perficere cursum : similiter astra nitentia contra mundi cursum suis itineribus perficiunt circuitum, sed caeli versatione redundationibus referuntur cotidiana temporis circumlatione.

16 Esse autem alias stellas temperatas, alias ferventes, etiamque frigidas haec esse causa videtur, quod omnis ignis in superiora loca habet scandentem flammam. Ergo sol aethera, qui est supra se, radiis exurens efficit [2] candentem, in quibus locis habet cursum Martis stella; itaque fervens ab ardore solis efficitur. Saturni autem, quod est proxima extremo mundo tangit congelatas caeli regiones; vehementer est frigida. Ex eo Iovis, cum inter utriusque circuitiones habet cursum, a refrigeratione caloreque eorum medio convenientes temperatissimosque habere videtur effectus.

[1] earum *ed* : eorum *H*.　　　[2] effecit *H*.

[1] The illustration from the movements of ants was used by contemporary mathematicians. Schneider *ad loc.* quotes Cleomedes and Achilles Tatius (not the novelist).

[2] *Vehementer* with an adjective.

less orbit, more often moves under and passes the planet above it.

15. To illustrate [1] this: let us suppose that on a wheel such as potters use, seven ants are placed, and as many channels are made in the wheel round the centre as the lowest point, increasing in length to the most distant; let the ants be compelled to make a circuit in these channels and let the wheel be turned the other way; in spite of the revolution of the wheel, they will necessarily complete their journeys in the opposite direction. That which has the channel nearest the centre completes its wanderings more quickly; that which traverses the farthest circuit of the wheel, even if it walks as quickly, finishes its course much more slowly on account of the magnitude of the orbit. In like fashion, the planets advancing in a direction opposite to the movement of the firmament complete a circuit along their own paths. Yet in the revolution of the sky they are carried backwards, by the excess of it over their own motion, in the daily circuit of time.

16. The reason why some stars are temperate, others fiery and others cold, seems to be this, that all fire has a flame which rises to higher regions. Therefore the sun scorches with its rays the aether above it and causes it to burn, and the planet Mars has its course in these regions; hence it is made to burn by the heat of the sun. The planet Saturn, however, which is nearest to the verge of the firmament, touches the frozen regions of the sky; it is exceedingly cold.[2] Hence Jupiter, having its course between the circuits of either, seems to enjoy the most temperate effects of cold and heat, which suit its middle position.

De zona XII signorum et septem astrorum contrario opere ac cursu, quibus rationibus et numeris transeunt e signis in signa, et circuitum eorum, uti a praeceptoribus accepi, exposui; nunc de crescenti lumine lunae deminutioneque, uti traditum est nobis a maioribus, dicam.

II

1 BEROSUS, qui ab Chaldaeorum civitate sive natione progressus in Asia etiam disciplinam Chaldaicam [1] patefecit, ita est professus:

Pilam esse ex dimidia parte candentem, reliqua habere caeruleo colore. Cum autem cursum itineris sui peragens subiret sub orbem solis, tunc eam radiis et impetu caloris corripi convertique candentem propter eius proprietatem luminis ad lumen. Cum autem ea vocata ad solis orbem [2] superiora spectent, tunc inferiorem partem eius, quod candens non sit, propter aeris similitudinem obscuram videri. Cum ad perpendiculum esset ad eius radios, totum lumen ad superiorem speciem retineri, et tunc eam vocari primam.

[1] chaldaeicam *H.* [2] orbem *Gr :* orbis *H.*

[1] Berosus was a priest of Bel at Babylon, later he settled at Cos, *infra*, c. vi. 2. He dedicated his *Chaldaica* to Antiochus Soter. He invented a form of dial, c. viii. 1.

[2] Vitruvius' phrase ' city, or rather nation,' corresponds to the fact that the city of Babylon was in ruins beginning from its capture by Darius. Antiochus Soter, however, restored the temple of Bel.

I have explained the belt of the twelve signs, and the contrary operation and course of the seven planets; the causes and numerical relations by which they pass from sign to sign, and their revolutions as I have learned from my masters. I will now speak of the rising light and waning of the moon, as our predecessors have told us.

CHAPTER II

ON THE RISING AND WANING OF THE MOON

1. BEROSUS,[1] who sprang from the Chaldaean city, or rather nation,[2] expounded the Chaldaean discipline as far as Asia. He taught as follows:

The moon is a globe with one hemisphere luminous[3] and the other of a dark blue colour. Now when it traverses the course of its orbit, and comes under the sun's disk, it is attracted by the sun's rays and violent heat, and, because of the property of the sun's light, the shining hemisphere of the moon turns to that light. But while those upper parts which are attracted look towards the sun's sphere, the lower hemisphere of the moon, which does not shine, seems dark because of its resemblance to the air. When the moon is perpendicular to the sun's rays, all its light is held back on its upper face, and it is then called the first moon.

[3] Berosus uses the phrase ἡμιπύρωτον σφαῖραν, Stob. Ecl. I. 26. 12. From him Lucretius drew the description of the Chaldaean theory, v. 720–728 : versarique potest, globus ut, si forte, pilai dimidia ex parti candenti lumine tinctus, versandoque globum variantis edere formas, etc.

2 Cum praeteriens vadat ad orientis caeli partes,
relaxari ab impetu solis extremamque eius partem
candentiae oppido quam [1] tenui linia ad terram
mittere splendorem, et ita ex eo eam secundam
vocari. Cotidiana autem versationis remissione ter-
tiam, quartam in dies numerari. Septimo die, sol
sit ad occidentem, [luna autem inter orientem et
occidentem] [2] medias caeli teneat regiones, quod
dimidia parte caeli spatio distaret a sole, item dimid-
iam [3] candentiae conversam habere ad terram. Inter
solem vero et lunam cum distet totum mundi spatium
et lunae orienti [4] sol trans contra sit [5] ad occidentem,
eam, quo longius arsit, a radiis remissam XIIII die
plena rota totius orbis mittere splendorem, reliquos-
que dies decrescentia cotidiana ad perfectionem
lunaris mensis versationibus et cursu a sole revocation-
ibus subire sub rotam radiosque eius, et iam mens-
truas dierum efficere rationes.

3 Uti autem Aristarchus [6] Samius mathematicus
vigore magno rationes varietatis [7] disciplinis de
eadem [8] reliquit,[9] exponam. Non enim latet lunam
suum propriumque non [10] habere lumen, sed esse uti
speculum et ab solis impetu recipere splendorem.

[1] quam *ed* : quamquam *H*.
[2] luna—occidentem *G*: *om. H S. luna facile intellegitur.*
[3] dimidiam *E* : -dia *H*.
[4] orienti *E* : -tis *H G S*.
[5] sol trans contra sit *Ro* : sol trans cum transit *H*.
[6] aristarchus *G* : arhistartus *H*.
[7] varietates *H G^c*. [8] *sc.* luna.
[9] reliquid *H*. [10] non *add. Joc.*

[1] Berosus' optical theory of the conflict between the rays
from the moon and the more powerful rays of the sun antici-

2. When the moon in its passage moves towards
the eastern parts of the sky, it begins to be released
from the sun's force, and the extreme edge of its
shining hemisphere in a very thin line lets fall its
splendour on the earth; and so therefrom it is called
the second moon. Owing to the daily retardation of
its revolution, the third and fourth moons and so on
are numbered. On the seventh day let the sun be
towards the west; the moon occupies the middle
region of the sky and has half of the shining hemi-
sphere turned upon the earth because it is distant
from the sun by a space equal to the half part of the
sky. But when the whole space of heaven separates
the sun and moon, and the sun is opposed on
the west to the rising moon, the moon, burning at a
greater distance, is released from the sun's rays,[1]
and on the fourteenth day sends forth its splendour
with the full disk of its whole orb. During the
remaining days there is a daily decrease until the
lunar month is complete; the moon as it revolves
along its course is recalled under the sun's disk and
rays, and now [2] completes the order of the days
of the month.[3]

3. I will now explain how Aristarchus the mathe-
matician of Samos, by his powerful intelligence, left
in his systematic works an explanation of the moon's
phases. For it does not escape him that the moon
has not its own proper light, and that it is like a
mirror and receives its splendour from the sun's

pated Young's discovery of the absorption of light by inter-
ference.

[2] *etiam = et iam*; cf. *quon-iam, nunc iam.*

[3] The whole theory of Berosus about the moon is to be read
in the light of the phases of the moon as shown in the diagram,
Pl. J.

Namque luna de septem astris circulum proximum
terrae in cursibus minimum pervagatur. Ita quot[1]
mensibus sub rotam solis radiosque uno die, ante-
quam praeterit, latens obscuratur. Cum est cum
sole, nova vocatur. Postero autem die, quo numer-
atur secunda, praeteriens ab sole visitationem facit
tenuem extremae rotundationis. Cum triduum
recessit ab sole, crescit et plus inluminatur. Cotidie
vero discedens cum pervenit ad diem septimum,
distans a sole occidente circiter medias caeli regiones,
dimidia luce, et eius quae ad solem pars spectat, ea
est inluminata.

4 Quarto[2] autem decumo[3] die, cum in diametro spatio
totius mundi absit ab sole, perficitur plena et oritur,
cum sol sit ad occidentem, ideo quod totum spatium
mundi distans consistit contra et[4] impetu solis totius
orbis in se recipit[5] splendorem. Septumo decumo
die cum sol oriatur, ea pressa est ad occidentem.
Vicensimo et altero die cum sol est exortus, luna
tenet circiter caeli medias regiones, et id quod
spectat ad solem, id habet lucidum reliquis[6] obscura.
Item cotidie cursum faciendo circiter octavo et
vicensimo die subit sub radios solis, et ita menstruas
perficit rationes.

 Nunc, ut in singulis mensibus sol signa pervadens
auget[7] et minuit dierum et horarum spatia, dicam.

[1] quod *H S*. [2] quarta *G*. [3] decima *G*.
[4] contra et *G* : contrah& *H*. [5] recepit *H G S*.
[6] reliquis *S G^e* : reliquus *H G*. [7] augit *H S*.

[1] *pressa* = 'near'; cf. Fr. *près*.

force. For, of the seven planets, the moon traverses that circle which is nearest the earth and least in its range. Every month, therefore, it is darkened under the disk and rays of the sun, and lies hid for one day before it passes. When it adjoins the sun, it is called the new moon. On the next day, which is counted the second, it passes away from the sun, and gives a slight visibility to the edge of its disk. When it is three days' distance from the sun, it waxes and receives more light. When in its daily departure it comes to the seventh day, being distant from the western sun about half the region of the sky, it has half its light and that part which looks towards the sun is illuminated.

4. On the fourteenth day, when it is distant from the sun by the diameter of the universe, it becomes full, and rises when the sun is in the west, because being distant the whole space of the universe it stands face to face, and by the force of the sun receives into itself the splendour of the sun's whole orb. When the sun rises on the seventeenth day the moon is near [1] to the west. When the sun is risen on the twenty-second day the moon holds nearly the middle region of the sky; it keeps bright the part which looks towards the sun; in the other parts the moon is darkened. Further, making its journey from day to day, it is absorbed in the rays of the sun about the twenty-eighth day, and thus completes the order of the month.

In the next place I will describe [2] how the sun going through the signs, augments and diminishes each month the length of the day and of the hour.

[2] Manilius describes the signs of the zodiac in their order, i. 262–274.

III

1 NAMQUE cum arietis signum iniit et partem octavam pervagatur, perficit aequinoctium vernum. Cum progreditur ad caudam tauri sidusque vergiliarum, e quibus eminet dimidia pars prior tauri, in maius spatium mundi quam dimidium procurrit procedens ad septentrionalem partem. E tauro cum ingreditur in geminos exorientibus vergiliis, magis crescit supra terram et auget[1] spatia dierum. Deinde ⟨e⟩ geminis cum iniit ad cancrum, qui brevissimum tenet caeli spatium, cum pervenit in partem octavam, perficit solstitiale tempus, et peragens pervenit[2] ad caput et pectus leonis, quod eae partes cancero[3] sunt attributae.

2 E pectore autem leonis et finibus cancri solis exitus percurrens reliquas partes leonis inminuit diei magnitudinem et circinationis[4] reditque in geminorum aequalem cursum. Tunc vero a leone transiens in virginem progrediensque ad sinum[5] vestis eius contrahit circinationem[4] et aequat ad eam, quam taurus habet, cursus[6] rationem. E virgine autem progrediens per sinum, qui sinus librae partes habet primas, in librae parte VIII perficit aequinoctium autumnale ;[7] qui cursus aequat eam circinationem,[4] quae fuerat in arietis signo.

3 Scorpionem autem cum sol ingressus fuerit occi-

[1] augit *H S*. [2] pervenit *Joc* : perveniens *H*.
[3] *Cf.* canceres, *Cato R. R.* 157. 3.
[4] circinationis-em *S* : circitionis-em *H*.
[5] signum *H*. [6] cursus *G* : cursū *H S*.
[7] autumnale *S* : autem tale *H*.

[1] *pars* = μοῖρα = degree.
[2] *aversum taurum*. Man. i. 264.

CHAPTER III

ON THE SUN'S COURSE THROUGH THE SIGNS

1. When he enters the sign of the Ram and traverses the eighth degree,[1] he makes the vernal equinox. When he goes on to the tail[2] of the Bull and the constellation of the Pleiades from which the first half of the Bull stands out, the space which he enters is more than half the firmament[3] as he moves to the north. When, after the Bull, he enters the Twins at the rising of the Pleiades, he rises higher above the earth and lengthens the day. Thereupon, after the Twins he enters the Crab, a sign which occupies the shortest space of the heavens; coming to the eighth degree, he completes the solstice, and in his progress reaches the head and breast of the Lion, these parts being assigned to the sign of the Crab.

2. Leaving the breast of the Lion and the limits of the Crab and passing through the remaining degrees of the Lion, he diminishes the length of the daylight and of his circuit, and returns to the movement which he had in the Twins. Passing then from the Lion to the Virgin and reaching the lap of her robe, he contracts his circuit and makes the amount of his course equal to that which the Bull holds. Proceeding from the Virgin over her lap which occupies the first degrees of the Balance, at the eighth degree of the Balance he completes the autumnal equinox. This passage equals the circuit which he made in the sign of the Ram.

3. When the sun enters the Scorpion at the setting

[3] *I.e.* his visible journey between sunrise and sunset.

dentibus vergiliis, minuit progrediens meridianas
partes longitudines dierum. E scorpione cum per-
currendo init in sagittarium ad femina eius, contracti-
orem diurnum pervolat cursum. Cum autem incipit
a feminibus sagittarii, quae pars est attributa capri-
corno, ad partem octavam, brevissimum caeli per-
currit spatium. Ex eo a brevitate diurna bruma ac
dies brumales appellantur. E capricorno autem
transiens in aquarium adauget et aequat [1] sagittarii
longitudine diei spatium. Ab aquario cum ingressus
est in pisces favonio flante, scorpionis comparat
aequalem cursum. Ita sol ea signa circum perva-
gando certis temporibus auget aut minuit dierum
et horarum spatia.

Nunc de ceteris sideribus, quae sunt dextra ac
sinistra zonam signorum meridiana septentrionalique
parte mundi stellis disposita figurataque, dicam.

IV

1 NAMQUE septentrio, quem Graeci nominant *arctum*
sive *helicen*, habet post se conlocatum custodem. Non
longe conformata est virgo, cuius supra umerum
dextrum lucidissima stella nititur, quam nostri pro-
vindemiatorem,[2] Graeci *protrugeten* [3] vocant; candens
autem magis spica [4] eius est colorata. Item alia

[1] et aequat : exaequat *H*.
[2] provindemiatorem *Scaliger* : providentiā maiores *H*.
[3] προτρυγητήν *Scal* : propygethon *H*.
[4] spica *Phil* : species *H*.

[1] Manilius describes the northern constellations, i. 308–
370; the southern, i. 373–406.

of the Pleiades, he diminishes the length of the day on his southward journey. Passing from the Scorpion when he enters the Archer near his thighs, he traverses a still shorter daily course. Beginning from the thighs of the Archer, a part which is assigned to the Goat, at the eighth degree of the Goat he passes through the shortest space of the sky. Hence, from the brevity of the days, the winter (*bruma*) and the days (*brumales*) receive their names. Passing now from the Goat to the Water-carrier, he increases the length of the day, and equals the circuit of the Archer. From the Water-carrier he enters the Fishes when the west wind blows, and makes a circuit equal to that which he made in the Scorpion. In this way the sun travels through the signs at fixed times, and augments or diminishes the lengths of the day and of the hour.

I will next speak of the other constellations [1] which are situated and figured with stars on the right and left of the zodiac both towards the Meridian and to the north.

CHAPTER IV

ON THE NORTHERN CONSTELLATIONS

1. THE Waggon, which the Greeks call the Bear or *Helice*, has the Keeper of the Bear placed behind it. Not far distant is the constellation of the Virgin. Above her right shoulder rests a very bright star which we call the Vintager, the Greeks *Protrugetes*. But *Spica*, a still more brilliant star in that constellation, is coloured.[2] There is also another

[2] Manilius v. 270, has *spica horrida*. Spica, however, is said to be pure white.

contra est stella media genuorum custodis arcti:
qui arcturus dicitur est ibi delicatus.

2 E regione capitis septentrionis transversus ad
pedes geminorum auriga stat in summo cornu tauri
—itemque in summo cornu laevo et auriga pedis [1]
una tenet parte stellam—et appelluntur [2] aurigae
manui [3] haedi, capra laevo umero. Tauri quidem et
arietis insuper Perseus—dexterioribus subter currens
basem vergiliis,[4] at sinisterioris caput arietis—et
manu dextra innitens Cassiepiae simulacro, laeva
supra tauri [5] tenet gorgoneum ad summum caput,
subiciensque Andromedae pedibus.

3 Item pisces supra Andromedam, et eius ventris et
equi sunt [6] supra spinam aequi, cuius ventris luci-
dissima stella finit ventrem equi et caput Andro-
medae. Manus Andromedae dextra supra Cassio-
piae simulacrum est constituta, laeva aquilonalem
piscem. Item aquarii [7] supra equi capitis est. Equi
ungulae attingunt aquarii genua; Cassiopia media
est dedicata. Capricorni supra in altitudinem aquila
et delphinus. Secundum eos est sagitta. Ab ea
autem volucris,[8] cuius pinna dextra Cephei manum
adtingit et sceptrum, laeva supra Cassiopiae innititur.
Sub avis cauda pedes equi sunt subtecti.

4 Inde sagittarii, scorpionis, librae insuper serpens

[1] pedis *Mar*: pedes *H*.
[2] appellantur *H*: appelluntur *Gr*.
[3] manui *Ro*: manus *H*.
[4] vergilius a *H*: vergiliis at *Kr*.
[5] supra tauri *Ro*: supra aurigā *H*.
[6] andromedam et eius ventris et equique sunt *H*: que *om*.
Gr.
[7] *sc.* simulacrum. [8] volucris e_2 *ed*: volueris *H*.

[1] Arcturus is yellow. [2] Aratus, 167.

star opposite which is between the knees of the
Keeper: this is called *Arcturus* and is of a delicate
colour.[1]

2. Opposite the top of the Waggon, across towards
the feet of the Twins, is the Charioteer [2] standing
on the horns of the Bull. Further, on the tip of the
left horn the Charioteer also has at his feet a star
on one side. Against the hands of the Charioteer,
the Kids are stationed.[3] *Capra* is on the left shoulder
of the Charioteer. Above the Bull and the Ram
stands Perseus; [4] his right foot supporting the
Pleiades; on his left, the head of the Ram; with
his right hand he rests on the constellation of
Cassiopeia; with his left he holds the Gorgon's
head above the Bull and lays it at the feet of
Andromeda.

3. The Fishes are beyond Andromeda and are
level with her belly and the back of the Horse. A
very bright star divides the belly of the Horse and
the head of Andromeda. The right hand of Andro-
meda is placed above the constellation of Cassiopeia,
and the left upon the Northern Fish.[5] The constel-
lation of the Water-carrier is against the Horse's
head. The Horse's hoofs touch the knees of the
Water-carrier. Cassiopeia is in the middle. Rising
above Capricorn [6] are the Eagle and the Dolphin.
Next is the Arrow. On it follows the Swan with its
right wing touching the hand and sceptre of Cepheus,
and its left resting upon Cassiopeia. Under the
tail of the Swan the feet of the Horse are concealed.

4. Then following the Archer, the Scorpion and
the Balance, comes the Serpent touching the Crown

[3] Aratus, 166. [4] *Ibid.*, 249 ff.
[5] *Ibid.*, 246. [6] *Ibid.*, 316.

summo rostro coronam tangit. Ad eum medium
ophiuchos in manibus tenet serpentem, laevo pede
calcans mediam frontem scorpionis. A parte [1] ophi-
uchi capitis non longe positum est caput eius, qui
dicitur nisus [2] in genibus. Autem eorum [3] faciliores
sunt capitum vertices ad cognoscendum, quod non
obscuris stellis sunt conformati.

5 Pes ingeniculati ad id fulcitur capitis tempus ser-
pentis, cuius arctorum, qui septentriones dicuntur,
inplicatus. Parve per eos flectitur delphinus; con-
tra volucris [4] rostrum proposita lyra. Inter umeros
custodis et geniculati corona [5] est ordinata. [6] In sep-
tentrionali vero circulo duae positae sunt arctoe
scapularum dorsis inter se compositae et pectoribus
aversae. E quibus minor *cynosura*, maior *helice* a
Graecis appellatur. Earumque capita inter se dispi-
cientia sunt constituta, caudae capitibus earum ad-
versae contra dispositae figurantur; utrarumque [7]
enim superando eminent.

6 In summo per caudas earum esse dicitur. Item
serpens est porrecta, e qua stella quae dicitur polus [8]
elucet circum caput maioris septentrionis; namque
quae est proxime draconem, circum caput eius involvi-
tur. Una vero circum cynosurae caput iniecta est
fluxu porrectaque proxime eius pedes. Haec autem

 [1] a parte *Ro* : partem *H.*
 [2] nisus *Phil* : nessus *H.*
 [3] eorum autem *Phil* : autem eorum *H, soloecismus, Quint.*
I. 5. 39.
 [4] volucris e_2 *ed* : volueris *H.*
 [5] corona e_2 *ed* : coronatā (-tam *E*) *H.*
 [6] ordinata *rec* : orinata *H S.*
 [7] utrarumque . . . earum *Heringa* : utrorumque . . .
eorum *H.*
 [8] polus *rec* : post plus *H.*

BOOK IX. c. iv.

with the tip of his mouth. The Serpent-holder has
the middle of the Serpent in his hands and treads
with his left foot the forehead of the Scorpion.[1]
The constellation which is called the Kneeler has its
head not far from the head of the Serpent-holder.
The tops of their heads are the more easily recog-
nised because they are marked by not inconspicuous
stars.

5. The foot of the Kneeler [2] rests on the temple
of the Dragon in which that one of the Bears which
is called the Waggon is enfolded. The Dolphin moves
dimly [3] among them; over against the beak of the
Swan the Lyre is prominent. Between the shoulders
of the Keeper and the Kneeler the Crown is set in
array. In the northern circle, the two Bears are
placed joined together with their shoulders back
to back and their breasts turned away. Of these
the less is called in Greek *Cynosura*,[4] the greater
Helice.[5] Their heads look, one up, one down.
Their tails are figured in opposite directions set
against each other's heads, and are raised so as to
project.

6. The highest point in the heavens is said to be
between their tails. The Dragon is also spread
out, and from this constellation the pole-star, so-
called, shines against the head of the Great Bear.
For the Bear which is nearest the Dragon has its
head bent round. At the same time the Dragon
is thrown in its flowing movement round the head
of the Little Bear and reaches its feet. And the

[1] Aratus, 85. [2] 'The Kneeler' is also called Hercules.
[3] *parve*: οὐ μάλα πολλός, Arat. 316.
[4] Lit. 'dog's tail,' from its shape.
[5] Helice from sweeping round in a 'curve.'

239

intorta replicataque capite minoris ad maiorem, circa
rostrum et capitis tempus dextrum. Item supra
caudam minoris pedes sunt Cephei, ibique ad sum-
mum cacumen facientes stellae sunt trigonum pari-
bus lateribus, insuper arietis signum. Septentrionis
autem minoris et Cassiopiae simulacri complures
sunt stellae confusae.

Quae sunt ad dextram orientis inter zonam signo-
rum et septentrionum sidera in caelo disposita dixi
esse; nunc explicabo, quae ad sinistram orientis
meridianisque partibus ab natura [1] sunt distributa.

V

1 PRIMUM sub capricorno subiectus piscis austrinus
caudam prospiciens ceti.[2] Ab eo ad sagittarium
locus est inanis. Turibulum sub scorpionis [3] aculeo.
Centauri priores partes proximae sunt librae et
scorpioni. Tenet [4] in manibus simulacrum, id quod
bestiam astrorum periti nominaverunt. Ad virginem
et leonem et cancrum anguis porrigens agmen stel-
larum intortus succingit, regione cancri erigens
rostrum,[5] ad leonem medioque corpore sustinens
craterem ad manumque virginis caudam subiciens
in qua inest corvos; quae sunt autem supra scapulas,
peraeque sunt lucentia.[6]

> [1] ob natura *H.* [2] ceti *Phil*: cephei *H.*
> [3] scorpioni *Phil*: -nem *H.*
> [4] tenet *Barbarus*: tenent *H.*
> [5] rostrum *S*: nostrum *H.* [6] lugentia *H.*

[1] The descriptions of Vitruvius are best understood with the
help of maps of the constellations: especially in Greek MS.
Vat. 1087. Boll, *Sphaera*, Pl. I.

Dragon is twisted and folded back from the head of the Little Bear to the Great Bear about his snout and the right temple of his head. Further, the feet of Cepheus are on the tail of the Little Bear. And there at the highest point are stars which form a triangle with its equal sides above the Ram. But many stars belonging to the Little Bear and to the constellation of Cassiopeia are confused.

The constellations which are to the right of the east between the Zodiac and the Waggon I have described as figured.[1] I will now explain those which are distributed by nature to the left of the east and in the parts south.

CHAPTER V

ON THE SOUTHERN CONSTELLATIONS

1. First, under Capricorn lies the southern Fish looking towards the tail of the Whale. From that to the Archer is a void. The Altar is under the Scorpion's sting. The front part of the Centaur is nearest to the Balance and Scorpion. He holds in his hands a figure which the astronomers have named the Beast.[2] The Virgin, the Lion and the Crab are girt about with the Serpent,[3] which in its twistings stretches through a procession of stars. It raises its snout to the Crab; against the Lion it supports the Cup with its middle; to the hand of the Virgin it raises its tail, on which rests the Crow. The stars above its shoulders are equally luminous.

[2] The modern constellation of the Wolf.
[3] The Hydra, Aratus, 444 ff.

2 Ad anguis inferius [1] ventris, sub caudam subiectus
est centaurus. Iuxta [2] cratera et leonem navis est,
quae nominatur Argo, cuius prora obscuratur, sed
malus et quae sunt circa gubernacula eminentia
videntur, ipsaque navicula et puppis per summam
caudam cani iungitur.[3] Geminos autem minusculus
canis sequitur contra anguis caput. Maior item
sequitur minorem. Orion vero transversus est
subiectus, pressus ungula tauri,[4] manu laeva tenens,
clavam altera ad geminos tollens.

3 Apud [5] eius vero basim canis parvo intervallo
insequens leporem. Arieti et piscibus cetus est
subiectus, a cuius crista ordinate utrisque piscibus
disposita est tenuis fusio stellarum, quae graece
vocitantur *harpedonae*.[6] Magnoque intervallo intror-
sus pressus serpentium, attingit summam ceti cristam.
Esse fuit per speciem stellarum flumen. Profluit
initium fontis capiens a laevo pede Orionis. Quae
vero ab aquario fundi memoratur aqua, profluit inter
piscis austrini caput et caudam ceti.

4 Quae figurata conformataque sunt siderum in
mundo simulacra, natura divinaque mente designata,
ut Democrito physico placuit, exposui, sed tantum
ea, quorum ortus et occasus possumus animadvertere
et oculis contueri. Namque uti septemtrionis circum
axis cardinem versantur non occidunt neque sub

[1] inferius *Mar* : interius *H*. [2] iusta *H*.
[3] *post* iungitur *H habet paginam aversam sine scriptura folii*
133; *cf.* VII. ix. 2.
[4] tauri *Phil* : centauri *H*. [5] apud *Phil* : caput *H*.
[6] ἁρπεδόναι *Turnebus* : hermedonae *H*.

[1] Cf. ἣν εἶναι Aristot. The river is the Eridanus.
[2] The description not only follows Aratus but seems to have
been written to a diagram based on the *Phaenomena*.

2. At the lower part of the Hydra's belly, under its tail, the Centaur is placed. Against the Cup and the Lion is the ship Argo; the bows are hidden but the mast and the parts about the stern are seen standing out. The Ship and its stern adjoins the Great Dog at the tip of its tail. The Twins are followed by the Little, and the Great, Dog, opposite the head of the Hydra. Orion lies across pressed by the hoof of the Bull, holding it in his left hand and with the right raising his club towards the Twins.

3. Near his feet is the Great Dog following the Hare at a short interval. Under the Ram and the Fishes comes the Whale; from its head there is a sprinkling of stars arranged in a band towards the two Fishes (called in Greek *harpedonae*), and at a great interval a downward weight of the winding stars touches the mane of the Whale. There was to be [1] a River under the semblance of stars.[2] It flows forth taking the beginning of its source from the left foot of Orion. The water which is said to be poured by the Water-carrier flows between the head of the Southern Fish and the tail of the Whale.

4. I have expounded in accordance with the principles of Democritus, the natural philosopher, the figures of the constellations [3] which are shaped and formed in the firmament, and planned by nature and the divine spirit; [4] but only those constellations whose risings and settings we can observe and see with our eyes. For just as the two Bears turn round the pole, neither setting nor going under the earth,

[3] Vitruvius goes back behind Aratus to the astronomical works of Democritus, which are only known to us in fragments; Diels *Vorsokratiker*, II. 390.

[4] An echo of Lucretius, iii. 15: *ratio tua coepit vociferari | naturam rerum divina mente coorta.*

terram subeunt, sic circa[1] meridianum cardinem,
qui est propter inclinationem mundi subiectus terrae,
sidera versabunda latentiaque non habent egressus
orientis supra terram. Itaque eorum figurationes
propter obstantiam terrae non sunt notae. Huius
autem rei index est stella Canopi, quae his regionibus
est ignota, renuntiant autem negotiatores, qui ad
extremas Aegypti regiones proximasque ultimis
finibus terrae terminationes fuerunt.

VI

1 DE mundi circa terram pervolitantia duodecimque
signorum ex[2] septentrionali meridianaque parte
siderum dispositione, ut sit perspectus docui. Nam-
que ex ea mundi versatione et contrario solis per
signa cursu gnomonumque[3] aequinoctialibus umbris
analemmatorum[4] inveniuntur descriptiones.

2 Cetera ex astrologia, quos effectus habeant signa
XII, stellae v, sol, luna ad humanam[5] vitae rationem,
Chaldaeorum ratiocinationibus est concedendum,
quod propria est eorum genethlialogiae[6] ratio, uti
possint ante facta et futura ex ratiocinationibus

[1] si circa H S. [2] ex E G : & H S.
[3] gnominum H. [4] analemnatorum H S G^c.
[5] humanae S : -nā H.
[6] genethlialogiae Joc : gentililogiae H.

[1] *versabunda*, rare, Lucr. vi. 581.
[2] Canopus is quoted as an example of the principle stated in
the next sentence. It is visible at Rhodes. Canopus seems

so round the southern pole which, because of the obliquity of the universe, lies under the earth, constellations are turning [1] in concealment without coming forth and rising above the earth. Hence the earth intervenes and prevents the knowledge of their configuration. A proof of this is the star Canopus,[2] which to us in these regions is unknown. Yet it (*i.e.* the fact of southern constellations) is reported by merchants who have been to the farthest parts of Egypt and the limits nearest to the ultimate bounds of the earth.

CHAPTER VI

ON ASTROLOGY

1. I HAVE described the revolution of the firmament round the earth and the arrangement of the twelve signs and of the constellations to the north and south so as to present them to a clear view. For from that revolution of the firmament and the contrary motion of the sun through the signs and the equinoctial shadows of the gnomons, the diagrams of the analemma are discovered.

2. For the rest, as to astrology, the effects produced on the human course of life by the twelve signs, the five planets, the sun and moon, we must give way to the calculations of the Chaldaean astrologers,[3] because the casting of nativities is special to them so that they can explain the past and the future from astronomical calculations.

to have served as a substitute for a polar star to the south; cf. Manilius, i. 218.

[3] Chaldaean = astrologer; *Babylonica Chaldaeum doctrina . . . astrologorum*: Lucr. vi. 727–728.

astrorum explicare. Eorum autem inventiones re-
liquerunt, in quae sollertia acuminibusque fuerunt
magnis, qui ab ipsa natione Chaldaeorum profluxe-
runt. Primusque Berosus in insula et civitate Coo
consedit ibique aperuit disciplinam, post ea studens
Antipater iterumque Athenodorus,[1] qui etiam non e
nascentia sed ex conceptione genethlialogiae[2]
rationes explicatas reliquit.

3 De naturalibus autem rebus Thales Milesius, Ana-
xagoras Clazomenius,[3] Pythagoras Samius, Xeno-
phanes[4] Colophonius, Democritus Abderites rationes,
quibus e rebus natura rerum gubernaretur[5] quem-
admodum cumque effectus habeat, excogitatas[6]
reliquerunt. Quorum inventa secuti siderum et
occasus tempestatumque significatus[7] Eudoxus, Eu-
demus,[8] Callippus,[9] Meto,[10] Philippus, Hipparchus,
Aratus ceterique ex astrologia parapegmatorum
disciplinis[11] invenerunt et eas posteris explicatas reli-
querunt. Quorum scientiae sunt hominibus suspi-
ciendae, quod tanta cura fuerunt, ut etiam videantur
divina mente tempestatium significatus post futuros
ante pronuntiare. Quas ob res haec eorum curis
studiisque sunt concedenda.

 [1] Athenodorus *Ro* : achinapolus *H.*
 [2] genethlialogiae *Joc*: gentililogiae *H.*
 [3] Clazomenius *Joc* : glagomeus *H.* [4] zenophanes *H.*
 [5] gubernaretur e_2 : gubernarentur *H.*
 [6] excogitatas *ed* : excogitatus *H.*
 [7] significatus *H S* : significatos *E G.*
 [8] Eudemus *Gr* : euchemon *H S*, Eudemon *Joc.*
 [9] callistus *H.* [10] mello *H* : *nomina restituit Turnebus.*
 [11] disciplinis *Joc* : disciplinas *H.*

 [1] Vitruvius assigns to Berosus the first place in the succes-
sion of Greek writers on astrology, but Babylonian writings
on astrology went back as far as Hammurabi, 2250 B.C.

Those who have sprung from the Chaldaean nation have handed on their discoveries about matters in which they have approved themselves of great skill and subtlety. And first,[1] Berosus settled in the island of Cos as a citizen and opened a school there. Then Antipater took up the pursuit, and further, Athenodorus, who left a method of casting nativities, not from the time of birth but from that of conception.

3. In natural philosophy, Thales of Miletus, Anaxagoras of Clazomenae, Pythagoras of Samos, Xenophanes of Colophon, Democritus of Abdera left elaborate theories on the causes by which nature was governed, and the manner in which each produced its effects. Eudoxus,[2] Eudemus,[3] Callippus,[4] Meton,[5] Philippus,[6] Hipparchus,[7] Aratus,[8] and others followed up their discoveries, and, with the help of astronomical tables,[9] discovered the indications of the constellations, of their setting, and of the seasons, and handed down the explanations to after times. Their knowledge is to be highly regarded by mankind, because they so applied themselves, that they seem by divine inspiration to declare beforehand the indications of the seasons. Wherefore these topics may be referred to their care and attention.

[2] Of Cnidus; rejected astrology. Aratus versified his *Phaenomena*.

[3] Mathematician; of Pergamus.

[4] Corrected the cycle of Meton.

[5] Reformed Attic calendar from 432 B.C.

[6] Of Opus; mathematician, edited Plato's *Laws*.

[7] Of Nicaea; greatest mathematician of antiquity, *c*. 150 B.C.; corrected Aratus.

[8] Of Soli; *c*. 270 B.C.; wrote the *Phaenomena*.

[9] *parapegma* = column with astronomical tables.

VII

1 Nobis autem ab his separandae sunt rationes et explicandae menstruae dierum brevitates itemque depalationes. Namque sol aequinoctiali tempore ariete libraque versando, quas e gnomone partes habent novem, eas umbrae facit viii in declinatione caeli, quae est Romae. Idemque Athenis quam magnae sunt gnomonis partes quattuor, umbrae sunt tres, ad vii Rhodo v, ad xi Tarenti ix, ad [1] quinque ⟨Alexandriae⟩ tres, ceterisque [2] omnibus locis [3] aliae alio modo umbrae gnomonum aequinoctiales a natura rerum inveniuntur disparatae.

2 Itaque in quibuscumque locis horologia erunt describenda, eo loci sumenda est aequinoctialis umbra, et si erunt quemadmodum Romae gnomonis partes novem, umbrae octo,[4] describatur [5] in planitia et e media *pros orthas* erigatur ut sit ad normam quae dicitur gnomon. Et a linea, quae erit planities in linea gnomonis circino [6] novem spatia demetiantur; et quo loco nonae partis [7] signum fuerit, centrum constituatur, ubi erit littera A; et deducto circino ab eo centro ad lineam planitiae,[8] ubi erit littera B, circinatio circuli describatur, quae dicitur meridiana.

3 Deinde ex novem partibus, quae sunt a [9] planitia ad gnomonis centrum, viii sumantur et signentur in

[1] adquinq, ii. rhodo xv. adtaranti .xi. quinque adtres *H*: *correxit Joc.*

[2] coterris *H*. [3] lonis *H*. [4] octogenae *H*.

[5] describatur *Joc*: -bantur *H*.

[6] circino *Joc*: circini *H*. [7] partes *H S*.

[8] ad lineam planitie e_2: ablinea planitia *H*.

[9] a *Joc*: in *H*.

[1] *pros orthas* seems to be the trade term for an upright line.

CHAPTER VII

ON THE PRINCIPLES OF DIALLING

1. WE must separate from other astronomical studies the description of the shortening and marking of the days, month by month, on the dial. For the sun, in his revolution, at the time of the spring and autumn equinoxes, casts a shadow, in the latitude of Rome, which is equal to eight-ninths of the height of the gnomon. Further, at Athens the shadows are three-quarters of the gnomon, at Rhodes five-sevenths, at Tarentum nine-elevenths, at Alexandria three-fifths; and in other places the shadows of the gnomon at the equinox are found to differ by different amounts, in accordance with the Nature of Things.

2. Therefore in whatever places dials are to be set out, the length of the shadow at the equinox is to be taken. If, as at Rome, there are nine parts of the gnomon, and eight parts of the shadow, let a line [1] be drawn on the level, and from the middle let there be set upright and with a set-square, a perpendicular which is called the gnomon; and on the line where the level surface is, let nine parts be measured starting from the foot of the gnomon; where the end of the ninth part is marked, let a centre be taken and indicated by the letter A; and extending the compasses from that centre to a point in the line, to be indicated by the letter B, let the circumference of the circle be described which we call the meridian.[2] 3. Then of the nine parts which are between the centre of the gnomon and the point on the level line, let eight be taken and indi-

[2] See diagram, Pl. L.

linea, quae[1] est in planitia, ubi erit littera c. Haec
autem erit gnomonis aequinoctialis umbra. Et ab
eo signo et littera c per centrum, ubi est littera a,
linea perducatur, ubi erit solis aequinoctialis radius.
Tunc a centro diducto circino ad lineam planitiae
aequilatatio signetur, ubi erit littera e sinisteriore
parte et i dexteriore[2] in extremis lineis circinationis.
Et per centrum perducendum, ut aequa duo hemi-
cyclia sint divisa. Haec autem linea a mathematicis
dicitur *horizon*.

4 Deinde circinationis totius sumenda pars est xv;
et circini centrum conlocandum in linea circinationis,
quod loci secat eam lineam aequinoctialis radius, ubi
erit littera f; et signandum dextra sinistra, ubi
sunt litterae g h. Deinde ab his ⟨et per centrum⟩
lineae[3] usque ad lineam planitiae perducendae sunt,
ubi erunt litterae t r. Ita erit solis radius unus
hibernus, alter aestivus. Contra autem ⟨e⟩[4] littera i
erit, qua[5] secat circinationem linea,[6] quae est
traiecta per centrum, ubi erunt[7] litterae y k l g, et
contra k litterae erunt k h x l; et contra c et f et a
5 erit littera n. Tunc perducendae sunt *diametro*[8] ab
g ad l et ab h ⟨ad k⟩.[9] Quae erit superior, partis
erit aestivae, inferior hibernae. Eaeque *diametro*[10]
sunt aeque mediae dividendae, ubi erunt litterae o
et m, ibique centra signanda. Et per ea signa et
centrum a[11] lineae ad extremas lineae circinationis

[1] qua est *H*. [2] i dexteriore *Joc* : et inde alteriore *H*.

[3] ⟨et per centrum⟩ lineae *Joc* : lineis *H*.

[4] e *add. Joc*. [5] qua *Kr* : qui *H*.

[6] linea *Joc* : lineae *H*.

[7] litterae i . k . l . m. et contra k lineae erunt k . h . x . i
H : y k l g . . . k h x l *Gr*.

[8] diametro ab .c. ad .i. et ab .h. *H* : *corr. Joc*.

[9] quae erit inferior partis erit aestiv(a)e superior hibernae *H*
(*corr. Mar*).

cated by a point c. This will be the equinoctial
shadow of the gnomon. From the point marked c
let a line be drawn through the centre A; and this
will represent a ray of the sun at the equinox. Then
extending the compasses from A let a line be drawn
parallel to the level surface, with the letter E on the
left side and the letter I on the right side of the
circumference, let them be joined through the
centre, so that they divide the circle into two equal
semicircles. This line is called the horizon by the
mathematicians.

4. Then the circumference is to be divided into
fifteen parts, and the centre of the compasses is to
be put at that point F in the circumference where it
is cut by the equinoctial ray c, and the points G H
are to be marked right and left. Then from these,
through the centre, lines are to be carried through
to the line of the plane where the letters T R are
to be put. One line will mark the ray of the sun
in winter, the other the ray of the sun in the summer.
Over against E will be the letter I on the horizon
which cuts the circumference and passes through
the centre. In this quarter are the points Y K L G.
Over against K will be the points K H X L. And
over against C F A will be the letter N. 5. Then
diameters are to be drawn from G to L and from H
to K. The upper will determine the summer por-
tion, and the lower the winter portion. These
diameters are to be equally divided in the middle
at the letters O and M, and the centres marked.
Through those letters and the centre A, a line is
to be produced to the circumference at the points

[10] aequ(a)e diametro *H*.　　[11] centrum .c. *H*.

sunt perducendae, ubi erunt litterae Q et P;[1] haec
erit linea *pros orthas* radio aequinoctiali. Vocabitur
autem haec linea mathematicis rationibus *axon*. Et
ab eisdem centris deducto circino ad extremas
diametros describantur hemicyclia,[2] quorum unum
erit aestivum, alterum hibernum.

6 Deinde in quibus locis secant lineae paralleloe[3]
lineam eam quae dicitur horizon, in dexteriore parte
erit littera s,[4] in sinisteriore v. Et ab littera s
ducatur linea parallelos axoni[5] ad extremum hemi-
cyclium, ubi erit littera y; et ab v[6] ad sinistram
hemicyclii item parallelos linea ducatur[7] ad litteram
x. Haec autem parallelos linea vocitatur *laeotomus*.[8]
Et tum circini centrum conlocandum est eo loci, quo
secat circinationem aequinoctialis radius, ubi erit
littera D;[9] et deducendum ad eum locum, quo secat
circinationem aestivus radius, ubi est littera H. E
centro aequinoctiali intervallo aestivo circinatio cir-
culi menstrui agatur, qui manaeus dicitur. Ita habe-
bitur analemmatos deformatio.

7 Cum hoc ita sit descriptum et explicatum, sive per
hibernas lineas sive[10] per aestivas sive per aequi-
noctiales aut etiam per menstruas in subiectionibus
rationes horarum erunt ex analemmatos[11] describen-
dae, subicianturque in eo multae varietates et genera

[1] Q et P *Gr* : G . P . T . R. *H.* [2] icyclia *H.*
[3] paralleloe *Ro* : parallelon & *H.*
[4] littera s *Joc* : littera .e. *H.*
[5] axoni *Joc* : axon *H.*
[6] ab v *Gr* : ab .c. *H.*
[7] linea vocitatur *Joc* : lineae vocitantur *H.*
[8] laeotomus *Turnebus* : locithomus *H.*
[9] littera D *Mar* : littera .e. *H.*
[10] *post* lineas sive *in H repetuntur* aequinoctialis radius —
secat circinationem.

Q and P. This line will be perpendicular to the equinoctial ray; in mathematical calculations it is called the axis. From M and O as centres, the compasses are extended to the ends of the diameters and semicircles are described, of which one will be for the summer, the other for the winter.

6. Then, at the places where the parallel lines cut the line called the horizon, let the right-hand point be s and the left-hand point be v. From the letter s let there be drawn a line parallel to the axis, to the farther semicircle at the point y; and from v let there be drawn also a parallel line on the left of that semicircle to the letter x. This parallel line is called the *laeotomus*.[1] Then the centre of the compasses is to be placed on the point marked D where the equinoctial radius cuts the circumference, and they are to be extended to the point H where the circumference is intersected by the summer radius. From the equinoctial centre with a radius to the summer intersection, let the circle of the months be drawn which is called *Manaeus*. This will complete the design of the analemma.

7. The analemma in this way has been set forth and explained, whether the figures of the hours are to be marked by the analemma according to the winter lines or the summer lines or the equinoctial or indeed the monthly lines in accordance with the annexed figure. From the analemma there may be deduced many varieties and kinds of dials and they

[1] *laeotomus* = cut to the left.

[2] Vitruvius seems to describe a diagram placed before the reader, but it is not possible to reconstruct with complete certainty the diagram which is lost, from his description.

[11] anallēatios *H*.

VITRUVIUS

horologiorum et describuntur rationibus his arti-
ficiosis. Omnium autem figurarum descriptionumque
earum effectus unus, uti dies aequinoctialis bruma-
lisque idemque solstitialis in duodecim partes aequa-
liter sit divisus. Quas ob res non pigritia deterritus
praetermissis, sed ne multa scribendo offendam, a
quibusque inventa sunt genera descriptionesque
horologiorum, exponam. Neque enim nunc nova
genera invenire possum nec aliena pro meis praedi-
canda videntur. Itaque quae nobis tradita sunt et a
quibus sint inventa,[1] dicam.

VIII

1 HEMICYCLIUM excavatum ex quadrato ad enclim-
aque succisum Berosus [2] Chaldaeus dicitur invenisse;
scaphen sive hemisphaerium dicitur Aristarchus
Samius, idem etiam discum in planitia; arachnen
Eudoxus astrologus, nonnulli dicunt Apollonium;
plinthium [3] sive lacunar,[4] quod etiam in circo Flaminio
est positum, Scopinas Syracusius; *pros ta historumena*,
Parmenion, *pros pan clima*, Theodosius et Andrias,
Patrocles pelecinum, Dionysodorus [5] conum, Apollo-

[1] inventi *H*. [2] berossus *H*.
[3] plinthium *Joc* : panthium *H*.
[4] lacunar *G* : lacunas *H S*.
[5] dioniso porusconum *H* : *corr. Mach.*

[1] Book IX. ii. 3. The following references relate to forms
of dials. [2] Of Perga. Book I. i. 17. [3] Book I. i. 6.
[4] Prof. Granger's belief that *panthium* of H is right, that
the Pantheon of Rome is meant, and that this was a great
sundial, is not credible.

are drawn by these technical methods. But of all these figures and drawings, the result is the same: the length of the day at the equinoxes and at the winter and summer solstices is divided into twelve equal parts. Wherefore they have not been omitted because I shrank from the labour involved; but without transgressing by long recitals, I will set forth the kinds and the figures of dials with the names of their inventors. For I cannot now invent new kinds, and the work of other men is not to be put forth as my own. Therefore I will say what has been handed down, and by whom it has been invented.

CHAPTER VIII

ON VARIOUS DIALS AND THEIR INVENTORS

1. Berosus the Chaldaean is said to have invented the semicircular dial hollowed out of a square block and cut according to the latitude; Aristarchus [1] of Samos, the Bowl or Hemisphere, as it is said, also the Disk on a level surface; the astronomer Eudoxus, or as some say Apollonius,[2] the Spider; Scopinas [3] of Syracuse, the *Plinthium* [4] or Ceiling, of which an example is in the Circus Flaminius; [5] Parmenio, the Dial for Consultation; Theodosius [6] and Andrias, the Dial for All Latitudes; Patrocles, the Dovetail; Dionysodorus,[7] the Cone; Apollonius, the Quiver.

[5] Augustus divided the city into fourteen regions. The ninth was known as the Circus Flaminius. Vitruvius refers to a temple of Castor in the same region, Book IV. viii. 4.

[6] Theodosius of Tripolis in Lydia, wrote on spherical trigonometry, 1st cent. B.C.

[7] Of Melos, geometer, Strabo, XII. 548.

nius pharetram, aliaque genera et qui supra scripti
sunt et alii plures inventa reliquerunt, uti con-
arachnen,[1] conicum [2] plinthium, antiboreum. Item
ex his generibus viatoria pensilia uti fierent, plures
scripta reliquerunt. Ex quorum libris, si qui velit,
subiectiones invenire poterit, dummodo sciat ana-
lemmatos descriptiones.

2 Item sunt ex aqua conquisitae ab eisdem scriptori-
bus horologiorum rationes, primumque a Ctesibio [3]
Alexandrino, qui etiam spiritus naturalis pneumati-
casque [4] res invenit. Sed uti fuerint ea exquisita,
dignum studiosis agnoscere. Ctesibius enim fuerat
Alexandriae natus patre tonsore. Is ingenio et
industria magna praeter reliquos excellens dictus est
artificiosis rebus se delectare. Namque cum voluisset
in taberna sui patris speculum ita pendere, ut, cum
duceretur susumque reduceretur, linea latens pondus
deduceret, ita conlocavit machinationem.

3 Canalem ligneum sub tigno fixit ibique trocleas
conlocavit; per canalem lineam in angulum deduxit
ibique tubulos struxit; in eos pilam plumbeam per
lineam demittendam curavit. Ita pondus cum
decurrendo in angustias tubulorum premeret caeli
crebritatem, vehementi decursu per fauces fre-
quentiam caeli compressione [5] solidatam extrudens
in aerem patentem offensione tactus [6] sonitus ex-
presserat claritatem.

[1] conarachnen *Mar* : conarchenen *H.*
[2] conicum *Ro* : conatum *H.*
[3] a Ctesibio *ed. Fl* : aclesbio *H.*
[4] pneumaticasque *ed* : ineŭ atticasq *H.*
[5] confressione *H S.*
[6] offensionē tactu *H* : offensione tactus *Ro.*

The persons already enumerated and many others left behind them other discoveries, such as the Conical Spider, the Conical Ceiling and the Antiborean. Many also have left instructions for making Hanging Dials for travellers. From such works anyone who wishes can find instructions, provided he understands the method of describing the analemma.

2. The same writers have also sought the methods of making water-clocks; [1] and first, Ctesibius [2] of Alexandria, who also discovered the nature of wind-pressure and the principles of pneumatics. It is worth a student's while to learn how these discoveries were made. Now Ctesibius was the son of a barber and was born at Alexandria. He was marked out by his talent and great industry, and had the name of being especially fond of mechanical contrivances. On one occasion he wanted to hang the mirror in his father's shop, in such a way that when it was pulled down and pulled up again, a hidden cord drew down the weight; and he made use of the following expedient.

3. He fixed a wooden channel under a beam of the ceiling, and inserted pulleys there. Along the channel he took the cord into a corner where he fixed upright tubes. In these he had a lead weight let down by the cord. Thus when the weight ran down into the narrow tubes, and compressed the air, the large amount of air was condensed as it ran violently down through the mouth of the tube and was forced into the open; meeting with an obstacle, the air was produced as a clear sound.

[1] Hero Alex. *ed.* Schmidt, I. 491–494. Vitruvius draws upon the same sources as Hero. Heiberg, *Gesch. d. Math.* 73.
[2] Book I. i. 7.

4 Ergo Ctesibius cum animadvertisset ex tractu
caeli et expressionibus spiritus vocesque nasci, his
principiis usus hydraulicas machinas primus instituit.
Item aquarum expressiones automatopoetasque [1]
machinas multaque deliciarum genera, in his etiam
horologiorum ex aqua conparationes explicuit.
Primumque constituit cavum ex auro perfectum aut
ex gemma terebrata; ea enim nec teruntur percussu
5 aquae nec sordes recipiunt, ut obturentur. Namque
aequaliter per id cavum influens aqua sublevat
scaphium [2] inversum, quod ab artificibus phellos sive
tympanum dicitur. In quo conlocata est regula
versatile tympanum.[3] Denticulis aequalibus sunt
perfecta, qui denticuli alius alium inpellentes versa-
tiones modicas faciunt et motiones. Item aliae
regulae aliaque tympana ad eundem modum dentata
una motione coacta versando faciunt effectus varie-
tatesque motionum, in quibus moventur sigilla, ver-
tuntur metae, calculi aut ova proiciuntur, bucinae
canunt, reliquaque parerga.
6 In his etiam aut in columna aut parastatica horae
describuntur, quas [4] sigillum egrediens ab imo virgula
significat in diem totum. Quarum [5] brevitates aut
crescentias cuneorum adiectus aut exemptus in
singulis diebus et mensibus perficere cogit. Prae-
clusiones aquarum ad temperandum ita sunt consti-
tutae. Metae fiunt duae, una solida, una cava, ex

[1] automato pictasque *H S*: *corr. Turnebus.*
[2] scaphium *Turn*: scaphum *H*. [3] *asyndeton ut saepe.*
[4] quas *Joc*: quae *H*. [5] quarum *Joc*: quorum *H*.

[1] Plate M, based upon Barbaro *Vitruvius*, A.D. 1584, p. 433,
illustrates the method of such contrivances.
[2] The upper part of Plate M exhibits an application to
this special case: see Notes on M.

4. Ctesibius, therefore, when he observed that the air being drawn along and forced out gave rise to wind-pressure and vocal sounds, was the first to use these principles and make hydraulic machines. He also described the use of water-power in making automata and many other curiosities, and among them the construction of water-clocks. First he made a hollow tube of gold, or pierced a gem; for these materials are neither worn by the passage of water nor so begrimed that they become clogged. 5. The water flows smoothly through the passage, and raises an inverted bowl which the craftsmen call the cork or drum.[1] The bowl is connected with a bar on which a drum revolves. The drums are wrought with equal teeth, and the teeth fitting into one another cause measured revolutions and movements. Further, other bars, and other drums toothed after the same fashion, and driven together in one motion cause, as they revolve, various kinds of movement; therein figures are moved, pillars are turned, stones or eggs are let fall, trumpets sound, and other side-shows.

6. Among these contrivances also, the hours are marked on a column or pilaster; and these are indicated by a figure [2] rising from the lowest part and using a pointer throughout the day. The shortening and lengthening of the pointers was brought about through the addition or removal of wedges for each day and each month.[3] To regulate the supply of water, stopcocks are thus formed. Two cones are made, one solid, one hollow, and so finished

[3] The apparatus required the adjustment of the pointers, and this was done by wedges.

torno ita perfectae, ut alia in aliam inire convenireque
possit et eadem regula laxatio earum aut coartatio
efficiat aut vehementem aut lenem in ea vasa aquae
influentem cursum. Ita his rationibus et machina-
tione ex aqua componuntur horologiorum ad hi-
bernum usum conlocationes.

7 Sin autem cuneorum adiectionibus et detractioni-
bus correptiones dierum aut crescentiae ex cuneis
non probabuntur fieri, quod cunei saepissime vitia
faciunt, sic erit explicandum. In columella horae
ex analemmatos transverse describantur, menstru-
aeque lineae columella signentur. Eaque columna
versatilis perficiatur, uti ad sigillum virgulamque,
qua virgula egrediens sigillum ostendit horas,
columna versando continenter suis cuiusque mensibus
brevitates et crescentias faceret horarum.

8 Fiunt etiam alio genere horologia hiberna, quae
anaphorica[1] dicuntur perficiuntque rationibus his.
Horae disponuntur ex virgulis aeneis ex analemmatos
descriptione ab centro dispositae in fronte; in ea
circuli sunt circumdati menstrua spatia finientes.
Post has virgulas tympanum, in quo descriptus et
depictus est mundus signiferque circulus descriptioque
ex XII caelestium signorum fit figurata, cuius ex[2]
centro deformatio, unum maius, alterum minus.
Posteriori autem parti[3] tympano medio axis versa-
tilis est inclusus inque eo axi aenea mollis catena est
involuta, ex qua pendet ex una parte phellos (sive

[1] anaporica H.
[2] ex (e) Joc : & H.
[3] parte G : parti H S : parti abl. Varro R. R. I. xiii. 5.

[1] When the sun is not shining.

by the lathe that one can enter and fit the other;
the same rod, by loosening or tightening them, pro-
duces a strong or gentle current of water flowing
into the vessels. Hence by this methodical con-
trivance, water-clocks are set up for use in the
winter.[1]

7. But if by adding or withdrawing wedges the
shortening or lengthening of the days shall not be
found to be correctly marked by using wedges
(because very often the wedges are faulty), the
solution must be reached as follows. The hours are
to be indicated cross-wise on a small column, in
accordance with the analemma. The lines of the
months also are to be marked on the column. And
this is to be made to revolve uninterruptedly, so
that it turns to the figure and the rod (with which
rod the figure as it moves on shows the hours), and
so causes the shortening and lengthening of the
hours, in their several months.

8. There are also made winter clocks of another
kind, which are called Anaphorica, and they make
them in the following fashion.[2] An analemma is
described, and the hours are marked with bronze
rods, beginning from a centre on the clock face.
On this circles are described which limit the spaces
of the months. Behind these rods there is a drum,
on which the firmament and zodiac are drawn and
figured: the drawing being figured with the twelve
celestial signs. Proceeding from the centre the spaces
are greater and less. On the back part in the middle
of the drum is fixed a revolving axle. On the axle
a pliable brass chain is coiled. On one end hangs a

[2] The figure indicates the relation of the various parts of the
water-clock, Pl. N, Barbaro, *op. cit.* p. 435.

tympanum), qui ab aqua sublevatur, altera[1] aequo
pondere phelli sacoma saburrale.[2]

9 Ita quantum ab aqua phellos sublevatur, tantum
saburrae pondus infra deducens versat axem, axis
autem tympanum. Cuius tympani versatio alias
efficit, uti maior pars circuli signiferi, alias minor[3]
in versationibus suis temporibus designet horarum
proprietates. Namque in singulis signis sui cuiusque[4]
mensis dierum numeri cava sunt perfecta, cuius bulla,
quae solis imaginem horologiis tenere videtur, signi-
ficat horarum spatia. Ea translata ex terebratione
in terebrationem mensis vertentis perficit cursum
10 suum. Itaque quemadmodum sol per siderum spatia
vadens dilatat contrahitque dies et horas, sic bulla
in horologiis ingrediens per puncta contra centri
tympani versationem, cotidie cum transfertur aliis
temporibus per latiora, aliis per angustiora spatia,
menstruis finitionibus imaginis efficit horarum et
dierum.

De administratione[5] autem aquae, quemadmodum
11 se temperet ad rationem, sic erit faciendum. Post
frontem horologii intra conlocetur castellum in idque
per fistulam saliat aqua[6] et in imo habeat cavum.
Ad id autem adfixum sit ex[7] aere tympanum habens
foramen, per quod ex castello in id aqua influat.
In eo autem minus tympanum includatur cardinibus
ex torno masculo et femina inter se coartatis, ita uti
minus tympanum quemadmodum epitonium in
maiore circumagendo arte leniterque versetur.

[1] altera *Joc* : -ro *H.* [2] saburrale *Joc* : -li *H.*
[3] minor *Joc* : minus *H.* [4] cuiusque *ed* : usque *H.*
[5] administratione̅ *H.* [6] saliata quae *H.*
[7] ex *ed* : & *H.*

[1] For equilibrium as a mechanical principle, see Book X. i. 1.

cork or drum raised by the water; on the other, a counterpoise [1] of sand equal in weight to the cork.

9. Thus, in so far as the cork is raised by the water, to that extent the weight of sand drags down and turns the axle, and the axle turns the drum. The revolution of this drum sometimes makes a greater part of the circle of the zodiac to indicate the proper length of the hour; sometimes a lesser part so to do. For in the several signs, holes are made to the number of the days of the several months; and the pin, which in dials seems to represent the sun, marks the spaces of the hours, and moving from one hole to another completes the course of the passing month. 10. Therefore just as the sun traversing the spaces of the constellations lengthens and contracts the days and hours,[2] so the index moving along the holes in the dial in the opposite direction to the revolving drum, passes daily sometimes over longer, sometimes over shorter spaces; thus it produces over the monthly periods the representation of the hours and days.

The supply of water and its adjustment to the machine is to be as follows. 11. Inside, behind the dial of the clock, a cistern [3] is to be placed. The water is to enter by a pipe, and the cistern is to have a hole at the bottom. Against this at the side there is to be fixed a bronze drum with an opening, through which the water flows into it from the cistern. Within this is enclosed a lesser drum joined to it with tenon and socket, so that the lesser drum turning round within the greater, like a stopcock, fits closely and smoothly in its revolution.

[2] By the different lengths of the day in summer and winter.
[3] *castellum*, a cistern or reservoir, Plin. *N.H.* XXXVI. 121.

12 Maioris autem tympani labrum aequis intervallis
CCCLXV puncta habeat signata, minor vero orbiculus
in extrema circinatione fixam habeat ligulam, cuius
cacumen dirigat ad punctorum regiones, inque eo
orbiculo temperatum sit foramen, quia in tympanum
aqua influit per id et servat administrationem. Cum
autem in maioris tympani labro [1] fuerint signorum
caelestium deformationes, id autem sit inmotum et
in summo habeat deformatum cancri signum,[2] ad
perpendiculum eius in imo capricorni, ad dextram
spectantis [3] librae, ad sinistram arietis signum,[4]
ceteraque inter eorum spatia designata sint, uti in
caelo videntur.

13 Igitur cum sol fuerit in capricorni, orbiculi [5]
ligula [6] in maioris tympani parte ex [7] capricorni
cotidie singula puncta tangens, ad perpendiculum
habens aquae currentis vehemens pondus, celeriter
per orbiculi foramen id extrudit ad vas. Tum [8]
excipiens eam, cum brevi spatio impletur, corripit
et contrahit dierum minora [9] spatia et horarum.
Cum autem cotidiana versatione minoris [10] tympani
ligula ingrediatur in aquarii puncta,[11] descendent
foramina perpendiculo et aquae vehementi cursu
cogitur tardius emittere salientem. Ita quo minus
celeri cursu vas excipit aquam, dilatat horarum
spatia.

[1] libro *H et a. c. S.*
[2] cancri signũ *S* : caneri signorũ *H.*
[3] spectantis *ed* : -tes *H.*
[4] signum *rec* : signi *H.*
[5] orbiculi *Perr* : -lo *H.*
[6] ligula *H G^ch* : lingula *l.*
[7] ex *Kr* : & *H.*
[8] vas tum *Joc* : vastum *H.*
[9] dierum minoris spatia *H* : minora *e₂ ed.*

264

12. The edge of the greater drum is to have 365 points marked at equal intervals. The lesser drum is to have on its outside circumference a tongue fixed, and is to direct the tip towards the places of the points. In the same drum a proportionate perforation is to be adjusted, because the water flows through it into the drum and guides the working. Now since the representations of the signs of the zodiac are on the margin of the greater drum, this is to remain unmoved. The sign of Cancer is to be figured at the top; perpendicularly below it, the sign of Capricorn is at the bottom. On the right of the spectator, the sign of Libra; on his left, that of Aries. The other signs are to be marked within their spaces as they appear in the sky.

13. Therefore, when the sun is in Capricorn,[1] the tongue in the lesser drum touches every day the several points in Capricorn on that part of the larger drum. The great weight of the running water being vertical, is quickly delivered through the perforation of the lesser drum into the vessel. The vessel which receives the water is soon filled, and arrests and contracts the spaces of the days and hours. When, however, by the continuous revolution of the lesser drum, the tongue enters all the points in Aquarius, the perforations leave the perpendicular, and after the downpour the water is compelled to send forth its current more slowly. Thus the slower is the flow by which the vessel receives the water, the more it extends the length of the hours.

[1] *capricorni* sc. *signo.*

[10] minoris *Barb* : maioris *H.*
[11] in aquarii puncta *Ro* : in aquario cuncta *H.*

14 Aquarii vero pisciumque punctis uti gradibus scandens orbiculi foramen in ariete tangendo octavam partem aqua temperate salienti praestat aequinoctiales horas. Ab ariete per tauri et geminorum spatia ad summa cancri puncta partis octavae foramen se[1] tympani versationibus peragens et in altitudinem eo rediens viribus extenuatur, et ita tardius fluendo dilatet morando spatia et efficit horas in cancri signo solstitiales. A cancro cum proclinat et peragit per leonem et virginem ad librae partis octavae puncta revertendo et gradatim corripiendo spatia contrahit horas, et ita perveniens ad puncta 15 librae aequinoctialis rursus reddit horas. Per scorpionis vero spatia et sagittarii proclivius deprimens se foramen rediensque circumactione ad capricorni partem VIII, restituitur celeritate salientis ad brumales horarum brevitates.

Quae sunt in horologiorum descriptionibus rationes et adparatus, ut sint ad usum expeditiores, quam aptissime potui, perscripsi. Restat nunc de machinationibus et de earum principiis ratiocinari. Itaque de his, ut corpus emendatum architecturae perficiatur, insequenti volumine incipiam scribere.

[1] se *Ro* : seu *H*.

14. Then the perforation of the lesser drum mounts by the points of Aquarius and Pisces, as though up a staircase, and touches the eighth degree in Aries; the water duly marks the equinoctial hours by its outflow. From Aries, the perforation proceeding by the revolution of the drum and returning, by way of Taurus and Gemini, to the top points of Cancer at its eighth degree, loses its strength; thus the water flowing more slowly, by its delay is to lengthen the spaces, and so it produces the hours of the solstice in the sign of Cancer. When it inclines from Cancer and proceeds on its return through Leo and Virgo to the points of the eighth degree of Libra, it gradually limits the spaces and contracts the hours; arriving thus at the points of Libra it again restores the equinoctial hours. 15. Through the spaces of Scorpio and Sagittarius, the perforation drops more steeply, and returning in its revolution to the eighth degree of Capricorn, is restored by the swiftness of the current to the short winter hours.

The proportions and constructions used in making dials have now been described, as exactly as I could, with a view to their ready use. Now it remains to discuss machines and their principles. In the next book I will begin to describe these and thereby finish a complete encyclopaedia of architecture.

BOOK X

LIBER DECIMUS

1 Nobili Graecorum et ampla civitate Ephesi lex
vetusta dicitur a maioribus dura condicione sed iure
esse non iniquo constituta. Nam architectus, cum
publicum opus curandum recipit, pollicetur, quanto
sumptui adsit[1] futurum. Tradita aestimatione magis-
tratui bona eius obligantur, donec opus sit perfectum.
Absoluto autem, cum ad dictum inpensa respondit,
decretis et honoribus ornatur. Item si non amplius
quam quarta in opere consumitur, ad aestimationem
est adicienda, de publico praestatur, neque ulla
poena tenetur. Cum vero amplius quam quarta in
opere consumitur, ex eius bonis ad perficiendum
pecunia exigitur.

2 Utinam dii inmortales fecissent, ea lex etiam P. R.
non modo publicis sed etiam privatis aedificiis esset
constituta! Namque non sine poena grassarentur
inperiti, sed qui summa doctrinarum subtilitate essent
prudentes, sine dubitatione profiterentur archi-
tecturam, neque patres familiarum inducerentur ad
infinitas sumptuum profusiones, et ut e bonis eice-
rentur, ipsique architecti poenae timore coacti dili-
gentius modum inpensarum ratiocinantes explicarent,
uti patres familiarum ad id, quod praeparavissent,
seu paulo amplius adicientes, aedificia expedirent.

[1] adsit futurum H.

[1] *Adsit futurum* for *sit futurum*.

BOOK X

Preface

1. In the renowned and spacious Greek city of
Ephesus, a law is said to have been made of old by
the forefathers of the citizens, in harsh terms but
not unjust. For when an architect undertakes the
erection of a public work, he estimates at what cost
it will be done.[1] The estimate is furnished, and his
property is assigned to the magistrate until the
work is finished. On completion, when the cost
answers to the contract, he is rewarded by a decree
in his honour. If not more than a fourth part has to
be added to the estimate, the state pays it and the
architect is not mulcted. But if more than a fourth
extra is spent in carrying out the work, the additional
sum is exacted from the architect's property.

2. Would that the Gods had impelled the Roman
people to make such a law not only for public, but
also for private buildings! In that case unqualified
persons would not swagger abroad with impunity,
but persons trained in entirely accurate methods
would profess architecture with confidence. Nor
would owners be led on to unlimited and lavish
expenditure, so that they are even dispossessed
of their property; and the architects themselves,
controlled by the fear of a penalty, would be more
careful in calculating and declaring the amount of
the cost. In this way the owners would finish their
buildings to the sum provided or with the addition

Nam qui quadringenta[1] ad opus possunt parare, si adicient centum, habendo spem perfectionis delectationibus tenentur; qui autem adiectione dimidia aut ampliore sumptu onerantur, amissa spe et inpensa abiecta, fractis rebus et animis desistere coguntur.

3 Nec solum id vitium in aedificiis, sed etiam in muneribus, quae a magistratibus foro gladiatorum scaenicisque ludorum dantur, quibus nec mora neque expectatio conceditur, sed necessitas finito tempore perficere cogit, id est sedes spectaculorum velorumque inductiones sunt et ea omnia, quae scaenicis moribus per machinationem ad spectationis populo conparantur. In his vero opus est prudentia diligens et ingenii doctissimi cogitata, quod nihil eorum perficitur sine machinatione studiorumque vario ac sollerti vigore.

4 Igitur quoniam haec ita sunt tradita et constituta, non videtur esse alienum, uti caute summaque diligentia, antequam instituantur opera, eorum expediantur rationes. Ergo quoniam neque lex neque morum institutio id potest cogere et quotannis et praetores et aediles ludorum causa machinationes praeparare debent, visum mihi est, imperator, non esse alienum, quoniam de aedificiis in prioribus voluminibus exposui, in hoc, quod[2] finitionem summam corporis habet constitutam, quae sint principia machinarum, ordinata praeceptis explicare.

[1] quadringenta *ed* : quadraginta *H*.
[2] quod *Schn* : qui *H*.

[1] Augustus, 22 B.C., entrusted games to praetors, Dio Cassius, LIV. 2.

of a little more. For those who can provide 400,000 sesterces, and have to add 100,000, are content to be so bound, in the hope of completing the work: while those who are burdened with the addition of a half, or more of the expense, lose hope, and declining further expenditure are forced to give up with broken fortune and spirit.

3. And this defect is found not only in building, but also in the public spectacles which are given by magistrates; whether of gladiators in the forum, or of plays with a theatrical setting. In these neither delay nor expectation is permitted, but necessity compels the performance to take place within a fixed time. There is the seating for the shows, and there are the awnings to be drawn, and all those other things which, in accordance with theatrical tradition, are provided for popular spectacles by means of machinery. Herein the requisites are careful foresight and the resources of a highly trained intelligence. For nothing of this sort is done without mechanical contrivance to which an alert and masterly attention has been applied.

4. Therefore, since these things have so been handed down and determined, it does not seem irrelevant to elucidate their provision with care and all diligence before the work is entered upon. For since neither law nor custom can compel this, while every year the praetors [1] and aediles must prepare the machinery for the spectacles, I thought it not irrelevant, your Highness, after dealing with buildings in the former books, to explain in this book (which rounds off the entire completion of the treatise) what the principles of machinery are, and the rules which guide them.

I

1 MACHINA est continens e materia coniunctio maxi-
mas ad onerum motus habens virtutes. Ea movetur
ex arte circulorum rutundationibus, quam [1] Graeci
cyclicen cinesin appellant. Est autem unum genus
scansorium, quod graece *acrobaticon* dicitur; alterum
spirabile, quod apud eos *pneumaticon* appellatur;
tertium tractorium, id autem Graeci *baru ison*
vocitant. Scansorum autem machinae ita fuerunt
conlocatae, ut ad altitudinem tignis statutis et
transversariis conligatis sine periculo scandatur ad
apparatus spectationem; at [2] spirabile,[3] cum spiritus
ex [4] expressionibus inpulsus et plagae vocesque
organicos exprimantur.

2 Tractorium vero, cum onera machinis pertrahuntur,
ut [5] ad altitudinem sublata conlocentur. Scansoria
ratio non arte sed audacia gloriatur; ea catenationi-
bus [et transversariis et plexis conligationibus] [6] et
erismatum [7] fulturis continentur. Quae autem
spiritus potestate [8] adsumit ingressus, elegantes artis
subtilitatibus consequetur [9] effectus. Tractoria [10]
autem maiores et magnificentia plenas habet ad
utilitatem opportunitates et in agendo cum prudentia
summas virtutes.

[1] quē *H.* [2] at *Ro*: ut *H.* [3] spirabilē *H*, -lem *S.*
[4] ex *Kr*: & *H.* [5] ut *S Gᶜ*: aut *H G.*
[6] et transversariīs—conligationibus *interpolavit G* : *om. H S.*
[7] erismatum *Joc*: chrismatorum *H.*
[8] potestate *Joc*: -tē *H.*
[9] consequetur *G*: -quentur *H S.* [10] *sc.* ratio.

[1] συνεχής, not involving action at a distance.
[2] *materia* is wrongly translated 'wood' by many writers;
Gwilt is correct in translating 'materials.'

CHAPTER I

ON MACHINES AND INSTRUMENTS

1. A MACHINE is a continuous[1] material[2] system having special fitness for the moving of weights. It is moved by appropriate revolutions of circles, which by the Greeks is called *cyclice cinesis*. The first kind of machine is of ladders (in Greek *acrobaticon*); the second is moved by the wind (in Greek *pneumaticon*); the third is by traction (in Greek *baru ison*[3] or equilibrium). Now scaling ladders[4] are so arranged that when the uprights are placed to a height and cross-pieces are tied to them, men may safely ascend to inspect military engines. But we have wind instruments when moving air is driven forth by pressure, and musical beats and vocal sounds are uttered by instruments.

2. Machines of draught draw weights mechanically so that they are raised and placed at an elevation. The design of the ladder prides itself not only on artifice but on military daring. It depends on using tie-pieces and the support of stays. But the design which gains an impulse by the power of moving air reaches neat results by the scientific refinement of its expedients. The traction machines offer in practice greater adaptation which reaches magnificence, and when they are handled carefully, supreme excellence.

[3] This third principle is seen in the water-clock of Ctesibius, Book IX. viii. 8, where the weights of the clock are in equilibrium.

[4] ἀκροβατῶ = 'to climb aloft': military phrase, Polyaen. *scansor*, found in late Latin, to be left here; cf. late Gk. ἀκροβάτης.

3　Ex his sunt quae *mechanicos* alia *organicos* moventur. Inter machinas et organa id videtur esse discrimen, quod machinae pluribus operis[1] ut vi maiore coguntur effectus habenti, uti ballistae[2] torculariorumque prela; organa autem unius operae prudenti tactu perficiunt quod est propositum, uti scorpionis seu anisocyclorum[3] versationes. Ergo et organa et machinarum ratio ad usum sunt necessaria, sine quibus nulla res potest esse non inpedita.

4　Omnis autem est machinatio rerum natura procreata ac praeceptrice et magistra mundi versatione instituta. Namque ni advertamus[4] primum et aspiciamus continentem[5] solis, lunae, quinque etiam stellarum, natura machinata versarentur,[6] non habuissemus interdum lucem nec fructûm maturitatis. Cum ergo maiores haec ita esse animadvertissent, e rerum natura sumpserunt exempla et ea imitantes inducti rebus divinis commodas vitae perfecerunt explicationes. Itaque conparaverunt, ut essent expeditiora, alia machinis et earum versationibus, nonnulla organis, et ita quae[7] animadverterunt ad usum utilia esse studiis, artibus, institutis, gradatim augenda doctrinis curaverunt.

[1] operis *Schn* : operib; *H.*　　[2] uallistae *H.*
[3] anisocyclorum *Joc* : latinis osciclorū *H.*
[4] namque enim advertamus *H.*
[5] vel ut alii vocant, firmamentum, *Quint.* III. 11. 1.
[6] *asyndeton.*
[7] itaq : *H.*

[1] The predecessor of the mediaeval arquebus.
[2] The brilliant conjecture of Giocondo based on late Gk. ἀνισόκυκλος.
[3] Gwilt paraphrases : ' the master movements of the universe itself.' This striking conception of machinery as natural,

3. Of these machines, some are moved mechanically, others are used like tools. There seems to be this difference between machines and instruments, that machines are driven by several workmen as by a greater force producing its effects, for example, projectile engines or wine presses. But instruments carry out their purpose by the careful handling of a single workman, such as the turning of a hand balista [1] or of screws. [2] Therefore both instruments and machinery are necessary in practice and without them every kind of work is difficult.

4. Now all machinery is generated by Nature, and the revolution of the universe guides and controls. [3] For first indeed, unless we could observe and contemplate the continuous motion of the sun, moon and also the five planets; unless [4] these revolved by the device of Nature we should not have known [5] their light in due season nor the ripening of the harvest. Since then our fathers had observed this to be so, they took precedents from Nature; imitating them, and led on by what is divine, [6] they developed the comforts of life by their inventions. And so, they rendered some things more convenient, by machines and their revolutions, and other things by handy implements. Thus what they perceived useful in practice they caused to be advanced by their methods, step by step, through studies, crafts, and customs.

extends the concept of nature and completes the Stoic pantheism.

[4] Supply *ni* from above.

[5] *habeo*, 'to know,' Cic. *Rep.* II. 33 : *matrem habemus, ignoramus patrem* ; cf. ἔχω.

[6] Vitruvius states clearly here the inspiration of the craftsman.

5 Attendamus enim primum inventum de necessi-
tate, ut vestitus, quemadmodum telarum organicis
administrationibus conexus staminis ad subtemen
non modo corpora tegendo tueatur,[1] sed etiam
ornatus adiciat honestatem. Cibi vero non habuisse-
mus abundantiam, nisi iuga et aratra bubus iumen-
tisque omnibus essent inventa. Sucularumque et
prelorum et vectium si non fuisset torcularîs prae-
paratio, neque olei nitorem neque vitium fructum
habere potuissemus ad iucunditatem, portationesque
eorum non essent, nisi plostrorum seu serracorum
per terram, navicularum per aquam inventae essent
6 machinationes. Trutinarum vero librarumque pon-
deribus examinatio reperta vindicat ab iniquitate
iustis moribus vitam. Non minus quae sunt innu-
merabili modo rationes machinationum, de quibus
non necesse videtur disputare, quando[2] sunt ad
manum cotidianae, ut sunt molae,[3] folles fabrorum,
raedae, cisia, torni ceteraque, quae communes ad
usum consuetudinibus habent opportunitates.[4] Itaque
incipiemus de îs, quae raro veniunt ad manus, ut
nota sint,[5] explicare.

II

1 PRIMUMQUE instituemus de îs, quae aedibus sacris
ad operumque publicorum perfectionem necessitate
comparantur. Quae fiunt ita. Tigna duo ad one-

[1] tueatur *Schn* : -antur *H.*
[2] quando *Gr* : quod non *H.* [3] molae *Ro* : motae *H.*
[4] opportunitates *G Sᵉ* : opportunitatib : *H.*
[5] sunt *H.*

5. Let us first consider necessary inventions. In the case of clothing, by the organic arrangements of the loom, the union of the warp to the web not only covers and protects our bodies, but also adds the beauty of apparel. Again, we should not have plentiful food, unless yokes and ploughs had been invented for oxen and other animals. If windlasses, press-beams and levers had not been supplied to the presses, we should not have had clear oil or the produce of the vine for our enjoyment. And their transport would have been impossible, unless the construction of carts or waggons by land, and of ships by sea had been devised. 6. The equilibrium of balances and scales has been applied to free human life from fraud by the provision of just measures. Besides, there are innumerable mechanical devices about which it does not seem needful to enlarge (because they are to hand in our daily use), such as millstones, blacksmiths' bellows, waggons, two-wheeled chariots, lathes and so forth, which are generally suitable for customary use. Hence we will begin to explain, so that they may be known, machines which are rarely employed.

CHAPTER II

ON MACHINES DEPENDING ON EQUILIBRIUM

1. AND first we will explain the machines [1] which must be provided for temples, and for the execution of public works. These are made as follows. Two

[1] Sackur, *Vitruv. u. die Poliorketiker*, furnishes an excellent commentary on the tenth book of Vitruvius.

rum magnitudinem [1] ratione expediuntur. A capite
a fibula coniuncta et in imo divaricata eriguntur,
funibus in capitibus conlocatis et circa dispositis
erecta retinentur. Alligatur [2] in summo troclea,
quem [3] etiam nonnulli rechamum dicunt. In tro-
cleam induntur [4] orbiculi ⟨duo⟩[5] per axiculos versa-
tiones habentes. Per orbiculum ⟨summum⟩ [6] traici-
tur ductarius funis, deinde demittitur et traducitur
circa orbiculum trocleae inferioris. Refertur autem
ad orbiculum imum trocleae superioris et ita descendit
ad inferiorem et in foramine eius religatur.[7] Altera
pars funis refertur inter imas machinae partes.

2 In quadris autem tignorum posterioribus, quo loci
sunt divaricata, figuntur chelonia,[8] in quae coiciuntur
sucularum capita, ut faciliter axes versentur. Eae
suculae proxime capita habent foramina bina ita
temperata, ut vectes in ea convenire possint. Ad
rechamum autem imum ferrei forfices religantur,
quorum dentes in saxa forata accommodantur.
Cum autem funis habet caput ad suculam religatum
et vectes ducentes eam versant, funis ⟨se⟩[9] involvendo
circum suculam extenditur et ita sublevat onera ad
altitudinem et operum conlocationes.

3 Haec autem ratio machinationis, quod per tres
orbiculos circumvolvitur, trispastos appellatur. Cum

[1] magnitudine *H*.
[2] alligatur . . . troclea *Joc* : alligantur . . . trocleae *H*.
[3] quem e_2 *ed* : quae *H*.
[4] induntur *Joc* : induuntur *H*. [5] duo *add. Joc.*
[6] summum *add. Joc.*
[7] religatur *ed* : -gantur *H*.
[8] chelonia e_2 *ed* : helonia *H*. [9] *add. Joc.*

pieces of timber are carefully prepared, which answer to the size of the load. They are set up, connected [1] at the top with a brace, and spreading at the base. They are kept upright by ropes fastened at the top and adjusted round them. At the top a block is made fast: these some call *rechamus*. On this block two pulleys are fixed, which revolve upon axles. Over the top pulley the leading rope is passed. It is then let down and drawn round a pulley of the block below. It is returned to the lower pulley of the top block, and so comes again to the lower block and is secured to the eye of it. The other end of the rope belongs to the lower part of the machine.[2]

2. On the back faces of the timbers where they separate, socket-pieces are fixed, into which the ends of the windlasses are put, so that the axles may turn easily. The windlasses near their ends have two perforations so adjusted that handspikes can fit into them. To the bottom of the block, iron pincers are fixed, the teeth of which are adjusted to holes in the blocks of stone. Now when the rope has its end tied to the windlass, and the handspikes draw and turn the windlass, the rope in winding round the axle is made taut and so lifts up weights to their place in the work.

3. Now this kind of contrivance, because it is turned by three pulleys, is called *trispastos*.[3] When,

[1] This passage seems to settle the reading *destinabantur, distinebantur* in Caes. *B. G.* IV. 17. 5; *binis utrimque fibulis ab extrema part destinabantur*, cf. Holmes *ad loc.* Caesar's account of the bridge was probably supplied by the engineer.

[2] The upper block seems to have had one pulley placed above the other. *imum* the superlative in a comparative sense. Neuburger, fig. 270.

[3] sc. *rechamus*.

vero in ima troclea duo orbiculi, in superiore
tres versantur, id pentaspaston dicitur. Sin autem
maioribus oneribus erunt machinae comparandae,
amplioribus tignorum longitudinibus et crassitudini-
bus [1] erit utendum; eadem ratione in summo
fibulationibus, in imo sucularum versationibus [2]
expediendum. His explicatis antarii funes ante
laxi conlocentur; retinacula super scapulas machinae
longe disponantur, et si non erit, ubi religetur,
pali resupinati defodiantur et circum fistucatione
4 solidentur, quo funes alligentur. Troclea in summo
capite machinae rudenti contineatur, et ex eo
funis perducatur [3] ad palum et quae est in palo
trocleam inligata. Circa eius orbiculum funis inda-
tur et referatur ad eam trocleam, quae erit ad
caput machinae religata. Circum autem orbiculum
ab [4] summo traiectus funis descendat et redeat ad
suculam, quae est in ima machina, ibique religetur.
Vectibus autem coacta sucula versabitur, eriget
per se machinam sine periculo. Ita circa dispositis
funibus et retinaculis in palis haerentibus ampliore
modo machina conlocabitur. Trocleae et ductarii
funes, uti supra scriptum est, expediuntur.
5 Sin autem colossicotera amplitudinibus et pon-
deribus onera in operibus fuerint, non erit
suculae committendum, sed quemadmodum sucula
chelonîs retinetur, ita axis includatur habens in
medium tympanum amplum, quod nonnulli rotam

[1] grassitudinibus *H*.
[2] versationibus *Joc* : venationibus *H*.
[3] funis perducatur *Rode* : funes pducantur *H*.
[4] ab summo *Joc* : ad summo *H* (a s. *G*ᶜ).

[1] sc. μηχάνημα, Baumeister, p. 1621.

however, there are two pulleys in the lower block and
three in the upper block, it is called *pentaspaston*.[1]
But if machines are to be prepared for greater loads,
we must use longer and thicker timbers. In the
same way we must use larger bolts at the top, and
larger windlasses below. When all is made ready,
the tackle,[2] which is previously loose, is to be attached;
the cables are to be carried over the shoulders of the
machine. If there is no place to which they may be
fixed, sloping piles are to be driven into the ground
and secured by ramming the ground round them; to
them the ropes are to be attached. 4. The block at
the top of the machine is to be attached by a cable.
And a rope is to be taken from the top to the inclined
pile and fastened to the block which is on the pile.
Passing over its pulley the rope is to be carried back
to the block which shall be bound to the top of the
machine. After passing round the pulley the rope
is to come down from the top and is to return to the
windlass which is below, and bound there. The
windlass being worked by handspikes will revolve:
and of itself will raise the machine without danger.
Thus the ropes are passed round, the cables are fixed
to the piles and the machine is in position for use. The
pulleys and the tackle are applied as it is described
above.

5. If, however, the works involve loads of immense
dimensions and weight, we must not trust to the
windlass. But an axle held in sockets like the
windlass is to be inserted having in the middle a large
drum,[3] which some call a wheel: the Greeks,

[2] Cf. *ansarii*, C.I.L. VI. 1016a.
[3] *multaque per trocleas et tympana pondere magno | com-
movet atque levi sustollit machina nisu.* Lucr. iv. 905-6.

appellant, Graeci autem *amphieren*,[1] alii *perithecium*
6 vocant. In his autem machinis trocleae non eodem
sed alio modo comparantur. Habent enim et in
imo et in summo duplices ordines orbiculorum.
Ita funis ductarius traicitur in inferioris[2] trocleae
foramen, uti aequalia duo capita sint funis, cum erit
extensus, ibique secundum inferiorem trocleam
resticula circumdata et contenta utraeque partes
funis continentur, ut neque ⟨in dextram neque⟩[3]
in sinistram partem possint prodire. Deinde capita
funis referuntur in summa troclea ab exteriore parte
et deiciuntur circa orbiculos imos et redeunt ad imum
coiciunturque[4] infimae trocleae ad orbiculos ex
interiore parte et referuntur dextra sinistra; ad
caput circa orbiculos summos redeunt.
7 Traiecti autem ab exteriore parte feruntur dextra
sinistra tympanum in axe ibique, ut haereant,
conligantur. Tum autem circa tympanum involutus
alter funis refertur ad ergatam, et is[5] circumactus[6]
tympanum et axem. Se involvendo pariter exten-
dunt, et ita leniter levant onera sine periculo.
Quodsi maius tympanum conlocatum aut in medio
aut in una parte extrema fuerit sine ergata, calcantes
homines expeditiores[7] habere poterunt[8] operis
effectus.
8 Est autem aliud genus machinae satis artificiosum
et ad usum celeritatis expeditum, sed in eo dare
operam non possunt nisi periti. Est enim tignum,
quod erigitur et distenditur retinaculis quadrifariam.

[1] amphieren *H* : ἀμφιήρης ut ἀμφιήκης *Hesych.*
[2] inferioris *G* : -res *H*, inferius *S*. [3] *add. Joc.*
[4] coniciuntur *H S*. [5] is *G S*ᶜ : his *H S*.
[6] circumactus *e₂ Joc* : circū auctus *H*.
[7] expeditiores *rec* : expeditores *H*.

amphieres, or otherwise *perithecium*. 6. In these machines the blocks [1] are made in a different way. For they have below and above two pulleys arranged vertically. The guide rope passes into a hole in the lower block in such a way that the rope when it is taut has its two ends equally long. The rope being passed round and secured to the lower block, both ends of the rope are secured so that they cannot swerve to the right or left. Then the ends of the rope are carried back on the outside of the upper block and are taken over its lower pulleys, and return below. They are passed from the inside to the pulleys of the lower block and are carried up right and left and return to the top round the highest pulleys.

7. Passing from the outside they are carried right and left of the drum on the axle, and are tied so as to hold there. Then another rope is wound round the drum and carried back to the capstan. This rope is turned round the drum and axle, winds itself up and the ends are stretched equally and so gently raise the loads in safety. But if a greater drum is fixed either in the middle or on one of the ends, the capstan is dispensed with, and the drum, being trodden by men, can produce results more quickly.

8. There is another [2] kind of machine ingenious enough and suitable for speedy use; but only skilled workmen can deal with it. A pole is set up and is kept upright by cables in four different directions.

[1] The pulleys are not side by side, but one above the other.

[2] Like a crane (ill. Neuburger, *op. cit.* 209). Plate O.

[s] poterunt *pro* poterit *Mar.*

Sub retinaculo chelonia[1] duo figuntur, troclea funibus[2] supra chelonia[1] religatur, sub troclea regula[3] longa circiter pedes duos, lata digitos sex, crassa quattuor supponitur. Trocleae ternos ordines orbiculorum in latitudine habentes conlocantur. Ita tres ductarii funes in machina[4] religantur. Deinde referuntur ad imam trocleam et traiciuntur ex interiore parte per eius orbiculos summos. Deinde referuntur ad superiorem trocleam et traiciuntur ab[5] exteriore parte in interiorem per orbiculos imos.

9 Cum descenderint ad imum, ex interiore[6] parte et per secundos orbiculos traducuntur in extremum et referuntur in summum ad orbiculos secundos; traiecti redeunt ad imum et per imum[7] referuntur ad caput; traiecti per summos redeunt ad machinam imam. In radice autem machinae conlocatur tertia troclea; eam autem Graeci *epagonta*, nostri *artemonem* appellant. Ea troclea religatur ad trocleae radicem habens orbiculos tres, per quos traiecti funes traduntur hominibus ad ducendum. Ita tres ordines hominum ducentes sine ergata celeriter

10 onus ad summum perducunt. Hoc genus machinae polyspaston[8] appellatur, quod multis orbiculorum circuitionibus et facilitatem summam praestat et celeritatem. Una autem statutio tigni hanc habet utilitatem, quod ante quantum velit et dextra ac sinistra a latere[9] proclinando onus deponere potest.

Harum machinationum omnium, quae supra sunt scriptae, rationes non modo ad has res, sed etiam

[1] celonia *H*. [2] funibus *Joc*: funis *H*.
[3] regula *ed*: aregula *H*.
[4] *i.e.* in summo machinae *Joc*. [5] ab: ad *H*.
[6] ex interiore *Joc*: exteriore *H*.
[7] et per imum *Gr*: & pimo *H*. [8] polyspasion *H*.
[9] a latere e_2: adlatere *H*.

Where the cables meet at the top, two sockets are fixed; the block is fixed to the sockets with ropes. Under the block is put a piece of timber about two feet long, six inches wide, and four inches thick. The blocks, with three sets of pulleys in their width, are fixed so that three guide ropes are inserted in the machine. These are brought down to the lower block and pass from the side next the pole over the upper pulleys; thence they are carried to the upper block and pass over the lower pulley, from the outside to within.

9. When they come below they pass over the second pulleys from within outwards, and are brought back to the second pulleys above. Passing on they return below, and from below they return to the top. And passing over the top of the pulleys, they return to the lower part of the machine. Further, at the foot of the machine a third block is fixed; this is called *epagon* by the Greeks, *artemon* [1] by us. The block is secured to its foot with three pulleys, over which the ropes pass, which are given to men to work. Thus three sets of men working without a capstan quickly draw a load to the top. 10. This kind of machine is called *polyspaston* [2] (a compound pulley), because with its many pulleys it is very easy and quick to work. The use of a single pole has this advantage, that by inclining it beforehand it can deposit the load sideways right or left as much as is desired.

The use of all the contrivances described above is available not only for these purposes, but also for

[1] 'The guiding pulley of a machine for raising weights.'

[2] This machine was used by Archimedes in launching a ship for Hiero, Plut. *Marcellus*, 14.

ad onerandas et exonerandas naves sunt paratae,
aliae erectae, aliae planae in carchesîs versatilibus
conlocatae. Non minus sine tignorum erectionibus
in plano etiam eadem ratione et temperatis funibus
et trocleis subductiones navium efficiuntur.

11 Non est autem alienum etiam Chersiphronos [1]
ingeniosam rationem exponere. Is enim scapos
columnarum e lapidicinis cum deportare vellet
Ephesi ad Dianae fanum, propter magnitudinem
onerum et viarum campestrem mollitudinem non
confisus carris,[2] ne rotae devorarentur, sic est
conatus. De materia trientali scapos quattuor, duos
transversarios interpositos,[3] quanta longitudo scapi
fuerit, complectet et conpeget[4] et ferreos cnodacas[5]
uti subscudes in capitibus scaporum inplumbavit et
armillas in materia ad cnodacas[5] circumdandos infixit;
item bucculis[6] tigneis capita religavit; cnodaces[5]
autem in armillis inclusi liberam habuerunt versa-
tionem tantam; ita, cum boves ducerent subiuncti,[7]
scapi[8] versando in cnodacibus et armillis sine fine
volvebantur.

12 Cum autem scapos omnes ita vexerunt et instabant
epistyliorum vecturae, filius Chersiphronos[9] Meta-
genes transtulit ex scaporum[10] vectura etiam in
epistyliorum deductione. Fecit enim rotas circiter
pedum duodenûm et epistyliorum capita in medias

[1] crestiphonos *H*. [2] carris *S*: caris *H*.
[3] interpositos *ed*: interpostios *H*.
[4] cônpeget *G* (*alternis temporibus futuro et praeterito utitur H
quasi sermone Semitico*).
[5] cnodac- *Turn*: chodac- *H*.
[6] bucculis *S*: bacculis *H*.
[7] subiuncti *G*: -tis *H S*.
[8] scapi *Joc*: scapo *H*. [9] cresiphonos *H*.
[10] excaporum *H*.

loading up and unloading ships: some being upright, others on the level, being fixed with revolving sockets.[1] In like fashion on the level (without erecting poles) blocks and ropes are adjusted in order to draw ships ashore.[2]

11. It is quite germane to our subject to describe an ingenious contrivance of Chersiphron.[3] When he desired to bring down the shafts of the columns from the quarries to the Temple of Diana at Ephesus, he tried the following arrangement. For he distrusted his two-wheeled carts, fearing lest the wheels should sink down in the yielding country lanes because of the huge loads. He framed together four wooden pieces of four-inch timbers: two of them being cross-pieces as long as the stone column. At each end of the column, he ran in iron pivots with lead, dovetailing them, and fixed sockets in the wood frame to receive the pivots, binding the ends with wood cheeks: thus the pivots fitted into the sockets and turned freely.[4] Thus when oxen were yoked and drew the frame, the columns turned in the sockets with their pivots and revolved without hindrance.

12. Now when they had thus brought all the shafts, and set about bringing the architraves, Metagenes, the son of Chersiphron, applied the method of conveying the shafts to the transport of the lintels. For he made wheels about twelve feet in diameter, and

[1] *carchesium*: here it seems to mean the 'top' of a mast, or alternatively a similar socket or shoe resting on the ground. Cf. Lucr. v. 418: *summi carchesia mali.*

[2] Caes. *B. G.* IV. 29. 2.

[3] Account probably based upon the treatise referred to, VII. *pref.* 12.

[4] The frame contained the column, like the frame which contains a garden roller when it is drawn by a horse.

rotas inclusit; eadem ratione cnodaces[1] et armillas
in capitibus inclusit: ita cum trientes a bubus
ducerentur, in armillis inclusi cnodaces versabant[2]
rotas, epistylia vero inclusa uti axes in rotis eadem
ratione,[3] qua scapi, sine mora ad opus pervene-
runt. Exemplar autem erit eius, quemadmodum in
palaestris cylindri exaequant ambulationes. Neque
hoc potuisset fieri, nisi primum propinquitas esset—
non enim plus sunt ab lapidicinis ad fanum milia
passuum octo—nec ullus est clivus sed perpetuus
campus.

13 Nostra vero memoria cum colossici Apollinis in
fano basis esset a vetustate diffracta, et metuentes,
ne cederet ea statua et frangeretur, locaverunt ex
eisdem lapidicinis basim excidendam. Conduxit
quidam Paconius. Haec autem basis erat longa
pedes duodecim, lata pedes VIII, alta pedes sex.
Quam Paconius gloria fretus non uti Metagenes
adportavit, sed eadem ratione alio genere constituit
14 machinam facere. Rotas enim circiter pedum XV
fecit et in his rotis capita lapidis inclusit, deinde
circa lapidem fusos sextantales[4] ab rota ad rotam
ad circinum compegit, ita uti fusus a fuso non
distaret pedem esse unum. Deinde circa fusos
funem involvit et[5] bubus iunctis funem ducebant.
Ita cum explicaretur, volvebat rotas, sed non poterat
ad lineam via recta ducere, sed exibat in unam

[1] chodaces *H*. [2] versabant *ed* : -bant *H G*.
[3] rationem *a. c. H*. [4] sextantales *Joc* : sextantes *H*.
[5] et *ed* : ut *H*.

[1] Like a garden roller with a stone cylinder.
[2] Vitruvius' account of the temple is correct. It is unlikely
that he was mistaken here. Wood, *op. cit.* 19, 265. There
are quarries some miles up the Cayster on the left bank.

fixed the ends of the architraves in the middle of the wheels. In the same way he fixed pivots and sockets at the ends of the architraves. Thus when the frames of four-inch timber were drawn by the oxen, the pivots moving in the sockets turned the wheels, while the architraves being enclosed like axles in the wheels (in the same way as the shafts) reached the building without delay. (A similar machine[1] is used when rollers level the walks in the palaestrae.) This expedient would not have been possible unless, to begin with, the distance had been short. It is not more than eight miles from the quarries to the temple, and there are no hills but an unbroken plain.[2]

13. Within living memory, when the base of the colossal statue of Apollo in the temple had been cracked across by age, it was feared lest the statue should give way and be broken, and a contract was let out for cutting a base from the same quarries. A certain Paconius[3] undertook the contract. The base was 12 feet long, 8 feet wide, 6 feet high. Paconius was so proud of his reputation that he did not convey it after the manner of Metagenes, but decided to construct a similar machine in another way. 14. He made two wheels about 15 feet in diameter and in them he enclosed the ends of the stone. Next, he fixed two-inch pieces less than a foot apart round the stone lengthwise from wheel to wheel. Then he wound a rope outside the wood pieces and drew the rope with a yoke of oxen. When the rope was pulled it caused the wheels to turn. However, he could not keep the machine straight along the road, but it kept

[3] The same name occurs Suet. *Tib.* 61.

VITRUVIUS

partem. Ita necesse erat rursus retroducere. Sic
Paconius ducendo et reducendo pecuniam contricavit,
ut ad solvendum non esset.

15 Pusillum extra progrediar et de his lapidicinis,
quemadmodum sint inventae, exponam. Pixodarus
fuerat pastor. Is in his locis versabatur. Cum
autem cives Ephesiorum cogitarent fanum Dianae
ex marmore facere decernerentque, a Paro, Proconnenso,[1] Heraclea, Thaso [2] uti marmor peteretur,[3]
propulsis ovibus Pixodarus in eodem loco pecus
pascebat, ibique duo arietes inter se concurrentes
alius alium praeterierunt et impetu facto unus
cornibus percussit saxum, ex quo crusta candidissimo
colore fuerat deiecta. Ita Pixodarus dicitur oves in
montibus reliquisse et [4] crustam cursim Ephesum,
cum maxime de ea re ageretur, detulisse. Ita
statim honores decreverunt ei et nomen mutaverunt:
pro Pixodaro Euangelus nominaretur. Hodieque
quotmensibus magistratus in eum locum proficiscitur
et ei sacrificium facit, et si non fecerit, poena tenetur.

III

1 DE tractoriis rationibus quae necessaria putavi,
breviter exposui. Quorum motus et virtutes duae

[1] proconesso *H*. [2] Thaso *ed* : thasii *H*.
[3] marmor peteretur *Mar* : marmo|rep&aĩ *H*.
[4] reliquiss& crustam *H*.

[1] Callistratus, another transport contractor, had a similar
experience. Athen. *Mech.* 7.
[2] *trico, Vulg. Ecclus.* xxxii. 15.

swerving to one side.[1] Thus it was necessary to draw
it back again. So Paconius by drawing it backwards
and forwards frittered [2] his money away and went
bankrupt.

15. I will make a small digression, and describe
how these quarries were discovered. Pixodarus was
a shepherd who lived in this neighbourhood. Now
when the citizens of Ephesus planned to build a
temple of marble and decided to obtain marble from
Paros, Proconnesus, Heraclea, and Thasos, Pixodarus
was driving his sheep and was pasturing them in the
same place. And there two rams, butting together,
overran one another, and, in the rush, one of them
struck a rock with his horns and a chip of the whitest [3]
colour was thrown down. So Pixodarus is said to
have left his sheep on the hills and to have run with
the chip of marble to Ephesus at the time when there
was a great discussion about the matter. Thus the
citizens decreed him divine honours [4] and changed
his name: instead of Pixodarus he was to be named
Evangelus. And to this day every month the
magistrate sets out to that place and sacrifices to
Evangelus. If he omits to do so he is subject to a
penalty.

CHAPTER III

ON RECTILINEAR AND CIRCULAR TRACTION

1. I HAVE set forth briefly what I thought neces-
sary about methods of Traction. Of these, the
effective movements [5] are two distinct and unlike

[3] White and black are colours, although not always re-
garded as such by the physicist.
[4] *Acts*, xiv. 11. [5] *motus et virtutes*, hendiadys.

res diversae et inter se dissimiles uti congruentes uti principia pariunt eos perfectos: una porrecti, quam Graeci *eutheiam* vocitant, altera rutunditatis, quam Graeci *cycloten*[1] appellant. Sed vero neque sine rutunditate motus porrecti nec sine porrecto rotationis versationes onerum possunt facere levationes.

2 Id autem ut intellegatur, exponam. Inducuntur uti centra axiculi in orbiculos et in trocleis conlocantur, per quos orbiculos funis circumactus directis ductionibus et in sucula conlocatus vectium versationibus onerum facit egressus in altum. Cuius suculae cardines uti centra porrecti in cheloniis,[2] foraminibusque eius vectes conclusi capitibus ad circinum circumactis torni ratione versando faciunt oneris elationes. Quemadmodum etiam ferreus vectis cum est admotus ad onus, quod manuum multitudo non potest movere, supposita uti centro citro[3] porrecta pressione, quod Graeci *hypomochlion* appellant, et lingua sub onus subdita, caput eius unius hominis viribus pressum id onus extollit.

3 Id autem quod brevior pars prior vectis ab ea pressione, quod est centrum, subit sub onus, et quo longius ab eo centro distans caput eius deducitur.[4] Per id faciundo motus circinationis cogit pressionibus

[1] κυκλωτήν *Joc* : cycletoen *H.*
[2] cheloniis *S* : caeloniis *H.*
[3] citro *adj. Gr.* : cito *H.*
[4] deducitur per id *Ro* : per id deducitur *H.*

[1] The whole of the rest of this chapter seems to derive from the *Mechanica* (attributed wrongly to Aristotle), 850a–852a.

things, although they are co-operating principles in producing their results. There is the principle of the *straight* line (which the Greeks call *eutheia*); and that of the *circle* (which the Greeks call *cyclotes*). But neither rectilinear motion without circular, nor rotating movements without rectilinear, can produce the raising of loads.

2. I will illustrate this so as to make it understood. Axles are fixed as centres for the pulleys and fitted into blocks. The rope is taken round over the pulleys and drawn straight down; and being coiled round a windlass, when the levers are turned, causes the load to rise upwards. The pivots of the windlass being inserted, like centres, into the sockets, the levers are inserted into holes in the windlass, and their ends being pushed round in a circle and turning like a lathe, cause the movement upwards of the loads. After the same fashion, when an iron lever [1] is applied to a weight which a multitude of hands could not move, a fulcrum [2] is placed under it on the nearer side as a centre (which the Greeks call *hypomochlion*). The short end of the lever is placed under the load, and the long end of the lever, when it is pressed down by one man's strength, raises the load.

3. Now this lifting is accomplished because the short end of the lever is under the weight, and is nearer to the fulcrum where is the centre of motion; and in so far as the head of the lever which is pressed down is further distant from the fulcrum. When the lever is in action, the circular motion (*i.e.* of the

[2] *pressio*, Caes. *B.C.* II. 9. 6. Caesar here again, as in the case of the Rhine bridge, uses the technical knowledge of his engineers.

examinare paucis manibus oneris maximi pondus.
Item si sub onus vectis ferrei lingula subiecta fuerit
neque eius caput pressione in imum, sed adversus
in altitudinem extolletur,[1] lingula fulta in areae
solo habebit eam pro onere, oneris autem ipsius
angulum [2] pro pressione. Ita non tam faciliter quam
per oppressionem, sed adversus nihilominus in pondus
oneris erit exercitatum. Igitur si plus lingula
vectis supra hypomochlion posita sub onus subierit
et caput eius propius [3] centrum pressiones habuerit,
non poterit onus elevare, nisi, quemadmodum supra
scriptum est, examinatio vectis longitudinis per caput
neque ductionibus fuerit facta.

4 Id autem ex trutinis, quae staterae dicuntur, licet
considerare. Cum enim ansa propius caput, unde
lancula pendet, ibi [4] ut centrum est conlocata et
aequipondium in alteram partem scapi, per puncta
vagando quo longius aut etiam ad extremum perduci-
tur, paulo et inpari [5] pondere amplissimam pensionem
parem [6] perficit per scapi librationem, et examinatio
longius ab centro recedens ita inbecillior.[7] Aequi-
pondii brevitas maiorem vim ponderis momento de-
ducens sine vehementia molliter ab imo susum versum
egredi cogit futurum.

¹ extolletur *rec* : -litur *H*.
² *post* angulum *H folii 145 paginam aversam propter mem-
branae tenuitatem vacuam habet; in qua primum crux* (*Vol. I.
pref. xvii*) *delineata cui tenuitas nihil obstat, multis annis post
scriptor incertus addidit* Goderän' pposit' *a sinistro crucis, a
dextro fortasse* codex, *quasi in bibliothecae indice*.
³ proprius *H*. ⁴ ibi *Mar* : ubi *H*.
⁵ et impari *Rode* : etiam pari *H*.
⁶ parem *Joc* : parte *H*. ⁷ inbecilliora equipondii *H*.

¹ A blank page was left in *H*. 145*b*. See Vol. I. *pref.* xvii.
This probably contained a diagram of two positions of the

lever) [1] round the fulcrum causes the weight of a great load to be balanced by a few hands. [2] Also if the short arm of an iron lever is put under the load, and the long arm is raised from the fulcrum upwards against the load, instead of downwards, the short arm resting upon the ground, will have that for a load, and the corner of the actual load for a fulcrum. Thus —not so easily indeed as by pressing against the actual fulcrum—none the less by pressing against the weight of the load, the work will be done. Therefore if the shorter end of the lever, being applied above the fulcrum, goes too far under the load, and the longer arm has the fulcrum too near the centre, it will not be able to raise the load, unless (as it has been written above) the long arm of the lever is balanced from the end, and not by pressing down the centre.

4. We can consider this in the case of steel-yards which are called *staterae*. For when the handle of suspension is placed like a centre, nearer the end of the beam from which the scale hangs, and the weight moves along the points marked on the other side of the centre, the further it is taken (or even to the end), with a small and unequal weight, it is made equal to a very large weight by bringing the beam to a level. The further the balancing weight retreats from the centre, to that extent may it be of slighter amount. The small counter-weight brings down, as it moves, the more powerful weight, and causes it to rise gently and without violence up and down.

lever in the form of a cross ⟩⟨ which was worked over by the illuminator.

[2] When a lever is in motion the weight moved and the weight causing motion tend to be inversely proportionate to the lengths of the two arms measured from the fulcrum.

5 Quemadmodum etiam navis onerariae maximae
gubernator ansam gubernaculi tenens, qui *oiax*[1] a
Graecis appellatur, una manu momento per centrum
ratione pressionibus artis agitans, versat eam
amplissimis et inmanibus mercis et pinus ponderibus
oneratam. Eiusque vela cum sunt per altitudinem
mediam mali[2] pendentia, non potest habere navis
celerem cursum, cum autem in summo cacumine
antemnae subductae sunt, tunc vehementiore pro-
greditur impetu, quod non proxime calcem mali,
quod est loco centri, sed in summo longius et ab eo
progressa recipiunt in se vela ventum.[3]

6 Itaque uti vectis sub onere subiectus, si per medium
premitur, durior est neque incumbit, cum autem
caput eius summum deducitur, faciliter onus extollit,
similiter vela, cum sunt per medium temperata,
minorem habent virtutem, quae autem in capite
mali summo conlocantur discedentia longius a centro,
non acriore sed eodem flatu, pressione cacuminis
vehementius cogunt progredi navem. Etiam remi
circa scalmos strophis religati, cum manibus inpel-
luntur et reducuntur, extremis progredientibus a
centro parmis maris undis spumam inpulsu vehementi
protrudunt porrectam navem, secante prora liquoris
raritatem.

7 Onerum vero maxima pondera, cum feruntur a
phalangariis hexaphoris et tetraphoris,[4] examinantur
per ipsa media centra phalangarum, uti in diviso

[1] οἴιξ *Joc* : nox *H*.
[2] mediam mali *Joc* : mediā ali *H*, media mali *G S*.
[3] vela ventum *Joc* : velamentū *H*.
[4] exaphoris et raphoris *H*.

[1] Ciceronian phrase is *ingens immanisque*.

5. Just as also the steersman of a great merchant vessel holds the handle of the tiller (which is called *oiax* by the Greeks) with only one hand, and moves it skilfully round the centre where the fulcrum is tightly set, and guides the ship laden with an abundant or indeed enormous [1] cargo of merchandise and timber.[2] Further, when the sails are only half-mast high, the ship cannot run swiftly; but when the yard-arms are drawn up to the tops of the masts, the ship sails with a more vehement course, because the sails take the wind, not near the foot of the mast (which is like a fulcrum), but at the mast-head from which the distance is greater.

6. Therefore just as when a lever is put under a load and pressed down about the middle, it is moved with difficulty, but when the longer arm is pressed down from the top, it easily raises the load; so when the sails are set half-mast high, they are less effective, but when they are set at the mast-head at a greater distance from the centre, without any further rising of the wind, with the summit as fulcrum, they cause the ship to sail a stronger course. When also the oars of a ship are tied to the tholes with loops, and pushed backwards and forwards, the ends of the blades,[3] moving at a distance from the centre in the waves of the sea, drive the ship with a mighty impulse straight through the foam, as the bows cleave the yielding waters.

7. Again, when very heavy loads are carried by gangs of four or six porters, they are balanced exactly in the middle of the carrying-poles, so that

[2] *pinus* ' timber ' used generically.

[3] *parma* and *palma* interchanged in MSS.; cf. πάλμη Hesych. for πάρμη.

oneris solido pondere certa quadam divisionis
ratione aequas partis collis singuli ferant operarii.
Mediae[1] enim partes phalangarum, quibus lora
tetraphororum invehuntur, clavis sunt finitae, nec
labuntur in unam partem. Cum enim extra finem
centri promoventur, premunt eum locum, ad quem
propius[2] accesserunt, quemadmodum in statera
pondus, cum examine progreditur ad fines pondera-
tionum.

8 Eadem ratione iumenta, cum iuga eorum subiugiis[3]
loris per medium temperantur, aequaliter trahunt
onera. Cum autem inpares sunt eorum virtutes et
unum plus valendo premit alterum, loro traiecto
fit una pars iugi longior, quae inbecilliori[4] auxiliatur
iumento. Ita in phalangis[5] et iugis cum in medio
lora non sunt conlocata sed in una parte, qua pro-
greditur[6] lorum ab medio,[7] unam breviorem,
⟨alteram⟩[8] efficit partem longiorem. Ea ratione si
per id centrum, quo loci perductum est lorum,
utraque capita circumaguntur,[9] longior pars ampli-
orem, brevior minorem agit circinationem.

9 Quemadmodum vero minores rotae[10] duriores et
difficiliores habent motus, sic phalangae et iuga,
in quibus partibus habent minora a centro ad capita
intervalla, premunt duriter colla, quae autem
longiora habent ab eodem centro spatia, levant
oneribus et trahentes[11] et ferentes. Cum haec ita ad

[1] mediae *G^c* : media *H*. [2] proprius *H*.
[3] subiugiis *Schn* : subiugiorum *H*.
[4] inbecilliori *h* : -lior *H*.
[5] phalangis *S* : palangis *H*.
[6] progredit *H S^c*. [7] ad medio *H*.
[8] alteram *G*.
[9] circumagentur *Joc* : -gentes *H*.
[10] rotae *ed* : notae *H*.

the undivided solid weight is shared in a definite proportion, and each labourer carries an equal part of the load on his neck. For the middle parts of the carrying-poles, on which the straps of the porters are fixed, are provided with pegs so that the straps do not slip out of their place. For when the load slips away from the middle, it presses upon that side to which it is nearer, just as in the case of the weight on a balance when it is adjusted nearer one end of the beam.

8. In the same way, yokes of oxen draw their loads evenly, when the yokes are arranged about the middle, by the thongs of the yoke-straps. But when the strength of the oxen is not equal, and one by its greater pull burdens the other, the thong is moved on so that one part of the yoke is longer so as to help the weaker beast. Thus in the case of carrying-poles [1] and yokes, when the suspending thong is not placed in the middle but on one side, where the thong departs from the middle, it renders one side shorter and the other longer. By this means when the two arms of the yoke turn about the centre at which the thong is placed, the longer part describes a greater circle, the shorter arm a less.

9. Now just as smaller wheels are harder and more awkward to turn, so when carrying-poles and yokes have a less interval from the centre to the end of the arm, they press upon the neck, but those which have longer spaces from the same centre, ease off the load both in hauling and carrying. Since

[1] *phalanga*, in the sense of 'roller,' Caes. *B.C.* II. 10. It seems only to occur in the plural.

[11] et trahentes *Mar* : extrahentes *H.*

centrum porrectionibus et circinationibus reciperent
motos,[1] tunc vero etiam plostra, raedae, tympana,
rotae, cocleae, scorpionis, ballistae, prela ceteraeque
machinae isdem rationibus per porrectum centrum
et rotationem circini versantum faciunt ad pro-
positum effectus.

IV

1 Nunc de organis, quae ad hauriendam aquam
inventa sunt, quemadmodum variis generibus con-
parentur, exponam. Et primum dicam de tympano.
Id autem non alte tollit aquam, sed exhaurit expedi-
tissime multitudinem magnam. Ad tornum aut
circinum fabricatus ⟨axis,⟩[2] capitibus lamna ferratis,
habens in medio circa se tympanum ex tabulis inter
se coagmentatis, conlocatur in stipitibus habentibus
in se sub capita axis ferreas lamminas. In eius
tympani cavo interponuntur octo tabulae transversae
tangentes axem et extremam tympani circuitionem,
2 quae dividunt aequalia[3] in tympano spatia. Circa
frontem eius figuntur tabulae, relictis semipedalibus
aperturis ad aquam intra concipiendam. Item
secundum axem columbaria fiunt excavata in
singulis spatiis ex una parte. Id autem cum est
navali ratione picatum, hominibus calcantibus versatur
et hauriendo per aperturas, quae sunt in frontibus
tympani, reddit per columbaria secundum axem
supposito labro ligneo habente una secum coniunctum
canalem. Ita hortis ad inrigandum vel ad salinas
ad temperandum praebetur aquae multitudo.

[1] motos *H* : (*cf. Am. Apoc.* XI. 13, terrae moto).
[2] *add. Joc.* [3] equalia e_2 : aequali *H*.

[1] *E.g.* the wheels of a cart.
[2] Plate P from Fra Giocondo.

in this way such contrivances take movements at a centre, both rectilinear and circular, so also waggons, carts, drum-wheels and other wheels, screws, scorpions, balistae, presses and other machines produce the desired effect with parts moving about a centre along a straight line [1] and by a rotation round it.

CHAPTER IV

ON MACHINES FOR RAISING WATER, AND FIRST THE TYMPANUM

1. I will now explain the machines which have been invented for raising water and how they are contrived in their different kinds. And first I will speak of the *tympanum*.[2] Now this does not raise the water to a great height, but draws a large amount in a short time. The axle is wrought in a lathe or made circular by hand and its ends are hooped with iron bands. Round the middle it has a drum of planks fitted together; and it is placed upon posts cased with iron, under the ends of the axle. Within the drum are inserted eight cross-pieces going from the axle to the circumference of the drum, and these are arranged round the drum at equal intervals. 2. Around the rim of the drum, boards are fixed with six-inch openings to receive the water. Further, along the axle, holes are cut, one for each bay. When it has been tarred ship-fashion, it is turned by men on a treadmill. The water which is drawn through the openings in the outside of the drum is delivered also through the holes next to the axle into a wooden basin having a trough connected with it. Thus an abundant supply of water is furnished for irrigating gardens, or for diluting salt in salt pits.

3 Cum autem altius extollendum erit, eadem ratio
communicabitur. Sic rota fiet circum axem eadem
magnitudine, ut ad altitudinem, quae opus fuerit,
convenire possit. Circum extremum latus rotae
figentur modioli quadrati pice et cera solidati. Ita
cum rota a calcantibus versabitur, modioli pleni ad
summum elati [1] rursus ad imum revertentes infundent
4 in castellum ipsi per se quod extulerint.[2] Sin autem
magis altis [3] locis erit praebendum, in eiusdem rotae
axe involuta duplex ferrea catena demissaque ad
imum libramentum conlocabitur, habens situlos
pendentes aereos congiales. Ita versatio rotae
catenam in axem involvendo efferet situlos in sum-
mum, qui ⟨cum⟩[4] super axem pervehuntur, cogentur
inverti et infundere in castellum aquae quod extule-
rint.[2]

V

1 FIUNT etiam in fluminibus rotae eisdem [5] rationibus,
quibus supra scriptum est. Circa earum frontes
adfiguntur pinnae, quae, cum percutiuntur ab impetu
fluminis, cogunt progredientes versari rotam, et ita
modiolis haurientis et in summum referentes sine
operarum calcatura ipsius fluminis inpulsu versatae
praestant, quod opus est ad usum.
2 Eadem ratione etiam versantur hydraletae,[6] in
quibus eadem sunt omnia, praeterquam quod in
uno capite axis tympanum dentatum est [7] inclusum.

[1] elati *rec* : &lati *H S*.
[2] extulerint *S* : extullerint *H*.
[3] altis *Joc* : aliis *H*.
[4] *add. Joc.* [5] eisdem e_2 : eiusdē *H*.

3. When, however, the water is to be raised to a greater height, a similar method will be employed. A wheel is so constructed round the axle of such a size as shall suit the height required. Round the circumference of the wheel square buckets are to be fixed, made taut with pitch and wax. Thus, when the wheel is turned by men treading it, the buckets are raised full to the top, and on their return down, pour into a conduit what they have raised. 4. But if a supply is required at a still greater height, a double iron chain is made to revolve on the axle of the same wheel and let down to the lower level, with bronze buckets suspended to the chain, each holding 3 quarts. Thus the turning of the wheel makes the chain revolve round the axle, and carries the buckets to the top. These are carried over the axle; they are made to turn over and pour into the conduit the water they have raised.

CHAPTER V

ON MILL WHEELS

1. WHEELS are used in rivers in the same way as described above. Round the outside, paddles are fixed, and these, when they are acted on by the current of the river, move on and cause the wheel to turn. In this fashion they draw up the water in buckets and carry it to the top without workmen to tread the wheel. Hence, being turned by the force of the river only, they supply what is required.

2. Mill wheels are turned on the same principle, except that at one end of the axle a toothed drum is

[6] hydraletae *Schn* : hydraulae *H*. [7] est *Schn* : & *H*.

VITRUVIUS

Id autem ad perpendiculum conlocatum in cultrum
versatur cum rota pariter. Secundum id tympanum
maius item dentatum planum est conlocatum, quo
continetur. Ita dentes tympani eius, quod est in
axe inclusum, inpellendo dentes tympani plani [1]
cogunt fieri molarum [2] circinationem. In qua
machina inpendens infundibulum [3] subministrat molis
frumentum et eadem versatione subigitur farina.

VI

1 Est autem etiam cocleae ratio, quae magnam vim
haurit aquae, sed non tam alte tollit quam rota.
Eius autem ratio sic expeditur. Tignum sumitur,
cuius tigni quanta rata est [4] pedum longitudo, tanta
digitorum expeditur crassitudo. Id ad circinum
rutundatur. In capitibus circino dividentur circumi-
tiones eorum tetrantibus et octantibus in partes [5]
octo, eaeque lineae ita conlocentur, ut plano posito
tigno utriusque capitis ad libellam lineae inter
se respondeant, et quam magna pars sit octava [6]
circinationis tigni, tam magna spatia decidantur [7]
in longitudinem. Item tigno plano conlocato lineae
ab capite ad alterum caput perducantur ad libellam
convenientes. Sic et in rotundatione et in longitu-
dine aequalia spatia fient. Ita quod loci describuntur
lineae, quae sunt in longitudinem [8] spectantes,
facient decusationes et in decusationibus finita
puncta.

[1] plani *Joc* : plane *H*. [2] molarum *S* : malarum *H G*.
[3] infunibulū *H*. [4] rata est *Gr* : ratus *H*.
[5] partes *Joc* : pedes *H*. [6] octava *Joc* : -vae *H*.
[7] dicidantur *H G⁰*. [8] longitudinem *Schn* : -ne *H*.

fixed. This is placed vertically on its edge and turns with the wheel. Adjoining this larger wheel there is a second toothed wheel placed horizontally by which it is gripped. Thus the teeth of the drum which is on the axle, by driving the teeth of the horizontal drum, cause the grindstones to revolve. In the machine a hopper is suspended and supplies the grain, and by the same revolution the flour is produced.

CHAPTER VI

ON THE WATER SCREW

1. THERE is further an application of the screw which draws a large amount of water, but does not raise it as high as the wheel. The contrivance [1] is as follows. A beam is taken as many inches thick as it is feet long. This is rounded to an exact circle. At the ends the circumference is to be divided by a compass into quadrants and eighths and so to eight parts; and the diagonals are to be so drawn that when the beam is horizontal the lines at either end correspond exactly. The whole length is to be marked off into spaces equal to one-eighth of the circumference. Again, the beam is to be laid level and lines are to be drawn from one end to the other guided by a level. Thus there will be equal divisions both round the beam and along it. Where the longitudinal lines are drawn, they will intersect the cross-lines, and these intersections are to be marked by points.

[1] Plate Q from Fra Giocondo. A similar illustration is given in *p*, a Parisian MS. assigned by Rose to XI or XII *c*; it should rather be dated *c*. 1500. The illustration was probably contemporary with Fra Giocondo.

VITRUVIUS

2　His ita emendate descriptis sumitur salignea tenuis
aut[1] de vitice secta regula, quae uncta liquida pice
figitur in primo decusis puncto. Deinde traicitur
oblique ad insequentes longitudinis et circumitionis[2]
decusis, item ex ordine progrediens singula[3] puncta
praetereundo et circum involvendo conlocatur in
singulis decusationibus, et ita pervenit et figitur ad
eam lineam recedens a primo in octavum punctum,
in qua prima pars est eius fixa. Eo modo quantum
progreditur oblique spatium et per octo puncta,
tantundem et longitudine procedit ad octavum
punctum. Eadem ratione per omne spatium longitu-
dinis et rutunditatis singulis decusationibus oblique
fixae regulae per octo crassitudinis divisiones invo-
lutos faciunt canales et iustam cocleae naturalemque
imitationem.

3　Ita per id vestigium aliae super alias figuntur
unctae pice liquida, et exaggerantur ad id, uti
longitudinis octava pars fiat summa crassitudo.
Supra eas circumdantur et figuntur tabulae, quae
pertegant eam involutionem. Tunc eae tabulae
pice saturantur et lamminis ferreis conligantur, ut
ab aquae vi ne dissolvantur. Capita tigni ferrea.
Dextra autem ac sinistra cocleam tigna conlocantur
in capitibus utraque parte habentia transversaria
confixa. In his foramina ferrea[4] sunt inclusa inque
ea inducuntur styli, et ita cocleae hominibus calcanti-
4　bus faciunt versationes. Erectio autem eius ad
inclinationem sic erit conlocanda, uti, quemadmodum
Pythagoricum trigonum orthogonium describitur,

[1] aut *G* : ut *H.*
[2] longitudinis et circumitionis *Mar* : longitudines et cir-
cumitiones *H.*
[3] singula e_2 *ed* : -li *H.*　　[4] ferrea *Ro* : ferret *H.*

2. When these points are accurately marked in this way, there is taken a thin strip of willow or osier and this being smeared with liquid pitch is fixed upon the first intersection. Thence it is drawn across obliquely to the next intersections of the longitudinal and circular line. In like manner proceeding in due course it passes the successive points and winds round them, being fixed at the several intersections. Thus moving back from the first to the eighth point it reaches and is fixed on the line in which the first part of it was fixed. In this way, as far as it advances obliquely through eight points of the circumference, so far it proceeds longitudinally to the eighth point. In the same manner, throughout the whole distance of the length and of the circumference, strips of wood are fixed obliquely at the several intersections and make channels which wind round through the eight divisions of the thickness: thus forming an accurate and natural imitation of a spiral shell.

3. Then along this track, strips are fixed one above another and smeared with liquid pitch, and are piled up until the entire thickness is one-eighth the length. Above the strips, planks are placed all round and fixed to cover the winding strips. Then the planks are soaked in pitch and bound together with iron hoops to protect them against the effect of the water. The ends of the wood are covered with iron. On the right and left of the screw, beams are placed at the ends, with cross-pieces placed on either side. In these are iron sockets into which the pivots of the screws are inserted, and so the screws are made to turn by a treadmill. 4. The fixing of the screw is to be done at such a slope that it corresponds to the manner in which the Pythagorean right-angled

sic id habeat responsum, id est uti dividatur longitudo
in partes v, earum trium extollatur caput cocleae;
ita erit ab perpendiculo [1] ad imas naris spatium
earum partium [2] IIII. Qua ratione autem oporteat
id esse, in extremo libro eius forma descripta est in
ipso tempore.

Quae de materia fiunt organa ad hauriendam aquam,
quibus rationibus perficiantur quibusque rebus motus
recipientia praestent versationibus ad infinitas
utilitates, ut essent notiora, quam apertissime
potui, perscripta sunt in illo tempore.

VII

1 INSEQUITUR nunc de Ctesibica machina, quae in
altitudinem aquam educit, monstrare. Ea sit ex aere.
Cuius in radicibus modioli fiunt gemelli [3] paulum
distantes, habentes fistulas furcillae figura [4] similiter
cohaerentes, in medium catinum concurrentes. In
quo catino fiant asses in superioribus naribus fistularum
coagmentatione subtili conlocati, qui praeobturantes [5]
foramina narium [6] non patiuntur quod spiritu [7]
2 in catinum est expressum. Supra catinum paenula
ut infundibulum [8] inversum est attemperata et per
fibulam cum catino cuneo traiecto continetur, ne
vis inflationis aquae eam cogat elevari.[9] Insuper

[1] a perpendiculo *Joc* : adppendiculū *H*.
[2] partium *Mar* : pedes *H*.
[3] gememelli *H*.
[4] furcillae sunt figura *H* : (sunt *del. Ro*).
[5] praeobdurantes *H*.
[6] foraminariū *H*.
[7] spiritu *Joc* : -tus *H*.
[8] infudibulū *H*.
[9] elevari *Schn* : -re *H*.

triangle is described [1]: that is, the length is to be divided into 5 parts of which the head of the screw is to be raised three. Thus there will be, between the perpendicular and the lower mouth, a length of 4 parts. How this is to be done is shown by a diagram at the end [2] of the book.

And there I have displayed as clearly as I could for information the contrivances made of wood for drawing water, their construction and the means by which they are moved so as to furnish very great advantages.

CHAPTER VII

ON THE WATER MACHINE OF CTESIBIUS [3]

1. WE next proceed to describe the Ctesibian machine [4] which raises water to a height. It is to be of bronze. The lower part consists of two similar cylinders at a small distance apart, with outlet pipes. These pipes converge like the prongs of a fork, and meet in a vessel placed in the middle. In this vessel valves are to be accurately fitted above the top openings of the pipes. And the valves by closing the mouths of the pipes retain what has been forced by air into the vessel. 2. Above the vessel, a cover like an inverted funnel is fitted and attached, by a pin well wedged, so that the force of the incoming water may not cause the cover to rise.

[1] Book IX. *pref.* 6.

[2] *tempus*, 'the temple of the head.' Cf. Greek, κρόταφος Βιβλίου τὸ ὄπισθεν μέρος, Suidas. The illustrations were put together at the end of the whole work, Sackur, 14.

[3] This chapter is translated by Schmidt, Hero Alex. I. 494.

[4] Hero Alex. *Pneum.* I. 28; Schmidt, ill. p. 133.

fistula, quae tuba dicitur, coagmentata in altitudine
fit erecta. Modioli autem habent infra nares
inferiores fistularum asses interpositos supra foramina
3 eorum, quae sunt in fundis. Ita de supernis in
modiolis emboli masculi torno politi et oleo subacti
conclusique regulis et vectibus conmoliuntur.[1]
Qui erit aer ibi cum aqua, assibus obturantibus [2]
foramina cogent. Extrudent inflando pressionibus
per fistularum nares aquam in catinum, e quo
recipiens paenula spiritu [3] exprimit per fistulam in
altitudinem, et ita ex inferiore [4] loco castello conlocato
ad saliendum aqua subministratur.

4 Nec tamen haec sola ratio Ctesibii fertur exquisita,
sed etiam plures et variis generibus ab eo liquore
pressionibus coactae spiritus efferre ab natura
mutuatos effectus ostendentur, uti merularum [5]
aquae motu voces atque *angubatae*, bibentiaque et
eadem moventia [6] sigilla ceteraque, quae delecta-
tionibus oculorum et aurium usu sensus eblandiantur.

5 E quibus quae maxime utilia et necessaria iudicavi
selegi, et in priore volumine de horologiis, in hoc de
expressionibus aquae dicendum putavi. Reliqua,
quae non sunt ad necessitatem sed ad deliciarum
voluntatem, qui cupidiores erunt eius subtilitatis, ex
ipsius Ctesibii [7] commentariis poterunt invenire.

[1] conmoliuntur e_2: conmoliuntur *H*.
[2] obdurantibus *H*.
[3] spiritu *Perr*: spiritus *H*.
[4] inferiore *Joc*: interiore *H*.
[5] merularum (aquae) *Turn*: merulerūque *H*.
[6] moventia *Mar* (*intr. Liv*): movent ea *H*.
[7] ethesibi *H*.

[1] Hero Alex. (Schmidt) I. 91.

On the cover a pipe, which is called a trumpet, is jointed to it, and made vertical. The cylinders have, below the lower mouths of the pipes, valves inserted above the openings in their bases. 3. Pistons are now inserted from above rounded on the lathe, and well oiled. Being thus enclosed in the cylinders, they are worked with piston rods and levers. The air and water in the cylinders, since the valves close the lower openings, the pistons drive onwards. By such inflation and the consequent pressure they force the water through the orifices of the pipes into the vessel. The funnel receives the water and forces it out by pneumatic pressure through a pipe. A reservoir is provided, and in this way water is supplied from below for fountains.

4. Nor is this the only remarkable device of Ctesibius which is current. There are many others of various kinds which are driven by the pressure of water. The pneumatic pressure will be shown to produce effects borrowed from nature, both notes of blackbirds [1] by the motion of water, and walking automata [2]; little figures which drink and move; and other things which flatter the pleasure of the eyes and the use of the ears. 5. Of these I have chosen those which I have judged most useful and serviceable. In the last book I spoke about clocks; in this we have had to deal with water-pumps. The other things which are not for service, but for the purpose of our delight, can be found in the commentaries of Ctesibius by those who have a special wish for such ingenuity.

[2] Some such contrivance whereby the movement of an owl causes the blackbird to sing or be silent is described, *ib.*

VIII

1 DE hydraulicis autem, quas habeant ratiocinationes, quam brevissime proximeque attingere potero et scriptura consequi, non praetermittam. De materia conpacta basi, ara[1] in ea ex aere fabricata conlocatur. Supra basim eriguntur regulae dextra ac sinistra scalari forma conpactae, quibus includuntur aerei modioli,[2] fundulis ambulatilibus ex torno subtiliter subactis habentibus fixos in medio ferreos ancones[3] et verticulis cum vectibus coniunctos, pellibusque lanatis involutis.[4] Item in summa planitia foramina circiter digitorum ternûm. Quibus foraminibus proxime in verticulis conlocati aerei delphini[5] pendentia habent catenis cymbala[6] ex ore infra foramina modiolorum[7] calata.

2 Intra aram, quod loci aqua sustinetur, inest pnigeus[8] uti infundibulum inversum, quem subter[9] taxilli alti circiter digitorum ternûm suppositi librant spatium imum una inter labra pnigeos[10] et arae fundum. Supra autem cervicula eius coagmentata arcula sustinet caput machinae, qui[11] graece *canon musicus* appellatur. In cuius longitudine canales,[12] si tetrachordos est, fiunt quattuor, si hexachordos, sex, si octochordos, octo.

[1] ara *Turnebus* : aerea *H.* [2] modioli *ed*: moduli *H.*
[3] angones *H.* [4] involutis *Mar* : -tos *H.*
[5] dulpini *H.* [6] cymbala *Joc* : -li *H.*
[7] modiolorum *Joc* : modiorum *H.*
[8] pnigeus *Turn* : inid genus *H.*
[9] subter *Joc* : sup *H.* [10] pnigeos *Turn* : phiga eos *H.*
[11] qui *Ro* : quae *H.* [12] canales, si *Joc* : sicanales *H.*

[1] Aristocles, a younger contemporary of Vitruvius, compares the water organ to a clepsydra, Athen. IV, 174c.

CHAPTER VIII

ON WATER ORGANS

1. ON the principles of water organs,[1] I cannot omit to touch as briefly and precisely as possible, and commit them to writing.[2] A base is made of framed wood and a bronze vessel is placed upon it. On the base, uprights are set up right and left, with rungs like a ladder. Between these, bronze cylinders are enclosed. Pistons which move up and down are accurately wrought on a lathe, and with iron piston rods fixed in the middle. These rods are joined by pins to the levers, and the pistons are covered with leather and wool. Further, on the top surface of the cylinders are openings about three fingers ($2\frac{1}{2}$ in.) broad. Adjoining the openings and placed on pins are bronze dolphins with valves hanging by chains from their mouths and secured below the openings of the cylinders.

2. Within the chest where the water is stored there is an air-vessel, like a funnel inverted; beneath this, small blocks about three inches high are placed, and they keep even the lowest space between the lips of the air-vessel and the bottom of the chest. On the neck of the air-vessel a small box is constructed which carries the top of the instrument, which is called in Greek the *canon musicus*. Along this there are four channels, if the instrument is tetrachord; six if it is hexachord; eight if it is octochord.

[2] Schmidt, *op. cit.*, Vol. I. pp. 496–505, translates this chapter and gives two illustrations. Plate R is based upon the text with the help of Barbaro and Schmidt.

3 Singulis autem canalibus singula epitonia sunt
inclusa, manubriis ferreis conlocata. Quae manu-
bria, cum torquentur, ex arca patefaciunt nares in
canales. Ex canalibus autem canon habet ordinata
in transverso foramina respondentia naribus, quae
sunt in tabula summa, quae tabula graece *pinax*
dicitur. Inter tabulam et canona regulae sunt
interpositae ad eundem modum foratae et [1] oleo
subactae, ut faciliter inpellantur et rursus introrsus
reducantur, quae obturant ea foramina plinthidesque
appellantur. Quarum itus et reditus alias obturat
4 alias aperit [2] terebrationes. Haec regulae habent
ferrea choragia fixa et iuncta cum pinnis, quarum
pinnarum tactus motiones efficit regularum conti-
nenter. Supra tabulam foramina quae ex canalibus
habent egressum spiritus. Sunt anuli adglutinati,
quibus lingulae omnium includuntur organorum.
E modiolis autem fistulae sunt continentes coniunctae
pnigeos [3] cervicibus pertinentesque ad nares, quae
sunt in arcula. In quibus asses sunt ex torno
subacti et ibi conlocati, qui, cum recipit arcula animam,
spiritum non patientur [4] obturantes foramina rursus
redire.
5 Ita cum vectes extolluntur, ancones deducunt [5]
fundos modiolorum ad imum delphinique, qui sunt
in verticulis inclusi, calantes in eos cymbala, aere [6]
implent spatia modiolorum, atque ancones extollentes
fundos intra modiolos vehementi pulsus crebritate
et obturantes foramina cymbalis superiora, aera,
qui est ibi clusus,[7] pressionibus coactum in fistulas

[1] et oleo *Joc* : ex oleo *H*. [2] aperit *Joc* : operit *H*.
[3] pnigeos *Turn* : ligneis *H*.
[4] patientur *ed* : patietur *H*.
[5] deducunt *Joc* : deducunt *H*.
[6] cymbala, aere *Rode* : cymbaliare *H*.

3. In the several channels are single stopcocks fitted with an iron handle. When the iron handle is turned, it opens an aperture from the chest into the channels. The canon has openings from the channels; and the openings are placed along the canon corresponding to the openings in the top board which, in Greek, is called the *pinax*. Between the pinax above and the canon below, bars are fixed with openings corresponding to those of the canon and the pinax. The bars are well oiled so that they easily pass backwards and forwards, closing and opening the holes in the channels. The bars are called *plinthides*. 4. To these plinthides, iron springs are attached which connect with the keys of the organ, so that to touch the keys forthwith moves the plinthides. On the pinax, rings are fixed round the holes which allow the passage of the air from the channels. And these rings receive the feet of the organ pipes. Now from the cylinders, there run lengths of piping to the neck of the air-vessel and communicate with the openings in the chest. Over these openings there are placed valves wrought on the lathe. These valves, when the chest is supplied with air, close the openings and do not allow the air to escape.

5. Thus when the levers are raised, the piston rods draw down the pistons towards the bottom of the cylinder, and the dolphins working on pivots, releasing the valves in the cylinders, fill the cavity of the cylinders with air. Thereupon the piston rods raise the pistons within the cylinders with rapid and violent strokes and close the openings above, with the valves; the air in the cylinders is forced by the pumping into

⁷ clusus *H* (cludentes *Manil*).

VITRUVIUS

cogunt, per quas in pnigea[1] concurrit et per eius
cervices in arcam. Motione vero vectium vehe-
mentiore[2] spiritus frequens compressus epitoniorum
6 aperturis influit et replet animae canales. Itaque
cum pinnae manibus tactae propellunt et reducunt
continenter regulas alternis opturando[3] foramina
alternis aperiundo, e musicis artibus multiplicibus
modulorum varietatibus sonantes excitant voces.

Quantum potui niti, ut obscura res per scripturam
dilucide[4] pronuntiaretur, contendi, sed haec non est
facilis ratio neque omnibus expedita ad intellegendum
praeter eos, qui in his generibus habent exercita-
tionem. Quodsi qui parum intellexerit ex scriptis,
cum ipsam rem cognoscet, profecto inveniet curiose
et subtiliter omnia ordinata.

IX

1 TRANSFERTUR nunc cogitatio scripturae ad rationem
non inutilem sed summa sollertia a maioribus
traditam, qua in via raeda sedentes vel mari navi-
gantes scire possimus, quot milia numero itineris
fecerimus. Hoc autem erit sic. Rotae, quae erunt
in raeda, sint latae per medium diametrum pedum
quaternûm [et sextantes],[5] ut, cum finitum locum

[1] pnigea *Turn* : lignea *H.*
[2] vehementiore *Joc* : -res *H.*
[3] obturando *Phil* : opturant *H.* [4] delucide *H.*
[5] *del. Perrault, sed vide infra* ix. 5.

[1] The organist was called *hydraules*, Petron. 36.
[2] The diagram only shows one range of pipes, sometimes
other rows were added with different intonation.

the pipes. Through these it rushes into the air-vessel and by the neck into the chest. By a stronger motion of the levers, the air is further compressed, flows in by the openings of the stopcocks and fills the channels with air. 6. Therefore when the keys are touched by the hands, they forthwith move the sliding bars backwards and forwards, closing some holes and opening others. By the art of music,[1] the notes of the organ are struck with manifold [2] and varied modulation.

I have striven to the best of my ability to describe clearly in writing a complicated machine. The task is not an easy one, nor accessible to the general understanding, except for those who have experience in matters of this kind. Yet if anyone grasps them imperfectly from my writings, a knowledge of the instrument will disclose the ingenuity and precision of its design.[3]

CHAPTER IX

ON MEASURING A JOURNEY

1. OUR next specification concerns a contrivance not without its uses, which we owe to the great skill of our predecessors. By this contrivance, whether we travel on land in a four-wheeled carriage, or by sea in a ship, we can learn how many miles we have covered. It is as follows. The wheels of the carriage are to be 4 feet in diameter, and on one

[3] From the reference of Tertullian, *de baptismo* 8, the organ would seem to have been known to the Christian Church. In 1931 an organ dated A.D. 288 was found at Aquincum near Buda-Pesth with bronze manual. *Observer*, May 24, 1931.

habeat in se rota ab eoque incipiat progrediens in
solo viae facere versationem, perveniendo ad eam
finitionem, a qua coeperit versari, certum modum
spatii habeat peractum pedes xii s.

2 His ita praeparatis tunc in rotae modiolo ad partem
interiorem[1] tympanum stabiliter includatur habens
extra frontem suae rutundationis extantem denticu-
lum unum. Insuper autem ad capsum raedae
loculamentum firmiter figatur habens tympanum
versatile[2] in cultro conlocatum et in axiculo conclu-
sum, in cuius tympani frontem denticuli perficiantur
aequaliter divisi numero quadringenti convenientes
denticulos tympani inferioris. Praeterea superiori
tympano ad latus figatur alter denticulus prominens
extra dentes.

3 Super autem, planum eadem ratione dentatum
inclusum in alterum loculamentum conlocetur,
convenientibus dentibus denticulo, qui in secundi
tympani latere fuerit fixus, in eoque tympano fora-
mina fiant, quantum diurni[3] itineris miliariorum
numero cum raeda possit exire.[4] Minus plusve rem
nihil inpedit. Et in his foraminibus omnibus calculi
rotundi conlocentur, inque eius tympani theca, sive
id loculamentum est, fiat foramen unum habens
canaliculum, qua calculi, qui in eo tympano inpositi
fuerint, cum ad eum locum venerint, in raedae
capsum et vas aeneum, quod erit suppositum, sin-
4 guli cadere possint. Ita cum rota progrediens secum
agat tympanum imum et denticulum eius singulis
versationibus tympani superioris denticulos inpulsu

[1] interiorem *Joc* : inferiorem *H*.
[2] versatile *ed* : -lem *H*.
[3] diurni *ed Fl* : diuturni *H*.
[4] exire = praeterire, *cf. Sen. Tac.*

320

wheel a point is to be marked. When the wheel begins to move forward from this point and to revolve on the road surface, it will have completed a distance of $12\frac{1}{2}$ feet [1] on arriving at the point from which it began its revolution.

2. As the next step, let a drum be secured to the inner side of the hub of the wheel with one tooth projecting from its exterior circumference. Above this, in the body of the carriage, let a box be securely fixed with a drum revolving perpendicularly, and fastened to an axle. On the outside edge of the drum 400 teeth are to be set at equal intervals so as to meet the teeth on the lower drum. Further, at the side of the upper drum there is to be fixed a second tooth projecting beyond the other teeth.

3. Now above there is to be placed a horizontal wheel toothed in the same manner, and enclosed in a similar case, with teeth which fit upon the single tooth which projects on the side of the second drum. In this drum openings are to be made equal in number to the miles which can be covered with the carriage in a day: whether the miles are more or less makes no difficulty. In all these openings, round stones are to be placed, and in the lining of the drum there is to be one opening attached to a small channel, where the stones placed in the drum when they come to the corresponding place can fall one by one into the carriage body and a bronze vessel which is placed below. 4. Thus when the wheel moves forwards and carries with it the lowest drum, in a single revolution, the wheel causes its one tooth to strike in passing the teeth in the upper drum. The effect

[1] Very near the value of π: $\frac{25}{8} = 3 \cdot 125$. The value $\frac{22}{7} = 3 \cdot 14 \ldots$ was known to Archimedes and probably earlier.

cogat praeterire, efficiet, ⟨ut,⟩[1] cum cccc [2] imum
versatum fuerit, superius tympanum semel circum-
agatur [3] et denticulus, qui est ad latus eius fixus,
unum denticulum tympani plani producat. Cum
ergo cccc versationibus imi tympani semel [4] superius
versabitur, progressus efficiet spatia pedum milia
quinque, id est passus mille. Ex eo quot calculi
deciderint, sonando singula milia exisse monebunt.
Numerus vero calculorum ex imo [5] collectus summa
diurni ⟨itineris⟩[6] miliariorum numerum indicabit.

5 Navigationibus vero similiter paucis rebus com-
mutatis eadem ratione efficiuntur. Namque traicitur
per latera parietum axis habens extra navem pro-
minentia capita, in quae includuntur rotae diametro
pedum quaternûm et s [7] extantes habentes circa
frontes adfixas pinnas aquam tangentes. Item
medius axis in media navi ⟨habet⟩[8] tympanum cum
uno denticulo extanti extra suam rutunditatem.
Ad eum locum conlocatur loculamentum habens
inclusum in se tympanum, peraequatis dentibus
cccc convenientibus denticulo tympani, quod est in
axe inclusum, praeterea ad latus adfixum extantem
6 extra rotunditatem alterum dentem unum. Insuper
in altero loculamento cum eo confixo inclusum
tympanum planum ad eundem modum dentatum,
quibus dentibus ⟨convenit⟩[9] denticulus, qui est ad
latus fixus tympano, quod est in cultro conlocatum,
ut eos [10] dentes, qui sunt plani tympani, singulis

[1] add. Joc. [2] cccc rec : ecce H.
[3] circumagatur Joc : -gitur H.
[4] semel rec : simul H.
[5] imo e₂ ed : uno H. [6] add. Ro.
[7] et s extantes Gr : & sextantae H.
[8] add. Joc. [9] add. Kr.

will be that when the lower drum has revolved 400
times, the upper drum will revolve once; and the
tooth fixed on the side of the upper drum moves one
tooth of the horizontal drum. Since, therefore, in
400 revolutions of the lower drum, the upper drum
will revolve once, as it moves it will record thereby a
distance of 5000 feet, that is, of 1000 paces. Hence
when a stone falls, it will announce by its sound the
traversing of a single mile, and the number of the
stones collected from below will indicate, by their
total, the number of miles for the day's journey.

5. With a few changes, a similar procedure is
adopted for sea voyages. For an axle is passed
through the sides of the hull, with ends projecting
beyond the ship. On these axles are projecting wheels
with diameters of $4\frac{1}{2}$ [1] feet, having paddles round
the edge which touch the water. Also the middle
of the axle in the middle of the ship has a drum with
one tooth projecting beyond its circumference. At
this place a case is fixed with a drum enclosed within,
having 400 teeth at equal intervals corresponding to
the teeth of the drum which is fixed on the axle. In
addition, another single tooth is fixed to the side of
the drum and projects beyond it. 6. Above, and
adjoining it, another case is fixed, which contains a
horizontal wheel toothed in the same way. Answer-
ing to these teeth, there is the tooth which is fixed on
the side of the vertical drum. This tooth at each
revolution drives one of the teeth which belong to the

[1] Barbaro, *ad loc.*, suggests that the diameter was increased
to allow for the drag of the water or wind.

[10] (ita) ut eos *Schn* : in eos *H.*

versationibus singulos dens [1] inpellendo in orbem
planum [2] tympanum verset. In plano autem tym-
pano foramina fiant, in quibus foraminibus conlo-
cabuntur calculi rotundi. In theca eius tympani,
sive loculamentum est, unum foramen excavetur
habens canaliculum, qua calculus liberatus ab
obstantia cum ceciderit in vas aereum, sonitum
significet.

7 Ita navis cum habuerit impetum aut remorum
aut ventorum flatu, pinnae, quae erunt in rotis,
tangentes aquam adversam vehementi retrorsus
inpulsu coactae versabunt rotas; eae autem in-
volvendo se agent axem, axis vero tympanum, cuius
dens circumactus singulis versationibus singulos
secundi tympani dentes inpellendo modicas efficit
circuitiones. Ita cum cccc ab pinnis rotae fuerint
versatae, semel tympanum circumactum inpellet
dente, qui est ad latus fixus, plani tympani dentem.
Igitur circuitio tympani plani quotienscumque ad
foramen perducet calculos, emittet per canaliculum.
Ita et sonitu et numero indicabit miliaria spatia
navigationis.

Quae pacatis et sine metu temporibus ad utilita-
tem et delectationem paranda, quemadmodum
debeant fieri, peregi esse futurum.[3]

[1] dens *Ro* : dentes *H.*
[2] planum *Joc* : plenum *H.*
[3] peregi esse futurum *H* : esse futurum *epexeget. Gr* : *del.*
Ro (*cf.* IX., *pref.* 16).

horizontal drum and turns the horizontal drum round in a circle. Now in the horizontal drum, openings are to be made in which round stones are to be placed. One of these openings is to have a small channel adjoining it. Here when a stone can move without hindrance, it falls into the bronze vessel and announces this by a sound.

7. When, therefore, the ship receives an impulse from the force of the oars or the sails, the paddles fixed to the wheels touch the water which meets them, and being urged by a strong backward impulse, turn the wheels. These in turn move the axle by their revolutions; and the axle moves the drum, the tooth of which being driven round, strikes at each revolution a single tooth of the second drum, and produces the corresponding rotations. Thus when the wheels have been made to revolve 400 times by the paddles, the drum being once driven round will strike by the tooth placed on its side, a tooth in the horizontal drum. Therefore as often as the revolution of the horizontal drum brings the stones to the opening, it will let them drop through the small channel. And in this way, by the sound and number of the stones, it will indicate the miles traversed by the ship.

I have thus contrived the execution in proper form of the machines which may be carried out for useful purposes or for amusement in times of peace and tranquillity.[1]

[1] This passage could only have been written when the empire was in a settled state, and completes the programme outlined in the preface to the whole work. The sequel resumes the military studies with which Vitruvius' career began.

X

1 NUNC vero quae ad praesidia periculi et necessita-
tem salutis sunt inventa, id est scorpionum et
ballistarum rationes, quibus symmetriis comparari
possint, exponam.

Omnes proportiones eorum organorum ratiocina-
torum ex [1] proposita sagittae longitudine, quam id
organum mittere debet, eiusque nonae partis fit
foraminis in capitulis magnitudo, per quae [2] ten-
duntur nervi torti, qui bracchia continere ipsûm
2 tamen debent. Eorum foraminum capituli deform-
atur altitudo et latitudo. Tabulae, quae sunt in
summo et in imo capituli, peritreta [3] quae vocantur,
fiant crassitudine unius foraminis, latitudine [4] unius
et eius dodrantis, in extremis foraminis unius et
eius ⟨s⟩. Parastaticae [5] dextra ac sinistra praeter
cardines altae foraminum IIII, crassae foraminum
quinum; cardinis foraminis dimidi. A parastatica
ad foramen spatium foraminis s̄q̄, a foramine ad
medianam parastaticam item foraminis s̄q̄. Latitudo
parastados mediae [6] unius foraminis et eius т̄к,
crassitudo foraminis unius.

3 Intervallum, ubi sagitta conlocatur in media
parastade, foraminis partis quartae. Anguli quat-

[1] ex *Joc* : & *H.* [2] quae *ed* : quas *H.*
[3] peritreta *Voss ex Herone* : operae reliq; *H.*
[4] latitudine *G* : *om. H.*
[5] foraminibus unius et eius parastatice *H.*
[6] medius *H.*

[1] *scorpio* is used here generally for a catapult; its specific
meaning is that of a smaller machine worked by a single
individual, Book X. i, 3, Caes, *B.G.* VII. 25. 2.

CHAPTER X

ON CATAPULTS

1. WE now turn to the inventions which serve both to protect against danger and to satisfy the needs of safety; I will set forth the construction of scorpions [1] and balistae with the proportions on which they are based.

All the dimensions [2] of the machines as designed are given from the proposed length of the arrow which the machine is to let fly. The ninth part of this gives the size of the opening in the frame. Through these openings twisted cords are stretched,[3] which are to hold back the arms of the catapults themselves. 2. The height and breadth of the frame are fixed by the size of the holes. The cross-pieces at the top and bottom of the frame are called *peritreta* [4] and are to be one hole thick, and one and three-quarters wide; at the ends, one and a half. The side-pieces right and left (without the tenons) 4 holes high and five-eighths thick; the tenons half a hole. The side-piece to the hole, half a hole; from the hole to the middle upright, also half a hole. The breadth of the middle upright one hole and a third, its thickness one hole.

3. The aperture where the arrow is placed in the middle upright is to be $\frac{1}{4}$ of a hole. The four corners

[2] A unit of measurement is taken for military engines in the same way as for the orders of architecture. Hero, *Math. Gr.* 142. Vitruvius specifies the timber required by reference to this unit. Plate S.

[3] The cords are wound as tightly as possible round the nuts above and below the cross-pieces. The arm passes between the cords and still further stretches them.

[4] *peritreta.* Hero, *Math. Gr.* 132 (Voss).

tuor, qui sunt circa, in lateribus et frontibus lamnis
ferreis aut stylis aereis et clavis configantur. Canali-
culi, qui graece *syrinx*[1] dicitur, longitudo foraminum
XVIIII. Regularum, quas nonnulli bucculas appellant,
quae dextra ac sinistra canalem figuntur, ⟨longitudo⟩[2]
foraminum XVIIII, altitudo foraminis unius et crassi-
tudo. Et adfiguntur regulae duae, in quas inditur
sucula, habentes[3] longitudinem foraminum trium,
latitudinem dimidium foraminis. Crassitudo bucculae,
quae adfigitur (vocitatur camillum seu, quemad-
modum nonnulli, loculamentum) securiclatis cardini-
bus fixa, foraminis I, altitudo foraminis s—. Suculae
longitudo foraminum : :, crassitudo suculae foraminis
VIIII.[4]

4 Epitoxidos longitudo foraminis s—,[5] crassitudo :—.
Item chelonii. Chelae, sive manucla dicitur,[6] longi-
tudo foraminum trium, latitudo et crassitudo s÷.
Canalis fundi longitudo foraminis XVI, crassitudo
foraminis ◯, altitudo s÷.[7] Columellae basis[8] in solo
foraminum VIII, latitudo in plinthide, in qua statuitur
columella, foraminis s—., crassitudo FZ, columellae
longitudo ad cardinem foraminum XII, latitudo
foraminis s÷, crassitudo c̄c̄9. Eius capreoli tres,
quorum longitudo foraminum VIIII, latitudo dimidium
foraminis, crassitudo z. Cardinis longitudinis fora-
minis; columellae capitis longitudo ISK; antefixa
latitudo foraminis ⟂s9, crassitudo I.

5 Posterior minor columna, quae graece dicitur

[1] syrinx *ex Herone, Turnebus* : graece strix *H.*
[2] *add. Mar.* [3] habentes *Phil* : habens *H.*
[4] crassitudo scutulae foraminum .VIIII. *H.*
[5] foraminum .s÷ *H.*
[6] crassitudo :— item chelo. item geloni sive manucla d. *H.*
[7] latitudo .s÷ *H.* [8] columella & basis *H,*

which are on the sides and fronts are to be fixed with iron bands, or with bronze pins and nails. The length of the channel (which in Greek is called *syrinx*) is to be of 19 holes; of the strips (which some call cheeks) which are fixed right and left of the channel, the length is to be of 19 holes; their height and thickness, one hole. Two other strips into which the windlass [1] is put are fixed, having a length of three holes and a width of half a hole. The thickness of the frame which is attached (it is called a chamber or case) with dovetailed tenons is of one hole; the height, $\frac{7}{12}$ of a hole. The length of the windlass is 4 holes; the width, $\frac{3}{4}$.[2]

4. The hook (*epitoxis*) is $\frac{7}{12}$ of a hole long and $\frac{1}{4}$ thick. So also the socket-case. The trigger or handle, 3 holes long, $\frac{3}{4}$ wide and thick. The length [3] of the bottom of the channel, 16 holes; its width one,[4] and thickness $\frac{3}{4}$. The base of the column on the ground, 8 holes. The width of the column where it is fitted into the plinth, $\frac{3}{4}$; the thickness, $\frac{2}{3}$. The length of the column up to the tenon, 12 holes; $\frac{3}{4}$ of a hole wide; $\frac{5}{6}$ thick. The tenons are one hole long.[5] The column has three stays 9 holes long; $\frac{1}{2}$ a hole wide; $\frac{2}{3}$ thick. The head of the column is $1\frac{1}{2}$ holes long. The width of the antefix is $1\frac{1}{2}$ holes, the thickness is one.

5. The smaller column at the back, which the

[1] The windlass is at the end of the pipe, and draws back the cord at the back of the arrow.

[2] *I.e.* $\frac{9}{12}$.

[3] Vitruvius has given the scantling of the timber above as 19 holes. The channel itself is 3 holes less.

[4] The symbol \bigcirc seems *to denote the foramen.*

[5] I have moved this sentence up, although its reference to both column and stays is clear,

antibasis,[1] foraminum VIII, latitudo foraminis SI,
crassitudinis FZ. Subiecto foraminum XII, latitudinis
et crassitudinis eiusdem, cuius minor columna illa.
Supra minorem columnam chelonium, sive pulvinus
dicitur, foraminum IIS, altitudinis IIS, latitudinis SI $\overline{}$.
Cherolabae [2] sucularum foraminum II s—, crassitudo
foraminis sĪī, latitudo IS. Transversariis cum cardini-
bus longitudo foraminum ◌, latitudo IS et crassitudo.
Bracchi longitudo [IS][3] foraminum VII, crassitudo ab
radice foraminis FZ, in summo foraminis \overline{cc}z; curva-
6 turae foraminis VIII. Haec his proportionibus aut
adiectionibus aut detractionibus conparantur. Nam
si capitula[4] altiora, quam erit latitudo, facta fuerint,[5]
quae anatona dicuntur, de bracchiis demetur, ut, quo
mollior est tonus propter altitudinem capituli,
bracchii brevitas faciat plagam vehementiorem.
⟨Si⟩[6] minus altum capitulum fuerit, quod cata-
tonum [7] dicitur, propter vehementiam bracchia paulo
longiora constituentur, uti facile ducantur. Namque
quemadmodum vectis, cum est longitudine pedum
quinque, quod onus IIII[8] hominibus extollit, id, qui[9]
est X, duobus elevat,[10] eodem modo bracchia, quo
longiora sunt, mollius, quod breviora, durius ducuntur.

 [1] ante basis *H*.
 [2] cherolabae *Köchly* : carchebi *H*.
 [3] *del. Mar.* [4] capitula e_2 : -li *H*.
 [5] fuerint e_2 *ed* : fuerit *H*.
 [6] *add. ed.*
 [7] catatonum *ed* : catonum *H*.
 [8] quinque . . . IIII *Köchly* : IIII . . . quinque *H*.

Greeks call *antibasis*,[1] is of 8 holes; the width, $1\frac{1}{2}$ holes; the thickness, $\frac{2}{3}$. The prop has a length of 12 holes; and the breadth and thickness of the smaller column. Above the smaller column is a socket-piece or cushion as it is called, $2\frac{1}{2}$ holes long, the same thickness and $\frac{3}{4}$ of a hole broad. The handles of the windlass are $2\frac{7}{12}$ holes long; the thickness, $\frac{2}{3}$; the breadth, $1\frac{1}{2}$. The length of the cross-pieces and tenons is . . . holes; the width and thickness, $1\frac{1}{2}$. The length of the arm[2] is 7 holes; its thickness at the bottom, $\frac{2}{3}$; and at the top, $\frac{1}{2}$ a hole: its curve amounts to $\frac{2}{3}$ of a hole. 6. These proportions are attained in the work by additions or subtractions. For if the frames are too high for the breadth and these are called *anatona* [or ' tightened up '], something must be taken from the arms; so that the tension being relaxed, because of the height of the frame, the shortness of the arm may make the stroke more powerful. Let the frame be not so high and this is called *catatonum*,[3] the arms will be made somewhat longer more effective so as to be easily pulled down. For just as when a lever five feet long raises a load with four labourers, that same load is raised by two labourers when the lever is 10 feet long; so the longer arms are pulled down more easily, the shorter arms with more difficulty.

[1] Hero gives ἀντιστάτης.
[2] The arms pass through the cords and are united by a string in which the notch for the arrow was placed.
[3] = less tight.

[9] id, qui *Kr* : idque *H*.
[10] x, duobus elevat *Köchly* : ex duobus elevatum *H*.

XI

1 CATAPULTARUM rationes, e quibus membris ex
portionibus conponantur, dixi. Ballistarum autem
rationes variae sunt et differentes unius effectus causa
conparatae. Aliae enim vectibus suculis, nonnullae
polyspastis, aliae ergastis, quaedam etiam tym-
panorum torquentur rationibus. Sed tamen nulla
ballista perficitur nisi ad propositam magnitudinem
ponderis saxi, quod id organum mittere debet.
Igitur de ratione earum non est omnibus expeditum,
nisi qui geometricis rationibus numeros et multi-
plicationes habent notas.

2 Nam quae[1] fiunt in capitibus foramina, per
quorum spatia contenduntur capillo maxime muliebri
vel nervo funes, magnitudine ponderis lapidis, quem
debet ea ballista mittere, ex ratione gravitatis
proportione sumuntur, quemadmodum catapultis
de longitudinibus sagittarum. Itaque ut etiam qui
geometrice[2] non noverunt, habeant[3] expeditum, ne
in periculo bellico cogitationibus detineantur, quae
ipse faciundo certa cognovi quaeque ex parte accepta
praeceptoribus, finita exponam, et quibus rebus
Graecorum pensiones ad modulos habeant rationem,

[1] namq H.
[2] geometrice e₂ (cf. nosse Graece Aug) : -cẹ H.
[3] habeant ed : habent H.

[1] *mittere* first means ' to let go.' The vernacular phrase
mitte, ' chuck it,' is illuminating. Hence the solemn name
of the mass, *missa* : ' the assemblage is dismissed, *ite*; *missa
est.'*

[2] Euclid treats numbers geometrically, Books VII–X. It
has been said of Newton that he could treat geometrically

CHAPTER XI

ON BALISTAE

1. I HAVE described the design of a catapult and the details which are combined in accordance with proportion. The design of the balista varies and its differences are adjusted for the purpose of a single effect. For some are worked by levers and windlasses, some by many pulleys, some by capstans, some by wheels. Yet all balistae are constructed with a view to the proposed amount of the weight of the stone which such a machine is to let fly.[1] Therefore only those craftsmen can deal with the design who are familiar with the geometrical [2] treatment of numbers and their multiples.

2. For the holes which are made in the frames (through the openings of which ropes are stretched, made especially of woman's hair or of the sinews of animals) are taken proportionately to the amount of the weight of the stone which the balista is to shoot, in accordance with gravity,[3] just as in the case of catapults the *length of the arrows* furnishes the module. Therefore in order that persons who are ignorant of geometry may be equipped and may not be delayed by calculation amid the perils of war, I will specify in accordance with my own knowledge gained in practice and also in accordance with the instructions of my teachers. Further, I will set forth in detail the manner in which the Greek

problems which other mathematicians could only solve by analysis of a numerical character.

[3] Specific gravity was discovered by Archimedes, Book IX., *pref.* 9 ff. The phrase 'centre of gravity,' κέντρον βάρους, was known before his time. Gow, *Greek Maths.* 238.

ad eam ut etiam nostris ponderibus respondeant,
tradam explicata.

3 Nam quae ballista duo pondo saxum mittere debet,
foramen erit in eius capitulo digitorum v; si pondo
iiii, digitorum sex, vi,[1] digitorum vii; decem
pondo digitorum viii; viginti pondo digitorum x;
xl pondo digitorum xii sk; lx pondo digitorum xiii
et digiti octava parte; lxxx pondo digitorum xv;
cxx pondo i pedis et sesquidigiti;[2] c et lx pedis 19;[3]
c et lxxx pes et digiti v;[4] cc pondo pedis[5] et
digitorum vi; cc et x pedis[5] et digitorum vi; ccclx,
pedis i s.

4 Cum ergo foraminis magnitudo fuerit instituta,
describatur scutula, quae graece *peritretos* appellatur,
cuius longitudo foraminum viii,[6] latitudo duo et
sextae partis. Dividatur medium lineae discriptae[7]
et, cum divisum erit, contrahantur[8] extremae partes
eius formae, ut obliquam deformationem habeat
longitudinis sexta parte, latitudinis, ubi est versura,
quartam partem. In qua parte autem est curvatura,
in quibus procurrunt cacumina angulorum, et fora-
mina convertuntur, et contractura latitudinis redeat[9]
introrsus sexta parte, foramen autem oblongius sit
tanto, quantam epizygis[10] habet crassitudinem. Cum
deformatum fuerit, circum dividatur, extremam ut
habeat curvaturam molliter circumactam.

5 Crassitudo eius foraminis s̄ī constituatur. Modioli

[1] vi *Gr*: et *H*. [2] pondo is et sesq. *H*.
[3] pedis 19 *Kr*: c et lx pedes ii· *H*.
[4] (c et lxxx) pes & et digiti GI *H*.
[5] pedes *H*. [6] viii *Gr*: vel *H*.
[7] discripta *H S*. [8] contrahatur *H*.
[9] redeant *H*.
[10] epizygis *Joc*: opytigis *H S*.

334

weights are related to the modules, so that their relation may correspond to our weights.[1]

3. For when a balista is to shoot a stone weighing two pounds, the aperture in the frame will be 5 digits; with four pounds, 6 digits; with ⟨six⟩ pounds, 7 digits; with ten pounds, 8 digits; with twenty pounds, 10 digits; with 40 pounds, $12\frac{1}{2}$ [2] digits; with 60 pounds, $13\frac{1}{8}$ digits; with 80 pounds, 15 digits; with 120 pounds, one foot and $1\frac{1}{2}$ digits; with 160 pounds, one foot and 4 digits; with 180 pounds, one foot 5 digits; with 200 pounds, one foot 6 digits; with 210 pounds, one foot 6 digits; with 360 pounds, $1\frac{1}{2}$ feet.

4. When, therefore, the size of the hole is determined (as the module), let the cross-piece, *scutula*,[3] which in Greek is called *peritretos*, be drawn; its length 8 holes; the breadth is to be $2\frac{1}{8}$ holes. The cross-piece when drawn is to be divided along the middle of the line, and when the middle is divided, the ends of the figure are to be contracted, so that it is bent obliquely to the extent of $\frac{1}{6}$ the length, and $\frac{1}{4}$ the breadth where the rope turns. The holes are to be made on the side of the curved part where the points of the angles converge; and the angles formed by contraction of the breadth are to turn $\frac{1}{6}$ inwards: the hole is to be longer than it is broad by the thickness of the bolt. When the frame is complete, it is to be dressed round so that it has the end of the curvature trimmed off.

5. The thickness of the frame is to be $\frac{9}{16}$ of a hole.

[1] The text is difficult to interpret owing to the notations employed. Plate S attempts to show the general design.

[2] SK = *semisque.*

[3] *scutula* in the balista corresponds to *tabula* in catapult, c. x. 2.

foraminum duo, latitudo 1s9, crassitudo praeterquam quod in foramine inditur foraminis s г, ad extremum autem latitudo foraminis īī¯. Parastatarum[1] longitudo foraminis vsϝ; curvatura foraminis pars dimidia; crassitudo foraminis c̄c̄ et partis LX. Adicitur autem ad mediam latitudinem, quantum est prope foramen factum in descriptione, latitudine et crassitudine foraminis v, altitudo parte IIII.

6 Regulae, quae est in mensa, longitudo foraminum VIII; latitudo et crassitudo dimidium foraminis. Cardines īīz, crassitudo foraminis ī99. Curvatura regulae ⌐Çк. Exterioris regulae latitudo et crassitudo tantundem; longitudo, quam dederit ipsa versura deformationis et parastaticae latitudo ad suam[2] curvaturam к. Superiores autem regulae aequales erunt inferioribus к. Mensae transversarii foraminis c̄c̄c̄ к.

7 Climacidos scapi longitudo foraminum XIII, crassitudo IK, intervallûm midiûm latitudo foraminis et[3] parte quarta, crassitudo pars VIII к. Climacidos superioris pars quae est proxima bracchiis, quae coniuncta est mensae, tota longitudine dividatur in partes v. Ex his dentur duae partes ei membro, quod Graeci *chelen*[4] vocant ◯ latitudo г, crassitudo 9, longitudo foraminum III et semis к; extantia cheles foraminis s; pterygomatos[5] foraminis z̄ et sicilicus.

[1] parastatorum *H*.
[2] & suam *H*.
[3] et *Köchly*: ex *H*.
[4] χηλήν *Turn*: chelon *H*.
[5] pterygomatos *Turn*: plentigomatos *H*.

[1] The boxes were fitted into the cross-pieces above and below, and contained the iron pins round which the cords

Of the box [1] the length is 2 holes; the breadth $1\frac{3}{4}$; the thickness, in addition to the part which is inserted in the hole, $\frac{9}{16}$; while at the end the breadth is $2\frac{1}{16}$. The length of the side-posts is $5\frac{9}{16}$; the curvature, $\frac{1}{2}$ a hole; the thickness is. . . .[2] Now there is added to the middle of their breadth, *i.e.* its size near the hole in the drawing: in breadth and thickness $\frac{1}{5}$, the height $\frac{1}{4}$.

6. The length of the cheek (on either side of the table) is 8 holes; the breadth and thickness $\frac{1}{2}$ a hole. The tenons are to be $\frac{2}{3}$ long and $\frac{1}{4}$ in thickness. The curvature of the cheek is $\frac{3}{4}$. The breadth and thickness of the outside cheek is as much. The length is given by the angle of the design, and the breadth of the side-piece which is in curvature. Now the upper cheeks shall be equal to the lower cheeks: the cross-pieces of the table ⟨in thickness⟩ $\frac{3}{4}$.

7. The length of the shaft of the *ladder* is 13 holes, its thickness one hole. The breadth of the middle spaces is a hole and a quarter: the depth $1\frac{1}{8}$. The part of the upper ladder which is nearest to the arms and conjoined to the table is to have its total length divided into five parts.[3] Two parts are to be given to that detail which the Greeks call *chēlē*; its breadth $1\frac{1}{16}$; its thickness $\frac{1}{4}$; its length $3\frac{1}{2}$ holes.[4] The projection of the claw is $\frac{1}{2}$ a hole, of the wings $\frac{3}{16}$. The

were wound. They were of bronze: *infra* xii. 1. The dimensions of the boxes are measured by a ' hole ' taken from the width of the cord.

[2] The thickness of the side-posts of the catapult is $\frac{5}{12}$, *supra* x. 2. These proportions are of the height of the side-posts, and are probably guides to the curvature.

[3] Of the remaining eight parts, three are above, and three below, the claw, which is two parts.

[4] The reference of this is doubtful.

Quod autem est ad axona, quod appellatur frons transversarius, foraminum trium.

8 Interiorum regularum latitudo foraminis ꞟ, crassitudo Ɜκ. Cheloni replum, quod est operimentum, securiculae includitur κ scapo [1] climacidos latitudo ≈ᏻ, crassitudo foraminis [2] xii κ. Crassitudo quadrati, quod est ad climacida, foraminis f c, in extremis κ, rutundi autem axis diametros aequaliter erit cheles, ad claviculas autem minus parte sexta decuma

9 κ. Anteridon longitudo foraminum iiiis,[3] latitudo in imo foraminis ꞟ, in summo crassitudo ꞁ κ. Basis, quae appellatur *eschara*,[4] longitudo foraminum ::::, antibasis [5] foraminum iiii, utriusque crassitudo et latitudo foraminis ∴. Conpingitur autem dimidia altitudinis κ columna, latitudo et crassitudo i s. Altitudo autem non habet foraminis proportionem,[6] sed erit quod opus erit ad usum. Bracchii longitudo foraminum vi, crassitudo in radice foraminis, in extremis f.

De ballistis [7] et catapultis symmetrias, quas maxime expeditas putavi, exposui. Quemadmodum autem contentionibus eae temperentur e nervo capilloque tortis rudentibus,[8] quantum conprehendere scriptis potuero, non praetermittam.

[1] scapo *Gr* : scapos *H*.
[2] foraminum *H*.
[3] iiiis *Gr* : eius *H*.
[4] schara *H*.
[5] ante basis *H*.

part ⟨from the claw⟩ to the *axon* which ⟨in Latin⟩ is called the front cross-piece, is of 3 holes.

8. The breadth of the interior cheeks is $\frac{1}{4}$, the thickness $\frac{1}{8}$. The *replum*[1] or covering moulding of the claw is dovetailed into the shaft of the ladder with a breadth of $\frac{1}{6}$, and a thickness of $\frac{1}{12}$. The thickness of the square piece[2] on the ladder is $\frac{2}{3}$, at the ends one hole. The diameter of the round axle is equal to that of the claw, but at its pivots $\frac{1}{16}$ less. 9. The length of the supports is $4\frac{1}{2}$ holes, the breadth at the bottom $\frac{2}{3}$, at the top the thickness is $\frac{7}{12}$. The base, which is called *eschara*,[3] is 4 holes long, the anti-basis[4] 4 holes long; the breadth and thickness of both, half a hole. A stay is jointed on half-way up the column, with a breadth and thickness of $1\frac{1}{2}$ holes. The height has no proportion of modules but will be in accordance with requirements. The length of the arms is 6 holes, the thickness at the root one hole, at the ends $\frac{2}{3}$.

I have set forth the proportions which I thought most convenient for catapults and balistae. I will now describe the way in which they are controlled by tension, with ropes twisted of sinews and human hair, as far as I can comprise it in writing.

[1] Book IV. vi. 5. This guides the claw in its movement along the ladder.

[2] This contains the claw and has the replum attached to it.

[3] Cf. *infra* xiv. 1.

[4] A similar horizontal piece at right angles to the base.

[6] proportione *H*.

[7] De ballistas *H*.

[8] rudentibus *rec* : rutundentibus *H*.

XII

1 SUMUNTUR tigna amplissima longitudine; supra
figuntur chelonia,[1] in quibus cluduntur suculae.
Per media autem spatia tignorum insecantur [2]
exciduntur formae, in quibus excisionibus cluduntur
capitula catapultarum, cuneisque distinentur,[3] ne in
contentionibus moveantur. Tum vero modioli aerei
in ea capitula includuntur et in eos cuneoli ferrei,
quas *epizygidas* [4] Graeci vocant, conlocantur.

2 Deinde ansae rudentum induntur per foramina
capitulorum, in alteram partem [5] traiciuntur, deinde
in suculas [6] coiciuntur [2] involvuntur, uti vectibus per
eas ext⟨enti⟩[7] rudentes,[8] cum manibus sunt tacti,
aequalem in utroque sonitus habeant [9] in responsum.
Tunc autem cuneis ad foramina concluduntur, ut non
possint se remittere. Ita traiecti in alteram partem
eadem ratione vectibus per suculas extenduntur,
donec aequaliter sonent. Ita cuneorum conclusioni-
bus ad sonitum musicis auditionibus catapultae [10]
temperantur.

De his rebus quae potui dixi. Restat mihi de
oppugnatoriis rebus, quemadmodum machinationibus
et duces victores et civitates defensae esse possint.

[1] cheloniae *H.*
[2] *asyndeton ut in sermone iudiciali.*
[3] distenentur *H.*
[4] ἐπιζυγίδας *Turn* : epysycidas *H.*
[5] pari&ē *H.* [6] suculas *Joc* : -lam *H.*
[7] extenti rudentes *Joc.*
[8] extrudentes *H.*

CHAPTER XII

ON THE PREPARATION OF CATAPULTS AND BALISTAE

1. ⟨Two square⟩ beams of considerable length are taken; sockets are fixed on them in which windlasses are enclosed. Now in the middle parts of the beams, rebates are cut and hollowed out. In these hollows, the frames of the catapults are fitted, and kept apart by wedges to prevent their moving when the ropes are stretched. Next, bronze boxes [1] are fitted into the frames, and iron pins are placed in them, which the Greeks call *epizygides*.

2. From these pins the ends of the ropes are passed through the holes of the frame and cross over to the other end. Thence they are taken and coiled round the windlass, so that when the ropes are stretched by the levers, and struck by hand, they may resound evenly on either side. Then they are secured by wedges at the holes so that they cannot become loose. Passing to the other end, they are stretched on the windlasses by the levers until they give an equal note. [2] So by the application of wedges, the catapults are tuned to the right note by a musical ear.

On these matters I have said what I could. It remains to me, as I deal with sieges, [3] to explain the machinery by the help of which generals may gain victories, and cities be defended.

[1] This description completes the account of the boxes in the last chapter.
[2] Book I. i. 8.
[3] *Oppugnatoria* is the Latin for πολιορκητικά.

[9] habeant *Joc*; habent *H*. [10] catapulta *H*.

VITRUVIUS

XIII

1 PRIMUM ad oppugnationis aries sic inventus
memoratur esse. Carthaginienses [1] ad Gadis oppug-
nandas castra posuerunt. Cum autem castellum
ante cepissent,[2] id demoliri [3] sunt conati. Postea-
quam non habuerunt ad demolitionem ferramenta,
sumpserunt tignum idque manibus sustinentes capite-
que eius summum murum continenter pulsantes
summos lapidum ordines deiciebant, et ita gradatim
ex ordine totam communitionem dissipaverunt.

2 Postea quidam faber Tyrius nomine Pephrasmenos
hac [4] ratione et inventione inductus malo statuto ex
eo alterum transversum uti trutinam suspendit et in
reducendo et inpellendo vementibus [5] plagis deiecit
Gaditanorum murum. Ceras [6] autem Carchedonius [7]
de materia primum basim subiectis rotis fecit supra-
que compegit arrectariis et iugis varas et in his suspen-
dit arietem coriisque bubulis texit, uti tutiores essent,
qui in ea machinatione ad pulsandum murum essent
conlocati. Id autem, quod tardos conatus habuerat,
3 testudinem arietariam appellare coepit. His tunc

[1] chartaginienes *H*. [2] coepissent *H*.
[3] demolliri *H*. [4] hac *G*: ac *H S*.
[5] vementibus *Lachm* : venientibus *H*.
[6] ceras *Gr* : caeteras *H*.
[7] carchedonius *Gr* : chalchedonius *H* (Καρχηδόνιος *Ath*), *cf.*
Carchedonius, *Plaut. Poen. prol.* 53.

[1] Vitruvius, as usual, begins with an historical sketch. He
drew upon sources older than Athenaeus Mechanicus who was
either later than or a contemporary of Vitruvius. The Marcellus
to whom Ath. dedicates his work may well have been the nephew
of Augustus. Hero and Philo Byzantius probably belong to
the end of the first century A.D. The works of these three
writers are given in *Mathematici Veteres*, Paris, 1693.

CHAPTER XIII

ON SIEGES

1. In the first place, the invention [1] of the battering-ram for sieges is related in the following manner. The Carthaginians had pitched their camp for the siege of Cadiz. Having already captured a fort, they set about demolishing it. Since they lacked iron tools for this purpose, they took a beam, and raising it by manual labour, they swung the end repeatedly against the top of the wall and brought down the top courses of the masonry. Thus they broke up the whole fortification little by little and in order.

2. Subsequently a Tyrian engineer [2] named Pephrasmenos, following the method of this invention, set up a pole and from it suspended a cross-beam, like the beam of a balance. This he drew backward and thrust forward, and by its violent blows overthrew the walls of Cadiz. Ceras [3] the Carthaginian first made a wooden platform [4] with wheels underneath, upon which he constructed penthouses with uprights and cross-pieces. In these he suspended a ram which he protected with oxhides, for the greater safety of the mechanics who were posted there to attack the wall. The contrivance, because it moved slowly, he was the first to call the "ram tortoise." 3. After these first steps had been

[2] Athen. *Math. Vett.* 3 gives the name as *Pephasmenos*.

[3] Ceras occurs among the names of the families of the Nethinim who returned with Nehemiah: *LXX, I Esdras*, v. 29.

[4] Athen. *Math. Vett.* 3.

primis gradibus positis ad id genus machinationis,[1]
postea cum Philippus, Amyntae filius, Byzantios[2]
oppugnaret, Polyidos[3] Thettalos[4] pluribus generibus
et facilioribus explicavit, a quo receperunt doctrinam
Diades et Charias,[5] qui cum Alexandro militaverunt.

Itaque Diades scriptis suis ostendit se invenisse
turres ambulatorias, quas etiam dissolutas in exercitu
circumferre solebat, praeterea terebram et ascen-
dentem machinam, qua ad murum plano pede
transitus esse posset, etiam corvum demolitorem,
4 quem nonnulli gruem appellant. Non minus ute-
batur ariete subrotato, cuius rationes scriptas reliquit.
Turrem autem minimam ait oportere fieri ne minus
altam cubitorum LX,[6] latitudinem XVII, contracturam
autem summam imae partis quintam, arrectaria
in turris in imo dodrantalia, in summo semipedalia.
Fieri autem ait oportere eam turrem tabulatorum[7]
5 decem, singulis partibus in ea fenestratis.[8] Maiorem
vero turrem altam cubitorum CXX, latam cubitorum
XXIII⟨s⟩,[9] contracturam[10] item quinta parte, arrectaria
pedalia in imo, in summo sedigitalia.[11] Hanc magni-
tudinem turris faciebat tabulatorum XX, cum haberent
singula tabulata circumitionem cubitorum ternûm.
Tegebat autem coriis crudis, ut ab omni plaga essent
tutae.

[1] machinationes H S.
[2] Byzantios Ro (Βυζαντίους Ath) : byzantio H, bizantio S G.
[3] pholydos H, pholidos S G.
[4] thethalos H S, thetalos G.
[5] carias H.
[6] LX Joc (ξ Ath) : novem H = IX.
[7] tabulatorum ed. Fl : tabularum H.
[8] Athen. περίπτερος.
[9] add. ex Ath.
[10] contracturam ed : contra fracturam H.

taken towards this kind of machine, when Philip the
son of Amyntas was besieging Byzantium, Polyidus a
Thessalian made a variety of designs with easier
construction; his method was continued by his
pupils, Diades and Charias, who accompanied
Alexander on his campaigns.[1]

Diades, then, in his books [2] shows that he invented
Movable Towers, the parts of which he used to
assemble and carry round with the army; in addition
to this, the Borer and the Climbing Machine by which
a passage from the level up the wall was possible;
further, the Grappling-hook for demolition which
some call the Crane. 4. Moreover, he used to
employ a ram on wheels for which he left detailed
descriptions. He says that the smallest tower
should be 60 cubits high and 17 broad, and that it
should be contracted at the top, by $\frac{1}{5}$ of the width
at the foot. The uprights for the towers should be
9 inches at the bottom and 6 inches at the top.
He says further that the tower should be ten stories
high, with openings like windows on each side.
5. The largest tower is to be 120 cubits high, $23\frac{1}{2}$
wide, the contraction at the top $\frac{1}{5}$; the uprights one
foot at the bottom, six inches at the top. He used
to construct this size of tower with 20 stories, and the
several stories had a balcony three cubits wide.
These he further covered with raw hides to preserve
them from attack.

[1] Athen. *loc. cit.*
[2] Athen. *op. cit.* pp. 4, 5, gives a summary closely corre-
sponding to the rest of this chapter. Sackur *op. cit.* 64.
Athenaeus interpolates phrases that are superfluous and some-
times display misunderstanding.

[11] sedigitalia *Ro* (*Ath*) : semipedalia *H.*

6 Testudinis arietariae comparatio eadem ratione
perficiebatur. Habuerat autem intervallum xxxii,[1]
altitudinem praeter fastigium xvi, fastigii autem
altitudo ab strato[2] ad summum cubita xvi.[3] Exibat
autem in altum et supra medium tectum fastigium
non minus cubita duo, et supra extollebatur turri-
cula cubitorum quattuor, tabulatorum iii, quo[4]
tabulato summo statuebantur scorpionis et cata-
pultae, inferioribus congerebatur aquae magna[5]
multitudo ad extinguendum, si qua[6] vis ignis in-
mitteretur. Constituebatur autem in eam arietaria[7]
machina, quae graece dicitur *criodocis*,[8] in qua
conlocabatur torus perfectus in torno, in quo insuper
constitutus aries rudentium[9] ductionibus et reduc-
tionibus efficiebat magnos operis effectus. Tegebatur
autem is coriis crudis quemadmodum turris.

7 De terebra has explicuit scriptis rationes. Ipsam
machinam uti testudinem in medio habentem con-
locatum in orthostatis canalem, quemadmodum in
catapultis aut ballistis fieri solet, longitudine cubi-
torum l, altitudine cubiti, in quo constituebatur
transversa sucula. In capite autem dextra ac
sinistra trocleae[10] duae, per quas movebatur quod
inerat in eo canali capite ferrato tignum. Sub eo
autem in ipso canali inclusi tori[11] crebriter celeriores
et vehementiores efficiebant eius motus. Supra

[1] xxxii *Sackur*: xxx *H*.
[2] ab strato *ed*: abst acto *H*.
[3] xvi (⇌ *Ath*): vii *H*.
[4] iii. quo *Gr*: inquo *H*. [5] magnae *H*.
[6] si qua *rec*: fiq; *H*. [7] varietaria *H*.
[8] criodocis *H*.
[9] rudentium *Joc*: prudentium *H*.
[10] trocliae *H*.
[11] inclusi tori *Laet*: inclusit uti *H*.

6. The construction of the Ram Tortoise was carried through with the same method. It had a breadth of 32 cubits, a height (not including the gable) of 16 cubits, and the height of the gable from the platform to the summit, of 16 cubits. Now the gable rose up above the middle of the roof not less than 2 cubits. Above this there was raised a small tower 4 cubits wide, of 3 stories;[1] in the top story of this there were placed scorpions and catapults,[2] in the lower stories a large quantity of water was stored to extinguish whatever flames should be kindled. Now there was constructed in the tortoise a machine for the ram, which in Greek is called *criodocis*. In this was fixed a roller finished on the lathe, on which the ram was placed, and being drawn forwards and backwards by ropes, produced great effects. This was covered with raw hides in the same way as the tower.

7. The method of constructing the Borer he described as follows: the machine itself was like the Tortoise, having, in the middle, a channel resting upon uprights (as is customary in catapults or balistas) 50 cubits long and a cubit high, on which there was placed a windlass crosswise. At the front were two pulleys, right and left, by which the beam with its iron front[3] was moved along the channel. Under the beam in the channel itself rollers were fixed at frequent intervals and rendered its movements quicker and more violent. Above the beam

[1] Vitruvius' text is quite clear if we take *in* as III, from which it is almost indistinguishable.

[2] These were small machines for sharpshooting.

[3] The Borer had a sharp iron point to pierce the wall, not to batter it down like the Ram. Athenaeus confuses the construction of the two, *op. cit.* 5.

autem ad tignum, quod inibi erat, arcus tegebantur
ad canalem crebriter, uti sustinerent corium crudum,
8 quod ea machina erat involuta. De corace nihil
putavit scribendum, quod animadverteret eam
machinam nullam habere virtutem. De accessu,
quae *epibathra* graece dicitur, et de marinis machina-
tionibus, quae per navium aditus habere posset,
scripsit tantum; pollicitum esse vehementer anim-
adverti neque rationes eorum eum explicavisse.

Quae sunt a Diade [1] de machinis scripta, quibus sint
conparationibus, exposui. Nunc quemadmodum a
praeceptoribus accepi et [2] utilia mihi videntur,
exponam.

XIV

1 TESTUDO, quae ad congestionem fossarum paratur
(eaque etiam accessus ad murum potest habere), sic
erit facienda. Basis compingatur, quae graece
eschara [3] dicitur, quadrata habens quoque versus
latera singula pedum XXI [4] et transversaria IIII. Haec
autem contineantur [5] ab alteris duobus crassis IS,
latis S; distent autem transversaria inter se circiter
pedes III S.[6] Supponanturque in singulis intervallis
eorum arbusculae, quae graece *amaxopodes* [7] dicuntur,

[1] a Diade *Joc*: ademade *H*.
[2] accepi et *S*ᶜ *G*ᶜ: accipiet *H*. [3] ἐσχάρα *Joc*: thera *H*.
[4] XXI *Kr* (πήχεων ιδ *Ath*): XXV *H*.
[5] contineantur *Joc*: -atur *H*.
[6] pedes III S *Kr* (δύο πήχεις καὶ παλαιστὴν ἕνα *Ath*): pede &
S *H*.
[7] anaxopodes *H*.

[1] Arrian reports the use of the *epibathra* by Alexander,
Anab. IV. 27. 1.

thus placed arches were placed frequently along the channel to hold up the raw hide with which the machine was enveloped. 8. Diades did not think it necessary to write about the Grappling-hook because he perceived that the machine had no value. Concerning the Climbing Machine, which in Greek is called *epibathra*,[1] and concerning the use, in naval engineering, of such a machine for boarding a ship, he just made mention. I noted especially that after making a promise he failed to explain their proportions.

I have set forth [2] the writings of Diades on the construction of machines. I will now set forth what I myself was taught, so far as it is of use.

CHAPTER XIV

ON THE TORTOISE FOR FILLING DITCHES

1. THE Tortoise which is applied to filling ditches [3] (and it thus furnishes an approach to the wall of the besieged) is to be constructed as follows. Let the base, which in Greek is called *eschara*, be made square, having on each side a length of 21 feet, with four cross-pieces. Now these are to be held together by two others 18 inches thick, and 6 inches broad. Let the cross-pieces be at intervals of 3½ feet. Timbers are to be fixed underneath in their several intervals (these are called *amaxopodes* [4] in Greek),

[2] Sackur sees Byzantine influences in the extant text of this chapter, p. 121. But there is little trace of this influence in the MS. tradition, Vol. I. *pref.* xv. *n.*

[3] χελώνη χωστρίς, Diod. II. 27, *testudo . . . aequandi loci causa*, Caes. *B.C.* II. 2.

[4] Athen. *op. cit.* 5.

in quibus versantur rotarum axes conclusi lamnis ferreis. Eaeque arbusculae ita sint temperatae, ut habeant cardines et foramina, quo vectes traiecti versationes earum expediant, uti ante et post et ad dextrum seu sinistrum latus, sive oblique ad angulos opus fuerit, ad id per arbusculas versatis progredi possint.

2 Conlocentur autem insuper basim tigna duo in utramque partem proiecta pedes senos, quorum circa proiecturas figantur altera proiecta duo tigna ante frontes pedes XII,[1] crassa et lata uti in basi sunt scripta. Insuper hanc conpactionem exigantur postes compactiles praeter cardines pedum VIIII, crassitudine quoquoversus palmopedales, intervalla habentes inter se sesquipedes. Ea concludantur superne intercardinatis[2] trabibus. Supra trabes conlocentur capreoli cardinibus alius in alium[3] conclusi, in altitudine excitati pedes VIIII. Supra capreolos conlocetur quadratum tignum, quo capreoli 3 coniungantur. Ipsi autem laterariis circa fixis contineantur teganturque tabulis maxime prinis,[4] si non, ex cetera materia, quae maxime habere potest virtutem, praeter pinum aut alnum; haec enim sunt fragilia et faciliter recipiunt ignem. Circum tabulata conlocentur crates[5] ex tenuibus virgis creberrime textae[6] maximeque recentibus. Percrudis coriis duplicibus consutis, fartis alga aut paleis in aceto maceratis, circa tegatur machina tota. Ita ab his reicientur plagae ballistarum et impetus incendiorum.

[1] XII ($\pi\eta\chi\epsilon\iota\varsigma$ η Ath) : VII H.
[2] intercardinatis H S G^c : interordinatis G S^c.
[3] alius an alium H. [4] prinis Gr : primis H.
[5] crates S^c G^c : grates H.
[6] textae rec : texta H.

in which the axles of the wheels turn, and arc sheathed in iron plates. And these timbers are to be constructed with pivots and holes whereby levers are passed through and cause them to turn, so that the machines can move front or back, right or left, or sideways as may be necessary, by the turning of the wheels by help of the timbers.

2. Let two beams be laid on the base projecting 6 feet on either side, and on the projecting parts let there be fixed two other beams projecting in front 12 feet and with the thickness and breadth as described for the base. On this frame let there be put up frame-posts 9 feet high not including the tenons, 15 inches square and 18 inches apart. Let these be joined above by beams mortised together. Above the beams let there be fixed rafters locked in one another by tenons and rising to a height of 9 feet. Above the rafters is a squared ridge-piece by which they are to be joined together. 3. Further, they are to be held together by purlins and covered by planks, best if of holm-oak, otherwise of wood which is very strong, but not of pine or alder; for these are brittle and inflammable. Around the framework are to be placed wattles, closely interwoven, of thin twigs which are to be as green as possible. The whole machine is to be covered [1] with double oxhide very raw sewn together and filled in with sea-weed or straw which is soaked in vinegar. For by these expedients the shots of the balistae and the danger of fire will be repelled.[2]

[1] This expedient was used by the Tyrians during the siege by Alexander, Diod. XVII. 45.

[2] Sackur, *op. cit.*, pp. 67–75, gives an elaborate discussion with illustrations.

VITRUVIUS

XV

1 Est autem et aliud genus testudinis, quod reliqua
omnia habet, quemadmodum quae supra scripta sunt,
praeter capreolos, sed habet circa pluteum et pinnas
ex tabulis et superne subgrundas proclinatas, supra-
que tabulis et coriis firmiter fixis continentur. Insuper
vero argilla cum capillo subacta ad eam crassitudinem
inducatur, ut ignis omnino non possit ei machinae
nocere. Possunt autem, si opus fuerit, eae machinae
ex VIII rotis esse, sed ad loci naturam ita opus fuerit
temperare. Quae autem testudines ad fodiendum
comparantur (*orynges*[1] graece[2] dicuntur), cetera
omnia habent, uti supra scriptum est, frontes vero
earum fiunt quemadmodum anguli trigoniorum, uti a
muro tela cum in eas mittantur, non planis frontibus
excipiant plagas sed ab lateribus labentes, sine
periculoque fodientes, qui intus sunt, intuentur.

2 Non mihi etiam videtur esse alienum de testudine,
quam Hagetor[3] Byzantius fecit, quibus rationibus sit
facta, exponere. Fuerat enim eius baseos longitudo[4]
pedum LX, latitudo XIII. Arrectaria, quae supra
compactionem erant quattuor conlocata, ex binis
tignis fuerant compacta, in altitudinibus singulo
pedum XXXVI, crassitudine palmopedali, latitudine
sesquipedali. Basis eius habuerat rotas VIII, quibus
agebatur. Fuerat autem earum altitudo pedum
VI s.÷, crassitudo pedum III, ita fabricata triplici

[1] ὄρυγγες *Gr* (*ex Hesych*): origines *H.*
[2] graeci *H S.*
[3] Hagetor *Gr* (Agetor *Joc*): hector *H.*
[4] longitudo *G*: -dine *H S.*

CHAPTER XV

ON THE TORTOISE OF HAGETOR

1. THERE is also another kind of tortoise which has everything in the manner above described except the rafters. Instead it has a parapet and battlements made of boards with sloping eaves above; these are held together by boards and skins securely fixed. Over these clay kneaded with hair is applied to such a thickness that fire cannot damage the machine. If it is required, these machines can be on eight wheels; but it will be necessary to adjust them to the lie of the ground. Now the tortoises which are designed for digging (in Greek they are called *orynges* [1]) follow the description in every respect but that their fronts are made like the angles of triangles, so that when arrows are shot against them from the walls the blows which they receive do not fall upon a plane surface, but slip along the sides, and the men within are protected [2] and dig without danger.

2. It now seems appropriate to explain the methods which Hagetor [3] of Byzantium used for his tortoise. [4] The length of the base was 60 feet, the breadth 13. The uprights which were set up on the frame, four in number, were each made of two timbers, of a height for each of 36 feet, and 15 inches broad with a thickness of 18 inches. The base had eight wheels on which it moved. The wheels had a height of 6 feet 9 inches, a thickness of 3 feet and were made of

[1] ὄρυξ (Hesych. ὀρύγξ) 'a tool, for digging.' It had a single edge like a hoe, μουνορύχαν ὄρυγα, *Anth. Pal.* VI. 297.

[2] *intueor* in pass. sense, Amm. Marc. XXIII. 5. 13.

[3] Athen. *op. cit.* 5. [4] Plate T.

materia: alternis se contra subscudibus[1] inter se
coagmentatae lamnisque ferreis ex frigido ductis
alligatae.

3 Eae in arbusculis, sive amaxopodes dicuntur,
habuerant versationes. Ita supra transtrorum plani-
tiem, quae supra basim fuerat, postes erant erecti
pedes XVIII ∻,[2] latitudine s∻,[3] crassitudine FZ,
distantes inter se IS∻. Supra eos trabes circum-
clusae continebant totam compactionem latae pede
I∻, crassae s∻. Supra eam capreoli extollebantur
altitudine pedum XII; supra capreolos tignum conlo-
catum coniungebat capreolorum compactiones. Item
fixa habuerant lateraria in transverso, quibus insuper
contabulatio circumdata contegebat inferiora.

4 Habuerat autem mediam contabulationem supra
trabiculas, ubi scorpiones et catapultae conlocabantur.
Et erigebantur arrectaria duo compacta pedum XXXXV,[4]
crassitudine sesquipedali, latitudine PII, coniuncta
capitibus transversario cardinato tigno et altero
mediano inter duos scapos cardinato et lamnis ferreis
religato. Quo insuper conlocata erat alternis materies
inter scapos et transversarium traiecta e chelonîs et
anconibus[5] firmiter inclusa. In ea materia fuerunt
ex torno facti axiculi duo, e quibus funes alligati
retinebant arietem.

5 Supra caput eorum, qui continebant arietem,
conlocatum erat pluteum turriculae similitudine
ornatum, uti sine periculo duo milites tuto stantes
prospicere possent et renuntiare, quas res adversarii

[1] subsudibus H.
[2] XVIII Joc ($\delta\omega^\varsigma\epsilon\kappa\alpha\pi\eta\chi\epsilon\iota\varsigma$ Ath) : XXVIIII. H S.
[3] latitudine (Ro) s ∻ Joc ($\pi\alpha\lambda\alpha\iota\sigma\tau\dot{\alpha}\varsigma$ $\bar{\gamma}$ Ath): latitudinis ∻ H.
[4] XXXXV ($\tau\rho\iota\dot{\alpha}\kappa\omega\nu\tau\alpha$ $\pi\dot{\eta}\chi\epsilon\iota\varsigma$ Ath) : XXXV H.
[5] angonibus H.

three layers of wood jointed together with alternating tenons and secured with plates of chilled iron.

3. They revolved in blocks (or as they are called *amaxopodes*). Above the cross-pieces of the floor which was above the base, posts were erected 18 feet high, 9 inches broad and 8 inches thick, and one foot 9 inches apart. Above the posts, beams one foot 9 inches wide and 9 inches thick were carried round and held the framing together. Above the framing struts [1] were raised with a height of 12 feet; above the struts a beam was fixed which received the joints of the struts. They had side-pieces placed obliquely on which boarding was carried to protect the lower parts.

4. The machine had in the middle aisle a floor upon joists, where the scorpions and catapults were placed. There were also set up two upright pieces jointed together, 45 feet high, 18 inches wide and 9 inches thick, joined at the top with a dovetailed cross-piece, and a second half-way up, mortised between the two uprights and secured with iron plates. Above this, between the uprights and the cross-piece, a wooden frame was placed consisting of blocks and firmly held by clamps. In this frame two axles turned on the lathe were placed, and the ram was controlled by ropes attached to the axles.

5. Above the heads of those who worked the ram, a shelter was placed built after the fashion of a turret, so that the two soldiers standing in safety could look out and report the movements of the enemy.

[1] These struts probably ran out from the base, were united by the beam and tied to the uprights of the frame by the sloping side-pieces.

conarentur. Aries autem eius habuerat longitudinem
pedum CIV, latitudine in imo palmopedali, crassitudine
pedali, contractum capite in latitudine[1] pes, crassi-
tudine s⌣.

6 Is autem aries habuerat de ferro duro rostrum, ita
uti naves longae solent habere, et ex ipso rostro
lamminae ferreae IIII circiter pedum XV fixae fuerant
in materia. A capite autem ad imam calcem tigni
contenti fuerunt funes III[2] crassitudine digitorum
VIII, ita religati, quemadmodum navis a puppi ad
proram continentur, eique funes praecinctura e
transversis erant religati habentes inter se palmi-
pedalia spatia. Insuper coriis crudis totus aries erat
involutus. Ex quibus autem funibus pendebat,[3]
eorum capita fuerunt ex ferro factae quadruplices
7 catenae, et ipsae coriis crudis erant[4] involutae. Item
habuerat protectura eius ex tabulis arcam conpactam
et confixam, in qua rete[5] rudentibus maioribus
extentis, per quarum asperitates non labentibus[6]
pedibus, faciliter ad murum perveniebatur. Atque
ea machina sex modis movebatur: progresso, item
latere dextra et sinistra, porrectiones non minus in
altitudinem extollebantur et in imum inclinatione
dimittebantur. Erigebatur autem machina in alti-
tudinem ad disiciendum murum circiter P. C, item
a latere[7] dextra ac sinistra procurrendo praestringe-
bat non minus P. C. Gubernabant eam homines C

[1] latitudine *Joc* : altitudine *H*.
[2] III *Ro* (τρισί *Ath*) : IIII *H*.
[3] pendebat *Mar* : -bant *H*.
[4] erant *S G^c* : erat *H G*.
[5] rete (δίκτυον *Ath*) *add. Ro*.
[6] labentibus *Joc* : habentibus *H*.
[7] a latere *Joc* : altera *H*.

The ram was 104 [1] feet long, with a breadth in the lower part of 15 inches, and a foot thick; tapering towards the head to a foot in width [2] and a thickness of 9 inches.

6. Now the ram had a beak of hardened iron like those of ships of war, and from it four iron plates, 15 feet long, were fixed to the timber. From the head to the butt of the ram three ropes were stretched 6 inches thick bound to the ends of the ram in the same way as ships [3] are held together from the stern to the bows, and these ropes were wound round obliquely, at intervals of 15 inches by another rope which encircled them. The whole ram was enveloped with raw skins above the ropes. The ends of the ropes by which it hung were made of quadruple iron chains, and they also were wrapped in raw skins. 7. The shelter [4] attached to the ram had a casing made of planks securely fixed, by which when a net of great ropes was stretched (over the roughness of which the feet were kept from slipping) there was an easy access to the wall. The whole machine could be moved in six [5] ways: in a straight line; right and left. Moreover, the thrust of the machine was directed upwards and let fall at an angle. Now the machine could be raised upwards to demolish the wall to about 100 feet; and by its lateral movements, right and left, it could strike at a length of not less than 100 [6] feet. It

[1] Athen. gives 180 feet.

[2] Literally, 'in contraction at the top a foot wide.'

[3] *Acts* xxvii. 17.

[4] *protectura*, probably a technical phrase.

[5] Backwards and forwards each way; the raising and dropping of the ram is additional.

[6] The length of 100 feet measures the amount of the wall affected.

habentem pondus [1] talentûm quattuor milium, quod fit cccclxxx pondo.

XVI

1 De scorpionibus et catapultis et ballistis etiamque testudinibus et turribus, quae maxime mihi videbantur idonea et a quibus essent inventa et quemadmodum fieri deberent, explicui. Scalarum autem et carchesiorum et eorum, quorum rationes sunt inbecilliores, non necesse habui scribere. Haec etiam milites per se solent facere. Neque ea ipsa omnibus locis neque eisdem rationibus possunt utilia esse, quod differentes sunt munitiones munitionibus [2] nationumque fortitudines. Namque alia ratione ad audaces et temerarios, alia ad diligentes, aliter ad 2 timidos machinationes debent conparari. Itaque his praescriptionibus si qui adtendere voluerit ex varietate eorum eligendo in unam conparationem conferre, non indigebit auxiliis, sed quascumque res ex [3] rationibus aut locis opus fuerit, sine dubitatione poterit explicare. De repugnatoriis vero non est scriptis explicandum. Non enim ad nostra scripta hostes conparant res oppugnatorias, sed machinationes eorum ex tempore sollerti consiliorum celeritate sine machinis saepius evertuntur. Quod etiam Rhodiensibus memoratur usu venisse.

3 Diognetus [4] enim fuerat Rhodius architectus, et ei

[1] pondos *H S.*
[2] monitiones monitionibus *H S.*
[3] ex *Ro* : & (et) *H.* [4] diogenes *H.*

had a weight of 4000 talents (which makes 480,000 pounds) and was controlled by 100 men.

CHAPTER XVI

ON MACHINERY FOR DEFENCE

1. WITH reference to scorpions and catapults and balistae, and also tortoises and towers, I have explained the details which seemed to me most suitable, stating the names of their inventors, and how they should be constructed. But I did not hold it necessary to write about ladders, cranes, etc., of which the principles are simpler. For the troops are accustomed to make these of themselves. And the measures to be taken cannot be used to advantage in the same way in all places. For there are differences between one mode of fortification and another, and in the military spirit of nations. Thus military engines should be provided in one manner against a bold and rash enemy, in another manner against a watchful enemy, and differently against the pusillanimous. 2. Therefore whoever will attend to these instructions so as to choose from their variety and combine in one provision, will not lack assistance, but will be able to set forth with assurance whatever is necessary to suit occasion and place. Measures of defence, however, are not to be prescribed. For the enemy does not enter on a siege in order to follow our precedents, and his engineering is more often baulked on the spur of the moment by swift and inventive tactics. And this, it is recorded, happened to the Rhodians. 3. Diognetus was an architect of Rhodes, and

de publico quotannis certa merces pro arti tribue-
batur ad honorem. Eo tempore quidam architectus
ab Arado nomine Callias Rhodum cum venisset,
acroasin fecit exemplaque protulit muri et supra id
machinam in carchesio [1] versatili constituit, qua
helepolim [2] ad moenia adcedentem corripuit et trans-
tulit intra murum. Hoc exemplar Rhodii cum
vidissent, admirati ademerunt Diogneto,[3] quod fuerat
quotannis constitutum,[4] et eum honorem ad Calliam [5]
transtulerunt.

4 Interea rex Demetrius, qui propter animi pertina-
ciam Poliorcetes [6] est appellatus, contra Rhodum
bellum conparando Epimachum Atheniensem nobi-
lem architectum secum adduxit. Is autem com-
paravit helepolim [7] sumptibus inmanibus industria
laboreque summo, cuius altitudo fuerat P. CXXV,
latitudo pedum LX. Ita eam ciliciis et coriis crudis
confirmavit, ut posset pati plagam lapidis ballista
inmissi P. CCCLX; ipsa autem machina fuerat milia
P. CCCLX. Cum autem Callias [8] rogaretur ab Rhodiis,
contra eam helepolim [9] machinam pararet, ut illam,
uti pollicitus erat, transferret intra murum, negavit
posse.

5 Non enim omnia eisdem rationibus agi possunt,
sed sunt alia, quae[10] exemplaribus non magnis similiter
magna facta habent effectus; alia autem exemplaria

 [1] carchesio *ed* : carceso *H*.
 [2] qua helepolim *Joc* : quem lepidolim *H*.
 [3] diogeni *H*.
 [4] constitutum et *S* : et constitutum *H*.
 [5] galliam *H*. [6] pollorcetes *H*.
 [7] heliopolim *H*. [8] gallias *H*.
 [9] heliopoliam *H*.
 [10] alia quae *R*? : alique *H*.

received from the state [1] a fixed salary proportionate to his professional skill and as an honorarium. In his time a certain architect from Aradus, Callias by name, came to Rhodes and gave a public lecture, at which he displayed the drawings of a city wall, and thereupon he set up a machine with a revolving crane which seized a siege engine [2] as it approached the ramparts, and removed it within the city. When the Rhodians saw the design, they admired it, and withdrew the appointed salary from Diognetus and gave the post to Callias.

4. Meanwhile King Demetrius, who on account of his stubbornness of mind was named the Besieger, prepared for war [3] against Rhodes and brought with him Epimachus, a famous architect of Athens. And he produced an elaborate siege engine at immense cost both in money and labour. Its height was 125 feet, and its breadth 60, and it was so secured with goatskins and undressed oxhide that it could withstand the blow of a stone weighing 360 pounds, hurled by a balista. The engine itself was 360,000 pounds in weight. But when Callias was asked by the Rhodians to construct a machine to countervail the City-taker and bring it within the walls as he had promised, he said he could not.

5. For not everything can be done by a single method; there are some things which, done on a large scale, produce effects corresponding to those instances which are done on a small scale, there are

[1] Hippodamus seems to have held a similar position at Athens; Vitruvius at Rome. At Athens c. 100 B.C. there was an architect to superintend the temples, C.I.A. II. 404.

[2] *helepolis, lit.* ' City-taker.' Athen. *op. cit.* 7; Diod. XX. 91.

[3] 305–4 B.C.

non possunt habere, sed per se constituuntur;
nonnulla vero sunt, quae in exemplaribus videntur
veri similia, cum autem crescere coeperunt, dilabantur.
Ut etiam possumus hic animum advertere. Tere-
bratur terebra foramen semidigitale, digitale, sesqui-
digitale. Si [1] eadem ratione voluerimus palmare
facere, non habet explicationem, semipedale autem
maius ne cogitandum quidem videtur omnino.

6 Sic item in nonnullis exemplaribus videntur, quae [2]
ad modum in minimis fieri videntur, atque eodem
modo in maioribus. Id eodem modo Rhodii eadem
ratione decepti iniuriam cum contumelia Diogneto [3]
fecerunt. [4] Itaque posteaquam viderunt hostem
pertinaciter infestum, periculum servitutis, machina-
tionem ad capiendam urbem conparatam, vastitatem
civitatis expectandam, procubuerunt Diogneto
rogantes, ut auxiliaretur patriae.

7 Is primo negavit se facturum. Posteaquam in-
genuae virgines et ephebi cum sacerdotibus venerunt
ad deprecandum, tunc est pollicitus his legibus, uti,
si eam machinam cepisset, [5] sua esset. Is ita consti-
tutis, qua machina accessura erat, ea regione murum
pertudit et iussit omnes publice et privatim quod
quisque habuisset aquae, [6] stercoris, luti per eam
fenestram per canales progredientes effundere ante
murum. Cum ibi magna vis aquae, luti, stercoris
nocte profusa fuisset, postero die helepolis [7] accedens,

[1] sic *H*.	[2] quae *Rouse*: quem *H*.
[3] diognito *H*.	[4] fecerunt *Sᶜ*: fecerint *H G S*.
[5] coepisset *H*.	[6] aqua *H*. [7] heliopolis *H*.

[1] Vitruvius anticipates the Law of Diminishing Returns,
namely, that the increasing of the scale of operations, as in
mechanical production, is not followed by a correspondingly
increased value in use. Athen. *op. cit.* 7.

other things which cannot follow precedents, but
are determined to their own results; but there are
some [1] which are promising in sample, but collapse
when they begin to increase in scale, as we can
perceive from this case: a hole is bored by an auger,
half an inch, an inch, $1\frac{1}{2}$ inches in diameter; if we
wish in the same way to bore a hole 3 inches wide,
our method does not apply; for a hole of 6 inches or
more, the notion seems generally inconceivable.

6. Thus also there are things which seem to be
done exactly on a smaller scale, and in the same
way on a larger scale. By the same rule and the
same principle the Rhodians, deceived herein, in-
flicted injury with violence [2] on Diognetus. There-
fore when they saw the stubborn enemy in the
field against them, the danger of enslavement, the
engine designed to take their city, the impending
desolation of the state, they fell at the feet of
Diognetus and implored him to come to the rescue
of his native city.

7. First he gave a refusal. Afterwards, when girls
and youths of noble birth came along with the
priests to intercede, he promised to help on the
terms that if he captured the siege engine, it should
be his own. This was settled. He made a breach
in the ramparts where the machine was to come,
and ordered everyone publicly and in private to
collect water, sewage and mud and, coming forth, to
pour it along channels through the breach in front
of the rampart. After a great amount of water,
mud, sewage, had been poured down overnight, the
next day the siege engine came along; and before

[2] For this sense of *contumelia*, Caes. *B.G.* III. 13, Tac.
Hist. III. 31.

antequam adpropinquaret ad murum, in umido vora-
gine facta consedit nec progredi nec egredi postea
potuit. Itaque Demetrius, cum vidisset sapientia
Diogneti se deceptum esse, cum classe sua discessit.
8 Tunc Rhodii Diogneti sollertia liberati bello publice
gratias egerunt honoribusque omnibus eum et orna-
mentis exornaverunt. Diognetus eam helepolim [1]
reduxit in urbem et in publico conlocavit et inscripsit
'Diognetus e manubiis id populo dedit munus.'
Ita in repugnatoriis rebus non tantum machinae,
sed etiam maxime consilia sunt comparanda.

9 Non minus Chio cum supra naves sambucarum
machinas hostes conparavissent, noctu Chii [2] terram,
harenam, lapides progesserunt in mare ante murum.
Ita illi postero die cum accedere voluissent, naves
supra aggerationem, quae fuerat [3] sub aqua, sederunt
nec ad murum accedere nec retrorsus se recipere
potuerunt, sed ibi malleolis confixae incendio sunt
conflagratae. Apollonia [4] quoque cum circumsedere-
tur et specus hostes fodiendo cogitarent sine sus-
picione intra moenia penetrare, id autem a specula-
toribus esset Apolloniatibus renuntiatum, perturbati
nuntio propter timorem consiliis indigentes animis
deficiebant, quod neque tempus neque certum locum
scire poterant, quo emersum facturi fuissent hostes.

[1] heliopolim *H*. [2] Chii *ed* : hii *H S G*⁰.
[3] fuerat *rec* : -rant *H*.
[4] appolonia *H* : appollonia *S*.

[1] Polyb. VIII. 6, describes the *sambuca*,

it drew up to the wall, it was engulfed in the wet ground and stuck nor could it get on or get out. Thereupon Demetrius perceived that he had been tricked by the skill of Diognetus, and sailed away with his fleet. 8. The Rhodians, therefore, being freed from their enemy by the artifice of Diognetus, gave him public thanks and decorated him with every honour and distinction. Diognetus brought the siege engine into the city, set it up in a public place with the inscription: DIOGNETUS DEDICATED THIS TO THE PEOPLE FROM THE SPOILS OF WAR. In defence therefore not only machines but, far more, are stratagems to be devised.

9. At Chios also, when the enemy had constructed storming-bridges [1] on board ship, the Chians overnight heaped up earth, sand, stones into the sea before the walls. Thus when the enemy next day wished to draw near, their ships grounded on the heaped material which was under water. The ships could neither approach the wall nor draw backwards, but being pierced by burning missiles, they were set ablaze and consumed on the spot.[2] Again, when Apollonia [3] was besieged, and the enemy designed by digging tunnels to penetrate unsuspected within the walls, this was reported by spies to the citizens of Apollonia. They were panic-stricken at the news and their spirits failed them in their lack of resource. For they could not know the time or the place for certain where the enemy were likely to emerge.

[2] Athen., *op. cit.* 9, refers to this same siege in somewhat different terms.

[3] In Illyria. It was attacked by Philip V in 214 B.C., Livy, XXIV. 40.

10 Tum vero Trypho Alexandrinus ibi fuerat archi-
tectus; intra murum plures specus[1] designavit et
fodiendo terram progrediebatur extra murum dum-
taxat extra sagittae missionem et in omnibus vasa
aenea suspendit. Ex his in una fossura, quae contra
hostium specus fuerat, vasa pendentia ad plagas
ferramentorum sonare coeperunt. Ita ex eo intel-
lectum est, qua regione adversarii specus agentes
intra penetrare cogitabant. Sic liniatione cognita
temperavit[2] aenea aquae ferventis et picis de
superne contra capita hostium et stercoris humani et
harenae coctae candentis. Dein noctu pertudit
terebra[3] foramina et per ea repente perfundendo qui
in eo opere fuerunt hostes omnes necavit.

11 Item Massilia cum oppugnaretur et numero supra
xxx speculatum[4] agerent, Massilitani suspicati totam
quae fuerat ante murum fossam altiore fossura
depresserunt. Ita specus omnes exitus in fossam
habuerunt. Quibus autem locis fossa non potuerat
fieri, intra murum barathrum amplissima longitudine
et amplitudine uti piscinam fecerunt contra eum locum,
qua specus agebantur, eamque e puteis et e portu
impleverunt. Itaque cum specus esset repente
naribus apertis, vehemens aquae vis inmissa sup-
plantavit fulturas, quique intra fuerunt, et ab aquae
multitudine et ab ruina specus omnes sunt oppressi.

12 Etiam cum agger ad murum contra eos conparare-

[1] specus *H S G*ᵉ. [2] temperavit *E G* : temperaret *H S*.
[3] pertuditerebra *H*, ptudit terebra *S*.
[4] speculatum *H*, specus *ex verbo subauditur?*

366

10. But at that time Trypho of Alexandria was the architect in charge. Within the walls he planned tunnels and, removing the soil, advanced beyond the wall the distance of a bowshot. Everywhere he hung bronze vessels.[1] Hence in one excavation which was over against the tunnel of the enemy, the hanging vases began to vibrate in response to the blows of the iron tools. Hereby it was perceived in what quarter their adversaries purposed to make an entrance with their tunnel. On learning the direction, he filled bronze vessels with boiling water and pitch overhead where the enemy were, along with human dung and sand roasted to a fiery heat. Then in the night he pierced many openings, and suddenly flooding them, killed all the enemy who were at work there.

11. Again, when Marseilles was besieged [2] and the enemy drove more than 30 tunnels,[3] the inhabitants were on their guard, and made a deeper ditch than the one in front of the ramparts. Hence all the tunnels came out into this. But where inside the wall a ditch could not be made, they dug a moat, like a fish-pond, of great length and depth, over against the quarter where the tunnels were being made, and filled it from the wells and from the harbour. Hence when a tunnel had its passage suddenly opened, a strong rush of water flowed in and threw down the props. The troops within were overwhelmed by the collapse of the tunnel and the flood of water.

12. Again, when a mound was heaped up against

[1] The same expedient is described in the siege of Barca by the Persians, Herod. IV. 200. [2] 49 B.C., Caes. *B.C.* II. 1 ff.
[3] *speculatum* cannot be right.

tur et arboribus excisis eoque conlocatis locus operibus exaggeraretur, ballistis vectes ferreos candentes in id mittendo totam munitionem coegerunt conflagrare.[1] Testudo autem arietaria cum ad murum pulsandum accessisset, permiserunt laqueum et eo ariete constricto, per tympanum ergata circumagentes suspenso capite eius non sunt passi tangi murum. Denique totam machinam malleolis candentibus et ballistarum plagis dissipaverunt. Ita eae victoriae civitatum [2] non machinis, sed contra machinarum rationem architectorum sollertia sunt liberatae.

Quas potui de machinis expedire rationes pacis bellique temporibus et utilissimas putavi, in hoc volumine perfeci. In prioribus vero novem de singulis generibus et partibus conparavi, uti totum corpus omnia architecturae membra in decem voluminibus haberet explicata.

<hr />

[1] conflagare H.
[2] victoriae civitatum *idem quod* civitates victrices : *cf.* uligines paludum, *Tac. Ann.* I. 17. 5.

the walls, and the site was further raised by cutting down trees and laying them there, the citizens shot red-hot iron bars from their balistae and caused the earthwork to blaze up. Again, when the ram tortoise came to demolish the wall, they let down a rope and caught the head of the ram. Then they wound the rope round a drum, using a windlass, and by keeping the ram raised, they prevented it from touching the wall. In the end they demolished the whole engine with fiery missiles [1] and blows from the balista. Thus these victorious cities were liberated not by military engines, but, in face of their employment, by the skill of the architects.

In this book I have fully set forth the mechanical methods which I could furnish, and which I thought most useful in times of peace and war. Now in the previous nine books I have dealt with the other several topics and their subdivisions, so that the whole work, in the ten books, describes every department of architecture.

[1] Caesar refers several times to the use of fire by the besieged, *loc. cit.*

INDEX OF TECHNICAL TERMS

BOOKS VI—X

INDEX OF TECHNICAL TERMS

Caelum, ὀροφή, ceiling, 91

Canon musicus, cf. κάνονες, stops of the flute, *Anth. Pal.* 9. 365; the part of the organ between the keys and the pipes; there seems no corresponding English term, 315

Canopus, κάνωπος, a bright star in Argo, guiding travellers to the South, 245

Capstan, *ergata*, ἐργάτης, a revolving barrel round which ropes are wound, 285

Carchesium, καρχήσιον, a block at the top of a mast, (*b*) socket on the ground, 289

Castellum (for water supply), κρουνός, fountain-head in city, 183

Catapult, *catapulta*, καταπέλτης, artillery discharging arrows, 327

Cena, dining-room, 21, cf. *triclinia*, 101, Plin. *N.H.* XII. 10

Chelonium, *pulvinus*, χελώνιον, socket-piece in catapult, 331

Chorobates, χωροβάτης, apparatus for levelling, 179

Chrysocolla, χρυσόκολλα, malachite, basic copper carbonate, 121

Cinnabar (artificial), *usta*, burnt cinnabar, 125

Climacis, κλιμακίς, ladder-shaped part of a balista, 337

Coelia (in aqueducts), *venter*, κοιλία, the U-shaped bend at the bottom of a valley, 185

Colliciae, ὑδρορόαι, gutters on the roof, 25

Columen, ὀρθυστάτης, upright wooden support, a stay, 347

Compluvium (or *impluvium*, Plaut. *Amph.*, V. i. 56), open space in centre of atrium, 25

Cone, *conus*, κῶνος, form of dial, 255

Crane (revolving), *carchesium*, καρχήσιον, 361

Crane (grappling-hook), *corvus demolitor*, ἐργάτη; *grus*, γέρανος, 345

Creca, κρεκη (lit. hair), hair-mortar, 91; cf. *argilla cum capillo subacta*, Book V. x. 2

Criodocis, κριοδοκίς, a frame to contain a battering-ram, 347

Dado, *podium*, πόδιον, lower part of wall, 101

Dial, *horologion*, ὡρολόγιον, 254

Dioptra, διόπτρα, a water-level, 179

Displuviate, *displuviatum*, court-yard in which the rafters rise from the side towards an opening in the middle, 25, Pl. J

Dusting, *spongiis extergere*, σπόγγῳ ἀπομοργνύναι, 91

Elbow (in aqueducts), *geniculus*, γόνυ, 185

Epagon, *artemon*, ἐπάγων, block of pulleys at the foot of a machine, 287

Epibathra, *accessus*, ἐπιβάθρα, gangway, 349

Epitonium, ἐπιτόνιον, a vertical perforated pipe turning in a horizontal pipe, a stop-cock, 263

Eschara, *basis*, ἐσχάρα, a base or stand of the balista, 339

Flanged Tiles, *tegulae hamatae*, κεραμίδες, tiles with projecting rib, 99

Fore-piece (*antefixa*), in base of catapult, 329

Fulcrum, *pressio*, ὑπομόχλιον, 295

Gimlet (machine), *terebra*, τρύπανον, siege-machine used to pierce a wall, 345

Gnomon, γνώμων, index of the sun-dial, 249

Grappling Hook, *see* Crane, *supra*

Gynaeconitis, γυναικωνῖτις, the women's quarters in a house; in small houses the name is given to all except the entrance court and the room adjoining, 47

Gypsum, γύψος, calcium sulphate; plaster of Paris is made from it, 91

Hamaxopodes, *arbusculae*, ἁμαξόποδες, wooden blocks to take the axle of wheels, 349

Helepolis, ἑλέπολις, *lit.* 'city-taker,' large siege-engine, 360

Herring-bone, *spicatum*, laid obliquely in alternate rows, 83

Hexachord (*hexachordos*), ἑξάχορδος, used of a water-organ with six notes, 315

Historia, ἱστορία, inquiry, history, 50

Hopper, *infundibulum*, χωνίον, a funnel through which grain passes into a mill, 307

INDEX OF TECHNICAL TERMS

Hydraulic machines, *hydraulicae machinae*, ὑδραυλικὰ ὄργανα, depends upon atmospheric pressure exerted through water, 259

Hypate, ὑπάτη, highest string of instrument, giving lowest note, 15

Hypogeon, ὑπόγαιον, underground chamber often vaulted, 53

Hypomochlion, *see* Fulcrum

Hysginum, ὕσγινον, scarlet dye made from parasite on kermes oak, *quercus coccifera*, 127

Imago, equivalent as in Lucr. to *simulacrum*, εἴδωλον, images supposed to be given off from bodies, 23

Impost (arch.), *incumba*, ἔρεισμα, the springing of an arch, 55

Inclination (astr.), *enclima*, ἔγκλιμα. Before the spherical form of the earth was known, it was supposed that there was a straight slope from the meridian to the north pole, 254

Indigo, *indicum*, ἰνδικόν, probably identical with our Indian ink, 121

Infundibulum, *see* Hopper

Jamb, *postis*, παραστάς, the side of a door or other opening, 52

Lacunae (a dial), lit. panelled ceiling, ὀρόφωμα ῥομβωτόν, a name given to the Pantheon, 255

Laeotomus, λαιότομος, a line in the analemma, 253

Laser, σιλφίου ὀπὸς, assafetida, juice of *laserpitium*, σίλφιον, a plant growing at Cyrene, 163

Lead, Red, *sandaraca*, σανδαράκη, produced by heating white lead, 125

Lead, White, *cerussa*, ψιμύθιον, preparation of, 125

Levelling, *perlibratio*, ὁμαλισμός, 179

Lever, *vectis*, μοχλός, 295

Liberal Arts, *disciplinae*, μαθήματα, according to Vitruvius: Grammar, Drawing, Mathematics, History, Philosophy including Natural Science, Music, Medicine, Law, Astronomy, Vol. I, 9; Vol. II, 7

Malachite, *see* Chryscocolla.

Manaeus, *manaios*, Ionic or Doric form of μηναῖος, circle of months in analemma, 253

Mechanics, principles of (*scientia machinalis*, Plin. *N.H.* VII. 125, not in Vitr.), μηχανικά, 275

Mesauloe, μέσαυλοι, Att. μέταυλοι, passages to guest-chambers, 49

Minium, κιννάβαρι, cinnabar, red mercuric sulphide, 115

Modiolus, κάδος, bucket, 305

Natura rerum, φύσις, (a) nature, the order of things; (b) nature personified; (c) subject of treatise by Democritus, 207

Nave (of wheel), *modiolus*, πλημνή, 321

Naves (*hamaxopodes*), *arbusculae*, ἁμαξόποδες, blocks in which wheels turned, 349

Nete, νήτη, lowest string of a musical instrument giving the highest note, 15

Node (astr.), *statio*, στηριγμός, apparent stationary position of planet where the orbit of the planet intersects the ecliptic, 217

Obliquity (astr.), *inclinatio*, ἔγκλισις, the inclination of the plane of the ecliptic to that of the equator, 163

Octachord (hydraulic), *octachordos*, ὀκτάχορδος, used of a water-organ with eight notes, 315

Octogenariae, (pipes) made of lead sheets 80 inches wide, 185

Oeci, οἶκοι, saloons, 31; in Odyssey, οἶκος sometimes means large room

Oiax, *ansa gubernaculi*, οἴαξ, tiller, 299

Orpiment, *see* Auripigmentum, 112

Papyrus, πάπυρος, paper prepared from strips of the Paper Rush, 67

Paranete, παρανήτη, the note next the highest, 15

Pelecinus, πελεκῖνος, a dial in the form of a double axe, 259

Pentaspastos, πεντάσπαστον, a tackle with five pulleys, 283

Penthouse, *pluteus*, σκέπη, shelter to protect troops, 354

Perithecium, περιθήκιον, the same as Amphieres, 285

Peritreta or -i, *scutulae*, περίτρητα or -οι, cross-pieces in front of balista, 335

373

INDEX OF TECHNICAL TERMS

374

INDEX OF TECHNICAL TERMS

375

GEOGRAPHICAL AND HISTORICAL INDEX TO BOTH VOLUMES[1]

The numbers refer mainly to the English version; a few to the Latin text

[1] This index has been constructed throughout by reference to the text of *H*. This circumstance and the special reference to craftsmanship has involved at least a hundred variations from the index of Rose and Müller–Strübing (ed. 1867), an edition which, following Mr. Krohn, I treat as the vulgate.

GEOGRAPHICAL AND HISTORICAL INDEX

377

GEOGRAPHICAL AND HISTORICAL INDEX

GEOGRAPHICAL AND HISTORICAL INDEX

NOTE ON THE ILLUSTRATIONS

The illustrations are intended, in the spirit of Vitruvius himself X. viii. 6, rather to indicate the principles on which machines are constructed than to exhibit the details of such construction which, he says, can only be understood in the presence of the machines themselves. The attempted restorations of the water-clock Pl. N, and the water-organ Pl. R are to be understood in this sense.

Plate K requires a further note. The problem of the Mesolabium is to find the proportion between the sides of two cubes one of which has double the content of the other. This is solved by taking two mean proportionals. The analytic solution is given in a note, p. 206.

The Mesolabium solves the problem geometrically.

It consists of three square frames with diagonals, moving in grooves so that MFGN can pass behind AEFM, and NGHQ, behind MFGN. Let QH be bisected at D.

Then the second frame is made to slide under the first, and the third under the second in such a way that the points at which the diagonals disappear, B and C, are in a straight line with AD. Let the line AD and the line EH be produced until they meet at K. By the similarity of the triangles, it may be shown that AE BF CG DH are in continued proportion; hence if AE = 2DH, $BF^3 = 2CG^3$.

The Cheirotometon was represented in a drawing—*quo scribitur*—and had reference to the impression made by a ring. We have seen how the perspective treatment of stage scenery revolutionised the art of painting. It is probable therefore that the cutting of intaglios with reference to perspective projection, explains the revolution which produced the masterpieces of the fifth century. The phrase ' cheirotometon ' or ' hand-cut ' is peculiarly appropriate because the

NOTE ON THE ILLUSTRATIONS

diamond-point, as contrasted with more mechanical tools, was used with greater freedom and revealed the touch of the artist.

Middleton, *Ancient Gems*, *app.* xxvi, refers to the impossibility of representing a rounded surface in a plane projection. Hence, some such diagram as Pl. K, fig. 3, would guide the artist. Let B . . B represent the plane containing the surface of the stone to be cut; and A . . A a line perpendicular to this plane. Let I . . I represent the depth of the intaglio; and S . . S the raised surface of the impression. Let C be taken as the vanishing-point of the intaglio. As a matter of fact, the subject of an intaglio is so near the imaginary spectator that a vanishing-point can usually be left out of account. There are exceptions. The chair on a gem of Dexamenos is rather absurd, Middleton, *op. cit.*, fig. 11. It clashes with the perspective of the figure. Hence a vanishing-point is sometimes necessary.

In addition to the vanishing-point which is the same for the intaglio and for the impression, there is the more difficult matter of adjusting the depth of the intaglio to the desired impression. As the eye moves from the vanishing-point, the corresponding points on the intaglio appear nearer to the centre of the picture, than the points on the actual impression. This appears from the dotted line R which indicates the ray from a point in the intaglio. The horizontal line drawn from the end of R shows the corresponding point in the impression, which is more distant from the centre, than the ray from the intaglio.

For Granger's belief that the Pantheon was a huge sundial, see *Journal R.I.B.A.*, 26 Nov. 1932. It is not credible—cf. D. S. Robertson, *Class. Rev.*, 1934, 229.

It is possible to form some idea of the automata constructed by Ctesibius and others. Plate M is based mainly on Barbaro *Vitruvio* A.D. 1584, p. 433. The motive power is supplied by an inverted bowl resting on water which rises or falls by a supply through a funnel (not shown), regulated as in the water-clock, Pl. N. A pull in the opposite direction is exercised by a bag of sand. It will appear that a small turn of the axle will cause a considerable movement of the vertical toothed wheel, and this movement is transmitted by the horizontal toothed wheel and is magnified in the large wheel turning on the same axle. A figure rising, as shown, from the large

NOTE ON THE ILLUSTRATIONS

wheel, carries a pointer which, by some use of wedges, is kept in contact at its upper end with the pillar. The pillar by its excentric position in regard to the large wheel, varies the distance by which the figure in its revolution, is separated from the pillar. In this way, the figure at its greatest distance points to the bottom of the pillar, and as it approaches nearer the pointer attached to it rises towards the top of the pillar, thus indicating the markings on the pillar. The difficulty of adjusting the pointer to the fixed pillar by wedges, suggested an alternative arrangement by which not only the figure but the pillar is made to revolve, IX. viii. 7. But the principle of the mechanism is the same. The reader must again be warned that precision of detail is not to be expected.

Plates O, P, Q, are taken from the small Junta edition of Vitruvius of 1522, and are due to Fra Giocondo. They illustrate the principles of the Pulley, the Tympanum, and the Water-screw.

The attempted restoration of the Water-organ, Plate R, owes something to the valuable illustration of W. Schmidt, *Hero*, I, p. 500. But as will be seen on comparison, my own figure is simplified.

PLATE I.

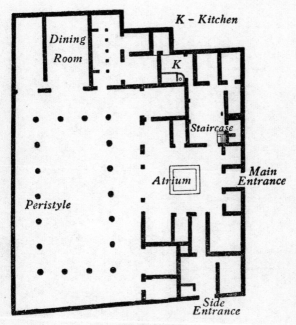

Dining Room

K – Kitchen

K

Peristyle

Staircase

Atrium

Main Entrance

Side Entrance

PLAN OF HOUSE

Book VI. iii. 3.

Domus Vettiorum, Pompeii.

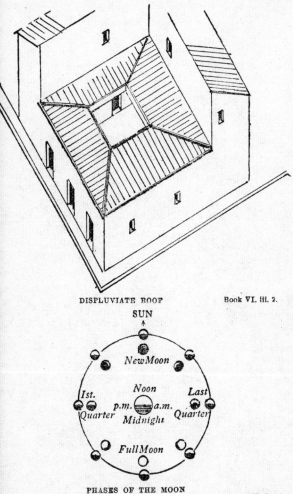

DISPLUVIATE ROOF Book VI. iii. 2.

SUN

NewMoon

1st.
Quarter

Noon
p.m. a.m.
Midnight

Last
Quarter

FullMoon

PHASES OF THE MOON Book IX. ii. 1.

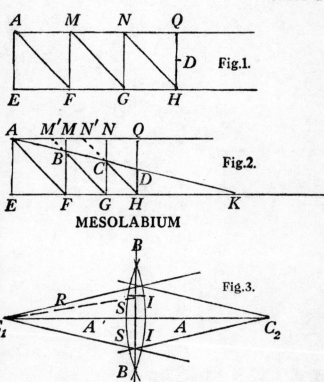

Fig.1.

Fig.2.

MESOLABIUM

Fig.3.

CHEIROTOMETON

Book IX, pref. 14.

Plate I

Fig. 1.

Fig. 2.

MESOLABIUM

Fig. 3.

CHEIROTOMETRON

PLATE L.

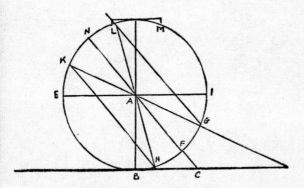

ANALEMMA: LATITUDE OF ROME

Book IX. vii. 1 ff.

AB.	Gnomon.	CFAN.	Equinoctial Ray.
BC.	Shadow.	GAK.	Winter Solstice.
EI.	Horizon.	HAL.	Summer Solstice.

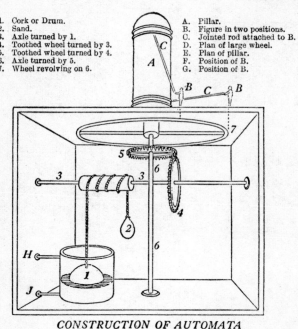

1. Cork or Drum.
2. Sand.
3. Axle turned by 1.
4. Toothed wheel turned by 3.
5. Toothed wheel turned by 4.
6. Axle turned by 5.
7. Wheel revolving on 6.

A. Pillar.
B. Figure in two positions.
C. Jointed rod attached to B.
D. Plan of large wheel.
E. Plan of pillar.
F. Position of B.
G. Position of B.

CONSTRUCTION OF AUTOMATA

Book IX. viii. 5.

H. Inlet to cistern.
J. Outlet.

CONSTRUCTION OF AUTOGRAPH

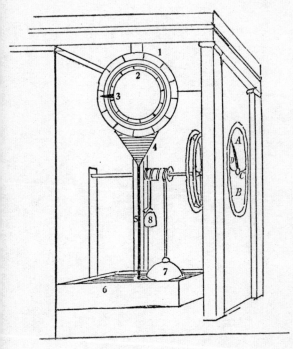

WATER-CLOCK OF CTESIBIUS

Book IX. viii. 8.

1. Outer fixed circle of signs.
2. Inner movable circle of months.
3. Point moving with inner circle.
4. Cistern receiving water from rotary valves of 2.
5. Pipe delivering into 6.
6. Main cistern.

7. "Cork" or drum.
8. Sand.
A. Hours of daylight.
B. Night hours.
C. Dividing line.
D. Finger of clock.

PLATE O.

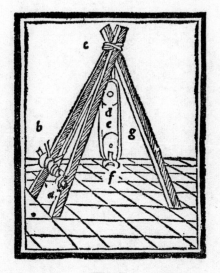

PULLEY.

Book X. ii. 1 ff.

a.	Windlass.	d.	Upper block.
b.	Socket of windlass.	e.	Lower block.
c.	Brace.		Pincers.

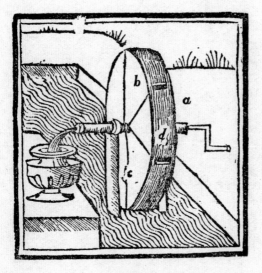

TYMPANUM

Book X. iv.

a. Axle. c. Upright.
b. Tympanum. d. Opening.

PLATE Q.

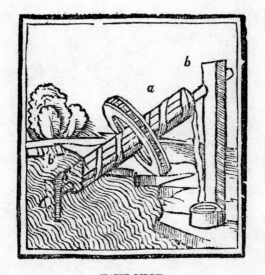

WATER-SCREW

Book X. vi.

a. Screw. *b.* Upright in which screw turns.

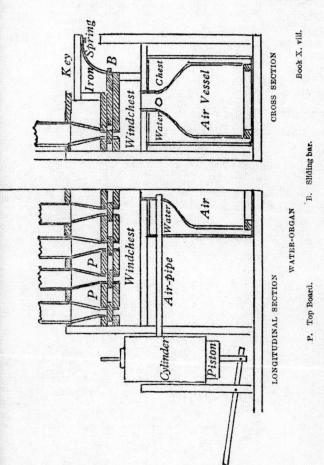

Book X. viii.

CROSS SECTION

Key

Iron Spring

B

Windchest

Water

Chest

O

Air Vessel

Windchest

P P

Air-pipe

Water

Air

Cylinder

Piston

LONGITUDINAL SECTION

WATER-ORGAN

P. Top Board. B. Sliding bar.

PLATE 8.

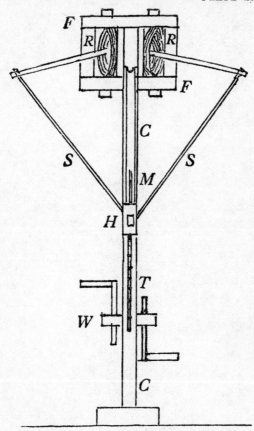

DIAGRAM OF BALISTA: BACK ELEVATION

BALISTA

Book X. xi.

C. Channel inclined 45°.
F. Frame.
R. Ropes in tension.
W. Windlass.

S. Bowstring.
M. Missile.
H. Hook to release bowstring.
T. Rope tightened by windlass.

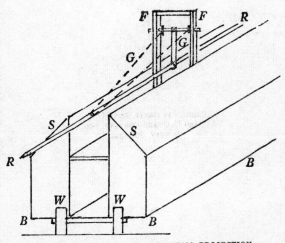

PLATE T

FRONT ELEVATION AND ISOMETRIC PROJECTION

TORTOISE OF HAGETOR

Book X. xv.

F. Frame.	B. Base.
G. Guiding ropes.	W. Wheels.
R. Ram.	S. Sloping roof.

PRINTED IN GREAT BRITAIN BY
RICHARD CLAY AND COMPANY, LTD.,
BUNGAY, SUFFOLK.

THE LOEB CLASSICAL LIBRARY

VOLUMES ALREADY PUBLISHED

Latin Authors

AMMIANUS MARCELLINUS. Translated by J. C. Rolfe. 3 Vols.

APULEIUS: THE GOLDEN ASS (METAMORPHOSES). W. Adlington (1566). Revised by S. Gaselee.

ST. AUGUSTINE: CITY OF GOD. 7 Vols. Vol. I. G. H. McCracken. Vol. VI. W. C. Greene.

ST. AUGUSTINE, CONFESSIONS OF. W. Watts (1631). 2 Vols.

ST. AUGUSTINE, SELECT LETTERS. J. H. Baxter.

AUSONIUS. H. G. Evelyn White. 2 Vols.

BEDE. J. E. King. 2 Vols.

BOETHIUS: TRACTS and DE CONSOLATIONE PHILOSOPHIAE. Rev. H. F. Stewart and E. K. Rand.

CAESAR: ALEXANDRIAN, AFRICAN and SPANISH WARS. A. G. Way.

CAESAR: CIVIL WARS. A. G. Peskett.

CAESAR: GALLIC WAR. H. J. Edwards.

CATO: DE RE RUSTICA; VARRO: DE RE RUSTICA. H. B. Ash and W. D. Hooper.

CATULLUS. F. W. Cornish; TIBULLUS. J. B. Postgate; PERVIGILIUM VENERIS. J. W. Mackail.

CELSUS: DE MEDICINA. W. G. Spencer. 3 Vols.

CICERO: BRUTUS, and ORATOR. G. L. Hendrickson and H. M. Hubbell.

[CICERO]: AD HERENNIUM. H. Caplan.

CICERO: DE ORATORE, etc. 2 Vols. Vol. I. DE ORATORE, Books I. and II. E. W. Sutton and H. Rackham. Vol. II. DE ORATORE, Book III. De Fato; Paradoxa Stoicorum; De Partitione Oratoria. H. Rackham.

CICERO: DE FINIBUS. H. Rackham.

CICERO: DE INVENTIONE, etc. H. M. Hubbell.

CICERO: DE NATURA DEORUM and ACADEMICA. H. Rackham.

CICERO: DE OFFICIIS. Walter Miller.

CICERO: DE REPUBLICA and DE LEGIBUS; SOMNIUM SCIPIONIS. Clinton W. Keyes.

CICERO: DE SENECTUTE, DE AMICITIA, DE DIVINATIONE. W. A. Falconer.

CICERO: IN CATILINAM, PRO FLACCO, PRO MURENA, PRO SULLA. Louis E. Lord.

CICERO: LETTERS to ATTICUS. E. O. Winstedt. 3 Vols.

CICERO: LETTERS TO HIS FRIENDS. W. Glynn Williams. 3 Vols.

CICERO: PHILIPPICS. W. C. A. Ker.

CICERO: PRO ARCHIA POST REDITUM, DE DOMO, DE HARUSPICUM RESPONSIS, PRO PLANCIO. N. H. Watts.

CICERO: PRO CAECINA, PRO LEGE MANILIA, PRO CLUENTIO, PRO RABIRIO. H. Grose Hodge.

CICERO: PRO CAELIO, DE PROVINCIIS CONSULARIBUS, PRO BALBO. R. Gardner.

CICERO: PRO MILONE, IN PISONEM, PRO SCAURO, PRO FONTEIO, PRO RABIRIO POSTUMO, PRO MARCELLO, PRO LIGARIO, PRO REGE DEIOTARO. N. H. Watts.

CICERO: PRO QUINCTIO, PRO ROSCIO AMERINO, PRO ROSCIO COMOEDO, CONTRA RULLUM. J. H. Freese.

CICERO: PRO SESTIO, IN VATINIUM. R. Gardner.

CICERO: TUSCULAN DISPUTATIONS. J. E. King.

CICERO: VERRINE ORATIONS. L. H. G. Greenwood. 2 Vols.

CLAUDIAN. M. Platnauer. 2 Vols.

COLUMELLA: DE RE RUSTICA. DE ARBORIBUS. H. B. Ash, E. S. Forster and E. Heffner. 3 Vols.

CURTIUS, Q.: HISTORY OF ALEXANDER. J. C. Rolfe. 2 Vols.

FLORUS. E. S. Forster; and CORNELIUS NEPOS. J. C. Rolfe.

FRONTINUS: STRATAGEMS and AQUEDUCTS. C. E. Bennett and M. B. McElwain.

FRONTO: CORRESPONDENCE. C. R. Haines. 2 Vols.

GELLIUS, J. C. Rolfe. 3 Vols.

HORACE: ODES AND EPODES. C. E. Bennett.

HORACE: SATIRES, EPISTLES, ARS POETICA. H. R. Fairclough.

JEROME: SELECTED LETTERS. F. A. Wright.

JUVENAL and PERSIUS. G. G. Ramsay.

LIVY. B. O. Foster, F. G. Moore, Evan T. Sage, and A. C. Schlesinger and R. M. Geer (General Index). 14 Vols.

LUCAN. J. D. Duff.

LUCRETIUS. W. H. D. Rouse.

MARTIAL. W. C. A. Ker. 2 Vols.

MINOR LATIN POETS: from PUBLILIUS SYRUS TO RUTILIUS NAMATIANUS, including GRATTIUS, CALPURNIUS SICULUS, NEMESIANUS, AVIANUS, and others with "Aetna" and the "Phoenix." J. Wight Duff and Arnold M. Duff.

OVID: THE ART OF LOVE and OTHER POEMS. J. H. Mozley.

Ovid: Fasti. Sir James G. Frazer.

Ovid: Heroides and Amores. Grant Showerman.

Ovid: Metamorphoses. F. J. Miller. 2 Vols.

Ovid: Tristia and Ex Ponto. A. L. Wheeler.

Persius. Cf. Juvenal.

Petronius. M. Heseltine; Seneca; Apocolocyntosis. W. H. D. Rouse.

Plautus. Paul Nixon. 5 Vols.

Pliny: Letters. Melmoth's Translation revised by W. M. L. Hutchinson. 2 Vols.

Pliny: Natural History. H. Rackham and W. H. S. Jones. 10 Vols. Vols. I.–V. and IX. H. Rackham. Vols. VI. and VII. W. H. S. Jones.

Propertius. H. E. Butler.

Prudentius. H. J. Thomson. 2 Vols.

Quintilian. H. E. Butler. 4 Vols.

Remains of Old Latin. E. H. Warmington. 4 Vols. Vol. I. (Ennius and Caecilius.) Vol. II. (Livius, Naevius, Pacuvius, Accius.) Vol. III. (Lucilius and Laws of XII Tables.) (Archaic Inscriptions.)

Sallust. J. C. Rolfe.

Scriptores Historiae Augustae. D. Magie. 3 Vols.

Seneca: Apocolocyntosis. Cf. Petronius.

Seneca: Epistulae Morales. R. M. Gummere. 3 Vols.

Seneca: Moral Essays. J. W. Basore. 3 Vols.

Seneca: Tragedies. F. J. Miller. 2 Vols.

Sidonius: Poems and Letters. W. B. Anderson. 2 Vols.

Silius Italicus. J. D. Duff. 2 Vols.

Statius. J. H. Mozley. 2 Vols.

Suetonius. J. C. Rolfe. 2 Vols.

Tacitus: Dialogues. Sir Wm. Peterson. Agricola and Germania. Maurice Hutton.

Tacitus: Histories and Annals. C. H. Moore and J. Jackson. 4 Vols.

Terence. John Sargeaunt. 2 Vols.

Tertullian: Apologia and De Spectaculis. T. R. Glover. Minucius Felix. G. H. Rendall.

Valerius Flaccus. J. H. Mozley.

Varro: De Lingua Latina. R. G. Kent. 2 Vols.

Velleius Paterculus and Res Gestae Divi Augusti. F. W. Shipley.

Virgil. H. R. Fairclough. 2 Vols.

Vitruvius: De Architectura. F. Granger. 2 Vols.

3

Greek Authors

ACHILLES TATIUS. S. Gaselee.

AELIAN: ON THE NATURE OF ANIMALS. A. F. Scholfield. 3 Vols.

AENEAS TACTICUS, ASCLEPIODOTUS and ONASANDER. The Illinois Greek Club.

AESCHINES. C. D. Adams.

AESCHYLUS. H. Weir Smyth. 2 Vols.

ALCIPHRON, AELIAN, PHILOSTRATUS: LETTERS. A. R. Benner and F. H. Fobes.

ANDOCIDES, ANTIPHON, Cf. MINOR ATTIC ORATORS.

APOLLODORUS. Sir James G. Frazer. 2 Vols.

APOLLONIUS RHODIUS. R. C. Seaton.

THE APOSTOLIC FATHERS. Kirsopp Lake. 2 Vols.

APPIAN: ROMAN HISTORY. Horace White. 4 Vols.

ARATUS. Cf. CALLIMACHUS.

ARISTOPHANES. Benjamin Bickley Rogers. 3 Vols. Verse trans.

ARISTOTLE: ART OF RHETORIC. J. H. Freese.

ARISTOTLE: ATHENIAN CONSTITUTION, EUDEMIAN ETHICS, VICES AND VIRTUES. H. Rackham.

ARISTOTLE: GENERATION OF ANIMALS. A. L. Peck.

ARISTOTLE: METAPHYSICS. H. Tredennick. 2 Vols.

ARISTOTLE: METEROLOGICA. H. D. P. Lee.

ARISTOTLE: MINOR WORKS. W. S. Hett. On Colours, On Things Heard, On Physiognomies, On Plants, On Marvellous Things Heard, Mechanical Problems, On Indivisible Lines, On Situations and Names of Winds, On Melissus, Xenophanes, and Gorgias.

ARISTOTLE: NICOMACHEAN ETHICS. H. Rackham.

ARISTOTLE: OECONOMICA and MAGNA MORALIA. G. C. Armstrong; (with Metaphysics, Vol. II.).

ARISTOTLE: ON THE HEAVENS. W. K. C. Guthrie.

ARISTOTLE: ON THE SOUL. PARVA NATURALIA. ON BREATH. W. S. Hett.

ARISTOTLE: CATEGORIES, ON INTERPRETATION, PRIOR ANALYTICS. H. P. Cooke and H. Tredennick.

ARISTOTLE: POSTERIOR ANALYTICS, TOPICS. H. Tredennick and E. S. Forster.

ARISTOTLE: ON SOPHISTICAL REFUTATIONS.
On Coming to be and Passing Away, On the Cosmos. E. S. Forster and D. J. Furley.

ARISTOTLE: PARTS OF ANIMALS. A. L. Peck; MOTION AND PROGRESSION OF ANIMALS. E. S. Forster.

ARISTOTLE: PHYSICS. Rev. P. Wicksteed and F. M. Cornford. 2 Vols.

ARISTOTLE: POETICS and LONGINUS. W. Hamilton Fyfe; DEMETRIUS ON STYLE. W. Rhys Roberts.

ARISTOTLE: POLITICS. H. Rackham.

ARISTOTLE: PROBLEMS. W. S. Hett. 2 Vols.

ARISTOTLE: RHETORICA AD ALEXANDRUM (with PROBLEMS. Vol. II.) H. Rackham.

ARRIAN: HISTORY OF ALEXANDER and INDICA. Rev. E. Iliffe Robson. 2 Vols.

ATHENAEUS: DEIPNOSOPHISTAE. C. B. Gulick. 7 Vols.

ST. BASIL: LETTERS. R. J. Deferrari. 4 Vols.

CALLIMACHUS: FRAGMENTS. C. A. Trypanis.

CALLIMACHUS, Hymns and Epigrams, and LYCOPHRON. A. W. Mair; ARATUS. G. R. Mair.

CLEMENT of ALEXANDRIA. Rev. G. W. Butterworth.

COLLUTHUS. Cf. OPPIAN.

DAPHNIS AND CHLOE. Thornley's Translation revised by J. M. Edmonds; and PARTHENIUS. S. Gaselee.

DEMOSTHENES I.: OLYNTHIACS, PHILIPPICS and MINOR ORATIONS. I.–XVII. AND XX. J. H. Vince.

DEMOSTHENES II.: DE CORONA and DE FALSA LEGATIONE. C. A. Vince and J. H. Vince.

DEMOSTHENES III.: MEIDIAS, ANDROTION, ARISTOCRATES, TIMOCRATES and ARISTOGEITON, I. AND II. J. H. Vince.

DEMOSTHENES IV.–VI.: PRIVATE ORATIONS and IN NEAERAM. A. T. Murray.

DEMOSTHENES VII.: FUNERAL SPEECH, EROTIC ESSAY, EXORDIA and LETTERS. N. W. and N. J. DeWitt.

DIO CASSIUS: ROMAN HISTORY. E. Cary. 9 Vols.

DIO CHRYSOSTOM. J. W. Cohoon and H. Lamar Crosby. 5 Vols.

DIODORUS SICULUS. 12 Vols. Vols. I.–VI. C. H. Oldfather. Vol. VII. C. L. Sherman. Vols. IX. and X. R. M. Geer. Vol. XI. F. Walton.

DIOGENES LAERTIUS. R. D. Hicks. 2 Vols.

DIONYSIUS OF HALICARNASSUS: ROMAN ANTIQUITIES. Spelman's translation revised by E. Cary. 7 Vols.

EPICTETUS. W. A. Oldfather. 2 Vols.

EURIPIDES. A. S. Way. 4 Vols. Verse trans.

EUSEBIUS: ECCLESIASTICAL HISTORY. Kirsopp Lake and J. E. L. Oulton. 2 Vols.

GALEN: ON THE NATURAL FACULTIES. A. J. Brock.

THE GREEK ANTHOLOGY. W. R. Paton. 5 Vols.

GREEK ELEGY AND IAMBUS with the ANACREONTEA. J. M. Edmonds. 2 Vols.

THE GREEK BUCOLIC POETS (THEOCRITUS, BION, MOSCHUS).
J. M. Edmonds.

GREEK MATHEMATICAL WORKS. Ivor Thomas. 2 Vols.

HERODES. Cf. THEOPHRASTUS: CHARACTERS.

HERODOTUS. A. D. Godley. 4 Vols.

HESIOD AND THE HOMERIC HYMNS. H. G. Evelyn White.

HIPPOCRATES and the FRAGMENTS OF HERACLEITUS. W. H. S. Jones and E. T. Withington. 4 Vols.

HOMER: ILIAD. A. T. Murray. 2 Vols.

HOMER: ODYSSEY. A. T. Murray. 2 Vols.

ISAEUS. E. W. Forster.

ISOCRATES. George Norlin and LaRue Van Hook. 3 Vols.

ST. JOHN DAMASCENE: BARLAAM AND IOASAPH. Rev. G. R. Woodward and Harold Mattingly.

JOSEPHUS. H. St. J. Thackeray and Ralph Marcus. 9 Vols. Vols. I.–VII.

JULIAN. Wilmer Cave Wright. 3 Vols.

LUCIAN. 8 Vols. Vols. I.–V. A. M. Harmon. Vol. VI. K. Kilburn.

LYCOPHRON. Cf. CALLIMACHUS.

LYRA GRAECA. J. M. Edmonds. 3 Vols.

LYSIAS. W. R. M. Lamb.

MANETHO. W. G. Waddell: PTOLEMY: TETRABIBLOS. F. E. Robbins.

MARCUS AURELIUS. C. R. Haines.

MENANDER. F. G. Allinson.

MINOR ATTIC ORATORS (ANTIPHON, ANDOCIDES, LYCURGUS, DEMADES, DINARCHUS, HYPEREIDES). K. J. Maidment and J. O. Burtt. 2 Vols.

NONNOS: DIONYSIACA. W. H. D. Rouse. 3 Vols.

OPPIAN, COLLUTHUS, TRYPHIODORUS. A. W. Mair.

PAPYRI. NON-LITERARY SELECTIONS. A. S. Hunt and C. C. Edgar. 2 Vols. LITERARY SELECTIONS (Poetry). D. L. Page.

PARTHENIUS. Cf. DAPHNIS and CHLOE.

PAUSANIAS: DESCRIPTION OF GREECE. W. H. S. Jones. 4 Vols. and Companion Vol. arranged by R. E. Wycherley.

PHILO. 10 Vols. Vols. I.–V.; F. H. Colson and Rev. G. H. Whitaker. Vols. VI.–IX.; F. H. Colson.

PHILO: two supplementary Vols. (*Translation only.*) Ralph Marcus.

PHILOSTRATUS: THE LIFE OF APOLLONIUS OF TYANA. F. C. Conybeare. 2 Vols.

PHILOSTRATUS: IMAGINES; CALLISTRATUS: DESCRIPTIONS. A. Fairbanks.

6

PHILOSTRATUS and EUNAPIUS: LIVES OF THE SOPHISTS. Wilmer Cave Wright.

PINDAR. Sir J. E. Sandys.

PLATO: CHARMIDES, ALCIBIADES, HIPPARCHUS, THE LOVERS, THEAGES, MINOS and EPINOMIS. W. R. M. Lamb.

PLATO: CRATYLUS, PARMENIDES, GREATER HIPPIAS, LESSER HIPPIAS. H. N. Fowler.

PLATO: EUTHYPHRO, APOLOGY, CRITO, PHAEDO, PHAEDRUS. H. N. Fowler.

PLATO: LACHES, PROTAGORAS, MENO, EUTHYDEMUS. W. R. M. Lamb.

PLATO: LAWS. Rev. R. G. Bury. 2 Vols.

PLATO: LYSIS, SYMPOSIUM, GORGIAS. W. R. M. Lamb.

PLATO: REPUBLIC. Paul Shorey. 2 Vols.

PLATO: STATESMAN, PHILEBUS. H. N. Fowler; ION. W. R. M. Lamb.

PLATO: THEAETETUS and SOPHIST. H. N. Fowler.

PLATO: TIMAEUS, CRITIAS, CLITOPHO, MENEXENUS, EPISTULAE. Rev. R. G. Bury.

PLUTARCH: MORALIA. 15 Vols. Vols. I.–V. F. C. Babbitt. Vol. VI. W. C. Helmbold. Vol. VII. P. H. De Lacy and B. Einarson. Vol. IX. E. L. Minar, Jr., F. H. Sandbach, W. C. Helmbold. Vol. X. H. N. Fowler. Vol. XII. H. Cherniss and W. C. Helmbold.

PLUTARCH: THE PARALLEL LIVES. B. Perrin. 11 Vols.

POLYBIUS. W. R. Paton. 6 Vols.

PROCOPIUS: HISTORY OF THE WARS. H. B. Dewing. 7 Vols.

PTOLEMY: TETRABIBLOS. Cf. MANETHO.

QUINTUS SMYRNAEUS. A. S. Way. Verse trans.

SEXTUS EMPIRICUS. Rev. R. G. Bury. 4 Vols.

SOPHOCLES. F. Storr. 2 Vols. Verse trans.

STRABO: GEOGRAPHY. Horace L. Jones. 8 Vols.

THEOPHRASTUS: CHARACTERS. J. M. Edmonds. HERODES, etc. A. D. Knox.

THEOPHRASTUS: ENQUIRY INTO PLANTS. Sir Arthur Hort, Bart. 2 Vols.

THUCYDIDES. C. F. Smith. 4 Vols.

TRYPHIODORUS. Cf. OPPIAN.

XENOPHON: CYROPAEDIA. Walter Miller. 2 Vols.

XENOPHON: HELLENICA, ANABASIS, APOLOGY, and SYMPOSIUM. C. L. Brownson and O. J. Todd. 3 Vols.

XENOPHON: MEMORABILIA and OECONOMICUS. E. C. Marchant.

XENOPHON: SCRIPTA MINORA. E. C. Marchant.

IN PREPARATION

Greek Authors

ARISTOTLE: HISTORY OF ANIMALS. A. L. Peck.
PLOTINUS: A. H. Armstrong.

Latin Authors

BABRIUS AND PHAEDRUS. Ben E. Perry.

DESCRIPTIVE PROSPECTUS ON APPLICATION

London
Cambridge, Mass.

WILLIAM HEINEMANN LTD
HARVARD UNIVERSITY PRESS